25·12·00

D1080123

fiona xxx.

THE WORLD OF
ART

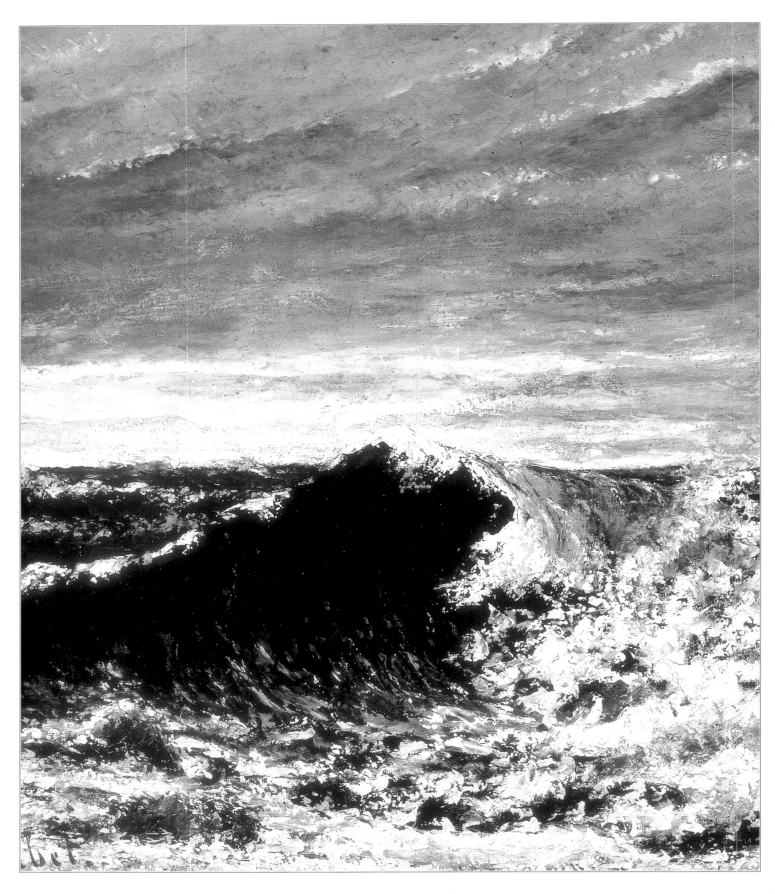

Gustave Courbet
THE WAVE (DETAIL)
(See page 370)

THE WORLD OF
ART

SANDRA FORTY

PARKGATE
BOOKS

First published in 1998 by
PRC Publishing Ltd,
Kiln House, 210 New Kings Road, London SW6 4NZ

This edition published in 2000 by
Parkgate Books
London House
Great Eastern Wharf
Parkgate Road
London
SW11 4NQ

All of the images featured in this publication have been supplied by The
Bridgeman Art Library, a commercial fine art photographic library
consisting of over 100,000 images. The archive ranges from prehistoric
cave paintings to the work of contemporary artists. The is also an
extensive collection of sculpture, ceramics, furniture, ancient artefacts,
and general objets d'art. The Bridgeman Art Library represents over
750 museums and galleries around the world and is expanding by
500 new images weekly.

ISBN 1 902616 55 3

Printed in Hong Kong

CONTENTS

INTRODUCTION

The appreciation of art is so highly personal and subjective that it defies scientific analysis. What makes one person revere High Renaissance art but dislike the work of the Impressionists is as much a mystery as what actually makes someone an artist in the first place. Great art is not merely a matter of brilliant technique, wonderful composition or ground-breaking theory—plenty of artists have had one or more of these attributes but not been judged "great." What makes great art is something that moves the inner spirit and fires the imagination of the observer, something that manages, for example, to transcend the simple application of paint to canvas—that is what many of the artists shown in these pages achieve.

This book is concerned only with painting, not with the parallel arts of sculpture and architecture. However, it is important to remember that none of these worked in isolation—the architect looked at the work of the sculptor, and he in turn watched what painters were doing, each absorbing the latest ideas thrown up by the other disciplines. Indeed, in many cases in the past—the Renaissance, as an example—the artists were multidisciplined. Each form of art influenced the other and gave new ideas and inspiration.

Furthermore, this book concerns itself only with Western painting, not with fine art as it was practiced elsewhere in the world. Western art, though, did take influence from other cultures from time to time: for example, Manet and many of the Impressionists were influenced and inspired by Japanese prints and paintings, and Matisse and Picasso among others learned an appreciation for African pattern-making, masks, sculpture, and, especially, use of vibrant color.

One of the greatest difficulties in art appreciation lies in trying to perceive a painting with the eyes of a contemporary: In trying to understand just how revolutionary was the way that Cézanne applied his paint, how assaulting was the use of Matisse's color, or just how different was the vision of the Impressionists. These days we are so used to the different approach of their paintings, that it is hard to see what all the fuss was about. But in their time many of our most treasured artists were dismissed as frauds and impostors; even an artist like Turner was vilified for his work.

A major factor, therefore, in who was able to become an artist was patronage—being able to earn sufficient money to be able to practice the art of painting. From the early years the two main sources of patronage were rulers, in particular princes and monarchs, and the church. It is unsurprising that many of the paintings that have survived the passage and ravages of time from before the fifteenth century are of a religious nature: the church was

It is difficult to appreciate today just how revolutionary Cézanne's use of color was to a contemporary. This is a detail from *The Poplars* (see page 393).

involved so much in daily life and was so wealthy that it could commission artists such as Michelangelo to portray Christian iconography. Royalty and nobility, too, were wealthy enough to be able to be patrons—and often sufficiently egocentric to want to perpetuate their image and that of their friends and family for the generations to come. In portraiture they could be remembered as better looking (mostly) than in life, and eternally youthful, and vigorous. In a time before photography, even marriage contracts could be based on a suitable painted image! Sadly, it is undoubtedly true that many of the greatest fine artists were unappreciated in their lifetime, could not find patrons, and died in poverty—men such as Vincent van Gogh and Amedeo Modigliani.

While patronage was, and still often is, crucial for an artist to survive, the works themselves have to survive the ravages of time. Take Sandro Botticelli, the Florentine who painted for a select but enthusiastic audience, primarily the Medici family and friends. Respected during his lifetime—he was involved in the fresco cycle in the Sistine Chapel in 1481—we recognize him today as a great artist. But he died in obscurity, his work was to a large extent unappreciated by history until resurrected by the Pre-Raphaelites, and only a very few of his beautiful paintings survive. Many others, particularly studies of Venus, were burned at the end of the fifteenth century during the crusade led by the fanatical Dominican friar Girolamo Savonarola.

Such fanatics down the centuries have been responsible for destroying many great works of art which did not meet with their approval. To begin with the intolerance was mainly religious, but later, particularly in the nineteenth and early twentieth centuries, politics became the all-important factor. Totalitarian regimes intent on ruling every aspect of society considered artists to be dangerous insurgents and did everything within their power to stop them. Hitler and the Nazi Party, for example, persecuted the German Expressionist painters for producing "degenerate art," and Stalin in Russia similarly eliminated all but Party art.

This political reaction is all-encompassing and memorable but, thankfully, less typical then the overt reaction to new styles and movements shown by both the public and the art establishment. This reaction can be every bit as destructive as the fanatic. The public, in general, is conservative in artistic appreciation, and this was particularly true in the nineteenth and early twentieth century, when it could take some years for a new artistic style to be appreciated—by which time it was often too late to help the artist concerned. Those artists lauded with honors and money within their own lifetime often

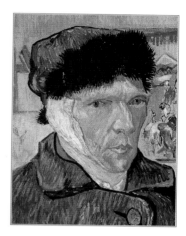

Within his own lifetime Van Gogh was almost completely ignored by the art establishment and utterly unappreciated by any save his closest friends and family until after his tragic death. He portrayed some of his despair in the painting *Self Portrait with Bandaged Ear* (see page 418).

disappear into obscurity, while their derided contemporaries emerge to be appreciated as great artists.

Most of the history of art until the mid-nineteenth century follows a broadly linear development. A new technique or approach is developed by one particular artist or school of artists, the style is then examined by other artists and the public and is either accepted or not as the case may be. There is room for both fashion and faddism, but, in general, the development is linear. From about the 1850s, however, the spirit of revolution that had been so apparent in Western society from the American Revolution onward seemed to affect the art world. In Britain the unique talents of Blake and then Turner appeared, a little later the Pre-Raphaelites began their work, then came the Symbolists, the Impressionists, and suddenly, it seems, a mounting number of art movements arose, that would influence and change the very nature of painting—surrealism, cubism, expressionism.

These movements overlapped each other, the protagonists often hating each other more than the establishment which they professed to disdain completely. But it is interesting to note how many anti-art establishment figures in time assumed gravitas and standing amongst their contemporaries and became part of the art establishment in their turn. Artists such as Millais, Picasso, and even Salvador Dali started out as revolutionaries and ended up as respectable affluent members of society.

So, this book is about paintings, primarily from Western artists, and in the main by men. The role of women in art is very one-sided—almost always they are the subject. Very few women, until the latter half of the twentieth century, have been accepted as commercial artists: one can think of only a handful such as Artemisia Gentileschi or Mary Cassatt. Women had the talent but rarely the training, were almost never taken on as apprentices outside their families, and few were given the chance to pick up a brush for anything more ambitious than a little watercolor picture of a family pet, or a particularly pretty view. The twentieth century has seen an improvement: perhaps the art of the twenty-first century will see proper balance restored.

HISTORY OF WESTERN PAINTING

This book displays Western painting chronologically so that the viewer can get a feeling for the way that the art, and artistic movements, progressed over the years. It starts in the medieval period, but in reality Western art started much earlier than that. The first known use of pigment for the rendition of an illustration was in prehistoric cave paintings and drawings on

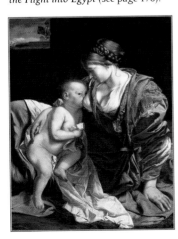

Artemisia Gentileschi is one of the very few women before the twentieth century to have made a living as a painter, and this was only because her father was a very successful artist. This is a detail from *Rest on the Flight into Egypt* (see page 176).

rocks. While not common—they are rarely seen by anyone except archaeologists and anthropologists—they have been found at many ancient locations around the world, most famously in America, Australia, France, and Spain. It is believed that these early artists were actually trying to capture the spirit of the animal they delineated, and probably supported by mystic incantations and ceremony, they were used as powerful magic to aid a successful hunt.

The key elements of Western art are provided by the classical civilizations—Egypt, Greece, and Rome—whose styles and practices form the basis for Western culture today. Most of their art comes to us in the form of buildings, sculpture, and pottery—stone, metal, and clay that has been able to survive the ages. Not as much of their painting survives—some frescoes, funerary work, paintings on pottery—but there is enough to show that the artists and artistic movements covered in the book are a progression from a long lineage extending back over a thousand years before the birth of Christ.

This book starts some centuries later, with the earliest medieval art. Much of this was produced by anonymous scribes working in monasteries painstakingly illuminating manuscripts. Many of these beautiful works still survive, ascribed to artists such as William de Brailes, who worked in Oxford between 1238 and 1252. Artists like him specialized in the illumination of bibles and psalters and worked in monasteries and workshops across the Christian world, producing uplifting volumes for the very richest clients.

At this time relatively few people could read, even among the ruling class, so illustration played a hugely important role in conveying the Christian message. Religious paintings were used also as teaching and learning tools, similar in intent in many ways to stained glass windows in cathedrals and churches. It was not until the nineteenth century that the majority of the population was able to read, so a painting of a pertinent story from, for example, the gospels, would be used to reinforce the verbal story from the local priest. Of course, not everyone had easy access to such magnificent pictures, but many were hung in the great cathedrals and institutions of Europe open to the public for their edification and enlightenment.

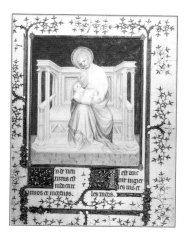

Some of the very earliest works of art to survive come from medieval prayer books and volumes of religious observance. This example is taken from the *Psalter du Duc de Berry* (see page 40).

GOTHIC AND INTERNATIONAL GOTHIC

The Church of the medieval period consciously searched for artists of ability to illustrate the Christian message and many artists worked exclusively for the Church. They worked in the Gothic style, which was, at heart, an architectural and decorative tradition from northern Europe, where actual

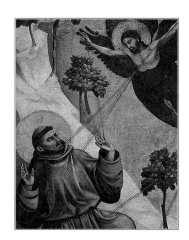

Giotto is credited as the first Western artist to attempt to render the human form as three-dimensional and to show landscape as naturally as possible. He was influential in his home town of Florence and in nearby Siena but it took a century for his ideas to penetrate further afield. This is from *St Francis Receiving the Stigmata* (see page 35).

painting was less usual. Painting didn't really come into its own until the Late Gothic period, when artists like Mathias Grünewald (c. 1475–1528) were working. Late Gothic started in the early twelfth century and lasted more or less until the end of the sixteenth, when the influence of the Renaissance swept away all medieval affectations. The greatest Late Gothic artist was indisputably Giotto (c. 1267-1337), a Florentine who is generally regarded as the father of modern painting. Impressed by the solidity of sculpture, he attempted to provide the same tangibility to his painted figures. Furthermore, he wanted to give his landscapes an equally natural, evocative look. His ideas were taken up with enthusiasm by the artists around him in Siena and Florence. Elsewhere Giotto's influence would not be truly felt until the mid-fifteenth century.

During the fourteenth century Europe's most magnificent courts were to be found in Burgundy and France. Along with all the other trappings of nobility, artists were important in their role of portraying the magnificence of their masters. These men still painted in Gothic style, but a more sophisticated and naturalistic vision suffused their work—especially with regard to landscapes and animals. This development is given the label International Gothic. The style rapidly spread east to Italy, where Simone Martini (1284-1344) and the sculptor Lorenzo Ghiberti (1378-1455) worked, and north to Germany and Bohemia.

The fourteenth century is popularly known in art history circles as the Trecento. It was a time of slow change and gradually increasing sophistication in painting and the arts generally. Many of the greatest artists of the time were from Siena, Florence, and Venice, and they worked for wealthy patrons. The use of perspective was explored: what artists particularly wanted to discover was how to convey a three-dimensional object—a figure or a building—on a two-dimensional canvas, and where to place the "vanishing point." Two of the main innovators in this field were Piero della Francesca (c. 1415-92) and Paolo Uccello (1396-1475), the latter in particular being consumed by the new science of foreshortening.

THE RENAISSANCE

The discovery of perspective led to major changes in artistic vision and, inevitably, led enquiring minds further. Around the middle of the fifteenth century, the very first lights of the Renaissance emerged, with artists looking back with renewed interest to the work of Giotto and his attempts at realism. Renaissance means literally "rebirth," and was a term used to

convey a return to classical arts and letters. Two of the earliest and greatest painters of the time were Florentines (like Giotto). Filippino Lippi (c. 1406-69) and Sandro Botticelli (c. 1445-1510); both benefited from this interest and their paintings reflect the new interest in naturalism, although their own particular style is so mannered as to be dubbed Quattrocento Mannerism.

Botticelli was particularly interested in line and mythological subjects which he painted for Humanist patrons, mainly the Medicis. Sadly many of his mythological paintings ended up on Savonarola's bonfires, so it is impossible to gauge how far from the norm he explored; instead we are largely left with his religious and social paintings.

In northern Europe the prevailing style was completely different, the Renaissance took much longer to penetrate a style that had moved on from Gothic to a more romantic, lyrical approach, attributable to the Danube School. The greatest luminary of this new interest in nature and the environment was Albrecht Altdorfer (c. 1480-1538), who is widely credited as being the first true landscape painter. He endeavored to convey the beauty of the Danube region and the Alps. His interpretation of landscape was romantic in the extreme and provided the template for the German romantic style.

Working at much the same time in the Netherlands was a group of artists known as the Antwerp Mannerists. They painted in a strange, hugely mannered style of elaborate artificial poses coupled with overwhelming floral ornamentation. The best-known artist from this group was Adriaen Isenbrandt (or Ysenbrandt, who died in 1551), but little is left of his work.

With the turn of the century into the Cinquecento, the Italian artists of the High Renaissance flourished. Men such as Leonardo da Vinci (1452-1519), Raphael (real name Giovanni Santi, 1483-1520), and Michelangelo Buonarroti (1475-1564) painted in such a way as never seen before—their absolute confidence and ability with their paint and brushes gave them a sheer mastery of technique that had not been achieved hitherto—and many would say has not been achieved since. They painted landscapes, figures, and buildings in pure, classical compositions presenting a painting as close to the actual as possible—a "true" rendition. These masterworks have a unique, calm, clarity and coolness of precision unmatched by any other era, and Christian iconography has never had better exponents. The Church knew this and used these artists to glorify and embellish its works and monuments.

Leonardo da Vinci was the quintessential Renaissance man—not only was he one of the greatest painters ever, he was also a man of incredible

For many art lovers Michelangelo is simply the greatest and most gifted artist ever. Certainly his works were on a grandiose scale, but none was bigger than his commission from Pope Leo X to paint the ceiling of the Sistine Chapel in the Vatican. This is a detail from *Sistine Chapel Ceiling: Creation of Adam* (see page 105).

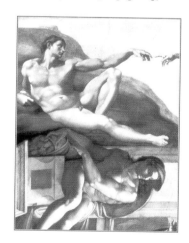

breadth of imagination and invention. His inquisitive mind and towering intelligence drove him to investigate the workings of the human body and other imponderbles such as how man could fly. He has left a legacy of sketches and drawings which show his startling imagination and inventive genius.

Michelangelo was more of a sculptor than painter and in both spheres qualified as a genius. Because of his enormous and diverse abilities—he was a sculptor, painter, draftsman, architect, and poet—he left remarkably few paintings. He spent much of his professional life working for the popes in Rome, his most important work being the painting of the Sistine Chapel ceiling in the Vatican.

Raphael was the youngest of this remarkable Renaissance trio and his flowering as an artist mirrors almost exactly the period of the High Renaissance. His talent was so prodigious, that he was elevated to being the equal of da Vinci and Michelangelo by the time he was twenty-six. Sadly, only eleven years later he was dead. He painted frescoes and canvases, designed buildings and tapestries, but towards the end of his short life his style was discernibly veering towards Mannerism.

MANNERISM

The Renaissance style was not, however, universal even within Italy; there were a number of artists whose approach did not fit comfortably within the category of Renaissance art, or of the later Baroque style. These men had a more intellectual approach to their canvases; human figures were stylized and their anatomy given a prominent musculature. Furthermore, the Mannerists used vivid, bold colors as a matter of course rather than as just highlights. This analytical approach to painting was later termed Mannerism and is taken roughly to cover the period 1520-1600, although the artists within this category differ enormously. Michelangelo in time came over to the Mannerists' way of thinking: other prominent Mannerists include Giovanni Battista Rosso Fiorentino (1494-1540), Jacopo Tintoretto (1518-94), Francesco Parmigianino (1503-40), and the completely individual, elongated, and colorful contortions of El Greco (properly named Domenikos Theotocopoulos, 1541-1614) also fall into this school.

As religious conflicts shattered Europe, the Catholic Church lost ground to the Protestant Reformation before fighting back with its own Counter-Reformation. This turbulent time saw different artistic styles arising to personify each church, as artists reflected the changing mores to keep their patrons happy. Broadly speaking, northern Protestant Europe favored a more

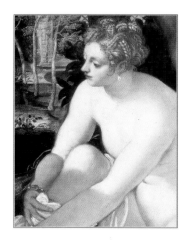

A move away from Renaissance art came with the development of Mannerism—a more intellectual and altogether more colorful approach to painting.One of the most celebrated artists of the style was Jacopo Tintoretto, who lived and worked in Venice where he developed a Mannerist style. Typical of his approach is this detail from *Susanna Bathing* (see page 136).

natural, rationalist, urban view of life, while southern, Counter-Reformation Catholics favored the more exuberant, stylized, and colorful works. In the south, and especially in Rome, the High Renaissance mutated into Baroque as a combination of classical and religious art mixed in with a new interest in pagan antiquity. The approach was to appeal directly to the onlooker at an emotional level with an onslaught of color, light, and composition, all conveying a clearly understood message. There was absolutely no subtlety with this approach.

BAROQUE

The High Baroque period can be considered to have started around 1630 and to have overlapped with the Mannerists until its extinction around fifty years later when the style continued on, although much changed. In its earliest days the most notable exponent was Michelangelo Merisi da Caravaggio (1573-1610), a highly individual artist who is still noted for his strongly contrasting use of light and shadow to model his figures—termed *chiaroscuro*.

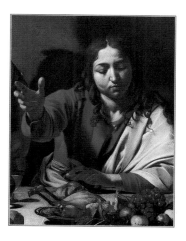

Caravaggio is the undisputed master of *chiaroscuro*—the boldly contrasting use of light and shade within a painting, as in this detail from *The Supper at Emmaus* (see page 157).

The Baroque style found early favor in France, especially at the court of the Sun King Louis XIV, who encouraged its opulence to enhance his own splendor, and as he ruled for 72 years the style became deeply entrenched in the French psyche. His undisputed favorite artist, to whom he granted immense power over the arts, was Charles Lebrun (1619-90), who painted magnificent portraits of the king, his mistresses, and his entourage. His contemporary, the French artist Nicolas Poussin (1594-1665), was more interested in the intellectual and classical approach, and did not find favor in his homeland or with his monarch, whose interest in excessive overelaboration was the rule of the day. Elsewhere, in Britain, Scandinavia, and the Protestant Netherlands, Baroque was not taken up to any degree as it was considered too Catholic and excessive.

Northern Baroque was a style favored in Catholic countries like Germany, Austria, and the Catholic parts of the Netherlands. There one of the most world's important artists, Peter Paul Rubens (1577-1640), lived for much of his life after traveling in Italy and Spain. There he saw the work of High Renaissance and Baroque artists such as Michelangelo, Raphael, Caravaggio, and Titian (properly called Tiziano Vecelli c. 1487-1576) for himself. He settled in Antwerp, from where his family came, and worked as court painter to the Spanish Governors of the Netherlands. His output was prolific: it had to be to meet the demands of the huge number of

commissions which rolled in. The sheer amount of work was far too huge for him to handle alone and he gathered a studio of apprentices around him to do the bulk of the background, working from his sketches. He would then do the detail himself.

As Baroque played itself out with ever-increasing profligacy, the excess finally began to stultify and people grew tired of it. Gradually a general toning-down started and the style mutated gently into the more refined Rococo.

DUTCH MASTERS

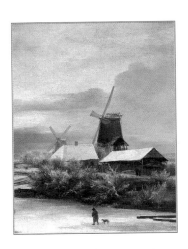

Dutch painters in the seventeenth century became synonomous with beautifully refined landscape paintings, and one of the very best was Jacob van Ruisdael. Snow scenes were a particular speciality of these Dutch masters as in this detail from *Winter Landscape* (see page 212).

While High Renaissance flowed effortlessly into the Baroque in Italy and around the Mediterranean, up in the colder, darker north the Utrecht School of painters developed around the 1620s. They took their inspiration from the stylized *chiaroscuro* paintings of Caravaggio. Of the school the most important members were Gerrit van Honthorst (1590-1656), Dirck van Baburen (c. 1590-1624), and Hendrick Terbrugghen (1588-1629). They had all been to Rome and seen the great Italian Renaissance masters before returning to Utrecht in the 1620s where they settled down to paint genre pictures and religious scenes.

Far more influential in the long term were two painters, master and pupil, Jacob van Ruisdael (1629-82) and Meindert Hobbema (1638-1709) both of whom became synonymous with the refined art of Dutch landscape painting. Van Ruisdael came from Haarlem, and took landscape painting onto a new peak with his realistic views of the flatlands of the Netherlands. He was a prolific painter, whose lot it was to achieve greater recognition two centuries later. He is known particularly for the way he handled huge skies and weather effects. In later life his landscapes took on a distinctly Romantic mood.

Ruisdael's apprentice, Hobbema, became his close friend to such an extent that their paintings are at times almost indistinguishable. However, the pupil is thought by some to excel his master. In fact, Hobbema's career was truncated and his oeuvre much smaller than his master's. He seems to have given up painting for much of the latter half of his life and we are left with but a few of his delightful landscapes.

Jan Vermeer (1632-75) was a contemporary compatriot of these two great landscape painters. He lived and worked quietly in the town of Delft. Unlike Ruisdael and Hobbema, his work was on the domestic scene, executed in meticulous detail: nobody has done it better. Sadly, he was unappreciated in his lifetime and his widow and eleven children were left destitute on his early death.

RUBÉNISME AND BAROQUE

In France, towards the end of the seventeenth century, a new era brought in Rubénisme, the most important artistic movement of the period. The supreme painter of the time was Jean-Antoine Watteau (1684-1721), a nominal Frenchman who was actually Flemish. He was greatly influenced by Rubens and also Veronese. His individual use of delicate brush strokes and color came to typify Rococo, which flowered after 1715 following the death of Louis XIV.

In common with Baroque, Rococo was principally an architectural and decorative style that found lesser expression in art; nevertheless, it produced some important painters and has widespread influence although the style never really caught on in England, Italy or Spain where it was considered too frivolous, but for that very reason it found favor in southern Germany and Austria. Rococo was primarily a French movement, coming from the word *rocaille* meaning rock-work. It is dated as lasting from the death of Louis XIV in 1715, hit its apogee in 1730, continued until around 1740 when it fell victim to its very fashionability and became replaced by the more cerebral and restrained Neo-classicism.

The other great archetypical Rococo painter, a follower of Watteau, was François Boucher (1703-70). His patrons were Madame de Pompadour and her circle, who admired his mythological semi-naked nymphs cavorting in shade-dappled flower-strewn glades.

Across the Alps in Italy the Venetian Giovanni Battista Tiepolo was the greatest artist of the time, the master of fresco work, his light allegorical style making him the supreme exponent of Rococo. Together with his brother-in-law, Francesco Guardi (1712-93) who specialized in Venetian scenes, he dominated Italian painting of the period.

Slightly later in the eighteenth century, the work of Francisco de Goya y Lucientes (1746-1828) attracted attention. One-time official portrait painter to the Spanish monarchy, he turned to fantasy and satire to assuage his soul. The 1790s were a time of savagery and bloodshed as France and Spain fought. Worse was to come in 1808 when Napoleon's armies invaded Spain and overthrew the monarchy of Ferdinand VII. In the bloody warfare which followed, atrocities and barbarism were rife. The regular armies ranged against the French were commanded by Wellington—but Spanish irregular troops ranged the Iberian peninsula. His heart bleeding for his country, Goya became the first and greatest chronicler of battle, showing it in all its hideous glory.

As different as it is possible to get from his series of paintings of bloody warfare, this portrait of *The Naked Maja* by Goya expresses a sensuality and unashamed eroticism which was barely acceptable in polite society of the time.(see page 280).

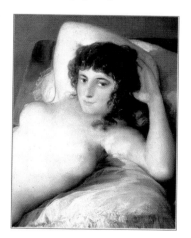

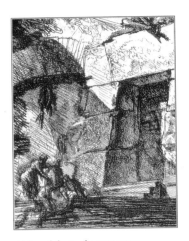

Although better known as an architect, Giovanni Piranesi was a draftsman of considerable verve and style. Here is a detail from one such example *An Imaginary Prison*, Plate IX from the *Carceri d'Invenzione* Series (see page 236).

NEO-CLASSICISM

After the over-embellishment of Baroque and Rococo, even in Rome and Paris the public mood turned to styles that showed more restraint. Around the 1740s a general interest in a return to classical heritage was heightened by the discovery of the buried towns of Herculaneum and Pompeii in 1748. The statuary and frescoes reminded Italians, in particular, of their ancient classical heritage, and they were desperate to rediscover the virtues of such artistic purity and strength. The style was dubbed Romanticism, or Classicism, but to distinguish the contemporary movement from the past it was termed Neo-classicism. Strangely enough the mental discipline of the approach appealed strongly to the German mentality (despite the enthusiasm of the painters of that country for the Baroque).

Rome and Greece were linked and virtually synonymous in the popular imagination, and artists were charged with bringing to life their times. They depicted everyday life to the best of their knowledge—and this was scant about ancient Greece until archaeological discoveries were made there in the next century. Instead artists were left to imitate as closely as they could the subject matter and styles left to them on ancient monuments and frescoes. Romanticism found a broad audience across western Europe, with many artists following suit including the Venetian architect Giovanni Battista Piranesi (1720-78), Giovanni Panini (1692-1765)—an artist who discovered and exploited the romance of ruins—and the German Anton Mengs (1728-79) who specialized in portraits and ceilings.

Following in their footsteps, but taking the artistic discipline to greater heights, Jacques-Louis David (1748-1825) was the greatest Neo-classicist. His style was inextricably bound up in his political views, which were distinctly Republican, and he painted the portraits of many Revolutionary leaders and important supporters. After meeting Napoleon, David became Bonaparte's ardent follower and, in many ways, his chief propagandist. His paintings extolled the virtues of order and form over color and imagination, even in his many portraits. He used classical subjects as examples of good citizenship, applying ancient morals to contemporary circumstances.

The other great French painter of the period—Eugène Delacroix (1798-1863)—was altogether more romantic in approach. He rejected the prevailing mood for Neo-classicism preferring, instead, the lighter touch of English landscape painters such as John Constable (1776-1837). He also took inspiration from adventure novels and poems, the works of writers such as Shakespeare, Byron, and Scott, as well as from the lives of people in North

Africa, which he visited in 1832. He took full part in the contemporary salon life of the Paris intelligentsia and used his friends there as subjects and inspiration. Establishment circles fought hard to keep him out, but his general popularity finally prevailed, and he was elected to the Institute in 1857. He is now regarded as one of the greatest French artists of all time.

LANDSCAPE PAINTING

Meanwhile, in England a completely maverick artist was emerging. Joseph Mallord Turner (1775-1851) had started as a painter of small, beautiful, but unremarkable, watercolor landscapes. Then, in the 1790s he saw and admired Dutch marine paintings and the magical romantic land- and seascapes of Claude Gellée, who was called Claude Lorraine in England (1600-82), and took to oil paints. The turning point in Turner's career came in 1819, during his first visit to Italy, where the colors and clear, penetrating, light of the Mediterranean completely altered his approach. His canvases exploded with vibrant color and light, applied vigorously to suggest form and shape, with far more of the technique of a watercolorist.

His unique approach to swirling color and light failed to impress many of his contemporaries. Towards the end of his life Turner's style was deemed unfashionable and fell from favor. Only after his death were his works viewed and appreciated. Arguably, he is the true ancestor of the Impressionists with his free use of color and light and lack of dependency on line.

Romanticism found echo across the Atlantic in the the United States, so recently freed from the controlling hands of the British crown. Here, established society figures wanted to distinguish themselves from their Old World cousins. These prosperous new citizens wanted to hang pictures of themselves and their families on their walls, and a thriving tradition of "limners" (face painters) arose, especially around New England and New York. Furthermore, Americans wanted pictures of their own country, not foreign lands thousands of miles away, on the walls of their grand houses. With much of the continent still to be explored and settled, it was only on the east coast that such distractions as art could be pursued. Between 1812 and the Civil War, massive social changes were taking place as the West was starting to open up and Americans found a new national identity.

So it was that, around 1800, the Hudson River School grew up. It started as a collection of American landscape artists who painted around the Catskills. Their style was, broadly, rural landscapes executed in a highly Romantic but hard-edged manner, with an emphasis on precise detail. The

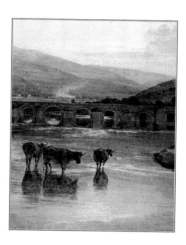

Arguably the greatest ever British painter, James Mallord Turner explored the way forward with his extravagant brush strokes and use of color. His influence on the later Impressionists is disputed, but his mature paintings certainly inhabit the same territory. This is a detail from one of his earlier works, *Bridge Over the River Usk*, painted before he had developed his swirling, impressionistic style (see page 298).

most prominent painter belonging to the group was Washington Allston (1779-1843), who started out producing Italianate landscapes but developed into a naturalistic, if highly romantic, portrayer of the American landscape. A later member of this school was Thomas Cole (1801-48). Born an Englishman, Cole came to the United States where he took up landscape painting after the style of Claude Lorraine, but executed with a higher degree of romance and drama. Another member of the Hudson River School was Asher B. Durand, one of the first landscape painters to work out of doors with the view directly in front of him.

A contemporary group of artists worked in England: the Norwich School, founded in 1803. These artists also concentrated on the landscapes around them, the difference being that they worked mainly on a smaller scale in watercolor. The two great masters of the school were John Crome (1768-1821), one of the founders of the school, and John Sell Cotman (1782-1842), who became its leading light.

The Nazarenes were founded in 1809 as a quasi-religious order, the Lukasbrüder, in Vienna by Friedrich Overbeck (1789-1869) and Franz Pforr (1788-1812). They wanted to revive German iconography in the style of earlier masters such as Dürer and the young Raphael. To explore their antecedents they went to Rome, where they started a medieval-style workshop. Though at the time they made little impact, their effect was felt by later artists such as the English Pre-Raphaelites, who admired their attempts to revive religious art and bring it up to date. Another rather more prominent European artist who was affected by their work and ideas was Ingres.

The veneration of antiquity of the Graeco-Roman world reached its apogee with the severely restrained, academic control and observation of Jean Auguste Ingres (1780-1867). He had studied for a time under David, where he learned the classical approach to painting. A great admirer of Raphael, in time he became the principal opponent to the Romantic movement as epitomized by Delacroix. Such extreme artistic discipline was associated with Humanism, and remained principally French; elsewhere the essence of the style had influence, but was much too rigid for widespread acceptance.

THE NINETEENTH CENTURY

The nineteenth century was a time of enormous change—political and economic. The aftermath of the French Revolution and the Napoleonic Wars led on to mid-century political unrest. 1848 was the year of revolution,

Ingres is notable for being the supreme classical painter, a style closely associated with the philosophy of Humanism, which was all the rage in his native France. It was not an approach which sat easily with his foreign contemporaries. This is a detail from *Portrait of Caroline Rivière (*see page 285).

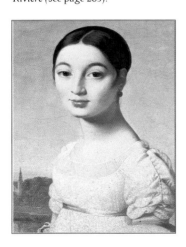

and there were continuous wars of nationalism—both Germany and Italy gained a political cohesiveness they had not seen before—and, later, colonialism. In North America, the Union would be racked by a debilitating Civil War, and all the time the Industrial Revolution gathered momentum. In Europe and America, industrialization, the railway boom, and population movement, led to big changes—the gap between rich and poor widened and, while still important to the structure of life, the Church generally was starting to lose its stranglehold on every facet of man's endeavor and this is reflected in the decline of religious subject-matter in paintings. More secular subjects, such as animal pictures and landscapes, were the norm.

The American painter James Audubon (1785-1851), after a Neo-classical training under David, returned home to study and paint American birds. By this time he had developed the ambition to study and paint every bird in America—a massive task at a time when much of the country was still being explored and mapped—and one he achieved to great popular acclaim. His magnum opus, published 1827-30 in four volumes entitled *The Birds of America*, contains 435 plates with 1,065 illustrations, magnificent etchings taken from life-size watercolors alongside scientific text. However, the most successful U.S. nineteenth century painter was Winslow Homer (1836-1910) from Boston. After drawing Union soldiers during the Civil War, he moved to Maine and started painting the sea and coastline and, principally, the weather.

A more relaxed painter who didn't quite fit into any contemporary artistic movements was Jean Baptiste Corot (1796-1875). Although born in Paris he, in common with so many artists both before and after him, went to Rome to study before returning to his homeland. While traveling in Italy, he developed his theory of the importance of tone achieved through the use of light and color rather than through form. He was, however, shrewd enough to produce paintings which would sell and he enjoyed a general popularity.

REALISM

In France the revolution and industrialization fueled the work of writers such as Emile Zola and Baudelaire, who explored the harsh reality of depredation. This in turn inspired the "truth" of the Realism movement, whose leading light was Gustave Courbet (1819-77). Realists brought the same attention to poverty and suffering as had always been applied to the nobility, to the everyday life of peasants and workers—rejecting any attempt to idealize the work of the "noble" peasant but rather depicting the bitterness

After Classicism came Realism, a political comment on the depravations and suffering which poverty inflicted on the majority of the population. Previously peasants had been depicted as romantically noble and charmingly naive, instead Gustave Courbet showed the grim reality of grinding poverty in works such as The Wave (see page 370). However here Courbet takes a break from paintings of social realism to show the sea in all its magnificence.

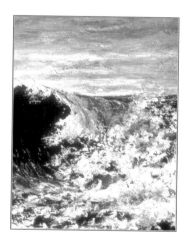

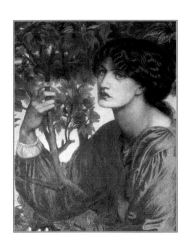

Severly criticized and derided at first, the Pre-Raphaelite Brotherhood grew to become hugely influential. Their use of metaphor and coded meaning was taken up with enthuasism by later artists as well as their contemporaries. This is a detail from *The Day Dream* by Dante Gabriel Rossetti (see page 399).

and grind of desperation. Courbet took this a step further, making himself even more unpopular by reviling the church and all its clergy. The violence within his paintings was matched by his own violence, and he was imprisoned before fleeing to Switzerland. His influence was felt abroad more than in his native France

By mid-century, Queen Victoria was settling comfortably onto the British throne and, while the Industrial Revolution was in full swing, unlike most other European countries, the political climate was relatively untroubled. The prevailing artistic atmosphere reflected the stability of middle and upper class society and produced unexceptional highly sentimental animal pictures by the likes of Edwin Landseer (1803-73), parlor pieces showing conventional landscapes, or highly flattering portraits such as executed by Franz Winterhalter (1806-73), the queen's favorite painter.

The next artistic movement to arrive on the scene was the strange little group of young artists in London, who formed in 1849. They called themselves the Pre-Raphaelite Brotherhood and wanted to take painting back to a time before Raphael, which they idealized as a time of purity and naturalism, and to re-invent Christian painting. They also emphasized the importance of working outdoors in the elements instead of safely closeted away in the studio. To this end they painted with faithful attention to the minutest detail, but included in their work elaborate symbolism so that their paintings could be "read" beyond their apparent surface meaning. In common with later innovative artistic styles, they were initially vilified by the art establishment. The most important painters to emerge were John Millais (1829-96), Dante Gabriel Rossetti (1828-82), and Edward Burne-Jones (1833-98), the latter providing inspiration to the Symbolists.

A few years later, in Italy around Florence in about 1855, a group of artists calling themselves the *Macchiaioli* (from the Italian meaning "blot") emerged. They, too, were anti-establishment but, as opposed to the PRB's hyper-realism and attention to nature, they wanted to explore the artistic possibilities of the blob of paint in relation to landscapes and genre paintings. They took their inspiration from the realism of Corot and Courbet, but no great artists emerged from this group. However, they, too, can be considered precursors of the Impressionists with their innovative use of technique.

Something was definitely in the air, because in France a similarly inspired group of landscape painters got together to paint rural scenes unsentimentalized by idealism. They gathered to live in and around the village of Barbizon in the Forest of Fontainebleau, and hence were christened the

Barbizon School. Their anti-academic landscapes won them few friends. They spent much of their lives struggling on the breadline, and thus were able to observe and experience at first hand the life of poverty of the peasants they depicted. They took their influence from the works of Corot and the Dutch landscape painters Hobbema and Ruisdael. Members of the group included Théodore Rousseau (1812-67), Narcisse-Virgile Diaz de la Peña (1808-76)—better known simply as Diaz—and Jean François Millet (1814-75), the son of a peasant himself.

THE IMPRESSIONISTS

In France the Académie Française was the supreme arbiter of taste and artistic acceptability—in exactly the same stultified manner as the Royal Academy in London ruled the artistic scene. Only academicians were endorsed and exhibited in both countries; artistic patrons also primarily came from within or via the academies. In the 1870s, there lived and worked in Paris a loose group of enthusiastic young artists. Unknown to everyone at the time, these painters were to comprise a great gathering of talented, inno-vative artists. They were to become known as the Impressionists, the most important artistic movement of the nineteenth century, after which painting and the public's perception of art have never been the same.

Unable to get their paintings accepted for showing at the Académie Française, this disparate group of artists arranged its own exhibition from April 15 to May 15, 1874; it became known as the First Impressionist Exhibition. The artists included Claude Monet (1840-1926), Pierre Auguste Renoir (1841-1919), Paul Cézanne (1839-1906), Edgar Dégas (1834-1917), Alfred Sisley (1839-99), Camille Pissarro (1831-1903), Eugène Boudin (1824-98), and Berthe Morisot (1841-95), the only woman at the time. Predictably, the public and, more pertinently, the art critics were outraged at what was exhibited at the First Impressionist Exhibition. They considered the works vulgar and coarse, far too free with the use of color, and, above all, form-less—where was line, shape, composition, and discernible subject matter? The critics chose to be scandalized by the works, and one painting in partic-ular jarred. This was *Impression, Sunrise* by Monet. The critics derided the painting as "Impressionism," and so the label was born.

Despite the notoriety the exhibition hardly made any money, but it did bind the group together and give them a name. While individually very dif-ferent, they shared a common love of painting outdoors where they could observe and attempt to capture the natural play of light and colors; they tried

Also initialy vilified, the group of largely French arists who became known as the Impressionists went on to become some of the most sought-after and venerated artists of all time. One of the greatest of these and one of the earliest exponents of the style was Pierre Auguste Renoir. This is a detail from *At the Theatre* (see page 383).

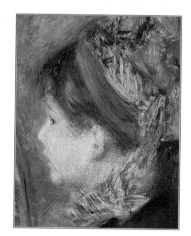

to paint movement and the fleeting moment. There was little or no intellectu-al basis for their approach, and the paintings appeared to be dashed off as quickly as the moments they tried to capture; they painted as if with a rush of blood to the head rather than with studied care.

Not all the Impressionists continued in the same lines; indeed, most of them changed as they refined their style. One artist to veer away from straightforward Impressionism was Paul Cézanne, who became interested in the use of color and tone to signify shape and form. It was his theory that an artist should look for the cone, the sphere, and cylinder in nature. To this end he obsessively painted and repainted views of Mont Sainte-Victoire, and his palette became ever brighter in his attempts to capture the Mediterranean ambience. However, his intellectualizing of his work made his efforts painful-ly slow, and more than many great artists, he has left behind many unfin-ished paintings. Unusually for such a great artistic innovator, he achieved recognition for his ability in his own lifetime and by the turn of the century he was a moderately wealthy and sought after artist.

An unexpected but important influence on the later paintings of the Impressionists came from a world away and had antecedents dating back hundreds of years into history. This was the inspiration that Japanese art and three artists in particular held: Utagawa Hiroshige (c. 1797-1858) who is principally known for his landscapes and views of his native Edo (modern Tokyo); Utamaro (1753-1806), a painter of beautiful women; and Hokusai (1760-1849), another landscape specialist. They were the absolute masters of the print and woodcut. Above all they depicted land and townscapes, in par-ticular of Edo, when snow-covered, or in the moonlight, at twilight, in cherry blossom time or with fireworks coloring the sky. But they also juxtaposed, in traditional Japanese (and Chinese) fashion, birds and flowers, popular groupings being kingfisher and irises, nightingales and cherry blossom, and peacocks and peonies. Other popular Japanese subjects included portraits of beautiful women in fashionable attire.

Japanese art appealed to many of the Impressionists, each finding some-thing different to admire in their work: Dégas was particularly taken by the strange, unconventional viewpoint from which the pictures were often seen, while Monet found their simplicity and use of minimal detail a revelation and bought Japanese prints whenever he could. Also, although not an Impressionist, Édouard Manet (1832-83) was very taken by their use of bril-liant color in strident, unadulterated blocks. Van Gogh and Gauguin, too, were affected, but by seemingly effortless exaggerated contours, the beauty

Across the other side of the world from Paris, and safely working with-in the strict rules and customs of their society, Japanese artists such as Utagawa Hiroshige had refined their art to the ultimate degree. To Western eyes, and to those of the Impressionists in particular, their silk screen prints offered a ravishing sim-plicity of form and color. This is a detail from *Kyobashi Bridge* (see page 332).

of line, and flat use of color. Pissarro was probably the first of the Impressionists to appreciate the work of Hiroshige and Utamaro when, in 1893, he visited an exhibition of 300 of their prints. From this time onward, Japanese influence is discernible in Western paintings—for example, they often appear in the background of James McNeill Whistler's (1834-1903) decorative paintings. All things Japanese became particularly popular among the cognoscenti around the turn of the century, and Japanese artworks were avidly sought.

POINTILLISM AND POST-IMPRESSIONISM

Georges Seurat (1859-91) was another strange talent who had his roots in Impressionism. He intellectualized and analyzed his art to such a degree as to make it almost a science. His style is popularly called Pointillism, but he and artists of his ilk preferred the term Neo-Impressionism or Divisionism. At source, what they wanted was to show pure, unadulterated color, which was best achieved, they thought, by applying dots of primary color in close sequence. To make a secondary color, the other primary was included: thus to show grass, yellow and blue points were put together. Up close the dots are obvious, but from a distance they merged visually to create a purer form of green than could be achieved by physically mixing yellow and blue. The resulting pictures all have a strangely dappled and stilted look about them. Seurat developed his theory of color as applied to painting around 1884-86 and would have doubtless explored it further than his few extant paintings had he not died so young.

This so-called Neo-Impressionism made its first public appearance in 1884 in Paris at the Salon des Artistes Indépendants. As well as Seurat and Pissarro, Paul Signac (1863-1935) exhibited, the latter a less effective Pointillist, although he wrote the main thesis on the group's theories of color use, elements of which were taken up by amongst others: van Gogh, Gauguin, and Henri Toulouse-Lautrec (1864-1901).

Around the mid-1880s the Impressionist and Neo-Impressionist backlash asserted itself with a group of artists who called themselves Post-Impressionists. They wanted to return to a more conventional, formal art where the subject and composition took prominence over the style. Three major artists formed the group: Vincent van Gogh (1853-90), Paul Gauguin (1848-1903), and Paul Cézanne.

The art world, particularly in Paris, was now a feverish cauldron of ideas, idealism, and influence, with constant cross-fertilization between the

Strangely still, trapped in time, *Bathers at Asnières* is a scientific approach to painting in terms of color theory. Developed by Georges Seurat Divisionism, or Pointillism as it is better known, was one of those artistic cul de sacs that history throws up from time to time. Seurat, nevertheless, somehow managed to transcend his theories to become a great artist (see page 408).

protagonists. Many of the artists knew each other, they would work together for a time, diverge, move on to another style with another colleague, and so on. Thus, many painters of this era turned up producing works in a number of different styles before, usually, settling down to one particular approach.

SYMBOLISM AND INTIMISME

The artists of mood and emotion who labelled themselves Synthetists explored the essence of the persona. They were influenced by many earlier artists who worked with allegory and imagination. One such original was Gustave Doré, a painter whose wild imaginings thrilled the Synthetists. Shown here is a detail from *The Siege of Paris* (see page 362).

In 1889, yet another new grouping assembled and exhibited. They called themselves Synthetists, although they are now better known as Symbolists. Their aim was to forget naturalism and, instead, attempt a far more difficult and intangible task—to convey mood and emotions, in effect the essence of the persona. Lyrical lines (initially always black or blue) were used to separate brilliant blocks of color, so that the final effect was decorative and abstract. The chief member of the group was Paul Gauguin, whose personal interest in cultures other than western—Japanese, Byzantine, Romanesque, and Middle and Far Eastern—brought a far richer diversity to his canvases than any of his contemporaries.

The Synthetists took art away into the unconscious world and their influence, in time, proved enormous. Their antecedents were diverse, everything from their contemporary Aubrey Beardsley (1872-98), to the mystic English watercolorist William Blake and the Pre-Raphaelite Brotherhood, to Titian, Botticelli, Andrea Mantegna (c. 1431-1506), Tiepolo, Henry Fuseli (1741-1825), Gustave Doré (1832-1883), and many others who painted pictures of allegory, wild imagination, and invention.

The chief members of the group, other than Gauguin, were Odilon Redon (1840-1916) and Emile Bernard (1868-1941). Others, such as Gustave Moreau (1826-98), an influential teacher at the École des Beaux Arts, and Pierre Puvis de Chavannes (1824-98) became much respected Symbolists.

Yet another group of French artists, who called themselves *Les Nabis* (from the Hebrew meaning "prophet"), was working at the same time—roughly 1889-99. They, too, were influenced by Symbolist writings and were (fashionably) anti-naturalistic and anti-Impressionistic; with them the subject matter was all-important, although they, too, painted in flat, pure colors. The prime movers in the group were Pierre Bonnard (1867-1947), his close friend Edouard Vuillard (1868-1940), and the sculptor Aristide Maillol (1861-1944).

Bonnard and Vuillard were both initially strongly influenced by the flat decoration of Japanese prints, before together they started specializing in domestic interior scenes. This particular offshoot of Impressionism was

termed *Intimisme* from its study of the minute detail of everyday domestic life. Another artist in this style was one of the few successful women painters, the Pittsburgh-born Mary Cassatt (1845-1926) who specialised in studies of mothers and children.

PRIMITIVE OR NAIVE ART

In spirit if not technique, an artist with distinctly Symbolist ideas emerged in Henri "*Le Douanier*" Rousseau (1844-1910). He is the ultimate primitive painter and the principal member of a long and healthy tradition of amateur painters who somehow managed to transcend technique and artistic ability to produce magical pictures of immense quality. After a career spanning nearly forty years, including spells in the French army and then in the Parisian Customs Office (1871-1893—but he never achieved the rank of *Douanier*, Customs Officer), Rousseau accepted early retirement and took up painting in his mid-fifties. He exhibited his large, elaborate paintings at the Indépendants exhibition from 1880, but it was not until Picasso proclaimed the Frenchman's genius that Rousseau found artistic acceptance.

Primitive painters have always existed; usually, they have little or no formal education or art training, and hence lack technique. Often (though not always) they are part-time painters, at least to begin with, and their primary concern is to earn a living by non-artistic means. Around the turn of the fourteenth century in the Netherlands and Italy many painters—journeymen craftsmen some of them—painted either for the love of art or for a little money. Their work lacked sophistication, but the best produced a directness of vision lacking in bona fide artists.

Although completely different, other members of this honorable group include the American Primitives or Folk Painters, the two most celebrated being the Quaker minister and artist Edward Hicks (1780-1849), and "Grandma" Moses (1860-1961). Edward Hicks, a carriage painter by trade, became the most celebrated painter of American religious and historical pictures who took much of his inspiration directly from the Bible. "Grandma" Moses, properly Ann Mary Moses (née Robertson), did not begin painting seriously until she was aged 67, when she began to suffer from arthritis after a hard life as a farmer's wife and mother of five surviving children in the Shenandoah Valley, Virginia. She returned to her childhood home of Eagle Bridge, New York and started painting colorful and simple scenes from her childhood. These—and especially her snowy winter scenes—found a ready audience when she had her first one-woman show at age eighty.

Not all great painters slaved for their art: many a frustrated soul could only put brush to canvas after earning a living at another trade. Such people were dubbed "Sunday Painters" or Naive artists. The supreme example is Henri "Le Douanier" Rousseau, a bureaucrat until he retired, but now regarded as a great artist in his own right—though it took Picasso to recognize his unique talent. Shown here is a detail from *The Cascading Gardens* (see page 456).

The best-known English primitive painter is Laurence Stephen Lowry (1887-1976) from Lancashire. While he did receive some art training, he spent his working life as a clerk and rent collector. His work is immediately recognizable for its strangely stilted, unsentimental, industrial townscapes peopled by matchstick figures.

THE NEW CENTURY

In the late nineteenth and early twentieth century the decorative Art Nouveau style became immensely popular. It revolved around the use of sinuous line with especial emphasis on flowers, leaves, and generally, naturalistic plant forms. It was an organic style and particularly prevalent in architecture of the time. Essentially French, it found widespread acceptance. In Germany much the same movement was termed *Jugendstil*, after the magazine called *Jugend* (meaning youth) which was first published in 1896. This was not an overly painterly style, instead it particularly lent itself to drawings and etchings, one of the earliest and best exponents of which was Aubrey Beardsley, the short-lived English illustrator. The best known name in Art Nouveau is the French poster artist Alphonse Mucha (1860-1930).

Around the turn of the twentieth century the art world exploded like a bomb, with young artists openly rebelling against the accepted forms of art—even the Impressionists had now become "establishment." Mirroring their revolutionary spirit elsewhere in Europe, these artists were hungry to explore any and every avenue open to them in terms of what they could paint and how they could apply their paint. Artists formed themselves into groups, each of which was intent on a particular form of expression. In an attempt to intellectualize their art, many of these groups published manifestos explaining the motives behind their work. Indeed, some artistic movements were more about ideas than art—Dadaism being the prime example.

Many of these young men attended the art schools in Paris, where they were soon kicking against the academic approach of their teachers. Painters such as Henri Matisse (1869-1954), André Derain (1880-1954), Maurice Vlaminck (1876-1958), and Georges Rouault (1871-1958) approached their canvases with verve and attack. They used the brightest colors and the wildest distortions and patterns. Their paintings were hung at the Paris Salon d'Automne, 1905: the critics were outraged, and one of them called them derisively *Les Fauves* (the Wild Beasts).

Henri Matisse, one of the most influential artists of the twentieth century, had a conventional art training given under the influence of the

By the late nineteenth century the art world was being turned upside down by the ever developing ideas of young artists. Maurice Vlaminck and his friends *Les Fauves* (the Wild Beasts), deliberately set out to shock the art establishment with their vivid colors and wild distortions of form. This is a detail from *Small Town by a Lake* (seee page 461).

Impressionists, and especially his friends Vuillard and Bonnard. Matisse tried various styles, each time using brighter colors, and was lucky in that he quickly attracted wealthy patrons to support him, particularly the American Stein family. After his Fauve period, in 1910 he visited an exhibition of Near Eastern art in Munich, where he was immediately riveted by the pure color, patterns, and arabesques of the works on show.

Just four or five years into the new century, many young artists casting around for stimulus started looking beyond Europe and Asia, and into Africa and the arts of the Pacific. In 1905 the artist Maurice Vlaminck was given an African wooden tribal mask. It was so different in every way from anything he had seen before that he showed it to André Derain, who loved it so much he persuaded his friend to sell it to him. He then took it to show Picasso and Matisse and Vollard, who were all transfixed by it. African art became a great stimulus with its simplistic forms, innovative patterns, and brilliant juxtaposition of color. Georges Braque (1882-1963) and Juan Gris (1887-1927) were also impressed by the African use of masks and sculpture, and their influence is clearly seen in the elongated figures and portraits of the young Italian painter Amedeo Modigliani (1884-1920).

In 1907 the first exhibition of the work of a group of artists calling themselves the Cubists went on show in Paris. They were a small but highly influential group who wanted to intellectualize the form and color of painting into a unity which showed the shape of any given object from more than one viewpoint to produce a multi-dimensional picture. The principal movers in this were Pablo Picasso (1881-1973) and Georges Braque (1882-1963). They looked at the paintings of Cézanne—who had worked along similar lines— but took his approach further, creating a two-dimensional picture surface that enabled the artist to analyse the form of the subject and its position in space and in relation to other objects. They dubbed the approach Analytical Cubism.

Other artists were quick to see that Cubism was the most innovative modern idiom and started painting in the style. The three best followers were Juan Gris (1887-1927), another Spaniard and the developer of "synthetic" Cubism, Fernand Léger (1881-1955), who developed his own brand of curvilinear Cubism based on geometric shapes, and Robert Delaunay (1885-1941) the inventor of Orphic Cubism. Two other painters, Albert Gleizes (1881-1953) and Jean Metzinger (1883-1956), intellectualized Cubism even further, and together wrote the first book on the movement, *Du Cubisme*, published in 1912. A further development of Cubism occurred around 1915 and was

Pablo Picasso was already widely considered the greatest living artist when he painted *Guernica*, a rage against the bombing of the Basque capital during the Spanish Civil War. He insisted that this painting was never to touch Spanish soil while a repressive régime ruled his beloved country. This is a detail from *Guernica* (see page 492).

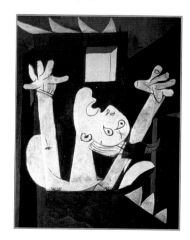

termed Suprematism. It was the invention of Kasimir Malevich (1878-1935), a Russian artist. This was simple, geometric, abstract art, that he claimed was a purer form of Cubism.

In 1911 Walter Sickert (1860-1942)—who was never a typical Impressionist, being too quirky and dark in tone—founded the Camden Town Group, an artistic exhibiting co-operative for late English Impressionism. Also in London, a fusion of Cubism and Futurism emerged when a group of painters calling themselves the Vorticists showed for the first time in 1915. The prime mover behind the movement was Wyndham Lewis (1884-1957), who was also a writer. It was an essentially semi-abstract geometric style, strong on line but with definable elements in the composition, such as machines and townscapes, and the urban environment generally. The Vorticists fairly rapidly merged with the Camden Town Group to become the London Group in 1913, from which Sickert and Lewis soon resigned.

The Spaniard Pablo Picasso is arguably the most important and innovative artist of the twentieth century, and not just because he lived a long and productive life. From a prodigious artistic start while still a boy, with his restless spirit he was also at the inception of many of the ground-breaking artistic movements. His so-called blue period progressed into Cubism, Collage, Surrealism, Metamorphism, and beyond. Picasso was, throughout his life, influenced by African primitive art, with its bold use of colors and line; he also liked pattern-making and Iberian sculpture. Furthermore, he was one of the very first artists to make serious amounts of money in his lifetime and was not the stereotypical artist starving in a garret—far from it.

OTHER MODERN ART FORMS

After the turmoil created by Impressionism, artists wanted to explore beyond naturalism to an art style that abandoned form altogether. So emerged in the late nineteenth century the honorable tradition of Abstract Art, wherein the subject of the picture is largely irrelevant; instead, the emphasis is on color and form. It breaks down into two distinct phases: the intellectual, which looked at the development of mechanical and geometric effects, and the emotional-expressive period, which tended to be much more organic in form and execution. It is a style that would be explored to a far greater extent in the twentieth century with artists such as Mark Rothko (1903-70), the Russian-American.

Another influential artistic movement which would take longer to get going but was bubbling under was termed Expressionism. This is a greatly

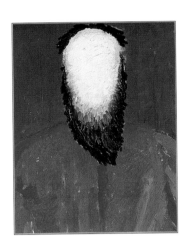

Suprematism was a peculiarly Russian form of Cubism invented by Kasimir Malevich, in which he glorifies pure, geometric abstract art. The style had no notable adherents and expired with its inventor. Shown here is a detail from Malevich's early work, *The Peasant* (see page 484), before he invented Suprematism.

simplified, distorted, and exaggerated style, whose impact lies with its harsh use of color and wild line, often used in outline. The artists who developed this were mostly German, causing Hitler to denounce it as "degenerate art." The principal artists were Emil Nolde (1867-1956), Oskar Kokoschka (1886-1980), James Ensor (1860-1949), and Max Beckmann (1884-1950)—and a bit later Georges Rouault, who moved on to join them when he left *Les Fauves*. The Austrian Egon Schiele (1890-1918) was an Expressionist whose prodigious talent was undeveloped because of his early death.

Around 1911, another small but important group of German artists appeared, this time based in Munich. They called themselves *Der Blaue Reiter* (the Blue Rider). Two important founder members were the Russian Wassily Kandinsky (1866-1944), an abstract painter, and Franz Marc (1880-1916) a German expressionist, who is best known for his beautifully colored paintings featuring blue horses. The Swiss painter Paul Klee (1879-1940) joined the group later, his speciality being, as he put it "taking a line for a walk."

Yet another principally German movement, *Die Brücke* (the Bridge) was founded in 1905 (and lasted until 1913) in Dresden. Also Expressionist in style, the group took in Fauvist elements and inspiration from the Post-Impressionist work of Gauguin and van Gogh. The principal artists were Karl Schmidt-Rottluff (1884-1976), Ernest Kirchner (1880-1938), and Erich Heckel (1883-1944). Their work was popular with the German public but reviled by the Nazis when they came to power.

In the United States, the same artistic frustrations were felt by young artists who were eager to explore all the possibilities open to them. Many crossed the Atlantic to live and learn about art in Paris, but one particular group of eight realist painters and illustrators based themselves in New York, calling their movement the Ashcan School. They set out to paint urban realism in all its grim entirety; they painted slums, bars, poolrooms, factories, and theaters. The most prominent member of the group, although not one of the founders, is George Bellows (1882-1925), who depicted urban degradation, in particular the vigor and squalidness of prize-fighting, as well as more conventional portraits and scenes along the Hudson River.

The magazine *Le Figaro* dated February 20, 1909, published an article by Filippo Marinetti (an Italian poet and later friend of Mussolini) in which he talked about heroism and the glory of war, and came up with the term Futurism to describe the type of art he espoused. In essence he wanted to see machines and figures in motion together in "universal dynamism." Earnest

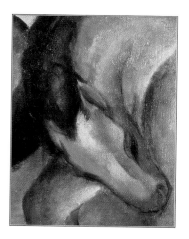

Obsessed with animals in general and horses in particular, Franz Marc's paintings show a generosity of line and appreciation of color unusual amongst most of his contemporaries. Sadly, he was a casualty of the First World War and died aged 36 at Verdun. This is a detail from *Little Yellow Horses* (see page 468).

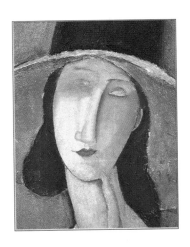

Amedeo Modigliani was the archetypal handsome young artist, suffering from poverty, drug addiction and alcoholism in a Parisian garret until he died of his excesses. Almost overnight his paintings became sought-after and earned him the recognition he craved. This is a detail from *Portrait of Jeanne Hebuterne* (see page 477).

manifestos were published explaining the theories further and the "Manifest of Futurist Painting" was signed by Umberto Boccioni (1882-1916), the most influential of the Futurists, Carlo Carrà (1881-1966), Giacomo Balla (1871-1958), and Gino Severini (1883-1966). The Futurist Exhibition was assembled and opened in Paris, where it caused a great scandal. It then continued around Europe causing riots virtually wherever it opened. Ironically, the movement petered out when its leading light, Boccioni, died in 1916 of wounds received in the Great War.

The Constructivists were a similarly mechanical-oriented movement, which came about some years later in 1917, but this time from within Russia; it died a death within four years. The main impact was through the constructivist exhibition held in 1920 entitled "Realistic Manifesto." It was principally a sculptural movement which grew out of the art of collage; this in turn influenced architecture and decoration more than fine art. The main artists associated with Constructivism are Naum Gabo (1890-1977) and László Moholy-Nagy (1895-1946).

World War I was raging when, around 1915, an artistic backlash erupted in the shape of Dadaism. Marcel Duchamp (1887-1968) provided much of the inspiration for Dadaism, and he did not so much paint as assemble art works; however, he left Zürich for New York before the official founding of the movement. As a neutral city, Zürich had become a rallying point for a community of artists who would otherwise have got drawn into the war. These artists decided to hold an entertainment, a cabaret, as an expression of their art; so in a public house a variety of international performance art was given and described as *Dada*—French for hobby-horse. Artists like Jean Arp (1887-1966)—one time Blue Rider, then Dada member, and finally Surrealist—Picasso, Kandinsky, and Modigliani, as well as the poet and writer Filippo Marinetti (1876-1944), became associated with the movement by contributing to a brochure entitled *Cabaret Voltaire*. This was followed by a shop, "Galerie Dada" and a number of articles and books on the theories they espoused. Dada was as much performance art as anything else. They wanted Dada to be "a rallying point for abstract energies." The movement was essentially nihilistic and anti-art, anti-bourgeois taste and expectations; it set out deliberately to flout acceptable behavior and taste.

Despite being a non-art art movement Dada, was hugely influential on many young artists who took the base ideas and developed them onto canvas. One such was a young Italian called Giorgio De'Chirico (1888-1978), who in 1920 was allied to Dada, but he wanted to explore dream images

drifting in romantic landscape in a style uniquely his own. Together with Carrà—they were in the Italian Army together—he founded the *Pittura Metafisica* (Metaphysical painting) movement in 1917, a precursor to the Surrealists. Another poetic visionary was the Russian painter Marc Chagall (1887-1985), who also charted the realms of the unconscious, highlighted with brilliant color.

Both De'Chirico and Chagall were to contribute to the inspiration which founded and fueled Surrealism. The word *Surréaliste* was used by Apollinaire in 1917 to mean "pure psychic automatism . . . freedom from the exercise of reason." This meant that the artist's unconscious should be allowed free rein without interference from his reason and logic. However, the first Surrealist artists were arguably the medieval painters who depicted weird, dreamsequences, and landscapes: for example, the great Dutch painter Hieronymus Bosch (c. 1450-1516) and his hellish, fantasy scenes; Giuseppe Arcimboldi (1527-93), a Milanese painter of truly weird fruit and vegetable-assembled portraits. Other antecedents include Fuseli, Goya, and Redon; certainly the twentieth century Surrealists revered their work. As with other contemporary movements, much of the work was sculptural and involved collage, but many great painters found their feet with Surrealism—Artists such as Yves Tanguy (1900-55), Salvador Dali (1904-1989), and the Belgian René Magritte (1898-1967), as well as Arp, De'Chirico, Klee and Picasso for a period.

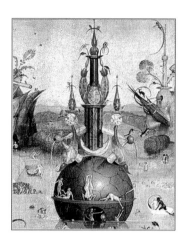

Hieronymous Bosch painted weird scenes of medieval violence and fantasy— exactly the type of imaginative work which was greatly admired by the Surrealists, although he was working almost five hundred years earlier. This is a detail from *The Garden of Earthly Delights* (see page 92).

In complete contrast, but still part of the unconscious era of painting, belongs Action Painting, where artworks are assembled by means of dribbling, dropping, squirting, splashing, and throwing paint onto canvas to produce great sweeps of spontaneous movement. The most luminous artist of this genre—who is also labeled as an Abstract Expressionist—is Jackson Pollock (1912-56), who did not use a brush at all for his early huge canvases. A similar movement was dubbed *Tachisme* from the French *tache*, meaning blot or stain, and this is often used to describe the early work of Pollock.

Then in the late 1950s, the most important late twentieth century artistic movement appeared out of popular culture—unsurprisingly, it was named Pop Art. It seems to have arisen simultaneously on both sides of the Atlantic in England and the United States. Like earlier movements, it was in many ways anti-art, except it wanted to present art in terms of popular culture and, therefore, to be accessible to all. Artists assembled works out of everyday objects, especially ephemera, to produce vividly colorful projects. The major British artists are David Hockney (born 1937), Richard Hamilton (born

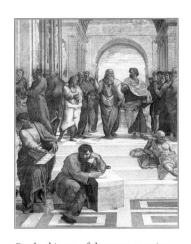

Raphael is one of the greatest artists who ever wielded a brush, and the youngest and most precocious of the three artists who epitomize the High Renaissance (the other two being da Vinci and Michelangelo). Shown here is *The School of Athens* (see page 100).

1922), Peter Blake (born 1932), and Eduardo Paolozzi (born 1924). In America, principally in New York, artists such as Andy Warhol (1928-1987), Jasper Johns (born 1930), Robert Rauschenberg (born 1925), and Roy Lichtenstein (1923-1998) were working to great acclaim. A minor sideline of this appeared in the 1960s in the form of Op Art or optical art which played games with the eyes and visual perception. The two principal protagonists were Victor Vasarely (born 1908) and Bridget Riley (born 1931).

And so we come to the present. What great artistic movements will influence the artists working into the twenty-first century? Certainly, there is—as there has been for much of the twentieth century—a great coming together of styles, bursting the definition of painting we discussed at the beginning of this Introduction. Performance art, sheep in tanks of formaldehyde, the global village, it is difficult to see whether there is potential for progress in the world of art. One thing, however, it is safe to say: the price of the great works of art of the past grow in value every year. It seems as if, today, we are prepared to put a higher price on perfection, particularly where that perfection involves the application of paint to a suitable surface.

Right: Detail from *The Archduke Leopold-Wilhelm's Studio*, by David Teniers, the Younger, 1610-90 (see page 205).

THE WORKS OF

Art

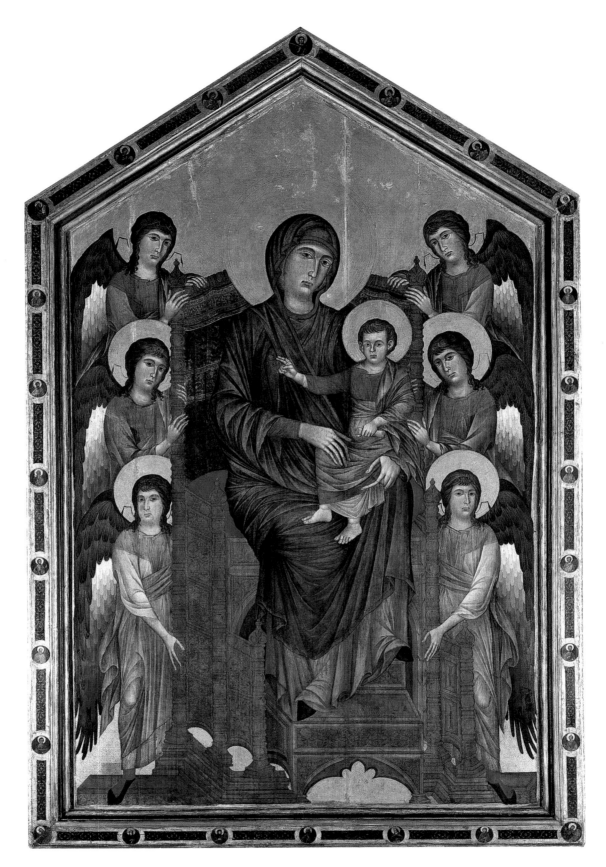

Giovanni Cimabue

THE VIRGIN AND CHILD IN MAJESTY SURROUNDED BY SIX ANGELS

Active in and died in Florence • 1240-1302
Panel • 168.1 in x 110.2 in • Musée du Louvre, Paris, France/Bridgeman Art Library, London

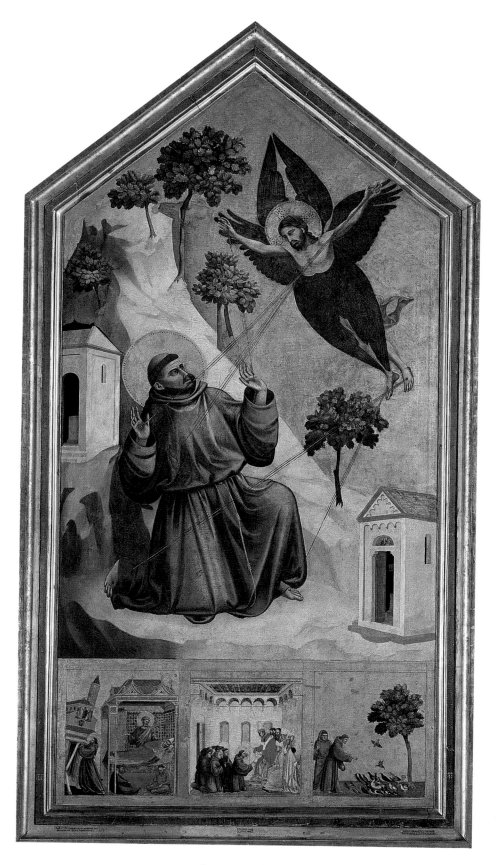

Ambrogio Bondone Giotto

ST. FRANCIS RECEIVING THE STIGMATA

Born in Colle di Vesprignano • Died in Florence • 1267-1337
Oil on board • 12.3 in x 6.4 in • Musée du Louvre, Paris, France/Bridgeman Art Library, London

Duccio di Buoninsegna

MAESTA; ENTRY INTO JERUSALEM
(DETAIL FROM THE MAESTA ALTERPIECE)

Born and died in Siena • c. 1278-1318
Tempera on panel • 97.5 in x 184.3 in (whole alterpiece) • Museo dell'Opera del Duomo, Siena, Italy/Bridgeman Art Library, London

Simone Martini

GUIDORICIO DA FOGLIANO

Born in Siena • Died in Avignon • 1284-1344
Fresco • Palazzo Communale, Siena, Italy/Bridgeman Art Library, London

Pietro Lorenzetti

THE ANNUNCIATION

Active in Siena 1319 • Died in Siena • c. 1300-48
Tempera on panel • 44.1 in x 46 in • Pinacoteca Nazionale, Siena, Italy/Bridgeman Art Library, London

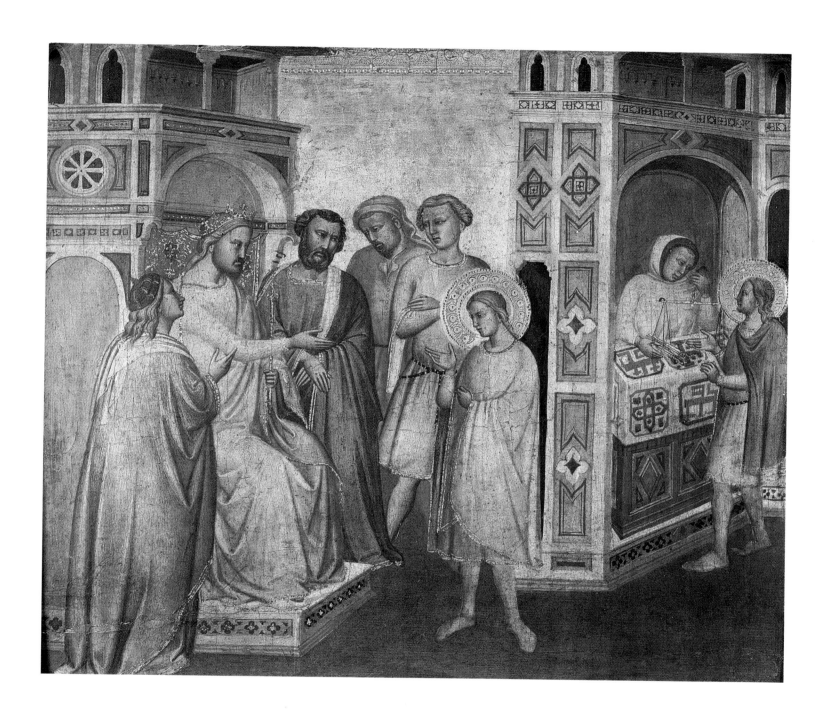

Taddeo Gaddi

St. Eloi Before King Clotarius

Born • Died in Florence • c. 1300-66
Panel • 13.8 in x 15.4 in • Museo del Prado, Madrid, Spain/Bridgeman Art Library, London

André Beauneveu

ST. PHILIP
(FROM THE PSALTER OF JEAN, DUC DU BERRY)

Active and died in Valenciennes • c. 1335-1403/13
Vellum • Bibliothèque Nationale, Paris, France/Bridgeman Art Library, London

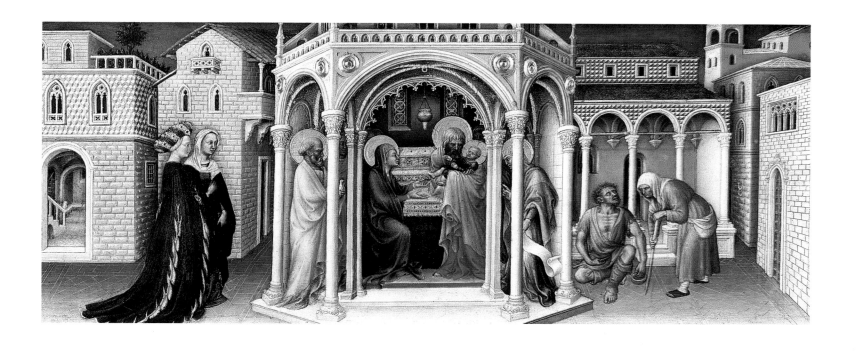

Gentile da Fabriano

THE PRESENTATION IN THE TEMPLE

Born in Fabriano • Died in Rome • 1370-1427
Wood • 10.4 in x 26 in • Musée du Louvre, Paris, France/Bridgeman Art Library, London

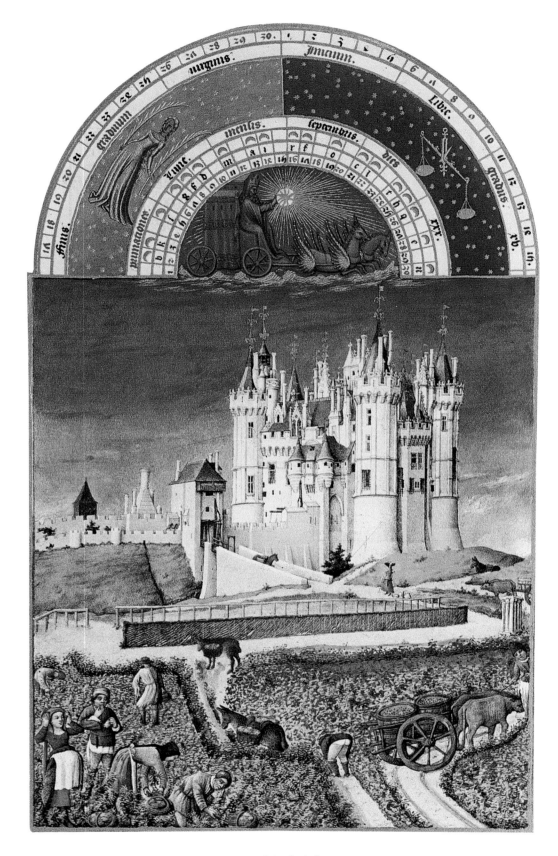

Jean and Paul Limbourg

SEPTEMBER; HARVESTING GRAPES
(FROM THE *Très Riches Heures du duc de Berry*)

Birth and death locations unknown • Active c. 1400
Illumination on vellum • 9.4 in x 6 in • Victoria and Albert Museum, London/Bridgeman Art Library, London

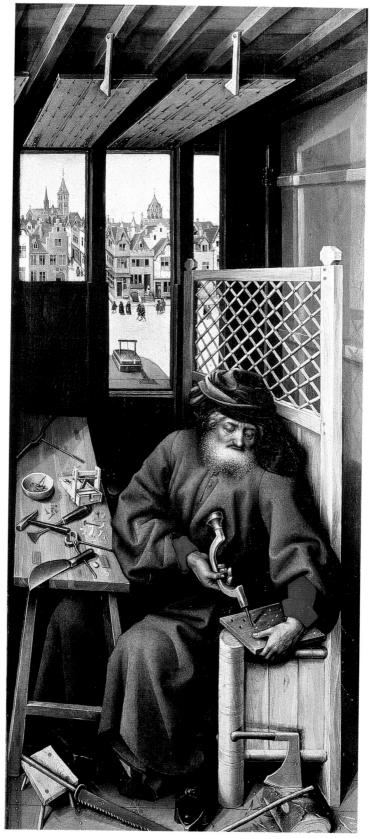

Master of Flemalle (Robert Campin)

ST. JOSEPH PORTRAYED AS A MEDIEVAL CARPENTER
(CENTER PANEL OF THE MERODE ALTARPIECE)

Born in South Netherlands • 1375/8-1444
Oil on wood panels • Center panel—25.3 in x 24.8 in; side wings 25.4 in x 10.8 in • Metropolitan Museum of Art, New York, USA/
Bridgeman Art Library, London

Tommaso Masaccio

ADAM AND EVE BANISHED FROM
PARADISE (DETAIL)

Born in San Giovanni Vladarno • Died in
Rome • 1401-28 • Fresco • Full size, 84.3 in
x 35.4 in • Brancacci Chapel, Santa Maria
del Carmine, Florence, Italy/Bridgeman
Art Library, London

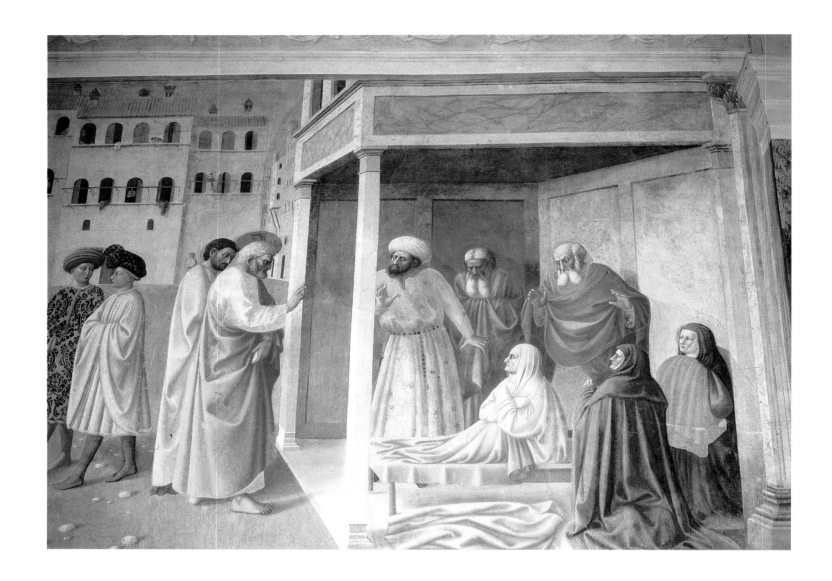

Tommaso Masolino

THE RESURRECTION OF TABATHA

Born and died in Florence • 1383-1447
Fresco • 100 in x 235 in • Brancacci Chapel, Santa Maria del Carmine, Florence, Italy/Bridgeman Art Library, London

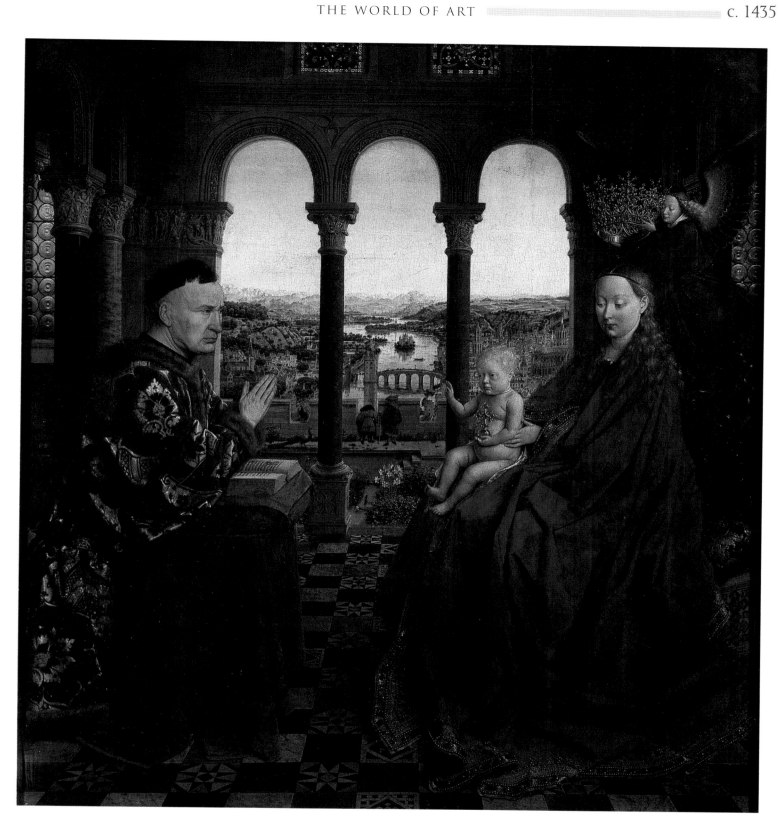

Jan van Eyck

THE ROLIN MADONNA (*LA VIERGE DE CHANCELIER ROLIN*)

Born in Maaseik • Died in Bruges • c. 1390-1441
Wood • 26 in x 24.4 in • Musée du Louvre, Paris, France/Bridgeman Art Library, London

Konrad Witz

St. Catherine of Alexandria

Born in Rottweil, Swabia • Died in Basle • c. 1400-1444/6
Oil on panel • Private Collection, Germany, Peter Willi/Bridgeman Art Library, London

ACTE CVM VENERIS ANTE FIGVRAM DRETEREVNDO CAVE NE SILEATVR AVE

Stefan Lochner

VIRGIN AND CHILD ALTARPIECE

Active in Cologne • Died in Cologne • Active, 1442-1451
Cologne Cathedral, Germany/Bridgeman Art Library, London

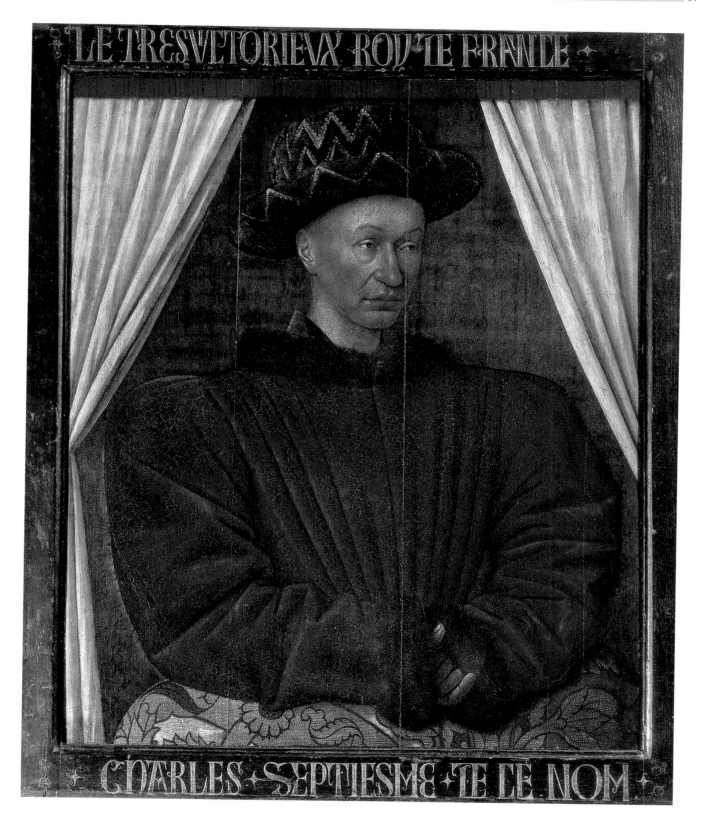

Jean Fouquet

CHARLES VII, KING OF FRANCE

Born and died in Tours • c. 1425-80
Panel wood • 33.9 in x 28 in • Musée du Louvre, Paris, France/Giraudon/Bridgeman Art Library, London

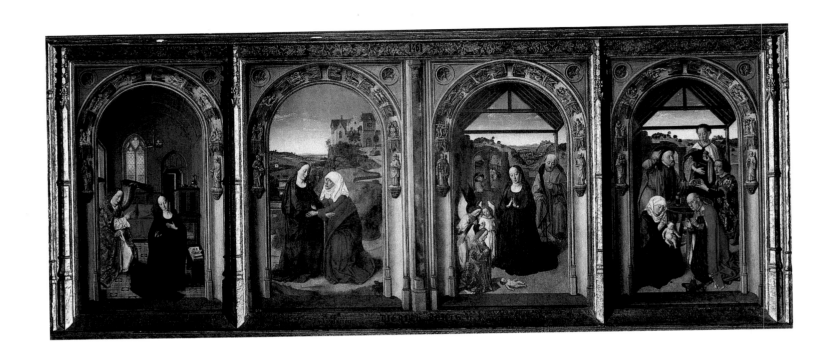

Dirck Bouts

POLYPTYCH SHOWING THE ANNUNCIATION, THE VISITATION, THE ADORATION OF THE ANGELS
AND THE ADORATION OF THE KINGS

Active and died in Louvain • 1415-75

Oil on board • 31.5 in x 41.3 in • Museo del Prado, Madrid, Spain/Bridgeman Art Library, London

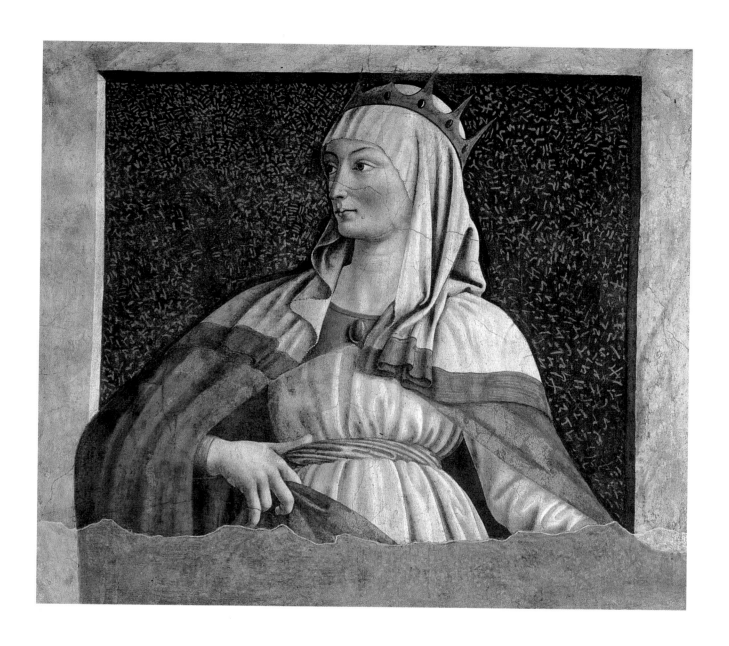

Andrea del Castagno

QUEEN ESTHER
(FROM THE VILLA CARDUCCI SERIES OF FAMOUS MEN AND WOMEN)

Born in Castagno • Died in Florence • 1423-1550
Fresco laid on canvas • 120 in x 150 in • Galleria Degli Uffizi, Florence, Italy/Bridgeman Art Library, London

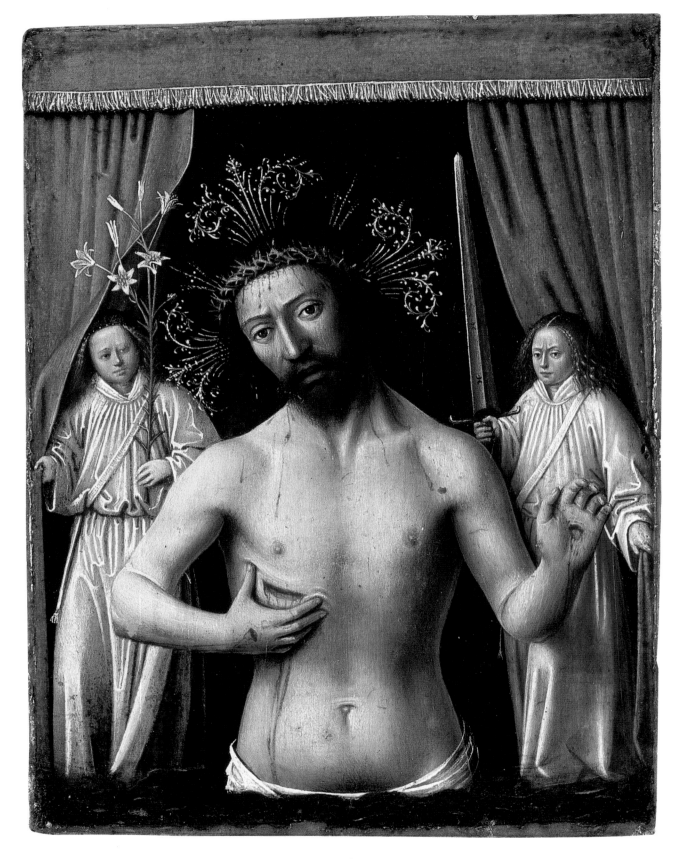

Petrus Christus

THE MAN OF SORROWS

Born in Baerle-Duc • Died in Bruges • 1444-72/3
Oil on panel • 4.5 in x 3.4 in • Birmingham Museums and Art Gallery/Bridgeman Art Library, London

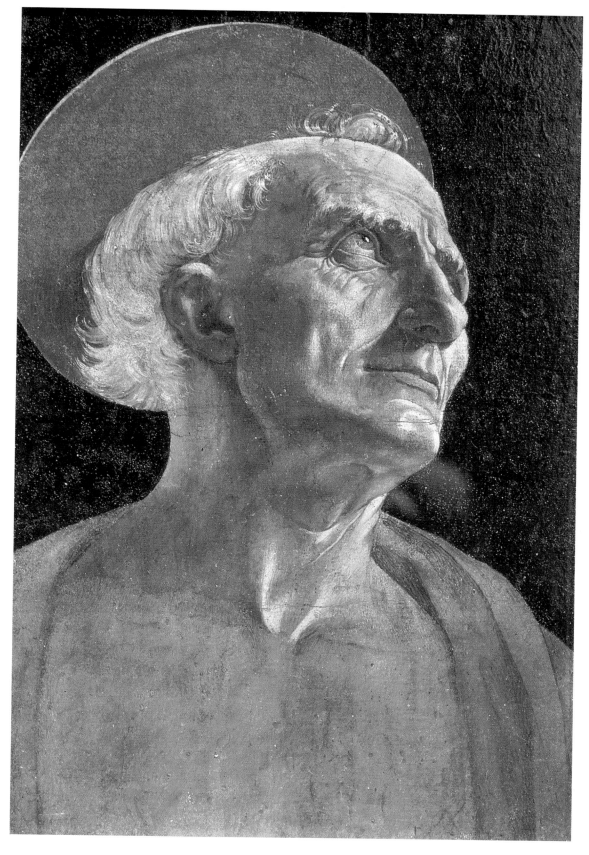

Antonio Pollaiuolo (attributed to)

ST. JEROME

Born and died in Florence • 1432/3-98
Palazzo Pitti, Florence, Italy/Bridgeman Art Library, London

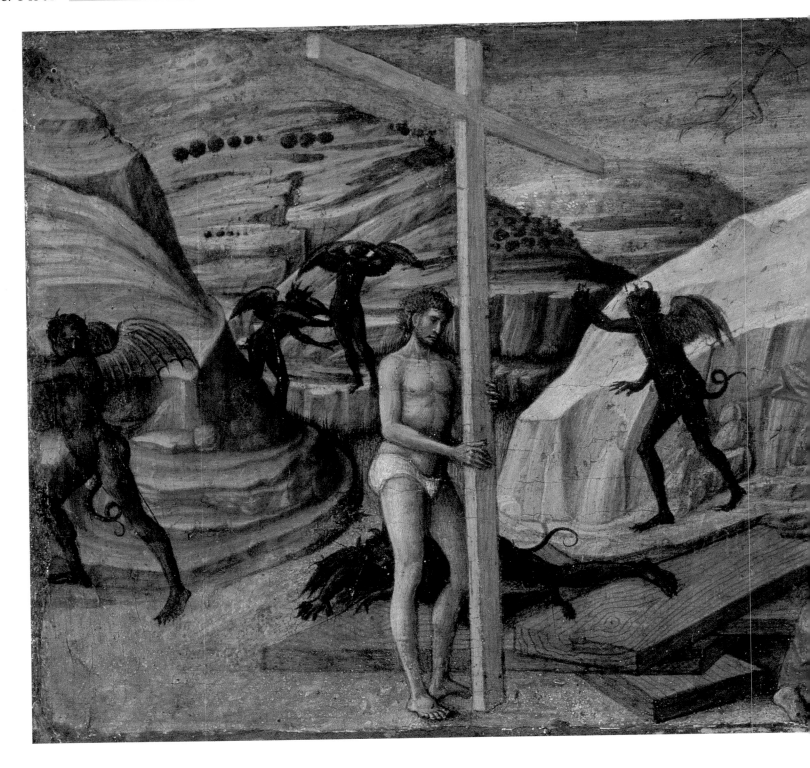

Jacopo Bellini

CHRIST'S DESCENT INTO LIMBO

Born and died in Venice • 1400-70
Oil on panel • Museo Bottacin e Museo Civico, Padua, Italy/Bridgeman Art Library, London

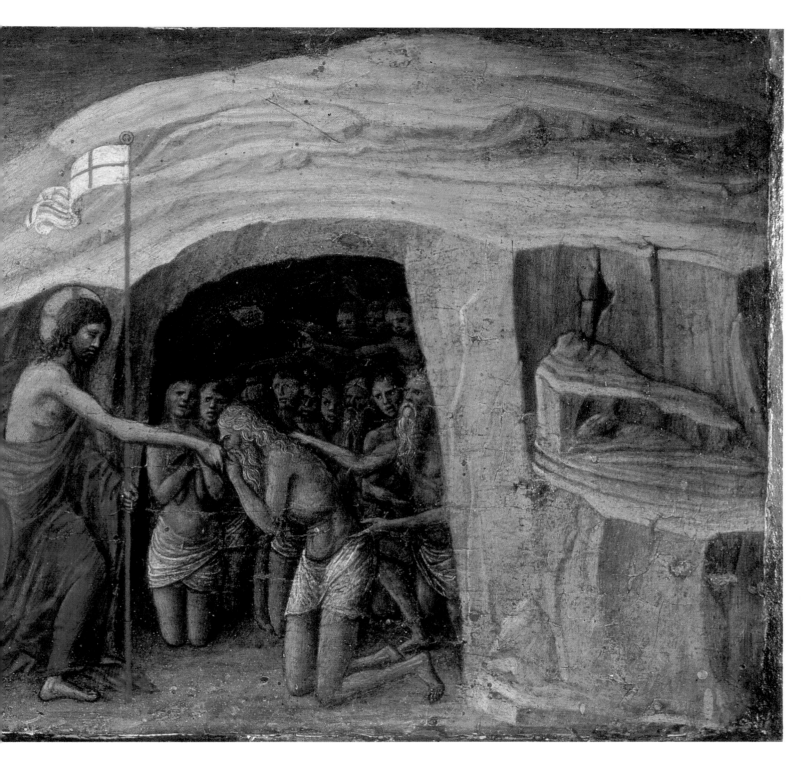

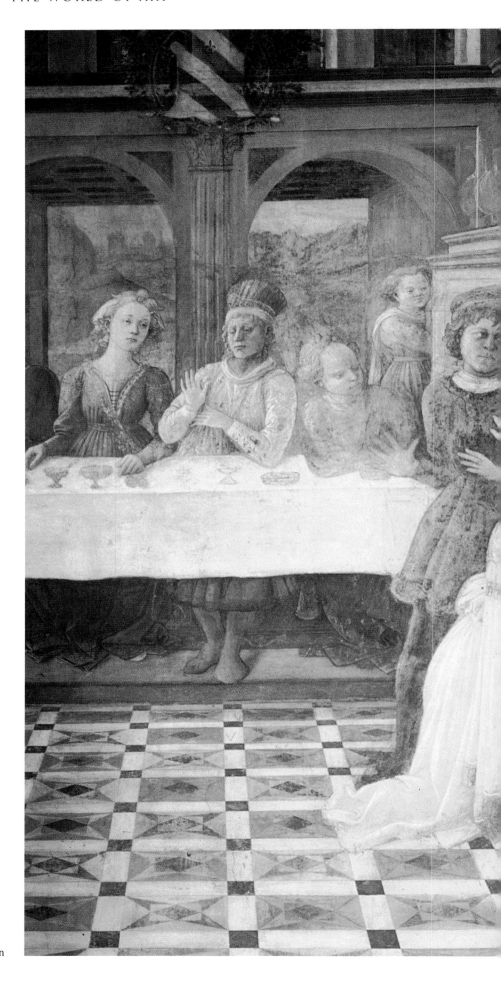

Fra Filippo Lippi

THE FEAST OF HEROD

Born in Florence • Died in Spoleto • c. 1406-69
Fresco • Prato Cathedral, Italy/Bridgeman Art Library, London

Antonello da Messina

THE DEAD CHRIST SUPPORTED BY AN ANGEL

Born and died in Italy • 1430-79
Oil on board • 29.1 in x 20.1 in • Museo del Prado, Madrid, Spain/Bridgeman Art Library, London

Benozzo di Lese di Sandro Gozzoli

PORTRAIT OF GIULIANO DE MEDICI (1453-78),
(DETAIL FROM THE JOURNEY OF THE MAGI CYCLE IN THE CHAPEL)

Born in Florence • Died in Pistoia • 1420-97
Fresco • Palazzo Medici-Riccardi, Florence, Italy/Bridgeman Art Library, London

Giovanni Bellini

THE VIRGIN AND CHILD WITH ST. CATHERINE
AND ST. URSULA

Born and died in Venice • 1430-1516
Oil on panel • 30.3 in x 41 in • Musée del Prado, Madrid,
Spain/Bridgeman Art Library, London

Paolo Uccello

ST. GEORGE AND THE DRAGON

Born and died in Florence • 1397-1475
Oil on canvas • 22.2 in x 29.3 in • National Gallery, London, UK/Bridgeman Art Library, London

Nicolas Froment

RESURRECTION OF LAZARUS TRIPTYCH; THE RAISING OF LAZARUS (CENTRAL PANEL); MARTHA AT THE FEET OF CHRIST (LEFT);
MARY MAGDALENE WASHES THE FEET OF CHRIST (RIGHT)

Born in Uzès, Languedoc • c. 1425-83/86
Oil on wood • 175 in x 200 in • Galleria Degli Uffizi, Florence, Italy/Bridgeman Art Library, London

Piero della Francesca

ST. MICHAEL

Born and died in Borgo Sansepolcro • c. 1419/21-92
Oil on poplar • 52.4 in x 23.4 in • National Gallery, London, UK/Bridgeman Art Library, London

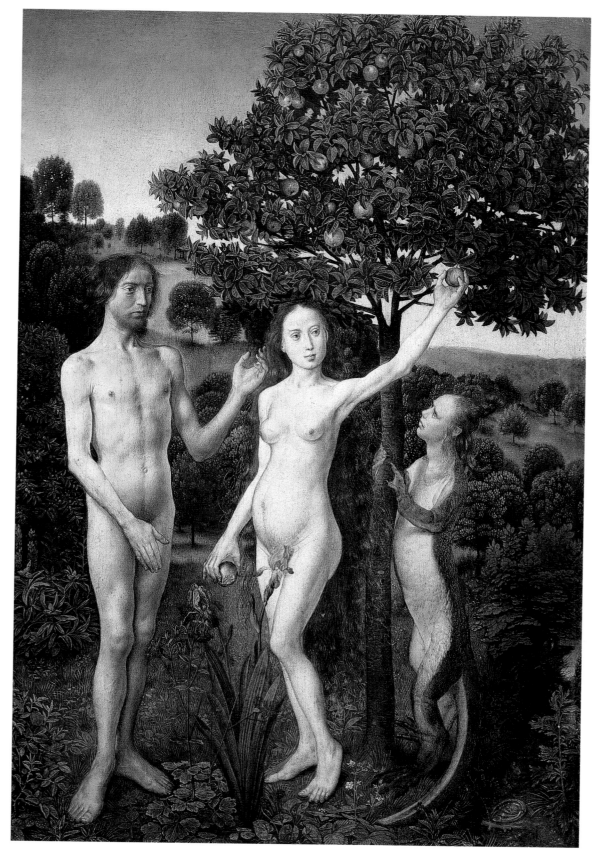

Hugo van der Goes

THE FALL OF MAN

Born in Ghent • Died in Rode Klooster, nr Brussels • c. 1440-82
Oil on panel • 14 in x 9.2 in • Kunsthistorisches Museum, Vienna, Austria/Bridgeman Art Library, London

Francesco del Cossa

St. Lucy

Born in Ferrara • Died in Bologna • 1435/6-c. 1477
Oil on panel • 31.25 in x 22 in • Kress Collection, Washington DC, USA/Bridgeman Art Library, London

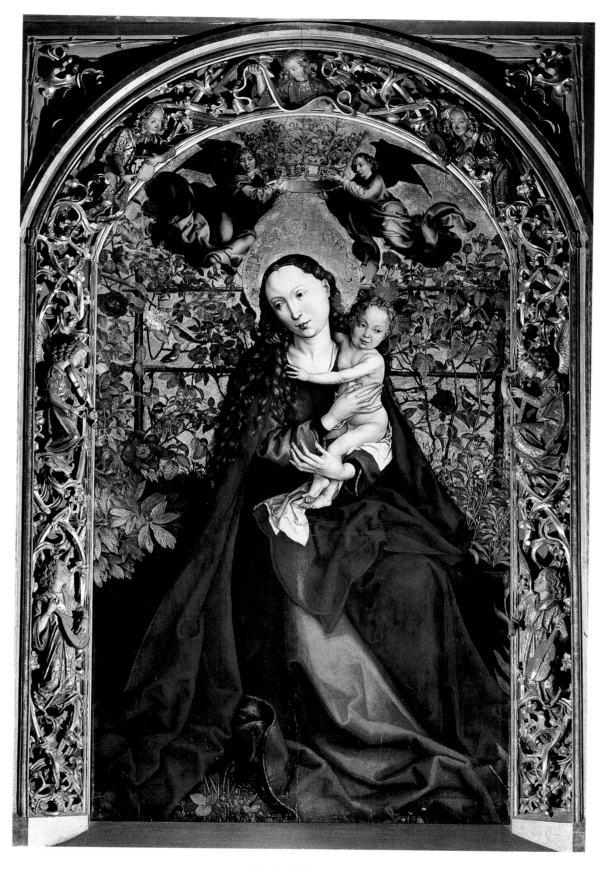

Martin Schongauer

MADONNA OF THE ROSE BOWER

Born in Augsburg • Died in Breisach • 1430-91
Oil on panel • 78.7 in x 45.3 in • St. Martin, Colmar, France/Bridgeman Art Library, London

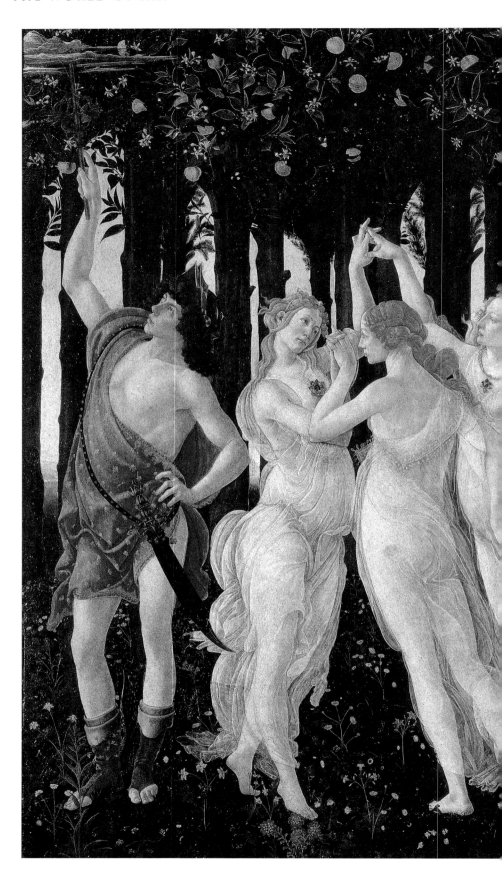

Sandro Botticelli

PRIMAVERA

Born and died in Florence • 1444/5-1510
Tempera on panel • 79.9 in x 123.6 in • Galleria Degli Uffizi, Florence, Italy/Bridgeman Art Library, London

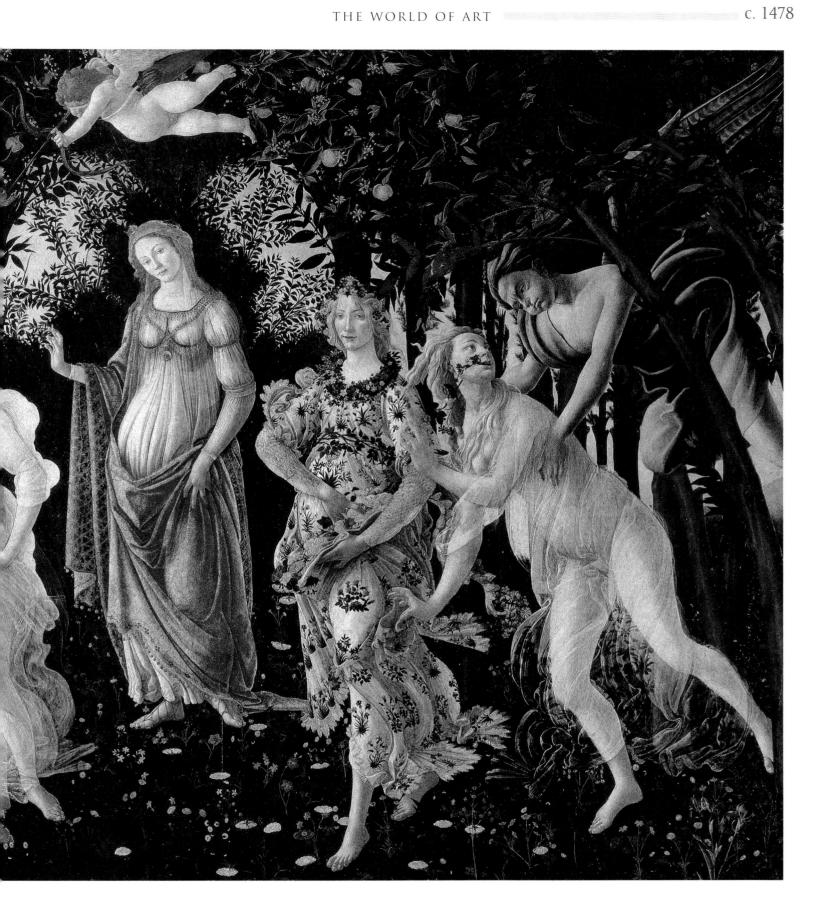

Bartoloméo de Cardenas Bermejo

ST. MICHAEL AND THE DRAGON

Born in Cordoba • Died in Barcelona • c. 1435/40-1500
Oil and gold on wood • 70.8 in x 32.2 in • National Gallery, London, UK/Bridgeman Art Library, London

Andrea Mantegna

St. Sebastian

Born in Isola di Carturo • Died in Mantua • 1431-1506
Canvas • 100.4 in x 55.1 in • Musée du Louvre, Paris, France/Bridgeman Art Library, London

Piero di Cosimo

THE END OF THE HUNT

Born and died in Florence • c.1462-1521
Tempera and oil on wood • 27.75 in x 66.5 in • Metropolitan Museum of Art, New York, USA/Bridgeman Art Library

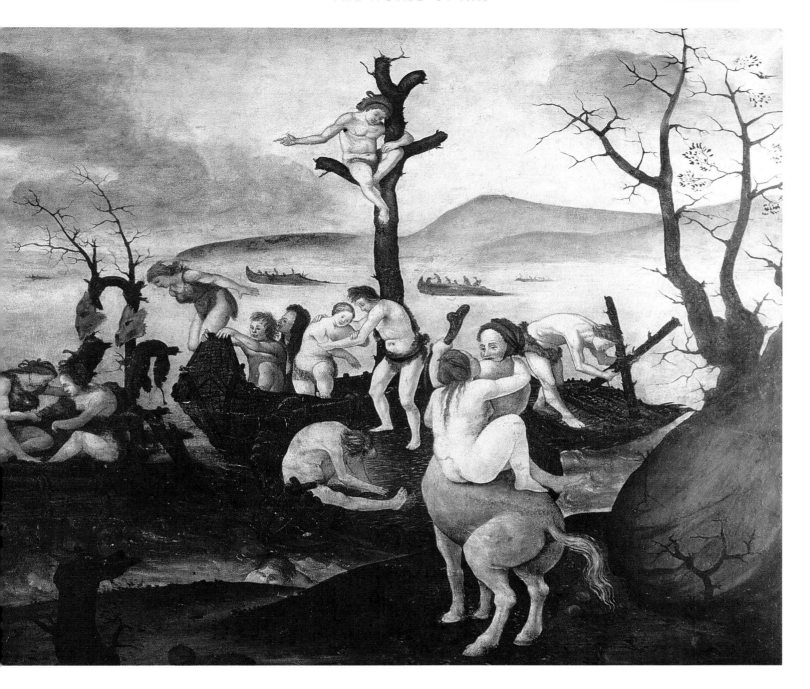

Filippino Lippi

ST. PETER VISITED IN JAIL BY ST. PAUL

Born and died in Florence • c. 1457-1504
Fresco • Brancacci Chapel, Santa Maria del Carmine, Florence, Italy/Bridgeman Art Library, London

Hans Memling

St. Veronica

Born in Selignestadt • Died in Bruges • 1433-94
Oil on panel • 11.95 in x 9 in • Kress Collection, Washington DC, USA/Bridgeman Art Library, London

Carlo Crivelli

St. George and the Dragon,
(Scene from the Predella Panel of the Madonna Della Rondine Altarpiece)

Born in Venice • Died in Ascoli Piceno • c. 1435/40-95
Panel • 59 in x 42 in (whole panel) • National Gallery, London, UK/Bridgeman Art Library, London

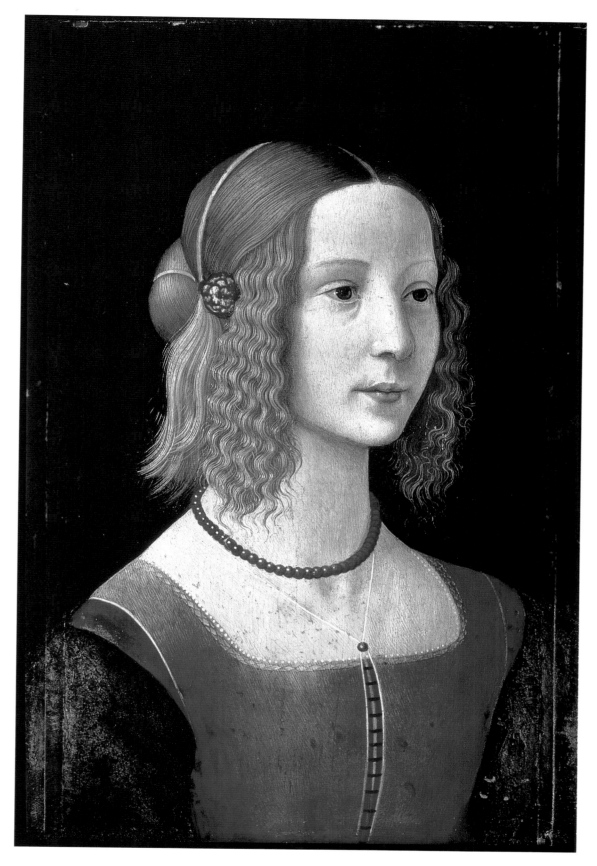

Domenico Ghirlandaio (attributed to)

PORTRAIT OF A GIRL

Born and died in Florence • 1449-94
Tempera on wood • 17.4 in x 10.4 in • National Gallery, London, UK/Bridgeman Art Library, London

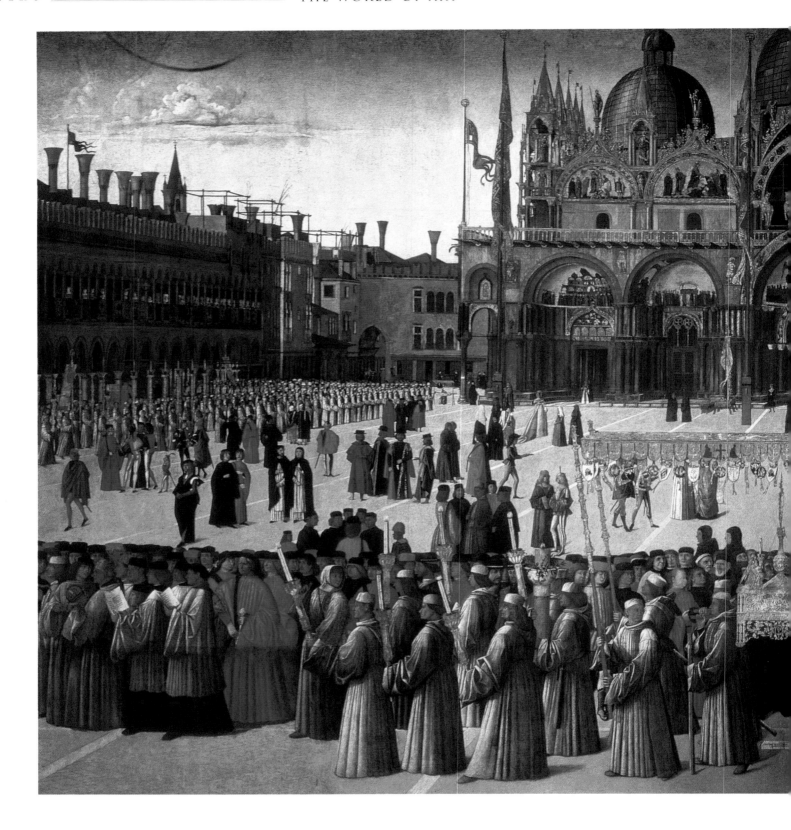

Gentile Bellini

PROCESSION IN ST. MARK'S SQUARE

Born and died in Venice • 1429–1507
Oil on canvas • 144.5 in x 293.3 in • Galleria dell'Accademia, Venice, Italy/Bridgeman Art Library, London

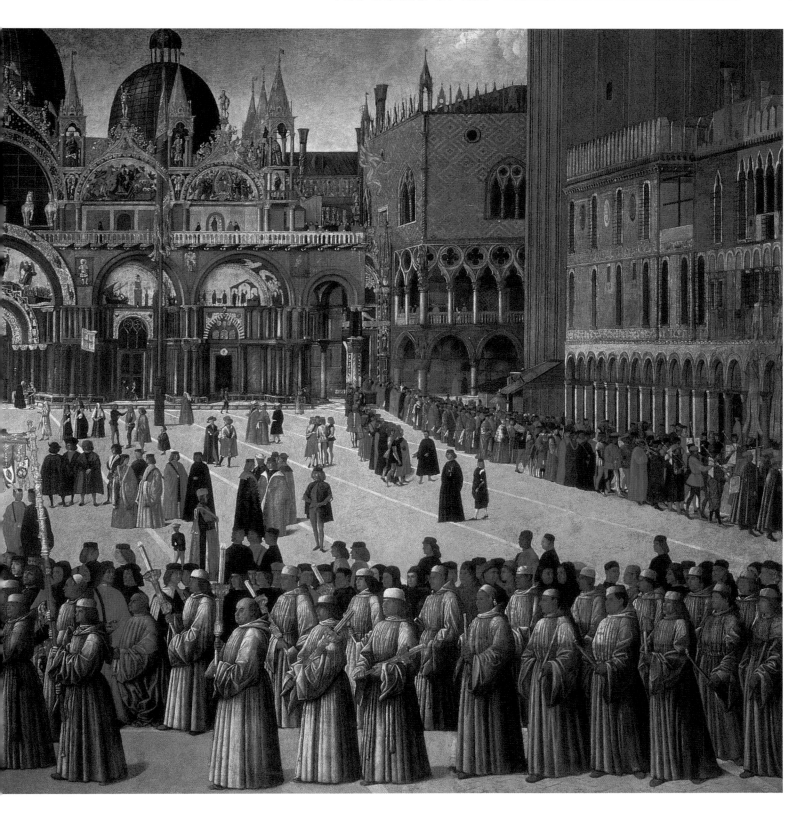

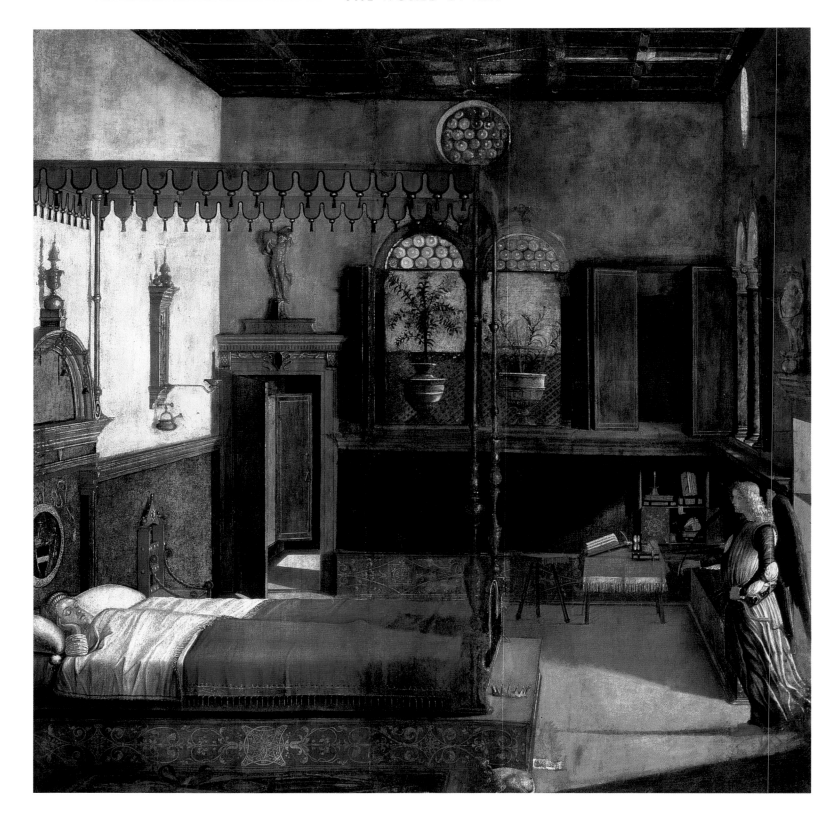

Vittore Carpaccio

DREAM OF ST. URSULA

Born and died in Venice • c. 1460/5-1523/6
Tempera on panel • 107.8 in x 105 in • Galleria dell'Accademia, Venice, Italy/Bridgeman Art Library, London

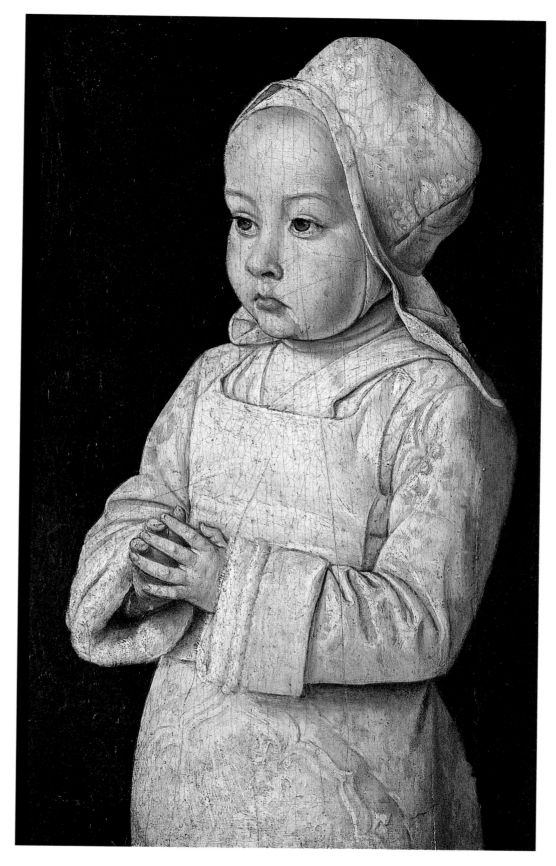

Master of Moulins (follower)

PORTRAIT OF SUZANNE OF BOURBON (1491-1521)
DAUGHTER OF PETER II AND ANNE OF FRANCE, DUKE AND DUCHESS OF BOURBON

Born in South Netherlands • c. 1483-c. 1529

Oil on panel • 10.6 in x 6.5 in • Musée du Louvre, Paris, France/Peter Willi/Bridgeman Art Library, London

Leonardo da Vinci

THE LAST SUPPER

Born in Vinci • Died in Amboise • 1452-1519
Tempera wall mural • 181.1 in x 346.5 in • Santa Maria della
Grazie, Milan, Italy/Bridgeman Art Library, London

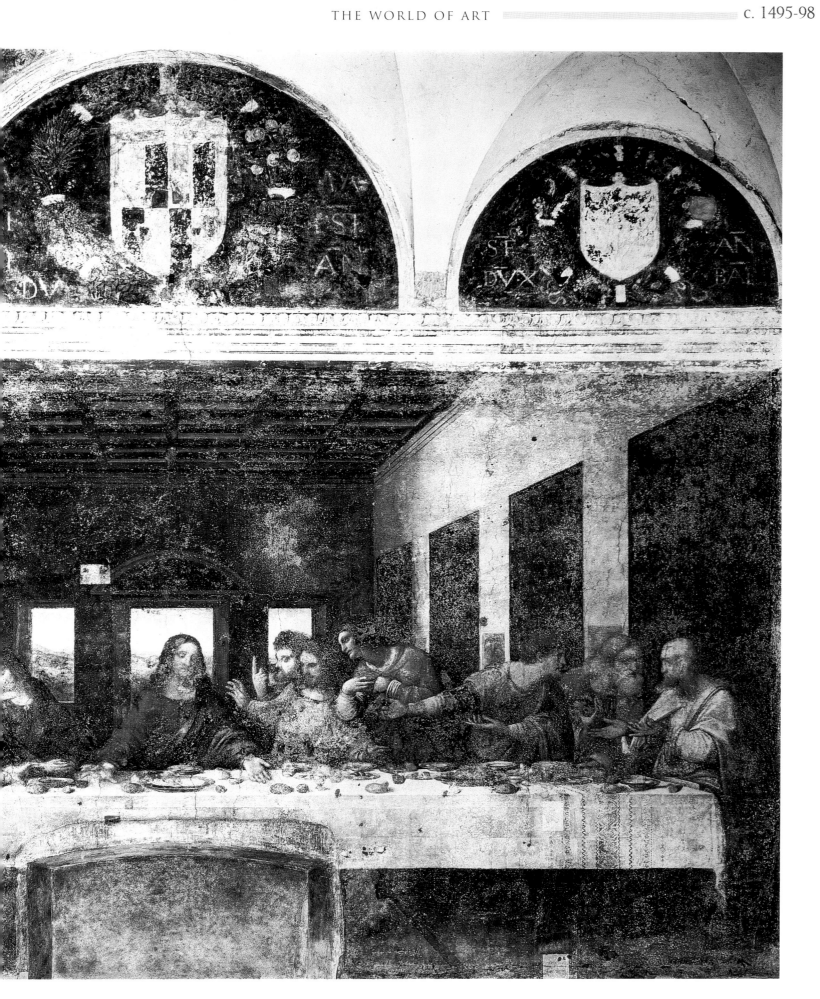

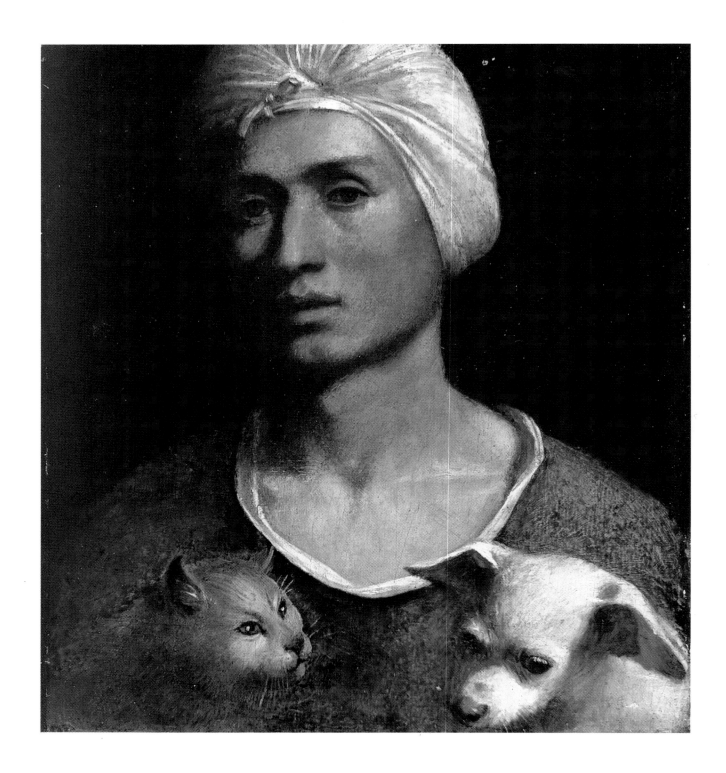

Dosso Dossi (Giovanni di Luteri)

PORTRAIT OF A YOUNG MAN WITH A DOG AND A CAT

Born and died in Ferrara • c. 1479-1542
Oil on panel • 10.9 in x 9.8 in • Ashmolean Museum, Oxford, UK/Bridgeman Art Library, London

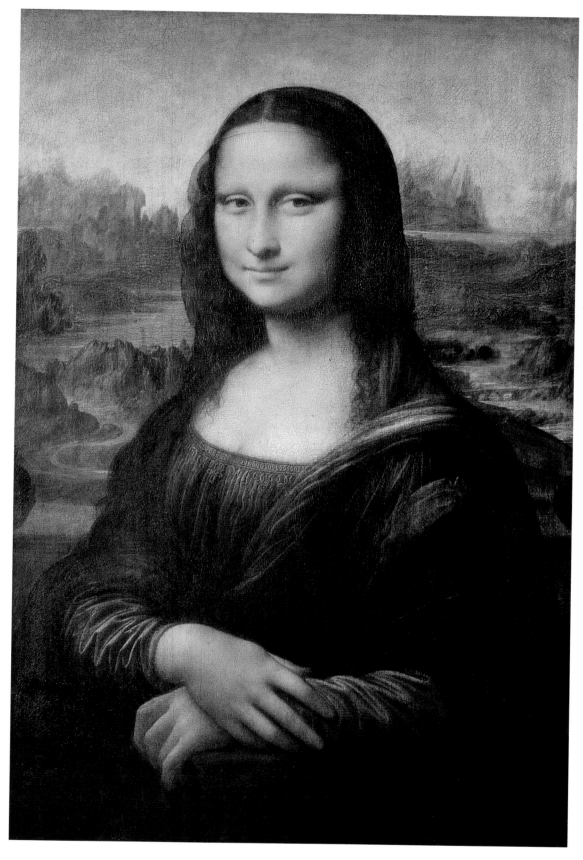

Leonardo da Vinci

MONA LISA

Born in Vinci • Died in Amboise • 1452-1519
Oil on panel • 30.3 in x 20.9 in • Musée du Louvre, Paris, France/Bridgeman Art Library, London

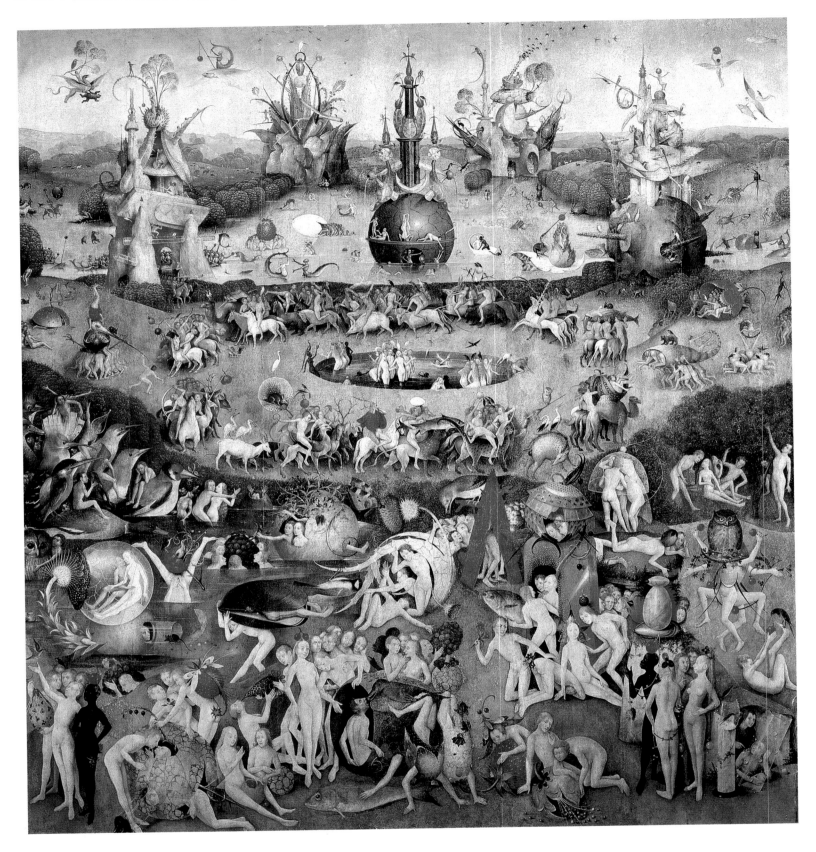

Hieronymus Bosch

THE GARDEN OF EARTHLY DELIGHTS

Born and died in 's Hertogenbosch • 1450-1516
Oil on panel, center panel • 86.6 in x 76.8 in • Museo del Prado, Madrid, Spain/Bridgeman Art Library, London

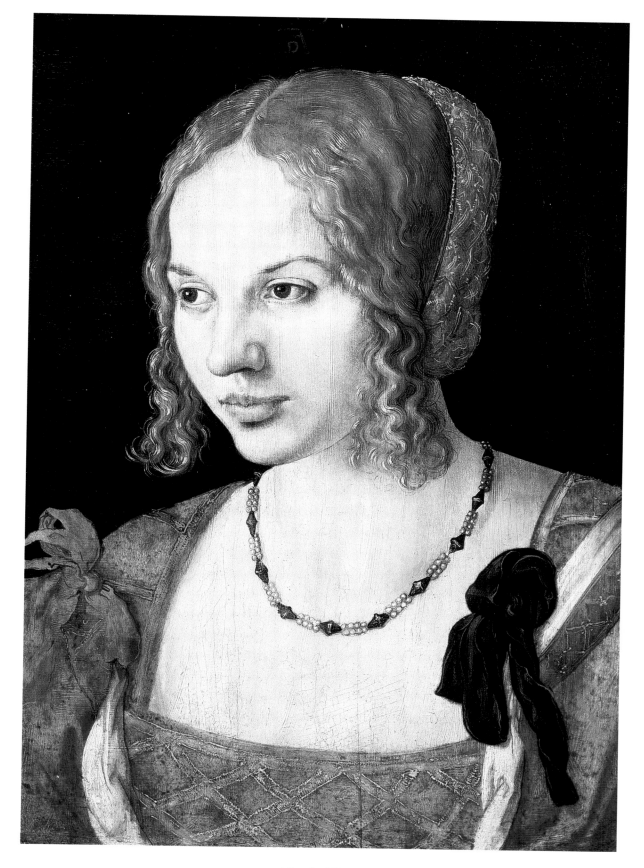

Albrecht Dürer

YOUNG VENETIAN WOMAN

Born and died in Nuremberg • 1471-1528
Wood • 12.8 in x 9.7 in • Kunsthistorisches Museum, Vienna, Austria/Bridgeman Art Library, London

Giorgio del Castelfranco Giorgione

CHRIST CARRYING THE CROSS

Born Castelfranco • Died in Venice • 1476/8-1510
Oil on panel • Scuola Grande di San Rocco, Venice, Italy/
Bridgeman Art Library, London

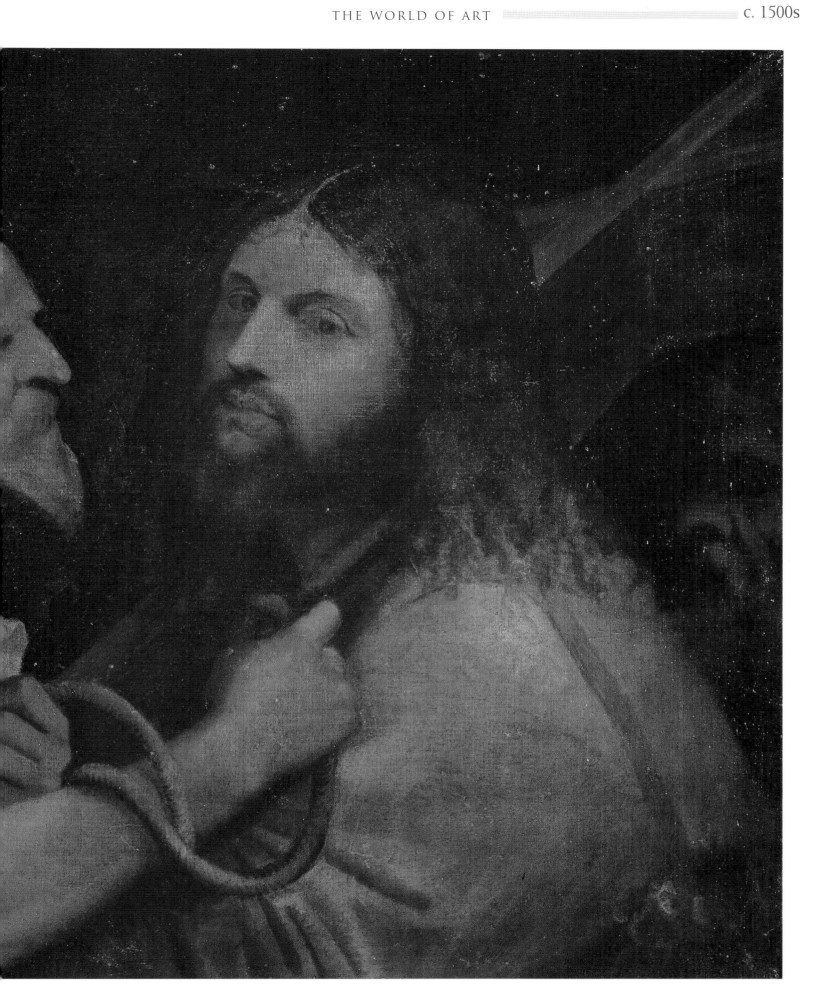

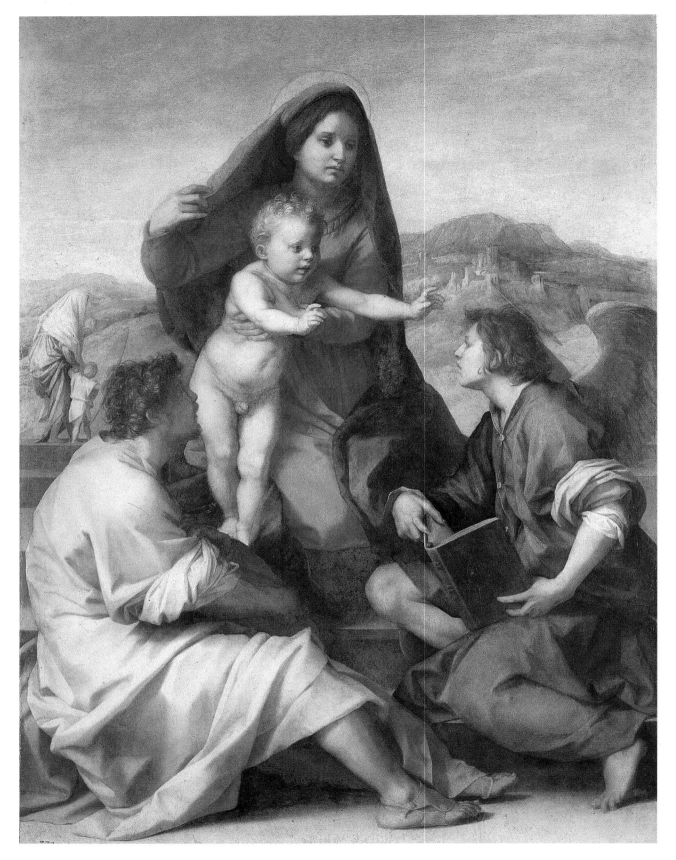

Andrea del Sarto

THE VIRGIN AND CHILD WITH A SAINT AND AN ANGEL

Born and died in Florence • 1486-1530
Oil on panel • 41.7 in x 31.1 in • Museo del Prado, Madrid, Spain/Bridgeman Art Library, London

Buonarroti Michelangelo

SISTINE CHAPEL CEILING; JUDITH CARRYING THE HEAD OF HOLOFERNES

Born in Caprese • Died in Rome • 1475-1564
Fresco on spandrel • Vatican Museums and Galleries, Vatican City, Italy/Bridgeman Art Library, London

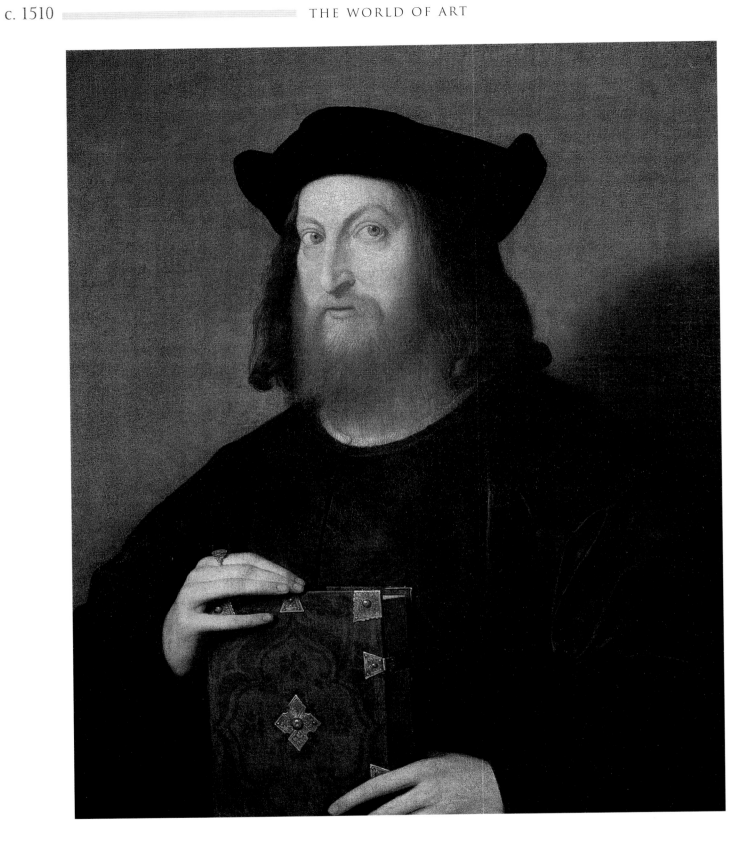

Vincenzo di Biagio Catena

PORTRAIT OF GIAN GIORGIO TRISSINO

Born and died in Venice • c. 1470-1531
Oil on canvas • 28.4 in x 25 in • Musée du Louvre, Paris, France/Bridgeman Art Library, London

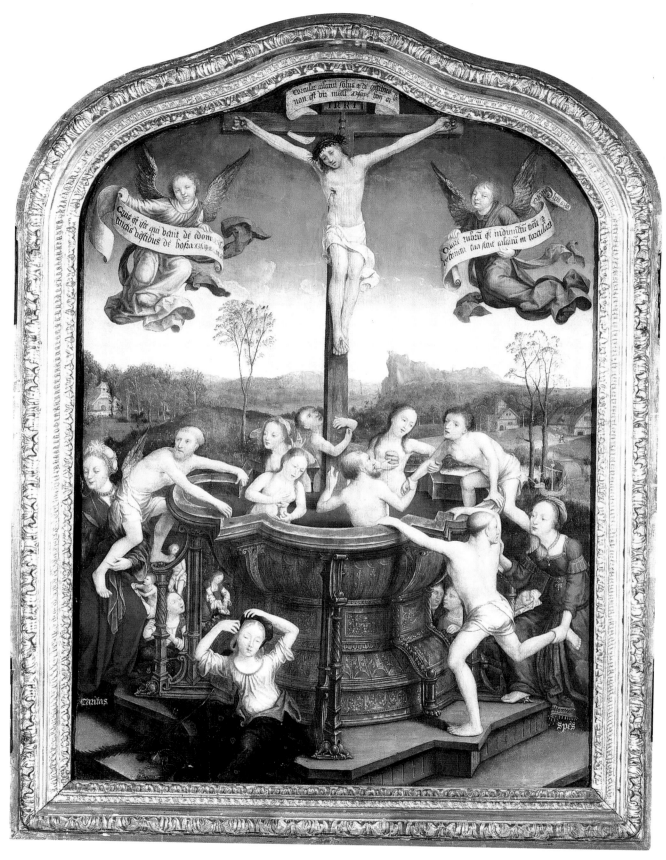

Jean Bellegambe, the Elder

THE MYSTICAL BATH

Born and died in Douai • c. 1470-1535
Oil on panel • 31.5 in x 9.1 in (central panel in tryptich) • Musée des Beaux-Arts, Lille, France/Giraudon/Bridgeman Art Library, London

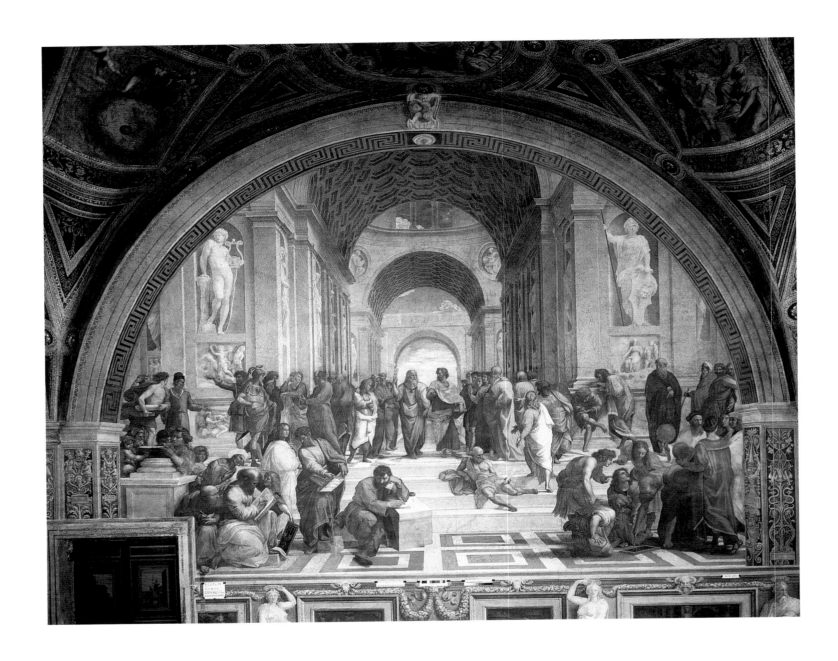

Raffaello Sanzio of Urbino (Raphael)

THE SCHOOL OF ATHENS

Born in Urbino • Died in Rome • 1483-1520
Fresco • Vatican Museums and Galleries, Vatican City, Italy/Bridgeman Art Library, London

Mariotto Albertinelli

MADONNA AND CHILD

Born and died in Florence • 1474-1515
Oil on panel • 31.7 in x 22.8 in • Noortman (London) Ltd/Bridgeman Art Library, London

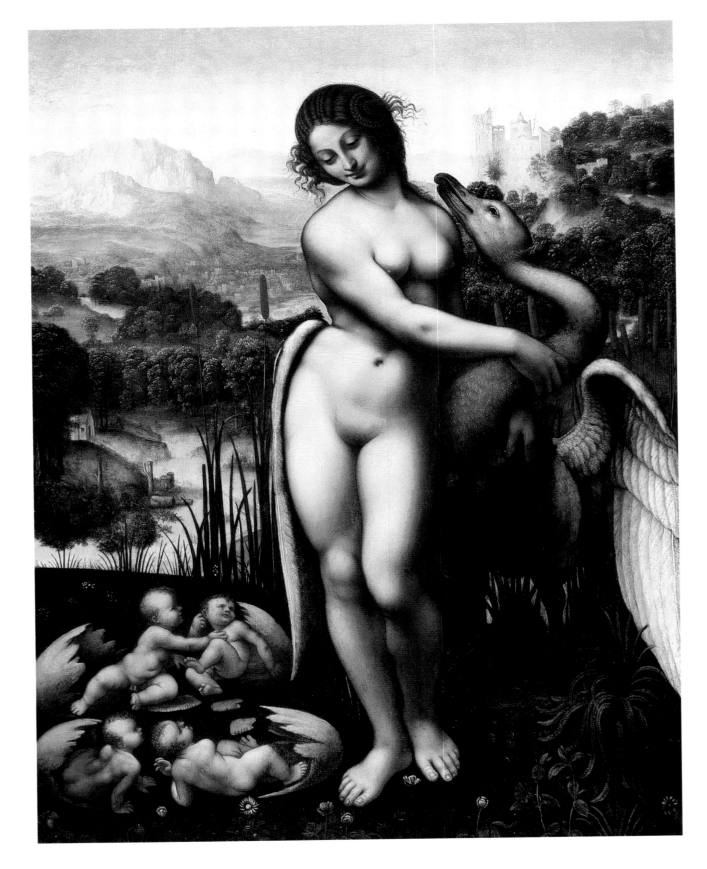

Cesare da Sesto

LEDA AND THE SWAN

Born and died in Italy • 1477-1523
Oil on canvas • 38 in x 29 in • Collection of the Earl of Pembroke, Wilton House, Wilts, UK/Bridgeman Art Library, London

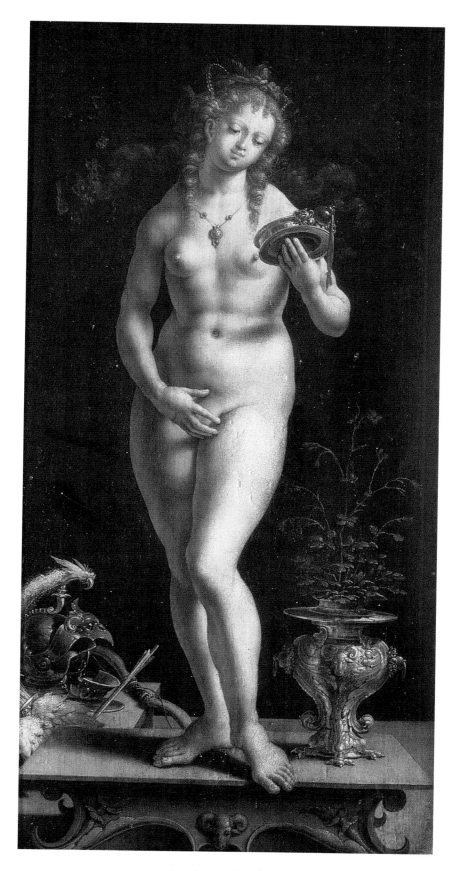

Jan Gossaert (Mabuse)

VENUS AND THE MIRROR

Born in Maubeuge • Died in Antwerp • c. 1478-1533/6
Oil on canvas • Pinacoteca dei Concordi, Rovigo, Italy/Bridgeman Art Library, London

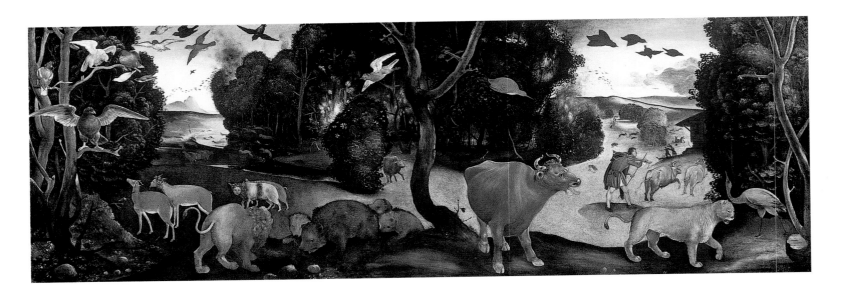

Piero di Cosimo

THE FOREST FIRE

Born and died in Florence • c. 1462-1521
Oil on panel • 28 in x 80 in • Ashmolean Museum, Oxford, UK/Bridgeman Art Library, London

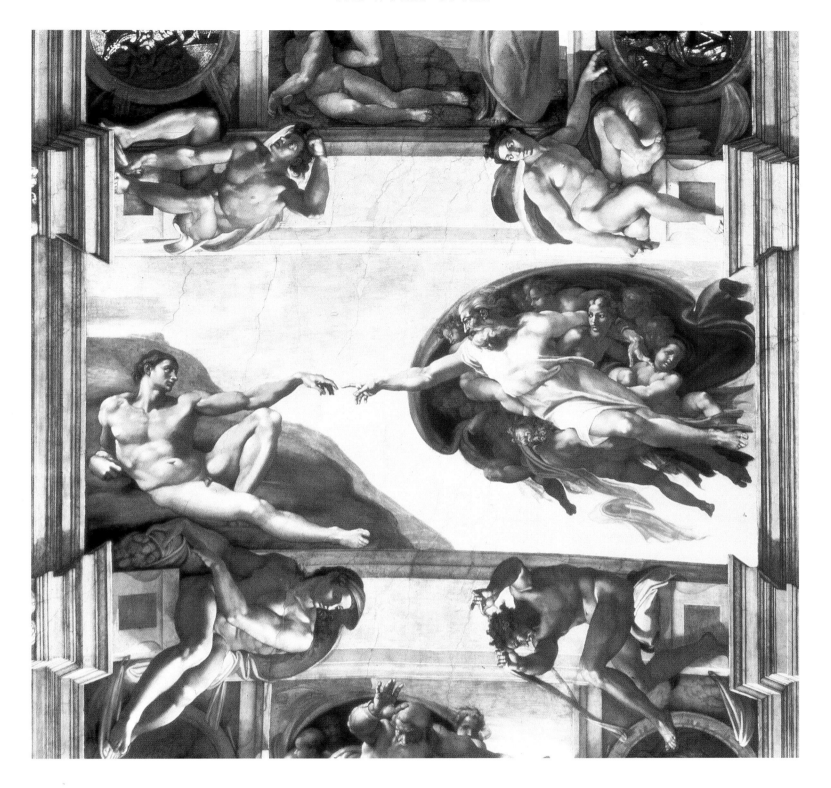

Buonarroti Michelangelo

SISTINE CHAPEL CEILING; CREATION OF ADAM (POST-RESTORATION)

Born in Caprese • Died in Rome • 1475-1564
Fresco • Vatican Museums and Galleries, Vatican City, Italy/Bridgeman Art Library, London

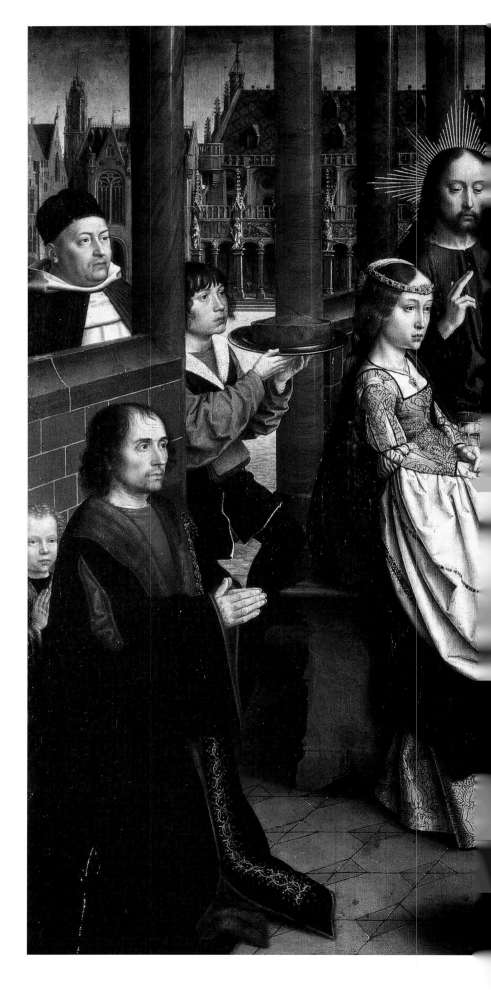

Gerard David

THE MARRIAGE FEAST AT CANA

Born in Ouwater • Died in Bruges • c. 1460-1523
Oil on panel • 39.4 in x 50.4 in • Musée du Louvre, Paris,
France/Giraudon/Bridgeman Art Library, London

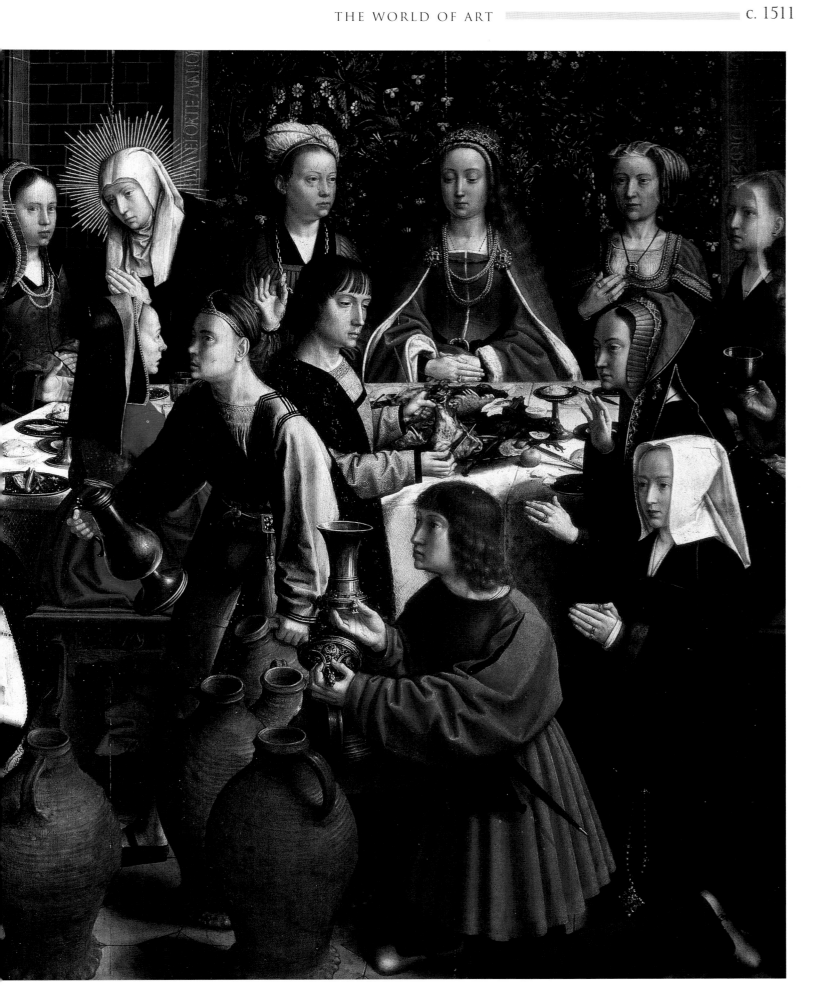

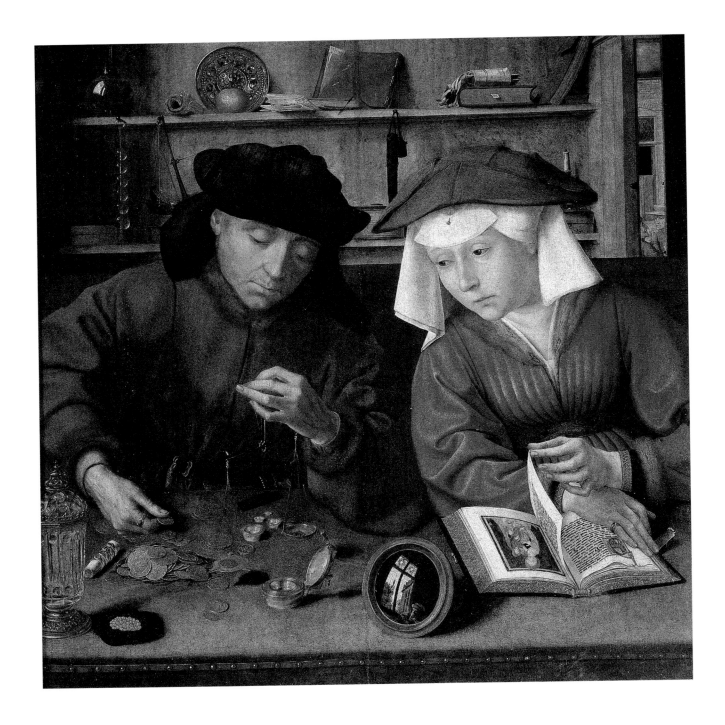

Quentin Massys (Metsys)

THE MONEY LENDER AND HIS WIFE

Born in Louvain • Died in Antwerp • c. 1466-1530
Oil on panel • 29.1 in x 26.8 in • Musée du Louvre, Paris, France/Giraudon/Bridgeman Art Library, London

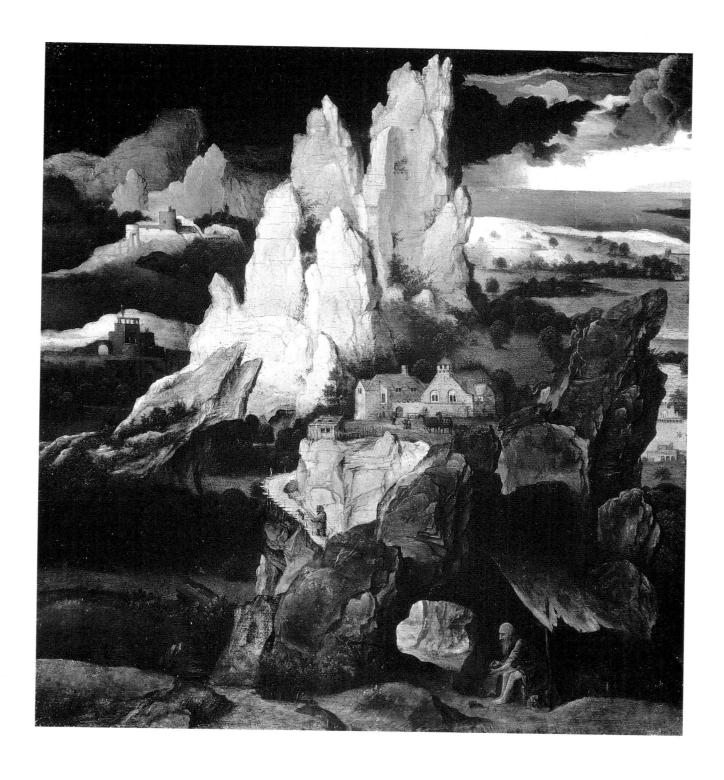

Joachim Patenier (Patinir)

ST. JEROME IN A ROCKY LANDSCAPE

Birthplace unknown • Died in Antwerp • 1487-1524
Oil on panel • 14.2 in x 13.4 in • National Gallery, London, UK/Bridgeman Art Library, London

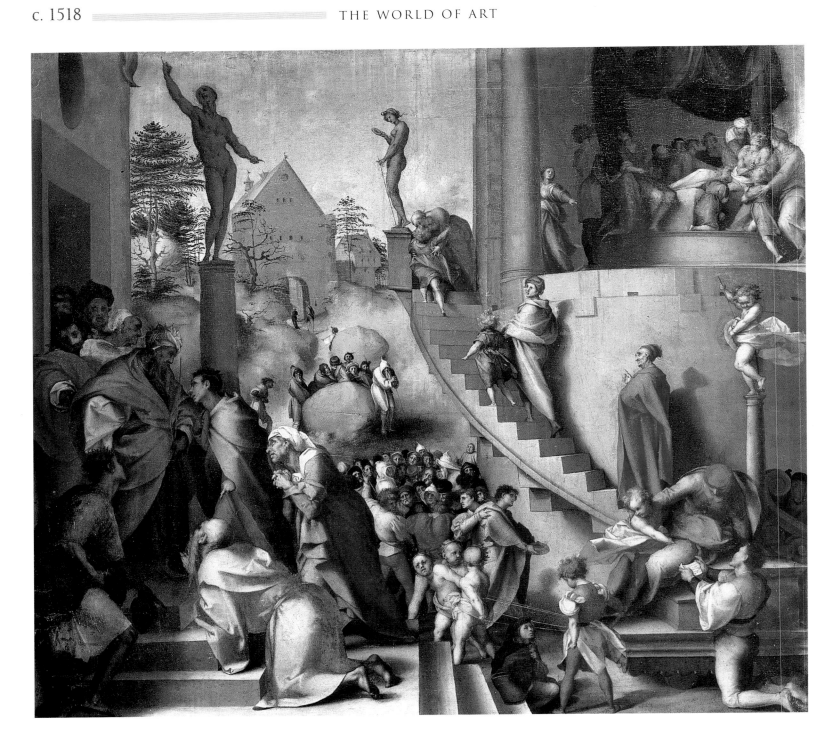

Jacopo Pontormo

JOSEPH WITH JACOB IN EGYPT

Born in Pontormo • Died in Florence • 1494-1557
Oil on panel • 38 in x 43.1 in • National Gallery London, UK/Bridgeman Art Library, London

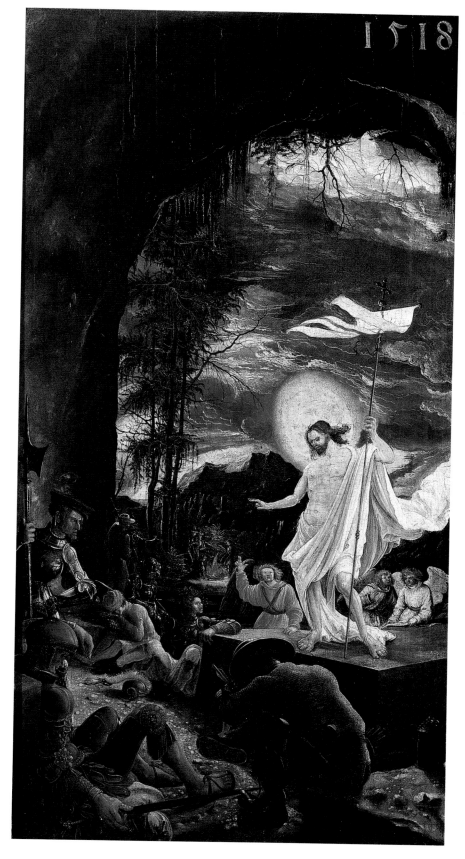

Albrecht Altdorfer

RESURRECTION OF CHRIST

Born and died in Regensburg • c. 1480-1538
Oil on panel • 27.8 in x 14.6 in • Kunsthistorischesmuseum, Vienna, Austria/Bridgeman Art Library, London

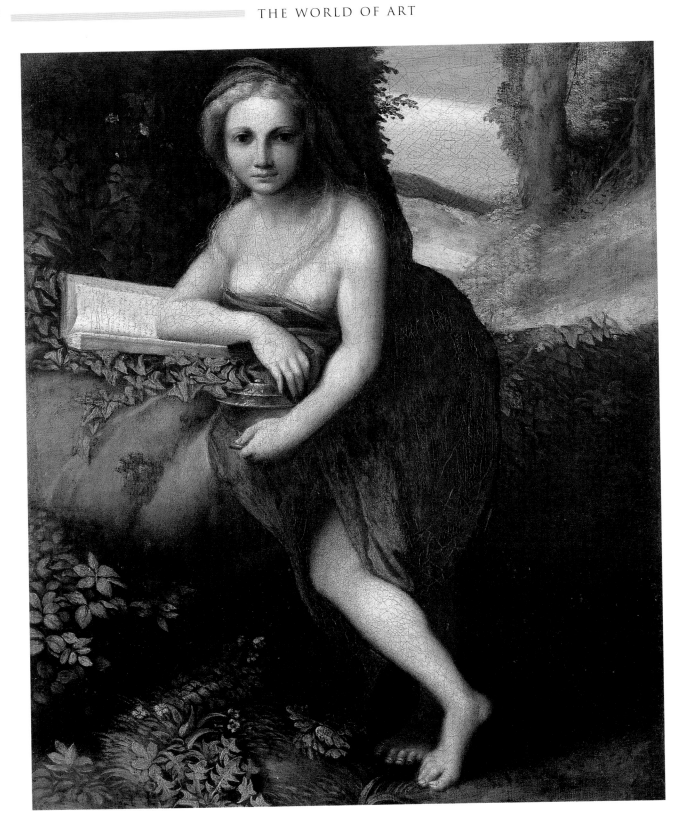

Antonio Allegri Correggio

THE MAGDALENE

Born and died in Correggio • c. 1489/94-1534
Oil on canvas • 15 in x 12 in • National Gallery, London, UK/Bridgeman Art Library, London

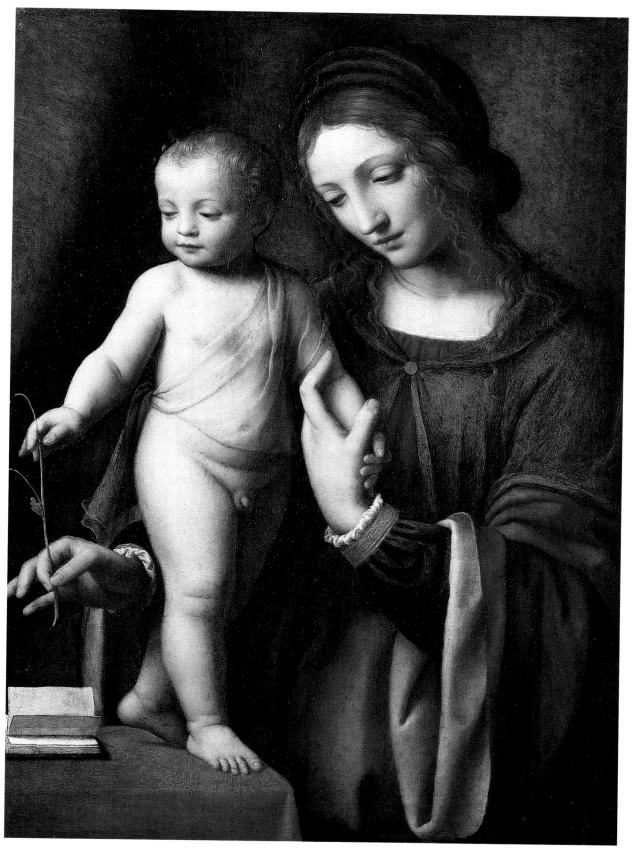

Bernardino Luini (attributed to)

THE VIRGIN AND CHILD WITH A COLUMBINE

Born in Luini • Died in Milan • c. 1480-1532
Oil on poplar panel • 28.9 in x 21.7 in • Wallace Collection, London, UK/Bridgeman Art Library, London

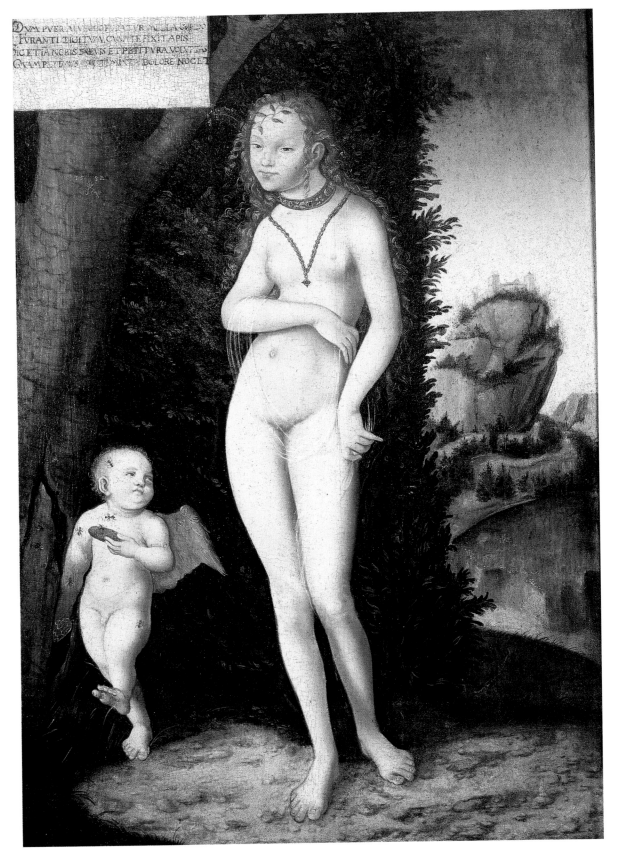

Lucas Cranach the Elder

VENUS WITH CUPID THE HONEY THIEF

Born in Kronach • Died in Weimar • 1472-1553
Oil on canvas • Christie's Images/Bridgeman Art Library, London

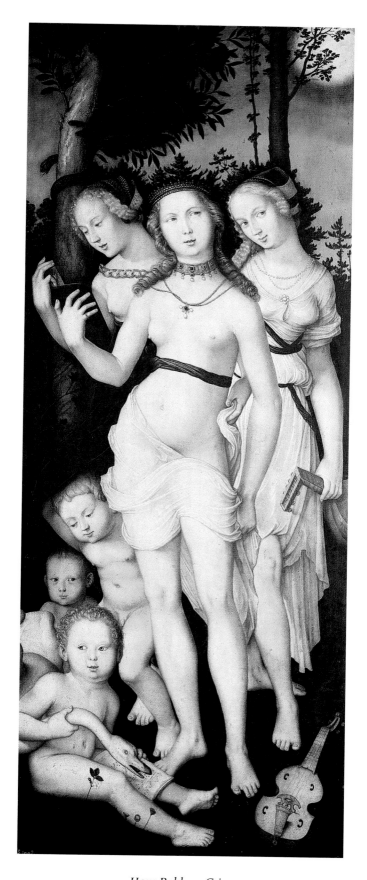

Hans Baldung-Grien

HARMONY OF THE THREE GRACES

Born in Schwabisch-Gmund • Died in Strasbourg • c. 1484-1545
Oil on board • 59.5 in x 24 in • Museo del Prado, Madrid, Spain/Bridgeman Art Library, London

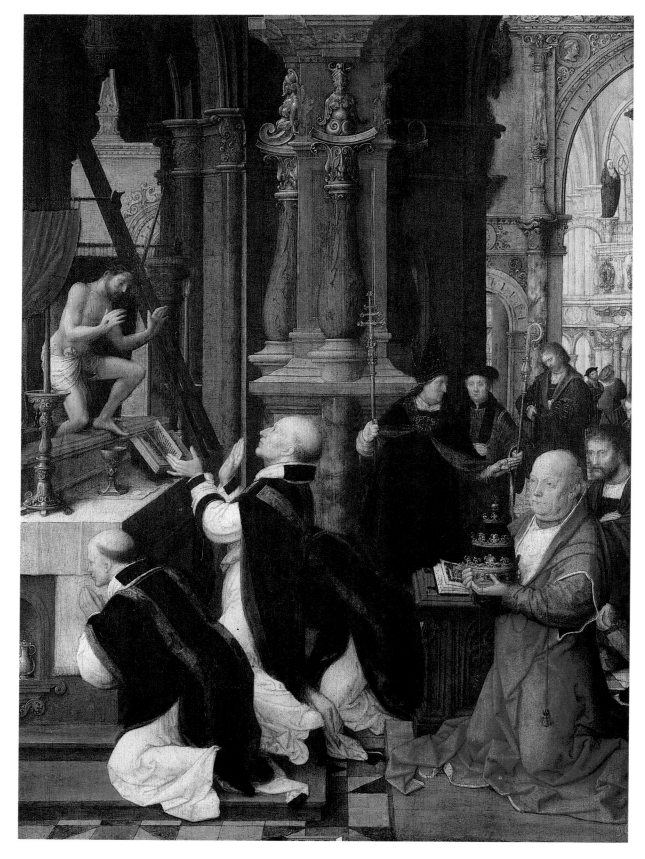

Adriaen Isenbrandt (Ysenbrant)

THE MASS OF ST. GREGORY

Born in Antwerp • Died in Bruges • c. 1490-1551
Oil on canvas • 28.4 in x 22 in • Museo del Prado, Madrid, Spain/Bridgeman Art Library, London

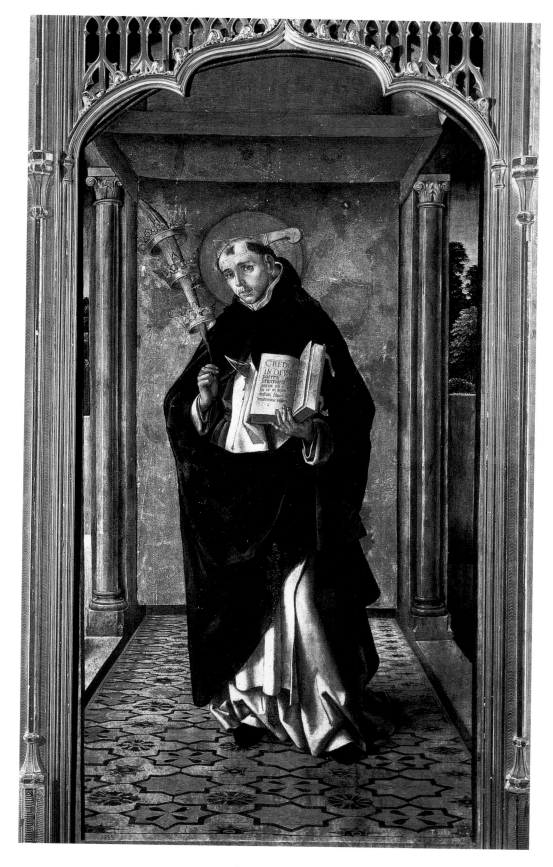

Alonso Berruguete

ST. PETER MARTYR
(DETAIL FROM THE ST. PETER ALTARPIECE)

Born in Paredes de Nava • Died in Toledo • 1488-1561
Oil on panel • 28.4 in x 22 in • Museo del Prado, Madrid, Spain/Bridgeman Art Library, London

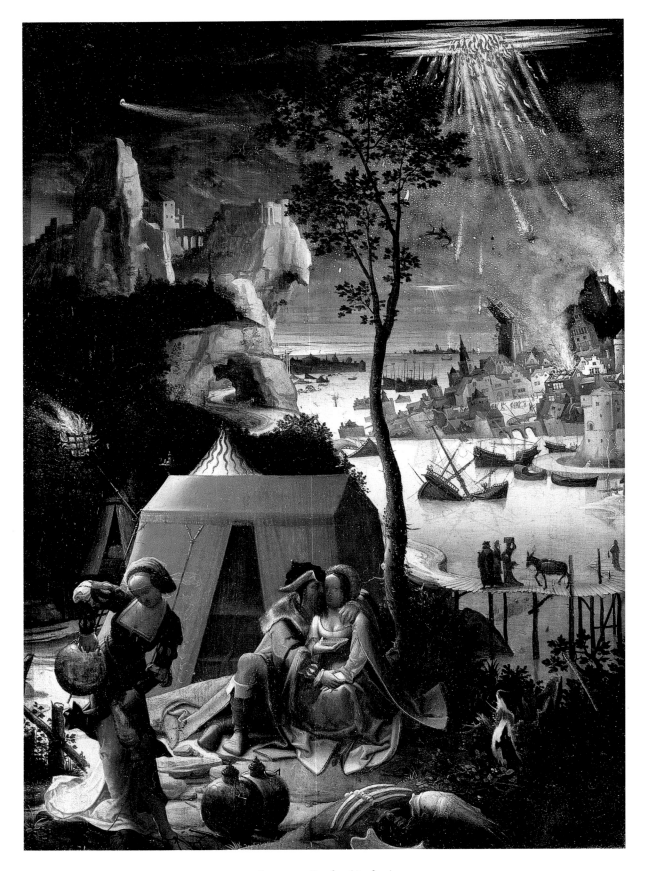

Lucas van Leyden (Anders)

Lot and His Daughters

Born and died in Leiden • c. 1494-1533
Oil on panel • 18.9 in x 13.4 in • Musée du Louvre, Paris, France/Peter Willi/Bridgeman Art Library, London

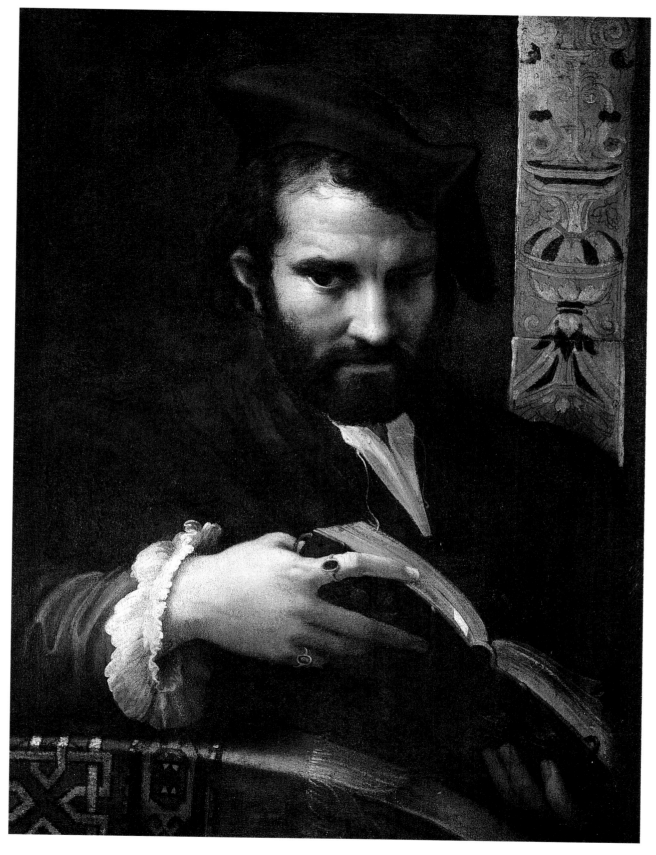

Girolamo Francesco Maria Mazzola (Parmigianino)

PORTRAIT OF A MAN WITH A BOOK

Born in Parma • Died in Cassalmaggiore • 1503-40
Oil on canvas • 27.7 in x 20.5 in • York City Art Gallery, Yorkshire, UK/Bridgeman Art Library, London

119

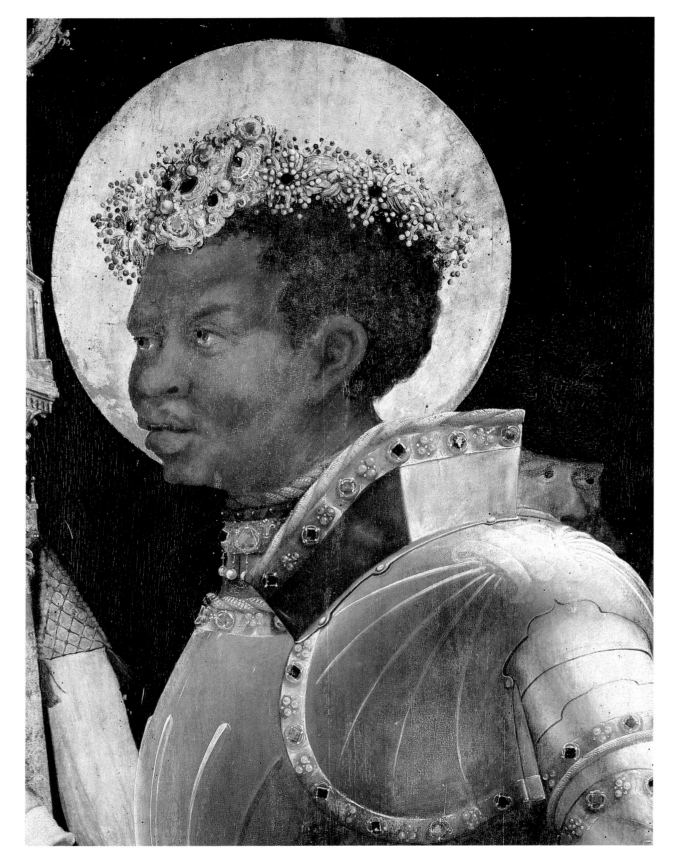

Mattias Grünewald

St. Maurice
(Detail from Meeting of Saints Eramus & Maurice)

Born in Wurzburg • Died in Halle • c. 1460/1528
Oil on panel • 89 in x 69.3 in (whole painting) • Alte Pinakothek, Munich, Germany/Bridgeman Art Library, London

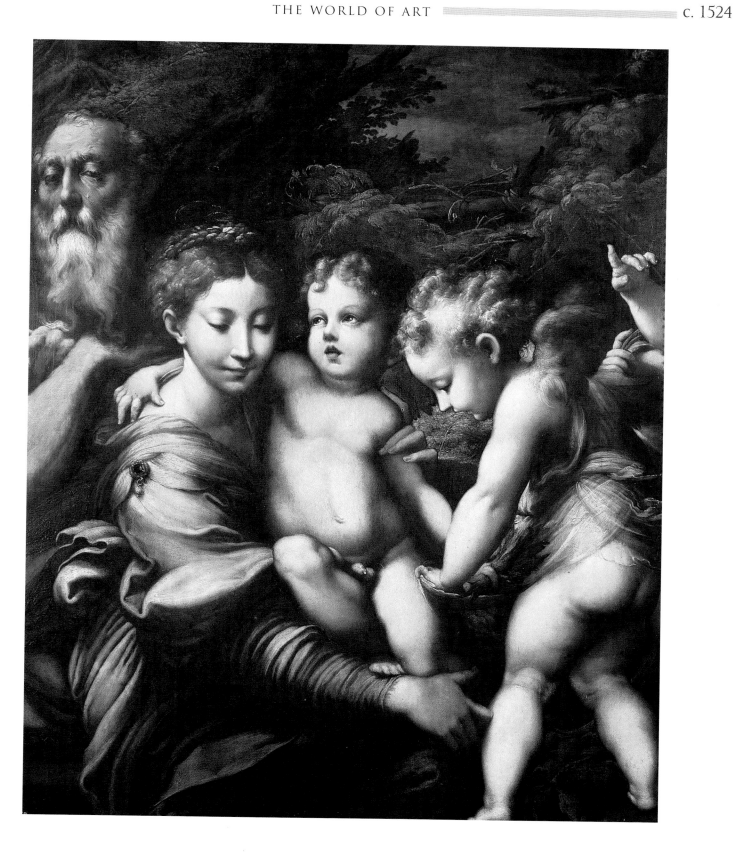

Girolamo Francesco Maria Mazzola (Parmigianino)

THE HOLY FAMILY

Born in Parma • Died in Cassalmaggiore • 1503-40
Oil on panel • 43.3 in x 35 in • Museo del Prado, Madrid, Spain/Bridgeman Art Library, London

Lorenzo Costa

THE GARDEN OF THE PEACEFUL ARTS (ALLEGORY OF THE COURT OF ISABELLE D'ESTE)

Born in Ferrara • Died in Mantua • 1459/60-1535
Oil on panel • 65 in x 78 in • Musée du Louvre, Paris, France/Bridgeman Art Library, London

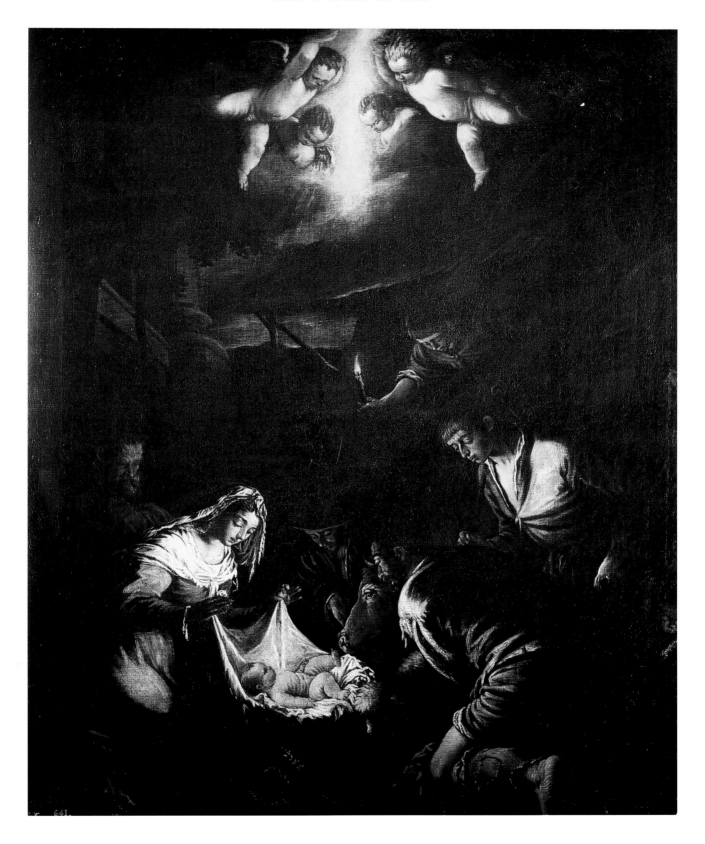

Jacopo Bassano (Jacopo da Ponte)

THE ADORATION OF THE SHEPHERDS

Born Dal Ponte • Died Bassano • c. 1510-1592
Oil on canvas • 50.4 in x 41 in • Museo del Prado, Madrid, Spain/Bridgeman Art Library, London

Marinus van Roejmerswaelen (Reymerswaele)

THE TAX COLLECTOR

Born in Seeland • c. 1493-1567
Oil on panel • 31.7 in x 45.35 in • Musée des Beaux-Arts, Valenciennes, France/Giraudon/Bridgeman Art Library, London

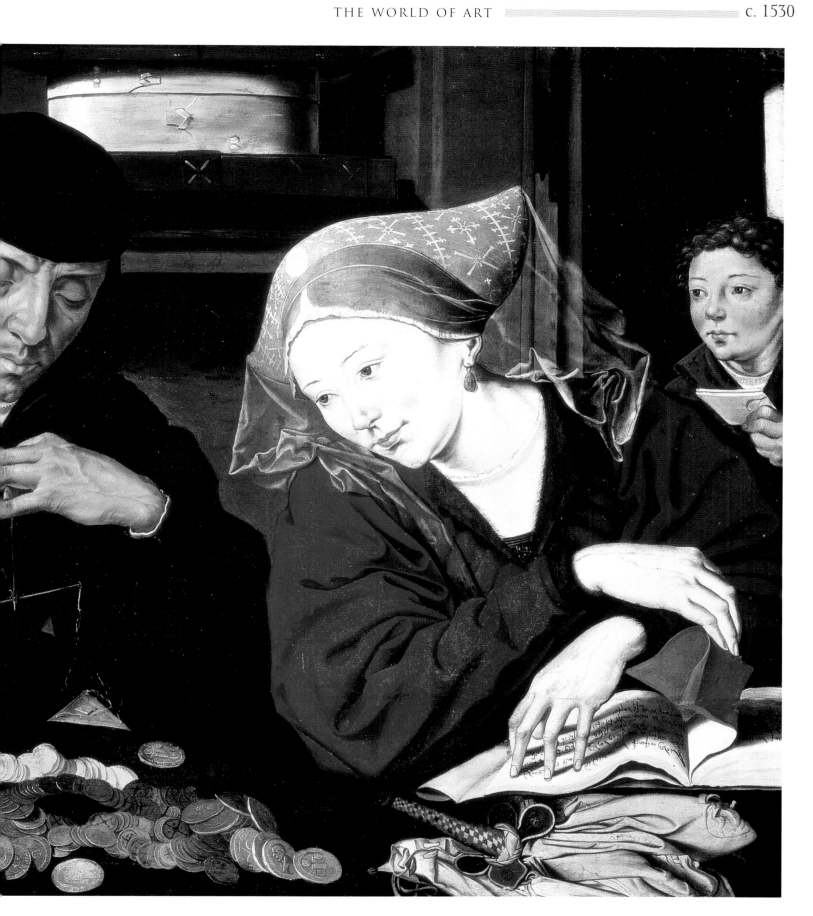

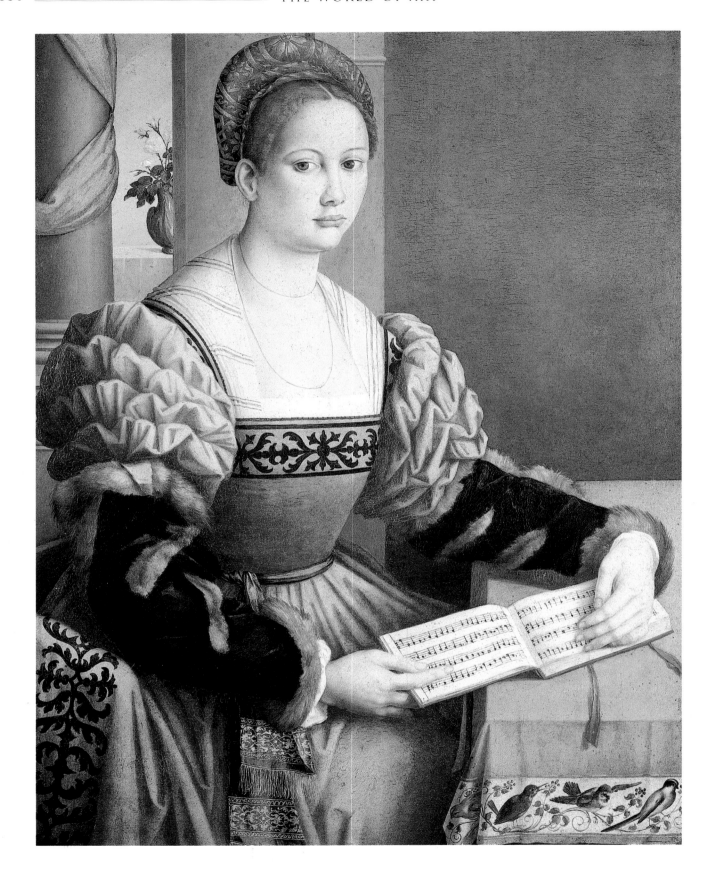

Francesco Ubertini Bacchiacca II

PORTRAIT OF A LADY

Born and died in Florence • 1494/95-1557
Oil on panel • Private Collection/Bridgeman Art Library, London

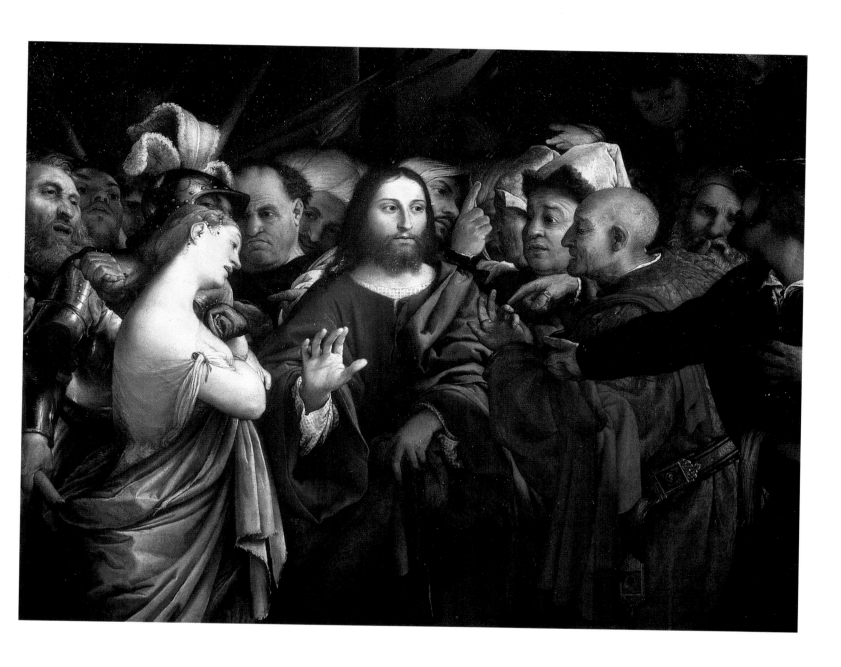

Lorenzo Lotto

CHRIST AND THE ADULTERESS

Born in Venice • Died in Loreto • c. 1480-1556
Oil on canvas • 48.8 in x 61.4 in • Musée du Louvre, Paris, France, Giraudon/Bridgeman Art Library, London

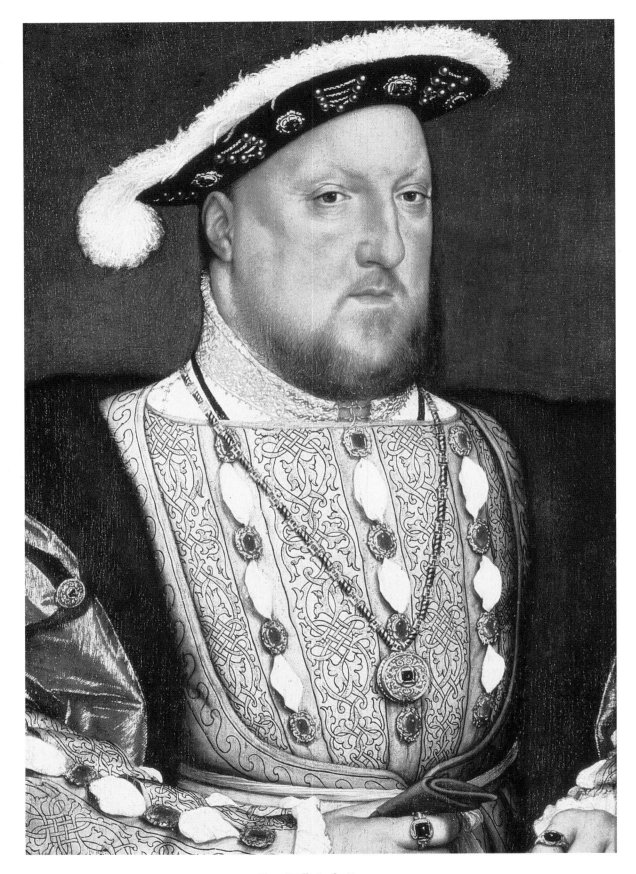

Hans Holbein the Younger

KING HENRY VIII

Born in Augsburg • Died in London • 1497/8-1543
Oil on panel • 11 in x 7.9 in • Thyssen-Bornemisza Collection, Madrid, Spain/Bridgeman Art Library, London

Domenico Beccafumi

St. Bernardino of Siena Preaching

Born in Valdibiena • Died in Siena • 1486-1551
Oil on panel • 12.8 in x 20.1 in • Musée du Louvre, Paris, France/Bridgeman Art Library, London

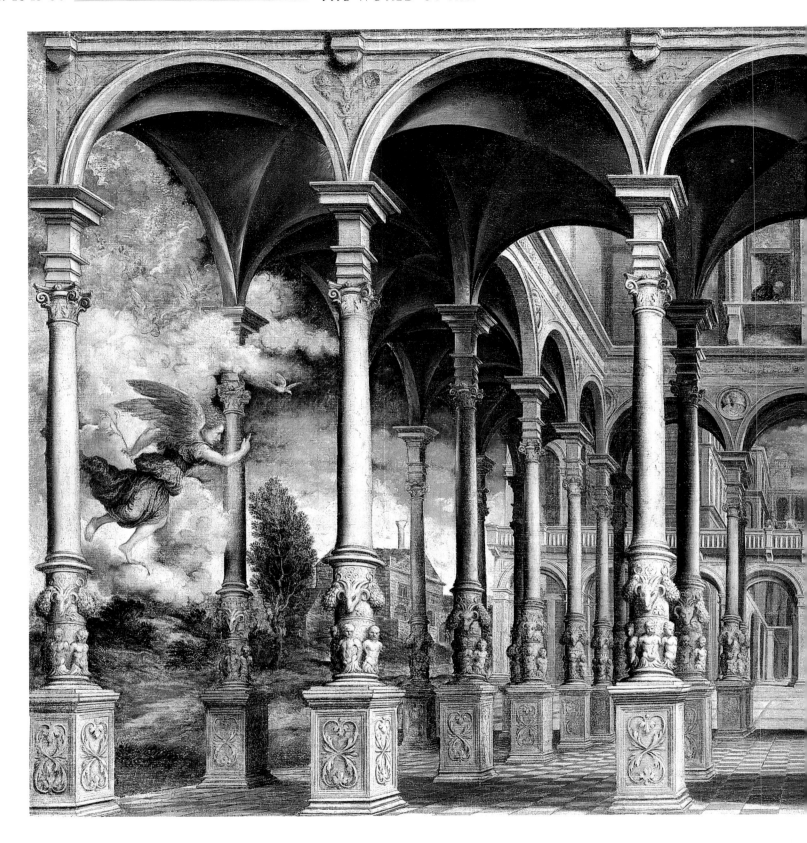

Paris Bordone

THE ANNUNCIATION

Born in Treviso • Died in Venice • 1500-71
Oil on canvas • 40.2 in x 77.2 in • Musée des Beaux Arts, Caen, France/Bridgeman Art Library, London

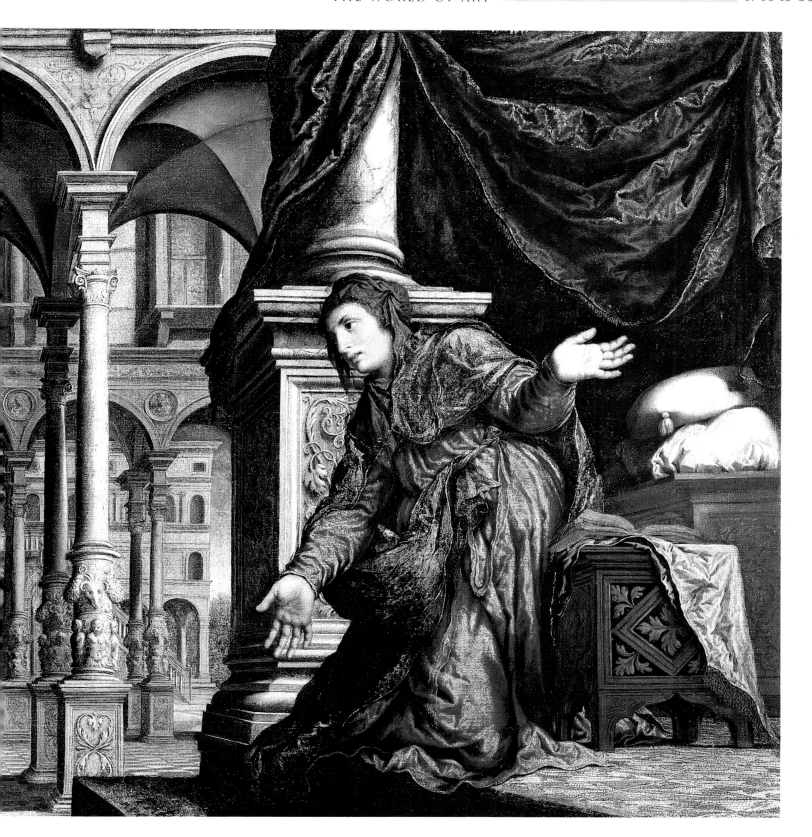

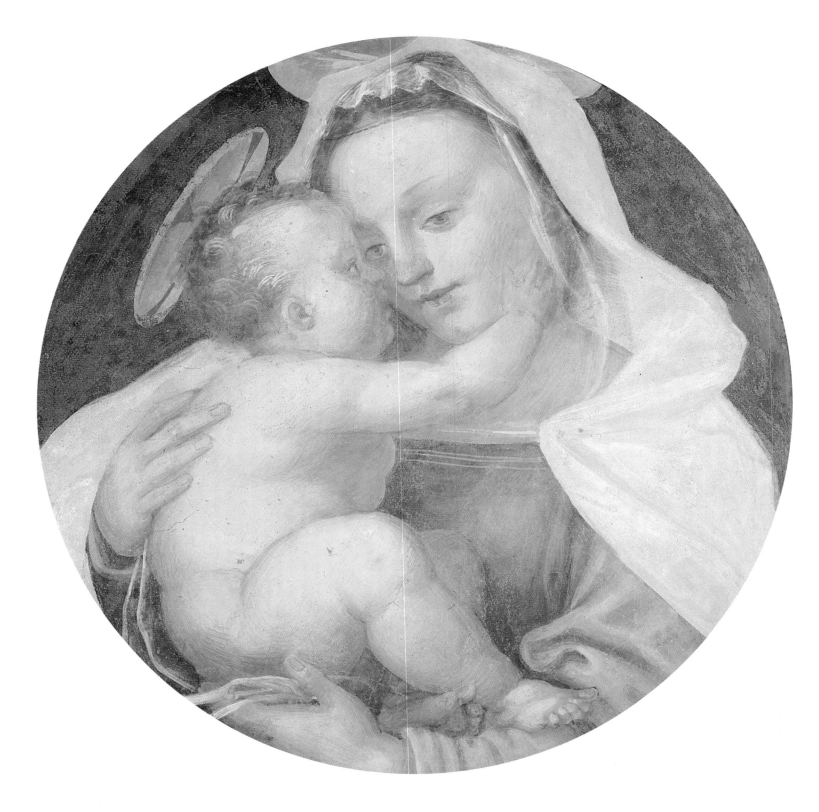

Fra Bartolommeo (Baccio della Porta)

MADONNA AND CHILD

Born and died in Florence • c. 1474-c. 1517
Fresco • Diameter 26 in • Museo di San Marco dell'Angelico, Florence, Italy/Bridgeman Art Library, London

François Clouet

A PORTRAIT PRESUMED TO BE OF THE DAUPHIN HENRI II ON HORSEBACK

Born in Tours • Died in Paris • 1510-72
Oil on panal • Collection of Mr. & Mrs. John de Menil, Houston, USA/Giraudon/Bridgeman Art Library, London

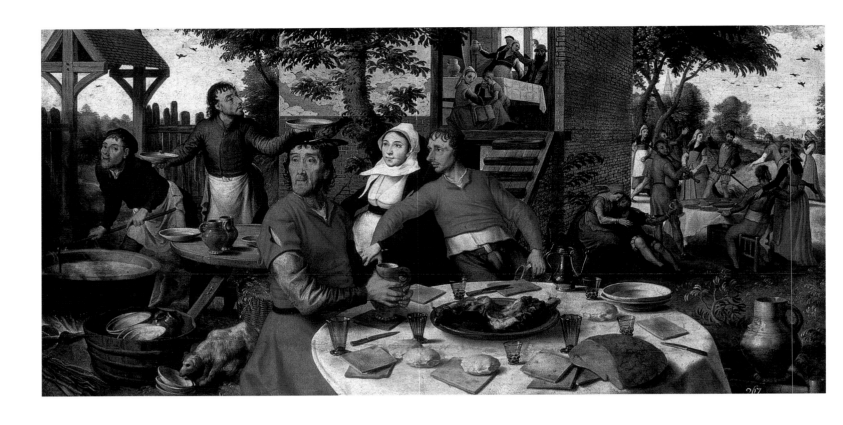

Pieter Aersten (Lange Pier)

PEASANT'S FEAST

Born and died in Amsterdam • 1508/9–1575
Wood • 33.5 in x 67.3 in • Kunsthistorisches Museum, Vienna, Austria/Bridgeman Art Library, London

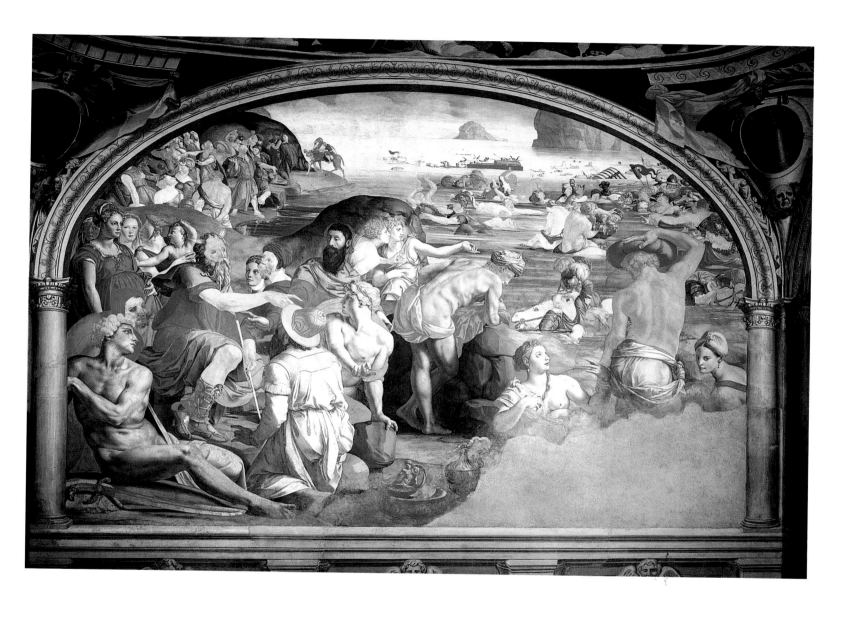

Agnolo Bronzino

THE CROSSING OF THE RED SEA

Born and died in Florence • 1503-72
Fresco • Palazzo Vecchio, Florence, Italy/Bridgeman Art Library, London

Jacopo Robusti Tintoretto

SUSANNA BATHING

Born and died in Venice • 1518-94
Oil on canvas • 57.5 in x 76.2 in • Kunsthistorisches Museum, Vienna, Austria/Bridgeman Art Library, London

Pieter Brueghel, the Elder

TOWER OF BABEL

Born in Brogel • Died in Brussels • 1515-69 • Oil on panel
44.9 in x 61 in • Kunsthistorisches Museum, Vienna,
Austria/Bridgeman Art Library, London

Pieter Brueghel, the Younger

THE SEVEN ACTS OF CHARITY

Born in Brussels • Died in Antwerp • c. 1564-1638
Panel • 16.7 in x 22.6 in • Galerie de Jonckheere, Paris, France

Paolo Caliari Veronese

THE HOLY FAMILY WITH ST. BARBARA

Born in Verona • Died in Venice • 1528-88
Oil on canvas • 33.9 in x 48 in • Galleria Degli Uffizi, Florence, Italy/
Bridgeman Art Library, London

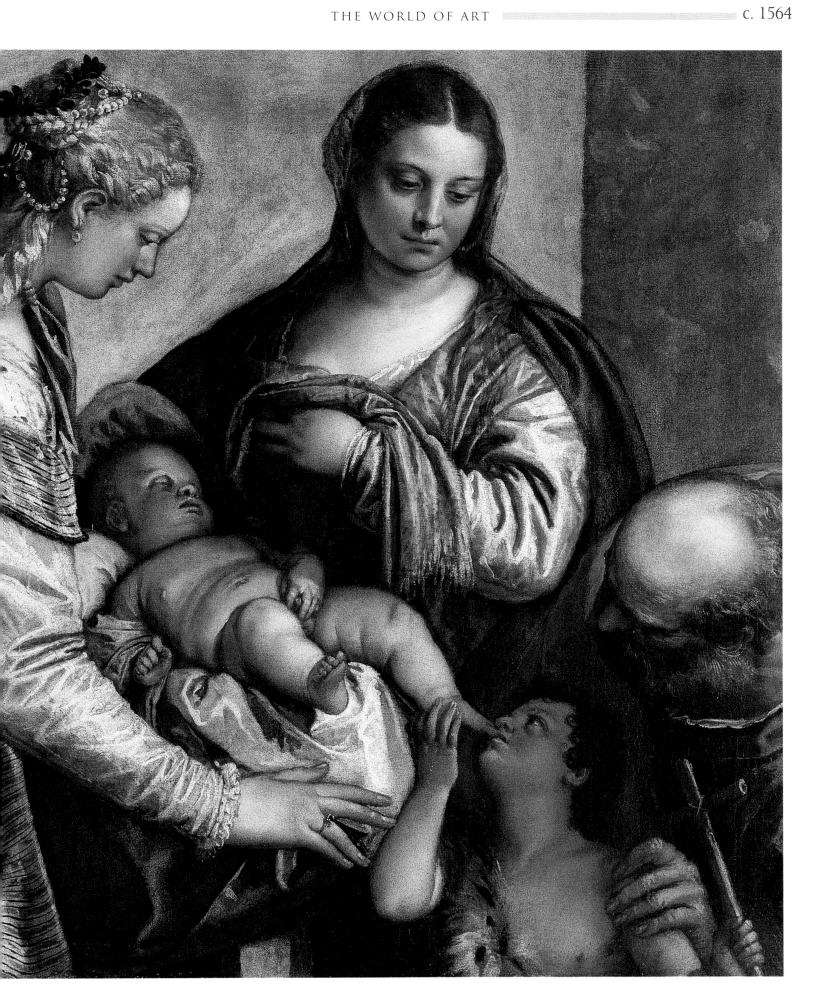

Titian (Tiziano Vecellio)

DEATH OF ACTAEON

Born in Pieve di Cadore • Died in Venice • c. 1485-1576
Oil on canvas • 70.2 in x 78 in • National Gallery, London, UK/Bridgeman Art Library, London

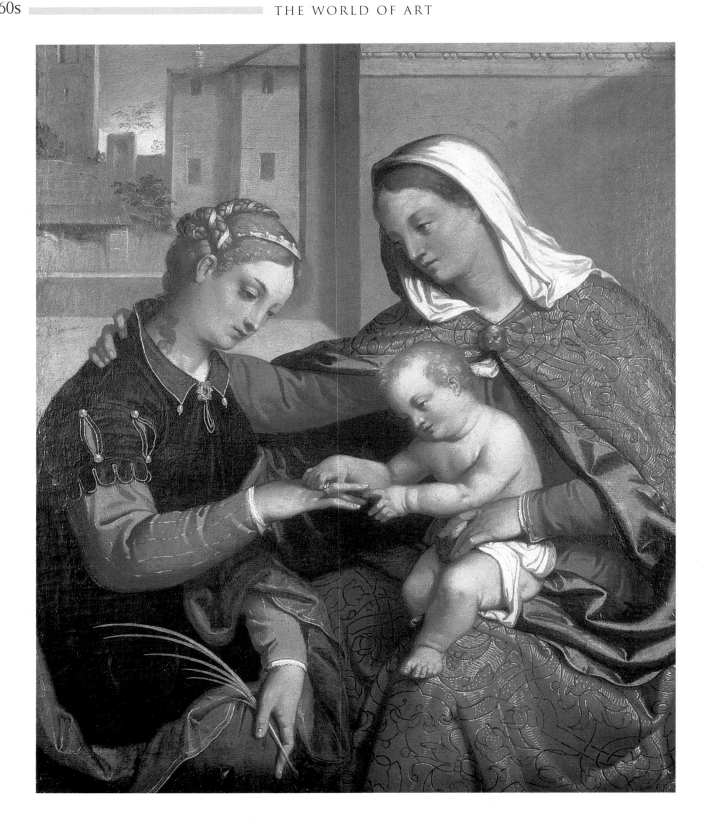

Giovanni Battista Moroni

THE MYSTIC MARRIAGE OF ST. CATHERINE

Born in Abino • Died in Bergamo • Active 1546-1578
Oil on canvas • 32.3 in x 26.4 in • Ashmolean Museum, Oxford, UK/Bridgeman Art Library, London

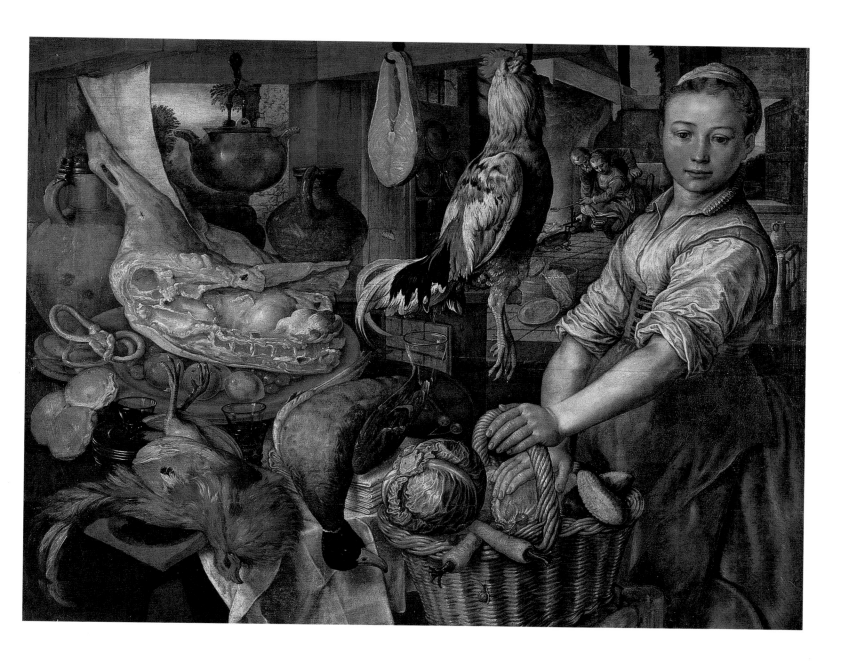

Joachim Bueckelaer

INTERIOR OF A KITCHEN

Born and died in Antwerp • 1530-73
Oil on wood • 76.8 in x 54.7 in • Musée du Louvre, Paris, France/Giraudon/Bridgeman Art Library, London

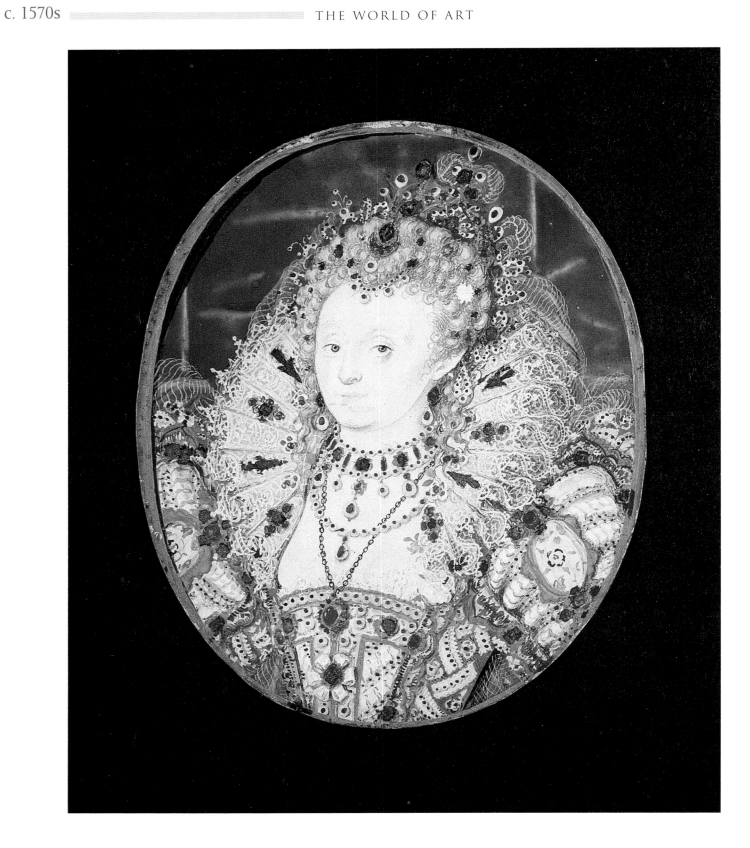

Nicholas Hilliard

QUEEN ELIZABETH I

Born in Exeter • Died in London • 1547-1619
Watercolor on vellum • 2.6 in x 2.1 in • Victoria and Albert Museum, London/Bridgeman Art Library, London

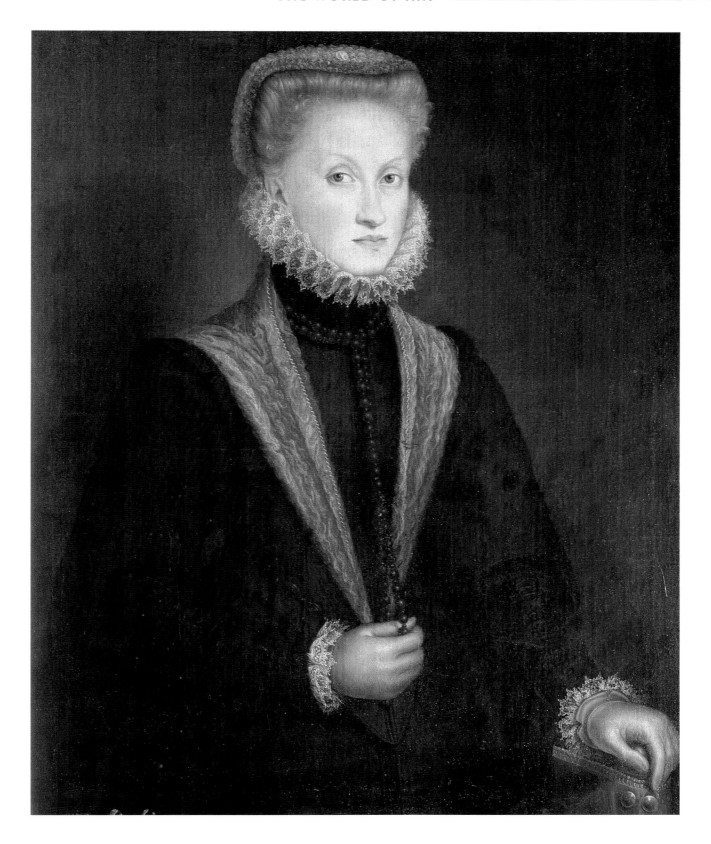

Sofonisba Anguisciola

ANNE OF AUSTRIA, QUEEN OF SPAIN (1549-80), WIFE OF PHILIP II OF SPAIN (1527–98)

Born in Cremona • Died in Palermo • c. 1532-1625
Oil on canvas • 33.1 in x 26.4 in • Museo del Prado, Madrid, Spain/Bridgeman Art Library, London

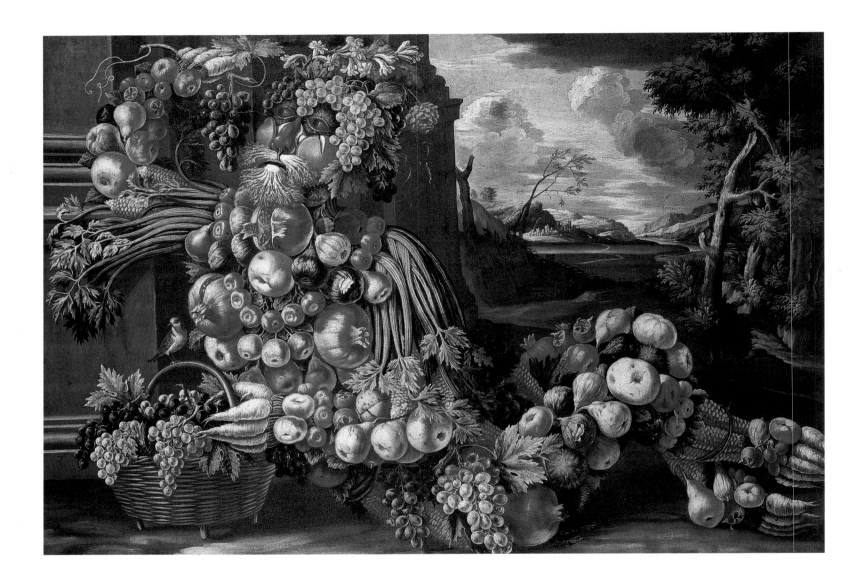

Giuseppe Arcimboldo (School of)

SUMMER

Born and died in Milan • 1527-93
Oil on canvas • 29.9 in x 25 in • Ex-Edward James Foundation, Sussex, UK/Bridgeman Art Library, London

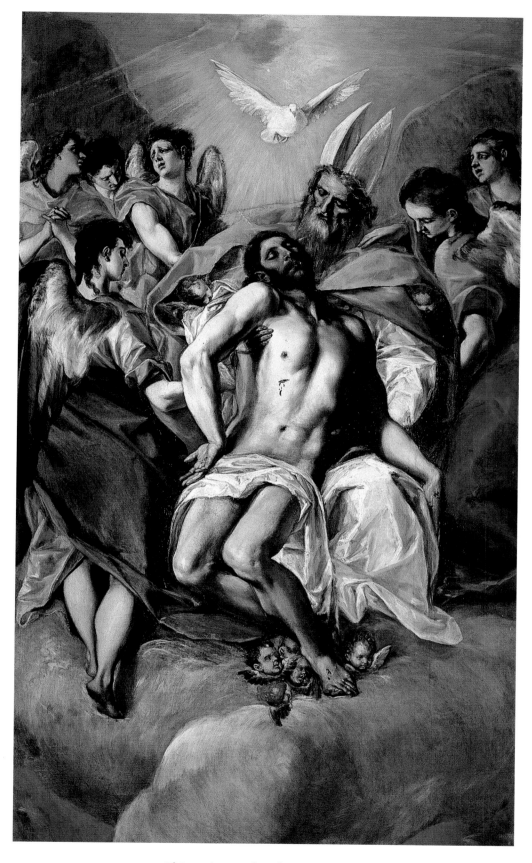

El Greco (Domenikos Theotocopoulos)

THE HOLY TRINITY

Born in Crete • Died in Toledo • 1541-1614
Oil on canvas • 118 in x 70.5 in • Prado, Madrid, Spain/Bridgeman Art Library, London

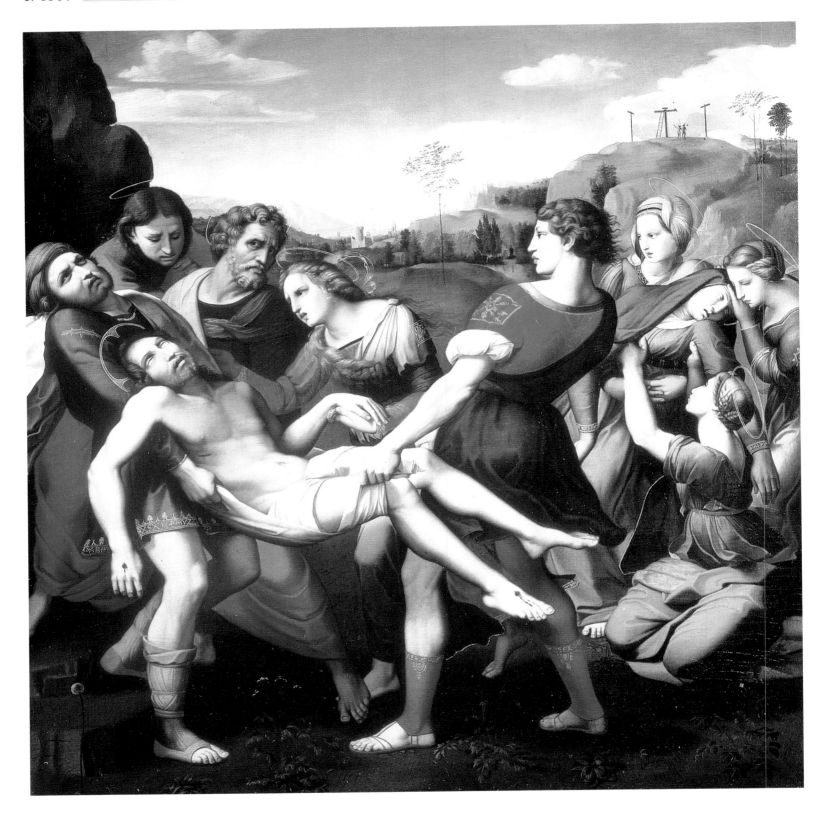

Giovanni Battista Salvi Sassoferrato

THE ENTOMBMENT
(AFTER A PAINTING BY RAPHAEL [1483-1520] IN THE VILLA BORGHESE, ROME)

Born in Sassoferrato • Died in Rome • 1609-85
Oil on canvas • Johnny van Heaften Gallery, London, UK/Bridgeman Art Library, London

Marcus Gheeraerts, the Younger

QUEEN ELIZABETH I

Born in Bruges • Died in London • c. 1561-1635
Oil on panel • Private Collection/Bridgeman Art Library, London

Adam Elsheimer

St. Jerome in the Wilderness

Born in Frankfurt • Died in Rome • 1578-1610
Oil on panel • Galleria dell Accademia Carrara, Bergamo, Italy/Bridgeman Art Library, London

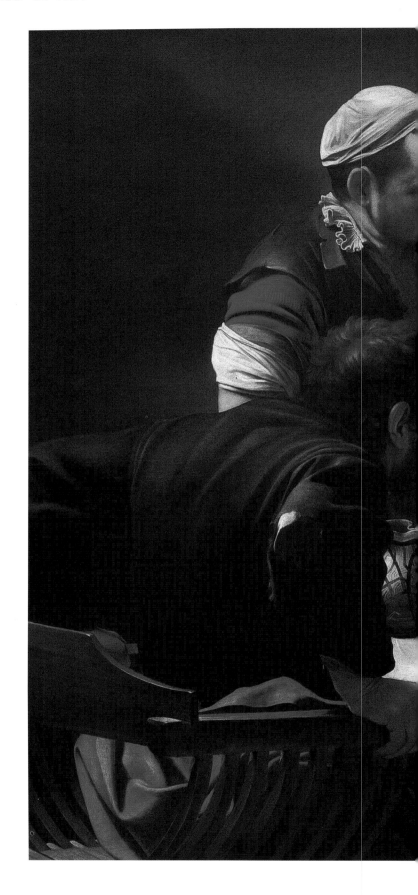

Michelangelo Merisi da Caravaggio

THE SUPPER AT EMMAUS

Born in Caravaggio • Died in Porto Ercole • 1571-1610
Oil on canvas • 55.5 in x 77.2 in • National Gallery, London, UK, Bridgeman Art Library, London

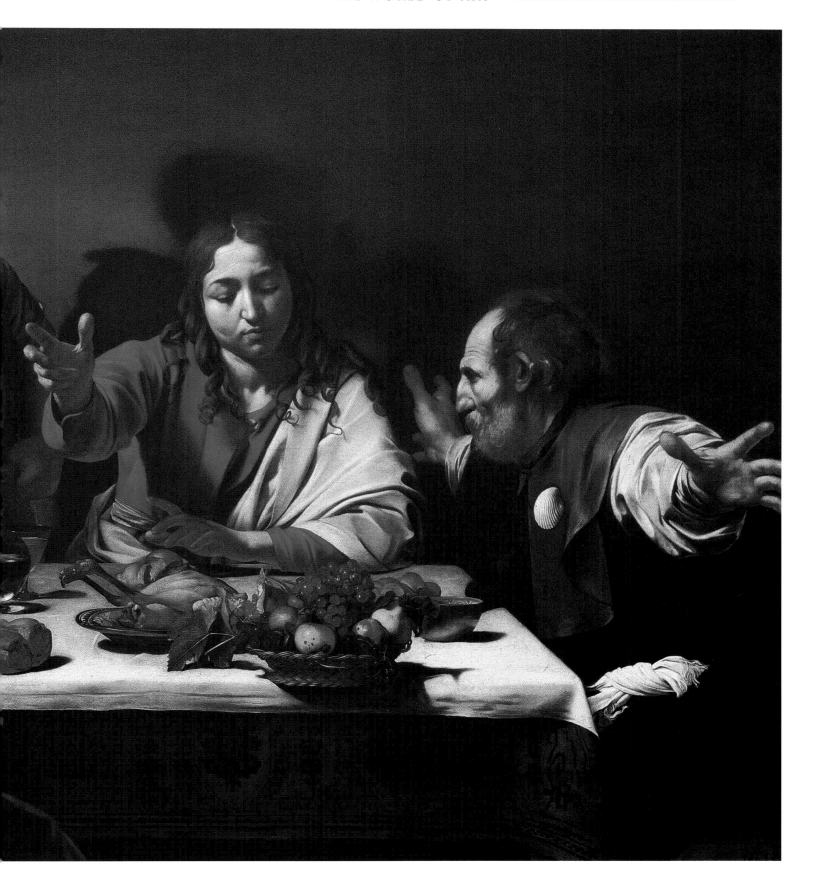

Jan Brueghel, the Elder

ON THE WAY TO MARKET

Born and died in Antwerp • 1568-1625
Oil on copper • 7.3 in x 10 in • Kunsthistorisches Museum, Vienna, Austria/Bridgeman Art Library, London

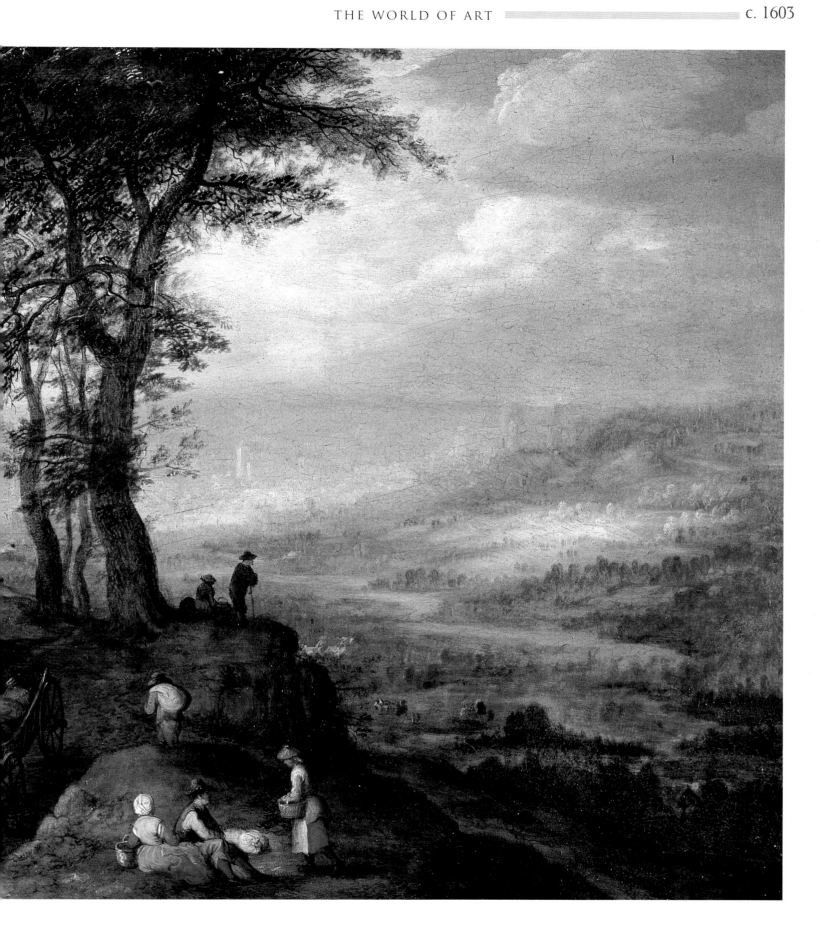

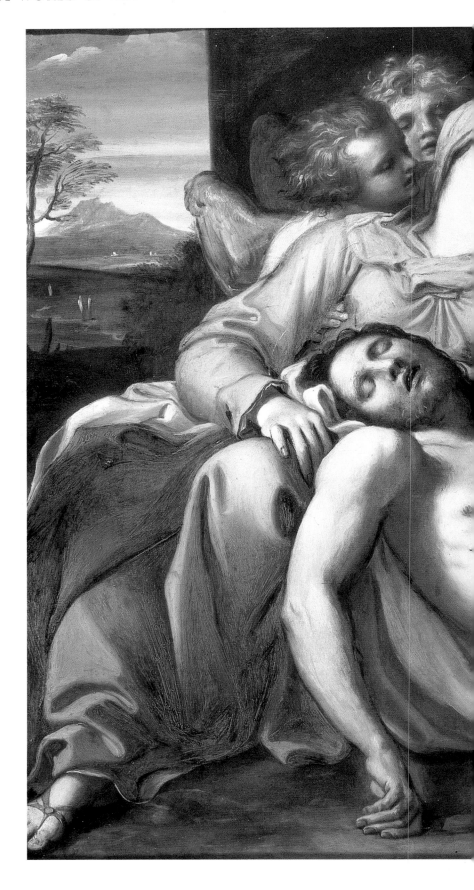

Annibale Carracci

PIETÀ

Born in Bologna • Died in Rome • 1560-1609
Oil on copper • 16.1 in x 23.6 in • Kunsthistorisches Museum, Vienna, Austria/Bridgeman Art Library, London

David Vinckboons

THE BLIND HURDY GURDY PLAYER

Born in Mechelen • Died in Amsterdam • 1576-1632
Oil on panel • 9.25 in x 12.5 in • Johnny van Haeften Gallery, London, UK/Bridgeman Art Library, London

Roelandt Jacobsz Savery

FLOWERS IN A VASE

Born in Courtrai • Died in Utrecht • 1576-1639
Oil on panel • 10.5 in x 7.2 in • Musée des Beaux-Arts, Lille, France/Giraudon/Bridgeman Art Library, London

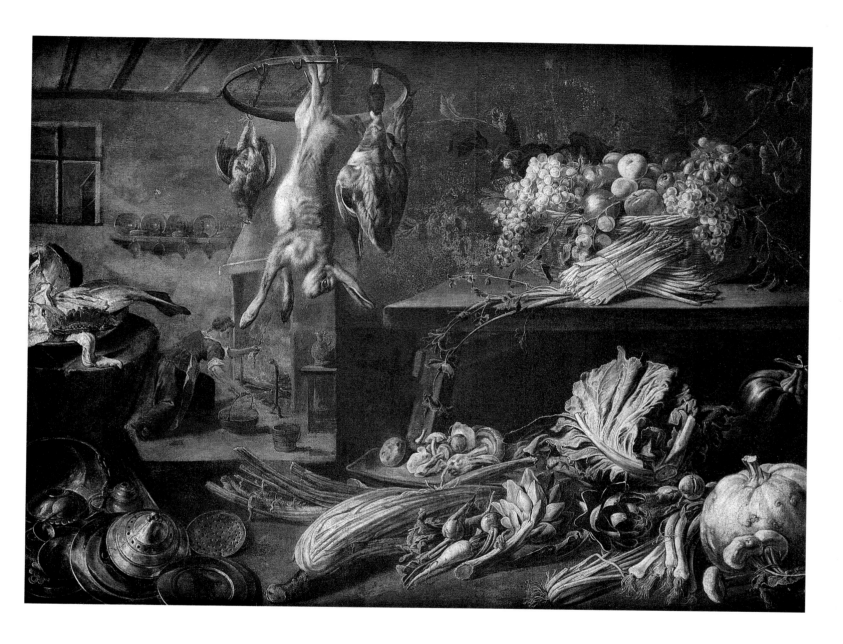

Adrian van Utrecht

KITCHEN INTERIOR WITH STILL LIFE, MAID BY THE FIRE

Born and died in Antwerp • 1599-1652
62.5 in x 83 in • Christie's Images/Bridgeman Art Library, London

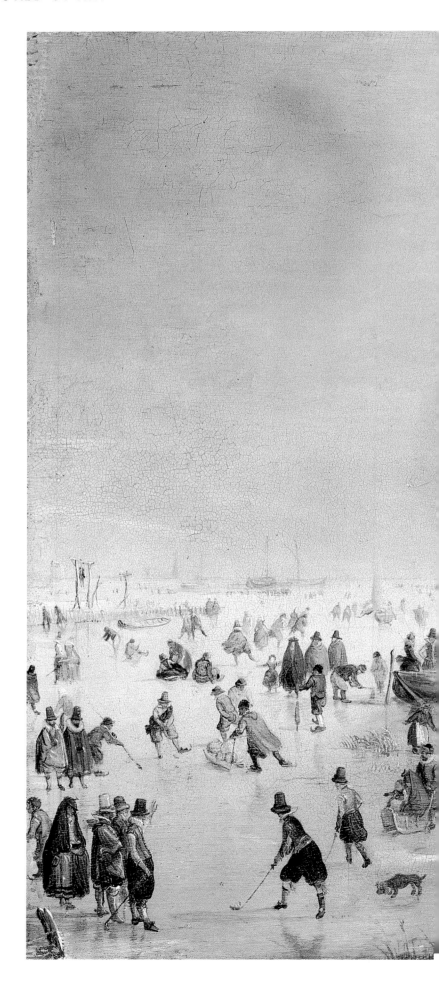

Hendrik Avercamp

A WINTER SCENE WITH SKATERS BY A WINDMILL

Born and died in Amsterdam • 1585-1634
Oil on canvas • 8 in x 10.4 in • Johnny van Haeften Gallery, London, UK.
Bridgeman Art Library, London

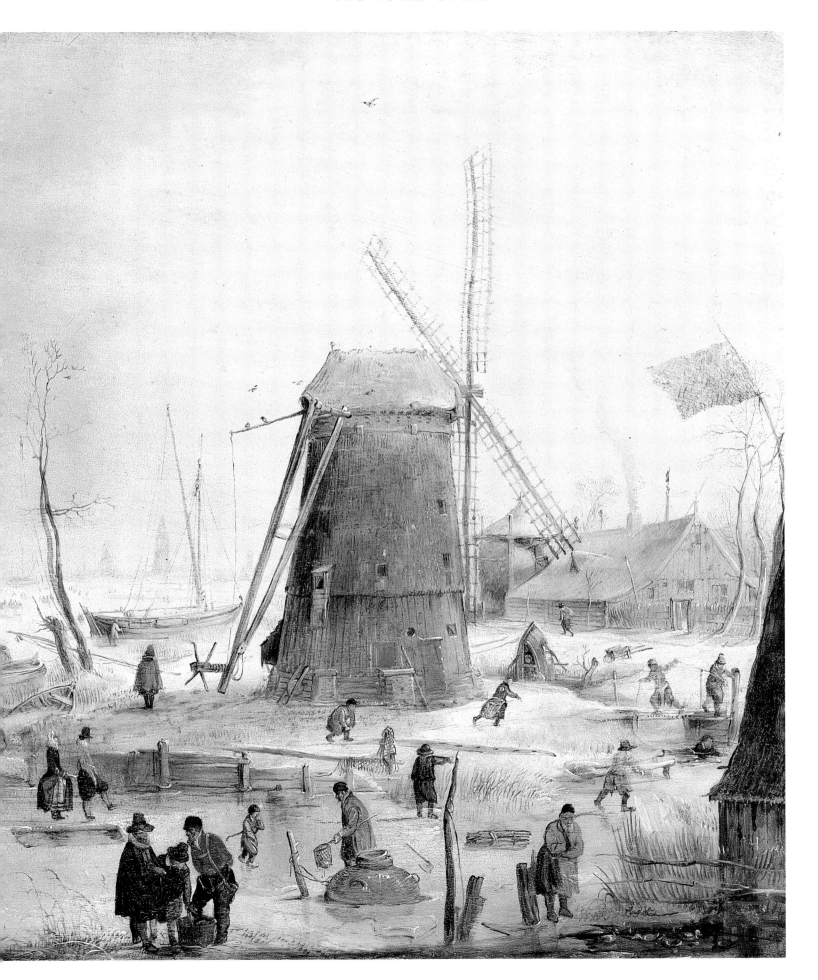

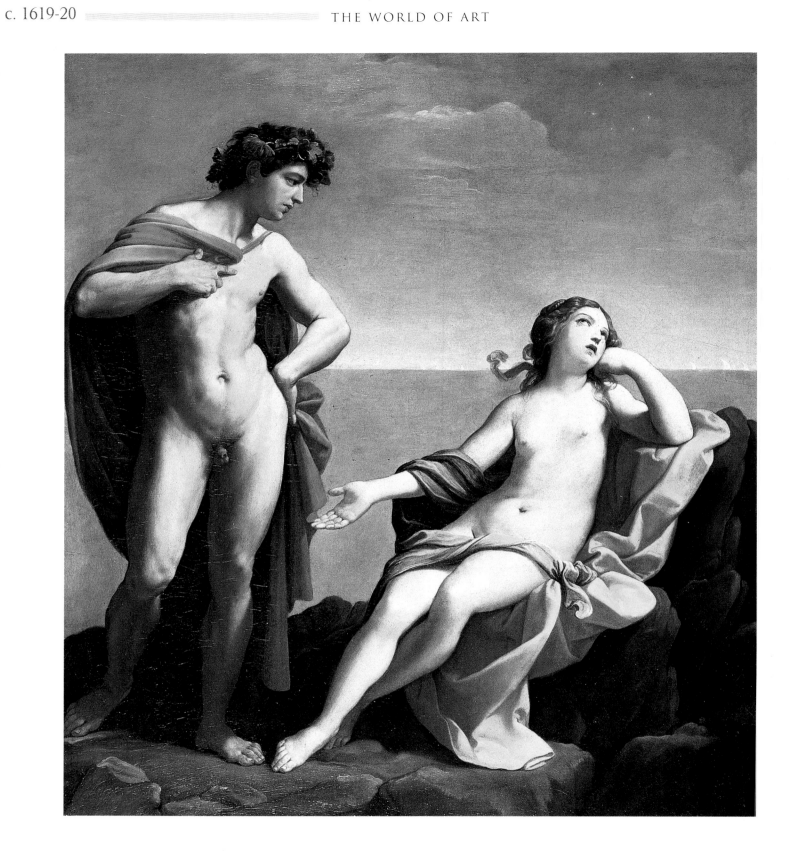

Guido Reni

BACCHUS AND ARIADNE

Born and died in Bologna • 1575-1642
Oil on canvas • 38 in x 34 in • Los Angeles County Museum of Art, CA, USA/Bridgeman Art Library, London

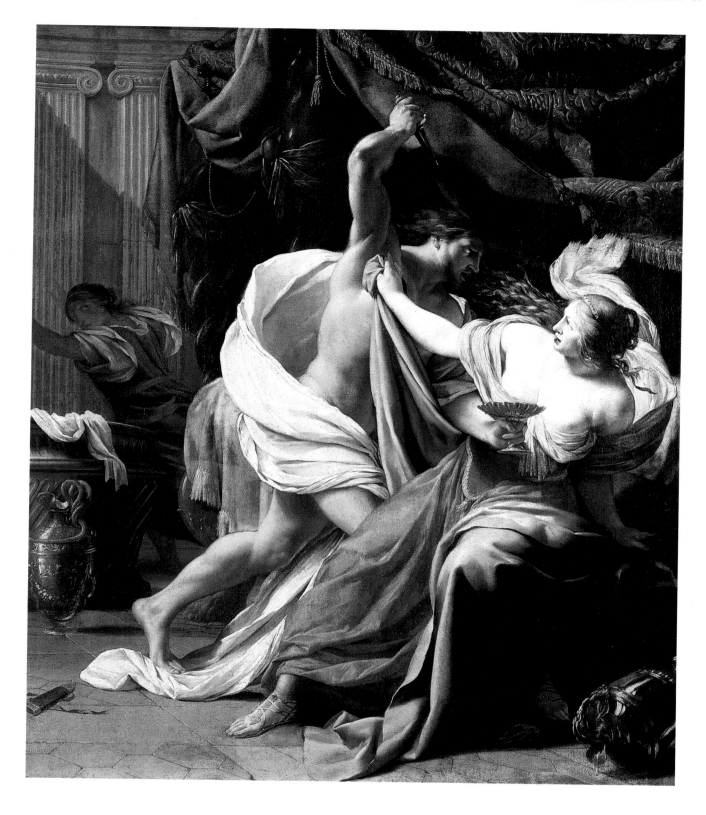

Simon Vouet

LUCRETIA AND TARQUIN

Born and died in Paris • 1590-1649
Oil on canvas • 73 in x 61 in • Christie's Images/Bridgeman Art Library, London

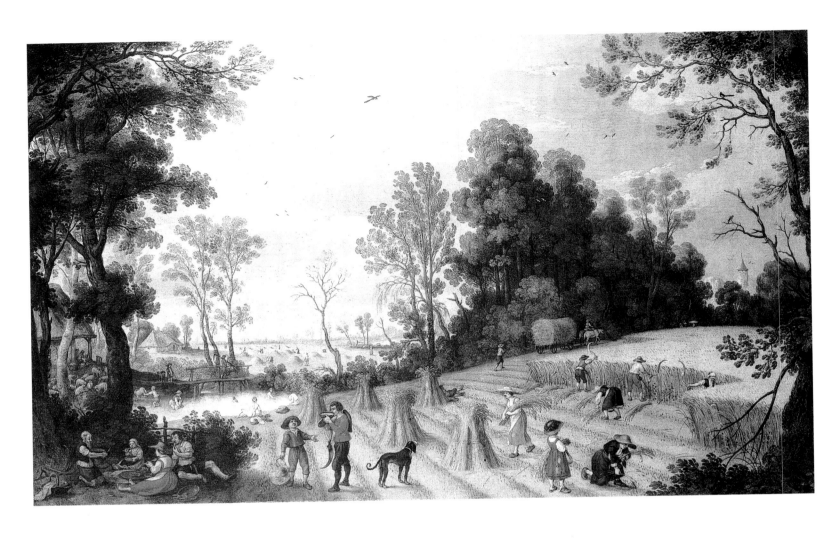

Sebastien Vrancx

THE FOUR SEASONS; SUMMER

Born and died in Antwerp • 1573-1647
Oil on canvas • Roy Miles Gallery, London, UK/Bridgeman Art Library, London

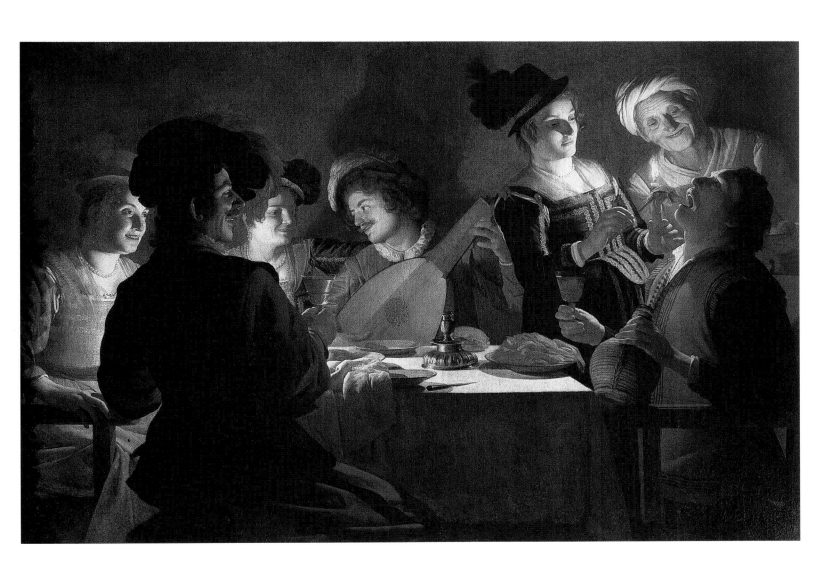

Gerrit van Honthorst

Supper with the Minstrel and His Lute

Born and died in Utrecht • 1590-1656
Oil on canvas • 56.7 in x 83.5 in • Galleria Degli Uffizi, Florence, Italy/Bridgeman Art Library, London

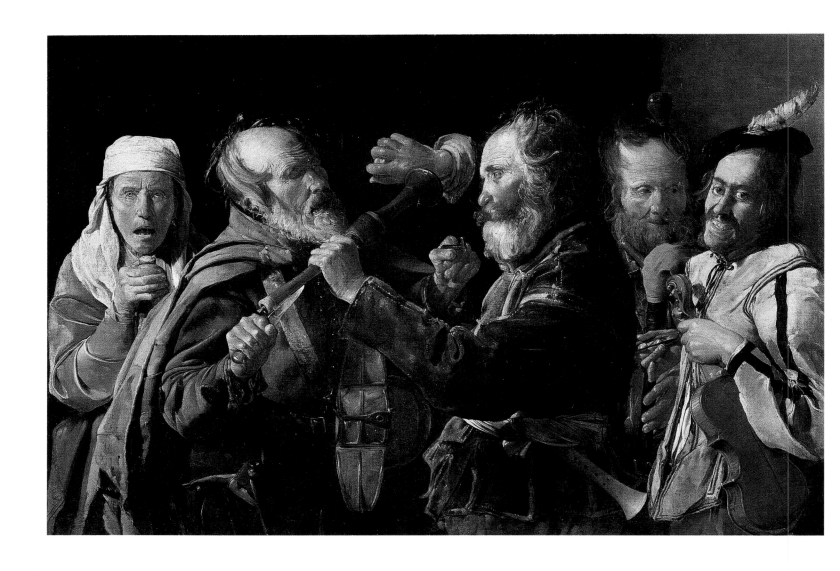

Georges de la Tour

THE BEGGARS BRAWL (*RIXE DE MUSICIENS*)

Born in Vic-sur-Seille • Died in Lunéville • 1593-1652
Oil on canvas • 33.75 in x 55.5 in • J. Paul Getty Museum, Malibu, CA, USA/Bridgeman Art Library, London

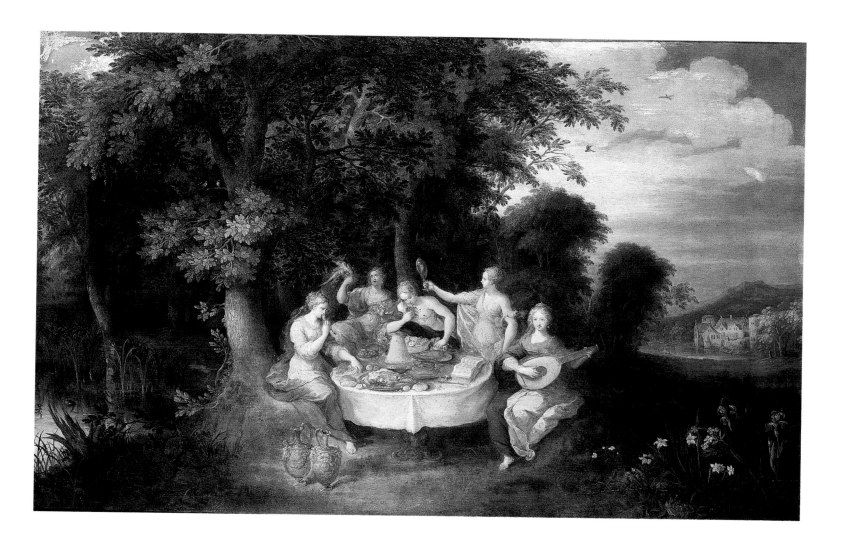

Abraham Govaerts and Frans Franckent

THE FIVE SENSES

Born and died in Antwerp • 1589-1626
Oil on wood • 22 in x 34.1 in • Musée du Louvre, Paris, France/Giraudon/Bridgeman Art Library, London

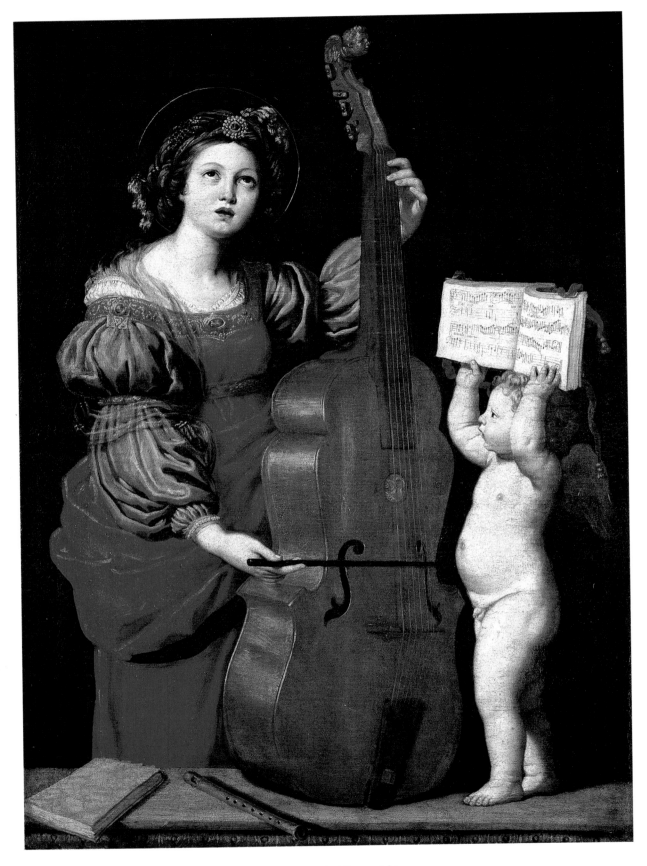

Domenico Zampieri Domenichino

St. Cecilia with an Angel Holding a Musical Score

Born in Bologna • Died in Naples • 1581-1641
Oil on canvas • 63 in x 47.2 in • Musée du Louvre, Paris, France/Bridgeman Art Library, London

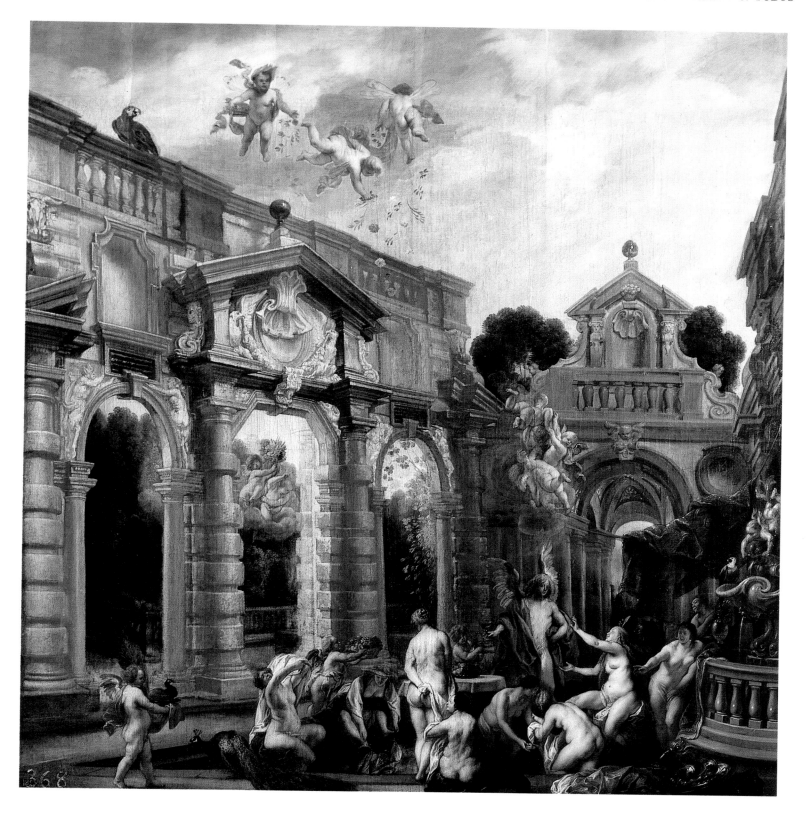

Jacob Jordaens

NYMPHS AT THE FOUNTAIN OF LOVE

Born and died in Antwerp • 1593-1678
Oil on panel • 51.6 in x 50 in • Museo del Prado, Madrid, Spain/Bridgeman Art Library, London

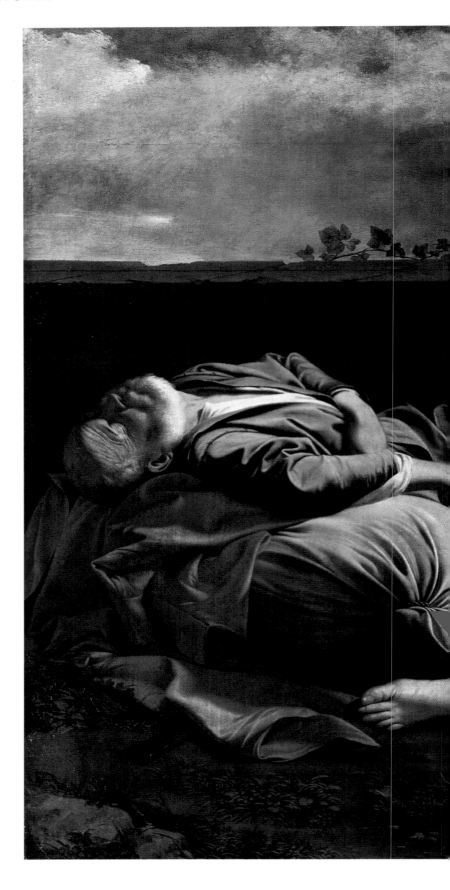

Orazio Gentileschi

THE REST ON THE FLIGHT INTO EGYPT

Born in Rome • Died in Naples • 1565-1647
Oil on canvas • 61.8 in x 88.6 in • Musée du Louvre, Paris, France/Bridgeman Art Library, London

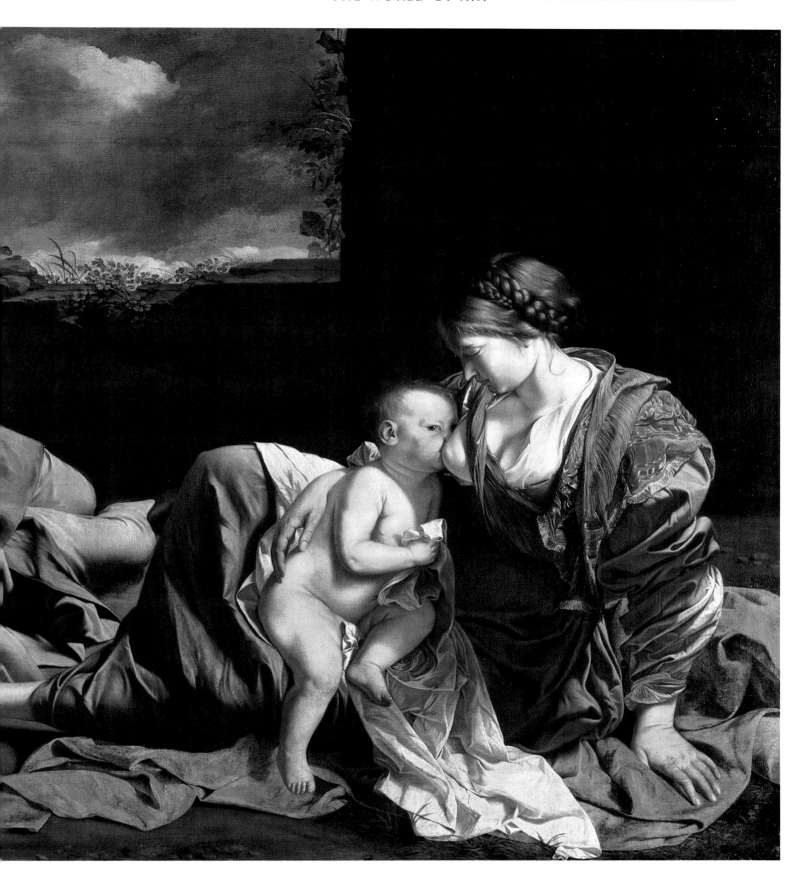

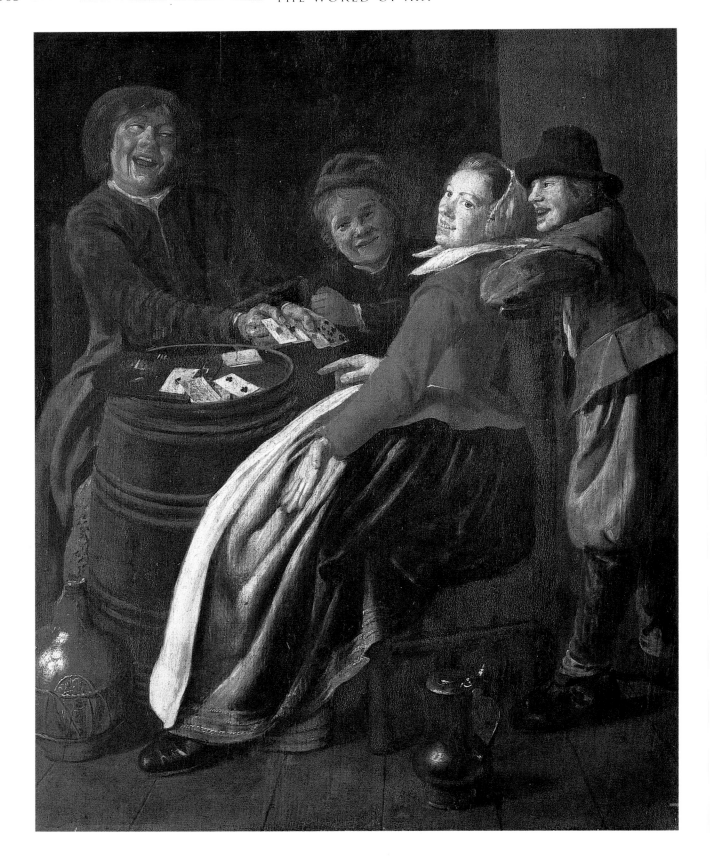

Judith Leyster

A GAME OF CARDS

Born in Haarlem • Died in Heemstede • 1600-60
Oil on canvas • 21.3 in x 17.1 in • Musée des Beaux-Arts-Rouen, France/Giraudon/Bridgeman Art Library, London

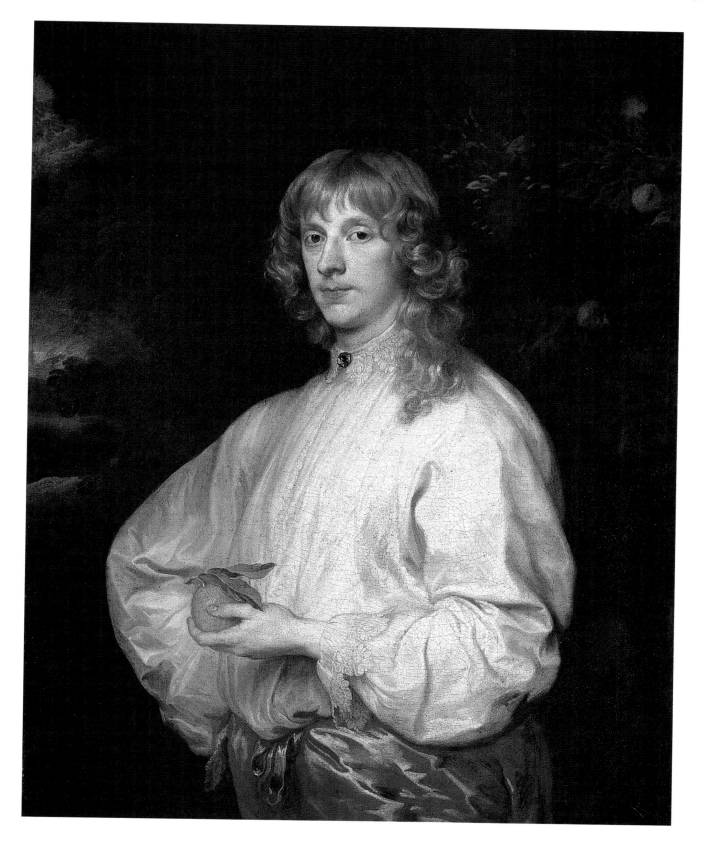

Sir Anthony van Dyck

JAMES STUART, DUKE OF RICHMOND AND LENNOX WITH HIS ATTRIBUTES

Born in Antwerp • Died in London • 1599-1641
Canvas • 42.1 in x 33.1 in • Musée du Louvre, Paris, France/Bridgeman Art Library, London

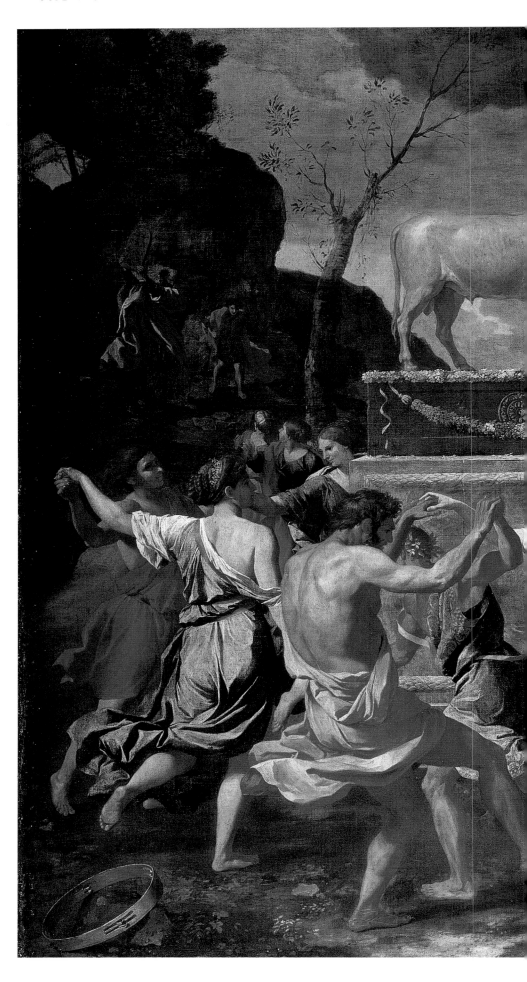

Nicolas Poussin

THE ADORATION OF THE GOLDEN CALF

Born in Les Andelys • Died in Rome • 1594-1665 • Oil on canvas and laid down on board • 60.7 in x 84.3 in National Gallery, London, UK, Bridgeman Art Library, London

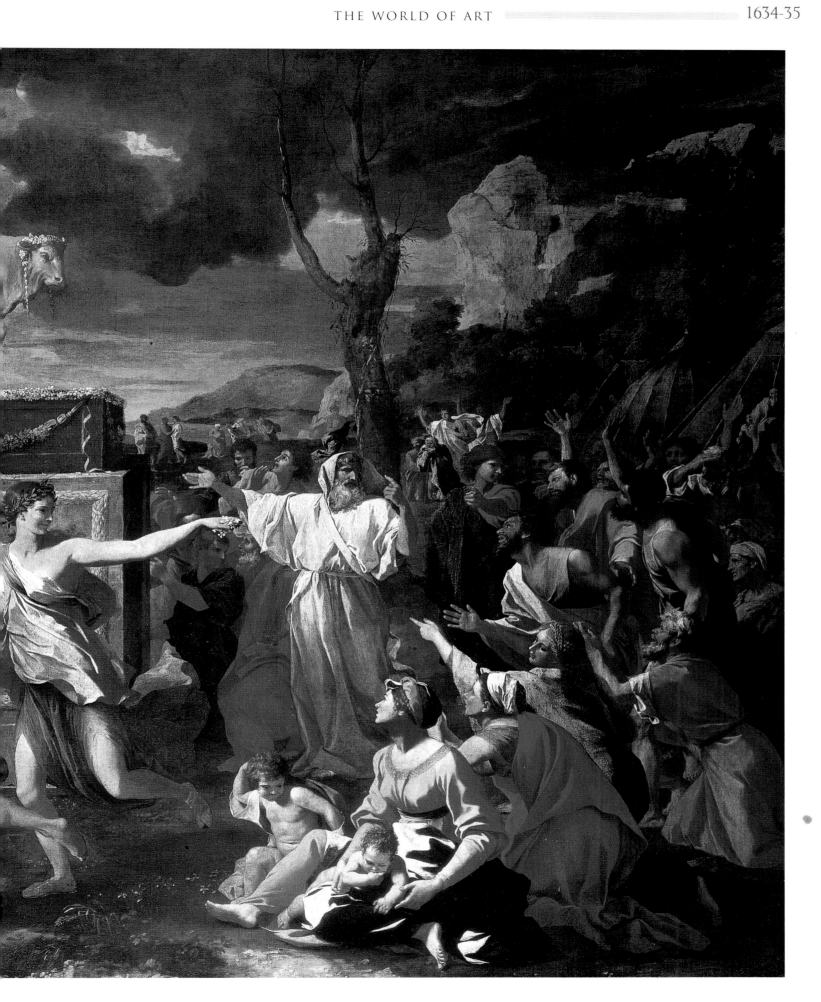

Francisco de Zurbarán

ST. APOLLONIA

Born in Fuente de Cantos • Died in Madrid • 1598-1664
Oil on canvas • 45.7 in x 26 in • Musée du Louvre, Paris, France/Giraudon/Bridgeman Art Library, London

Frans Snyders

THE BASKET OF FRUIT

Born and died in Antwerp • 1579-1657
Oil on canvas • 60.2 in x 84.3 in • Museo del Prado, Madrid, Spain/Bridgeman Art Library, London

Harmensz van Rijn Rembrandt

BELSHAZZAR'S FEAST

Born in Leiden • Died in Amsterdam • 1609-69
Oil on canvas • 66 in x 82.4 in • National Gallery, London, UK, Bridgeman Art Library, London

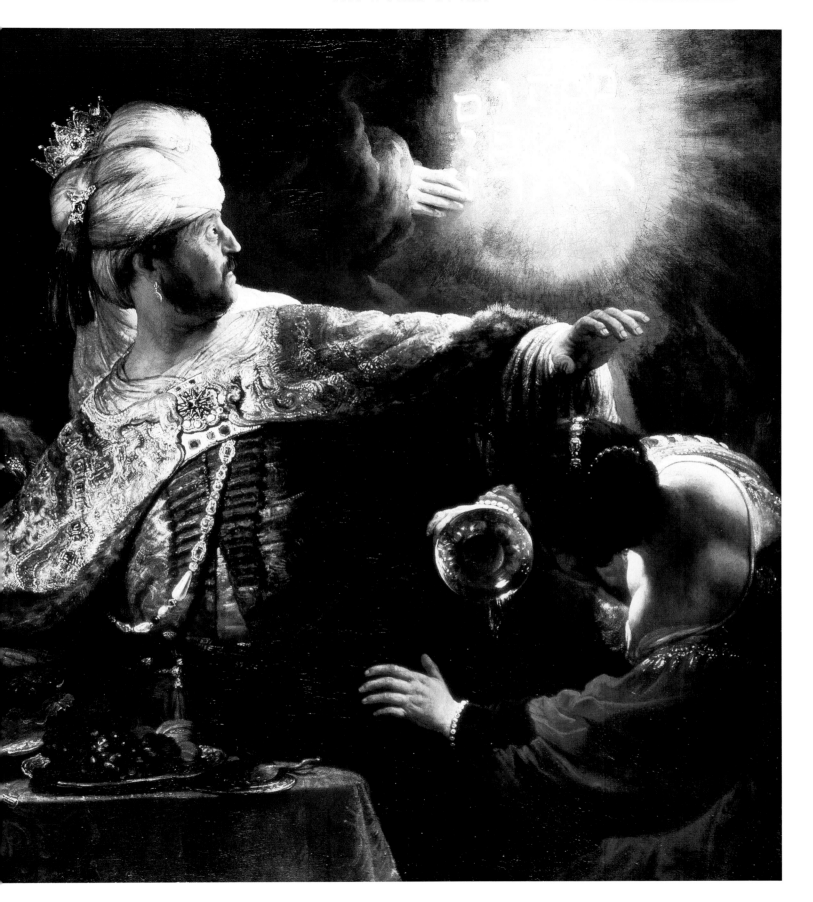

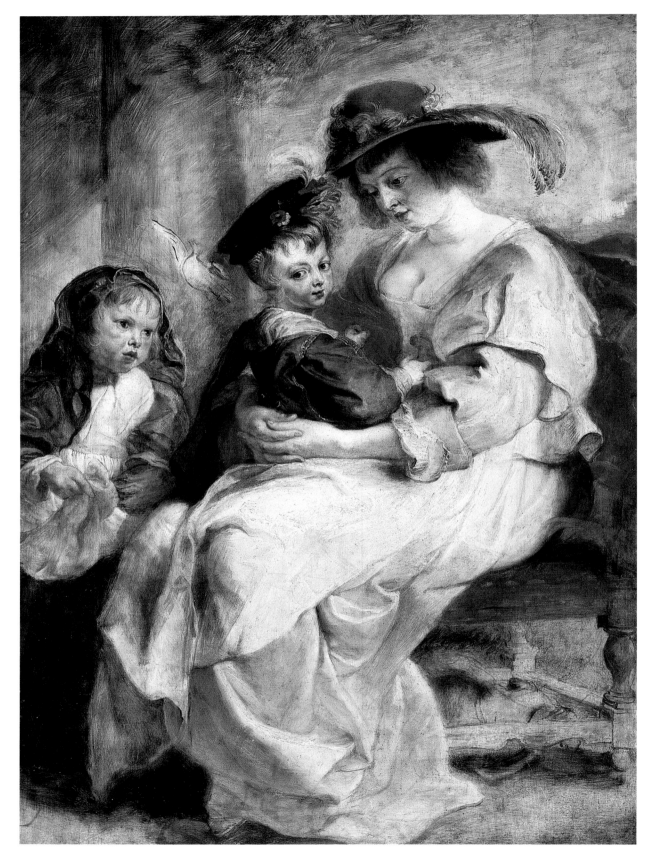

Peter Paul Rubens

HELENE FOURMENT WITH TWO OF HER CHILDREN, CLAIRE-JEANNE AND FRANÇOIS

Born in Siegen • Died in Antwerp • 1577-1640
Oil on panel • 45.3 in x 33.5 in • Musée du Louvre, Paris, France/Bulloz/Bridgeman Art Library, London

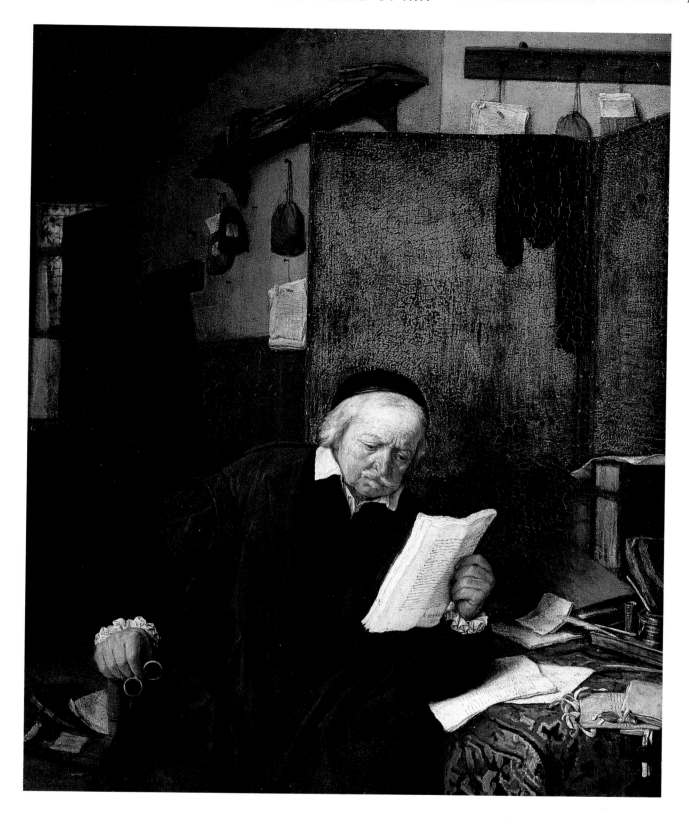

Adriaen Jansz van Ostade

LAWYER IN HIS STUDY

Born and died in Haarlem • 1610-85
Oil on panel • 13.6 in x 11 in • Museum Boymans van Beuningen, Rotterdam, the Netherlands/Bridgeman Art Library, London

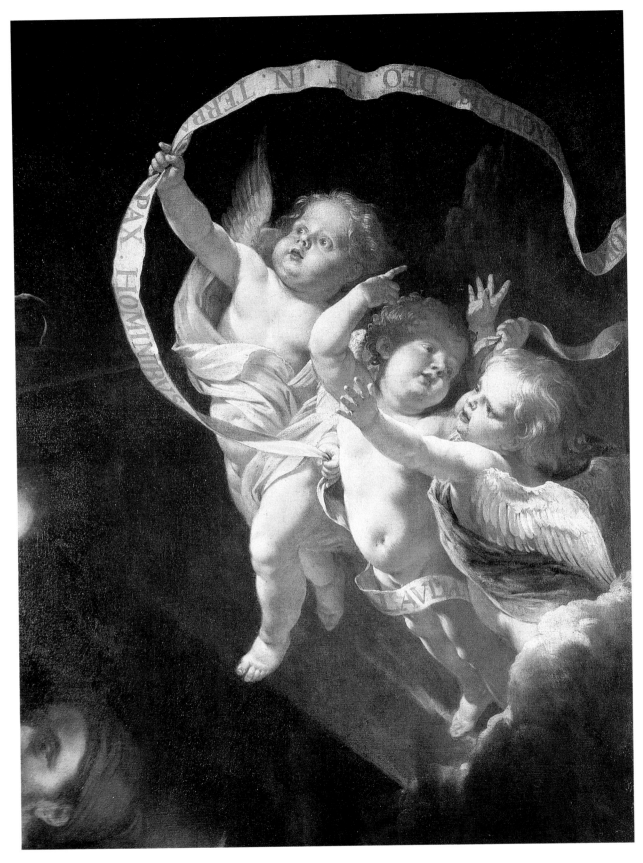

Philippe de Champaigne

CHERUBS
(DETAIL FROM THE ADORATION OF THE SHEPHERDS)

Born in Brussels • Died in Paris • 1602-74
Oil on canvas • 92 in x 64.2 in (full canvas) • Wallace Collection, London/Bridgeman Art Library, London

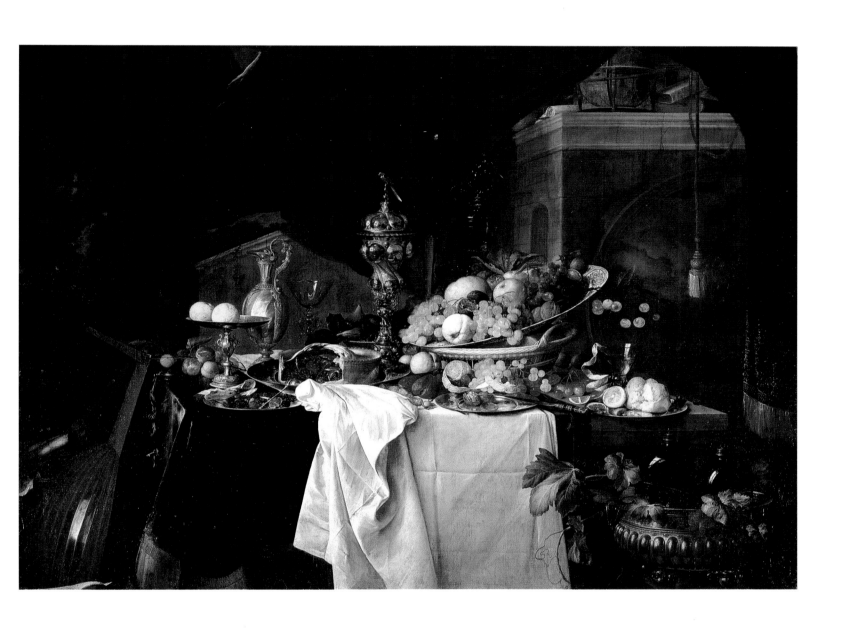

Jan Davidsz de Heem

STILL LIFE OF DESSERT

Born in Utrecht • Died in Antwerp • 1606-84
Oil on canvas • 58.7 in x 79.9 in • Musée du Louvre, Paris, France/Giraudon/Bridgeman Art Library, London

189

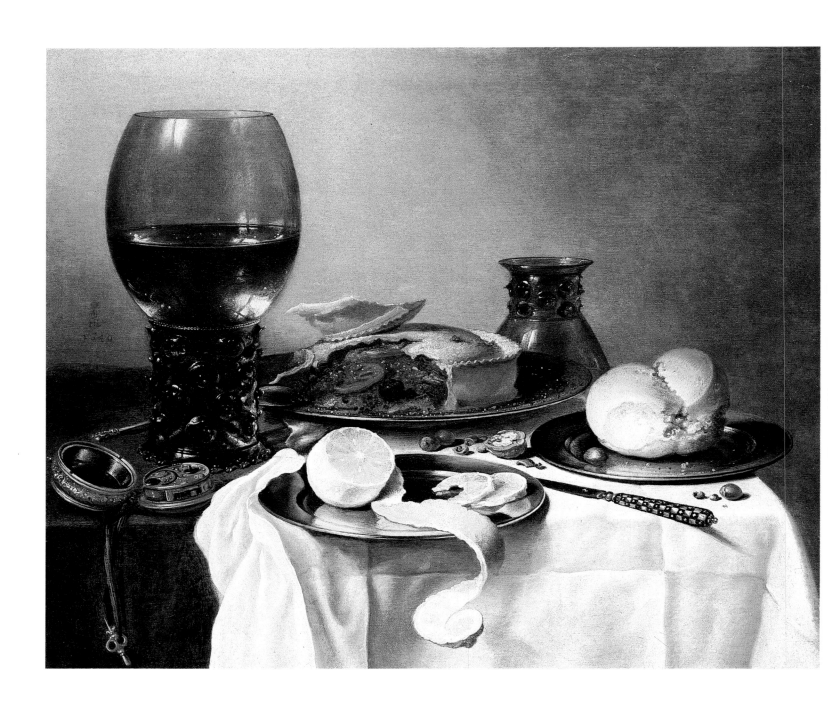

Pieter Claesz

BREAKFAST STILL LIFE WITH ROEMER, MEAT PIE, LEMON AND BREAD

Born in Burgsteinfurt • Died in Haarlem • 1596/7-1661
Oil on panel • 21.1 in x 25.1 in • Harold Samuel Collection, Corporation of London, UK/Bridgeman Art Library, London

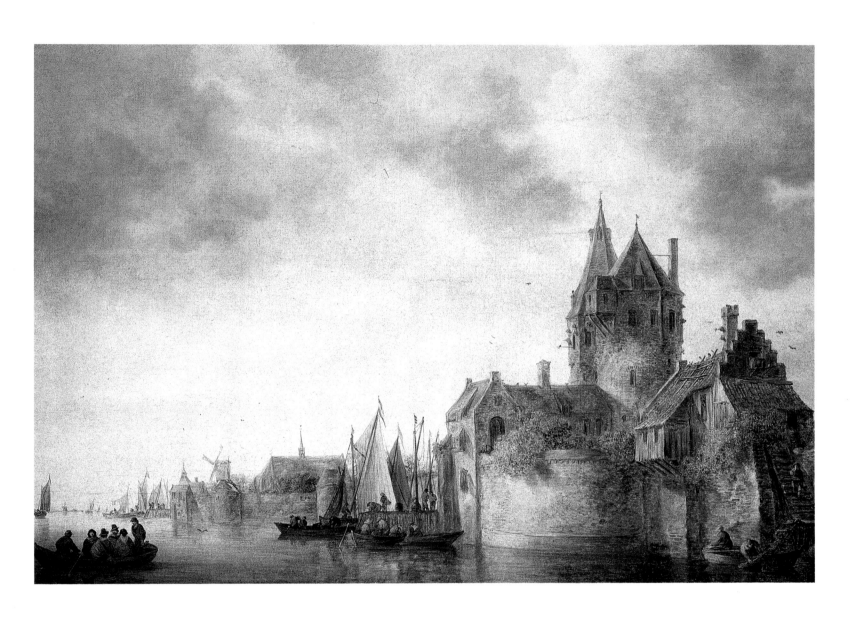

Jan Josefsz van Goyen

A CASTLE BY A RIVER WITH SHIPPING AT A QUAY

Born in Leiden • Died in The Hague • 1596-1665
Oil on canvas • 40 in x 55 in • Christie's Images/Bridgeman Art Library, London

191

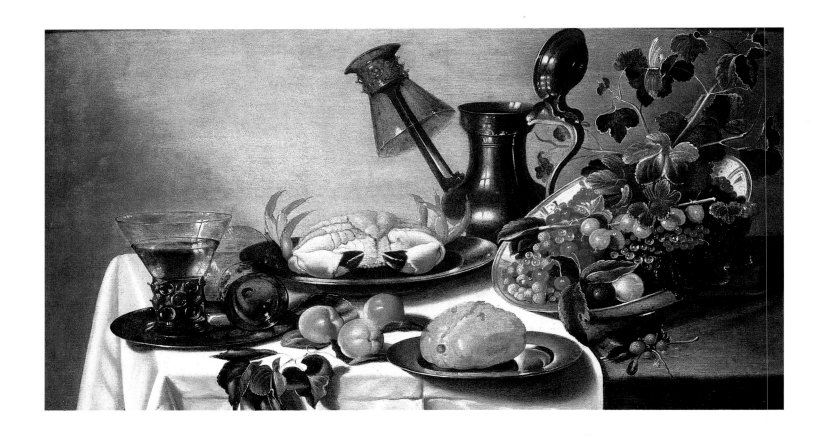

Cornelius Kruys

STILL LIFE OF FRUIT WITH CRAB, OVERTURNED ROEHMER ON SPOUT OF JUG

Born in the Netherlands • Died before 1660
Oil on canvas • Johnny van Haeften Gallery, London/Bridgman Art Library, London

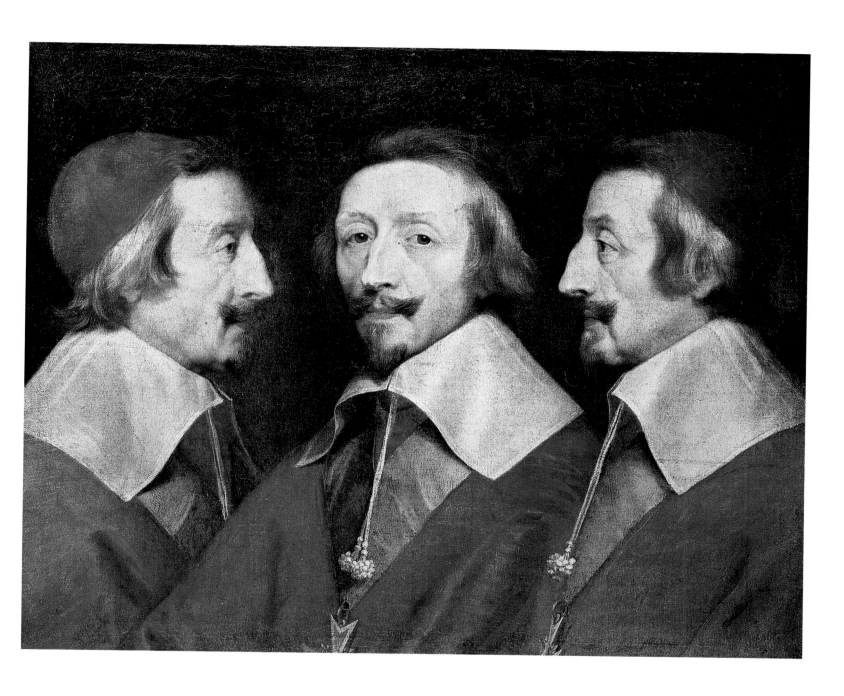

Philippe de Champaigne

TRIPLE PORTRAIT OF THE HEAD OF RICHELIEU

Born in Brussels • Died in Paris • 1602-74
Oil on canvas • 23 in x 28.5 in • National Gallery, London, UK/Bridgeman Art Library, London

Claude Lorrain (Claude Gellée)

LANDSCAPE WITH CEPHALUS AND PROCRIS
REUNITED BY DIANA

Born in Lorrain • Died in Rome • 1600-82 • Oil on canvas
40 in x 52 in • National Gallery, London, UK/
Bridgeman Art Library, London

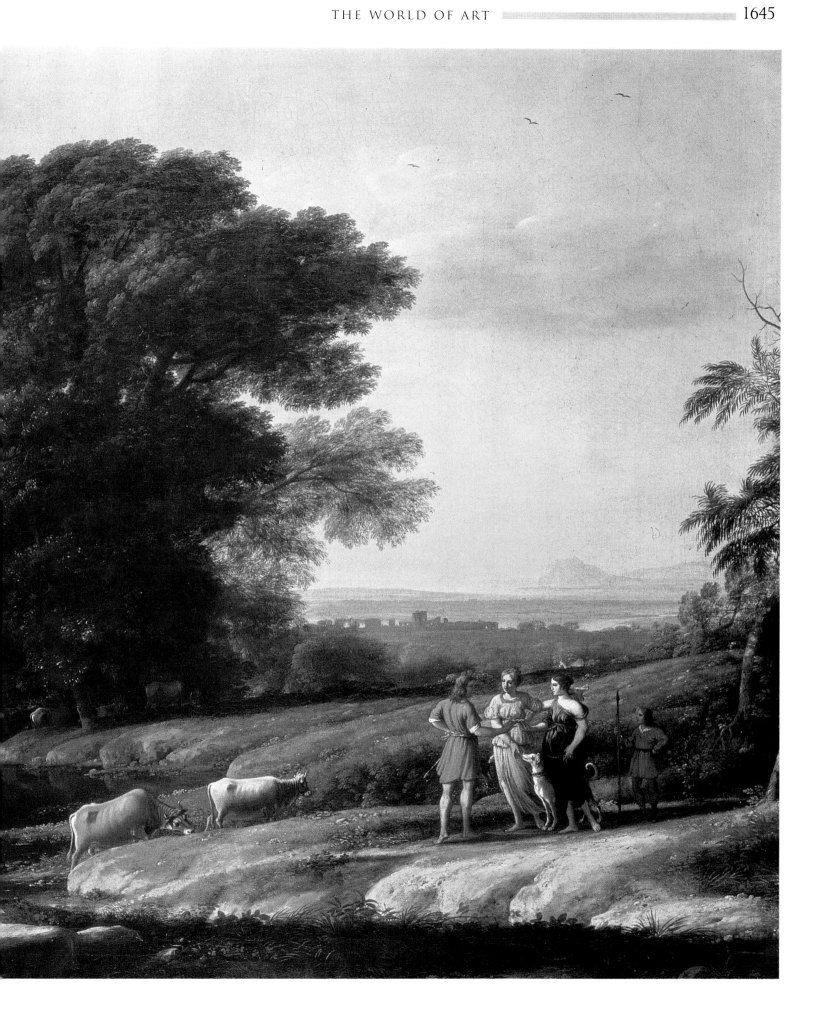

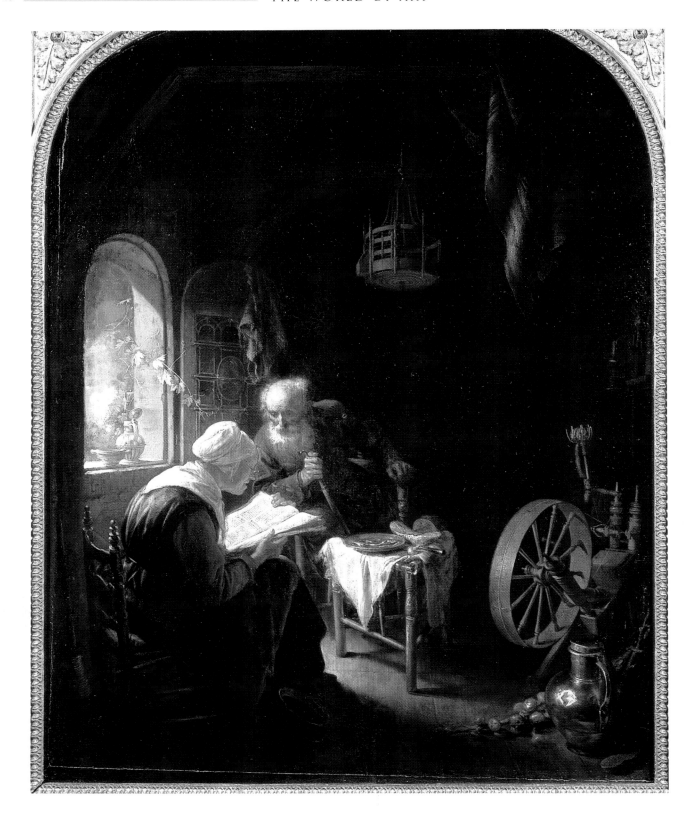

Gerrit (Gerard Dou)

THE BIBLE LESSON, OR ANNE AND TOBIAS

Born and died in Leiden • 1613-75
Oil on panel • 20.2 in x 15.6 in • Musée du Louvre, Paris, France/Bridgeman Art Library, London

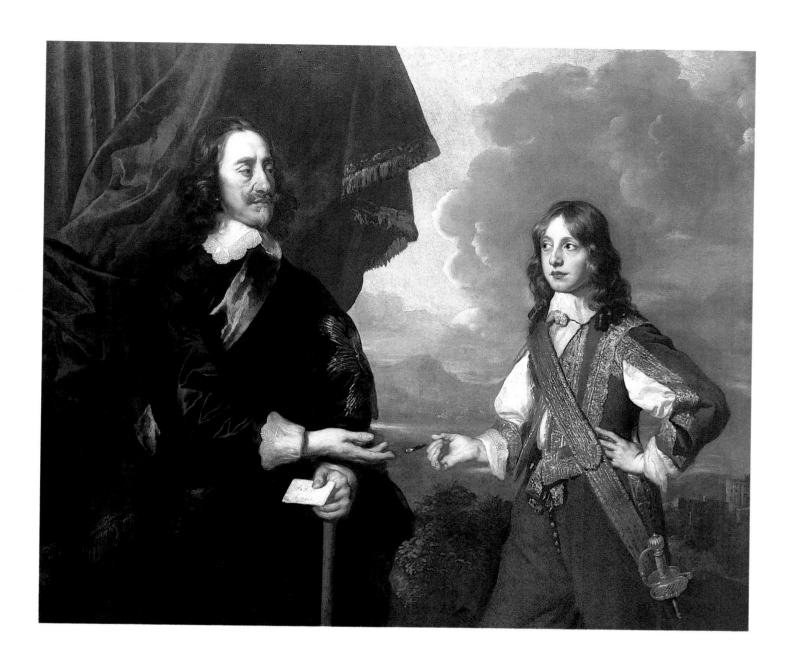

Sir Peter Lely

CHARLES I AND THE DUKE OF YORK

Born in Soest, Westphalia • Died in London • 1618-80
Oil on canvas • 48 in x 56.5 in • Duke of Northumberland, Syon House, London/Bridgeman Art Library, London

Dirck Hals

THE GAME OF BACKGAMMON

Born in Antwerp • Died in Haarlem • 1591-1656
Oil on canvas • 7.9 in x 11.8 in • Musée des
Beaux-Arts, Lille, France/Giraudon/
Bridgeman Art Library, London

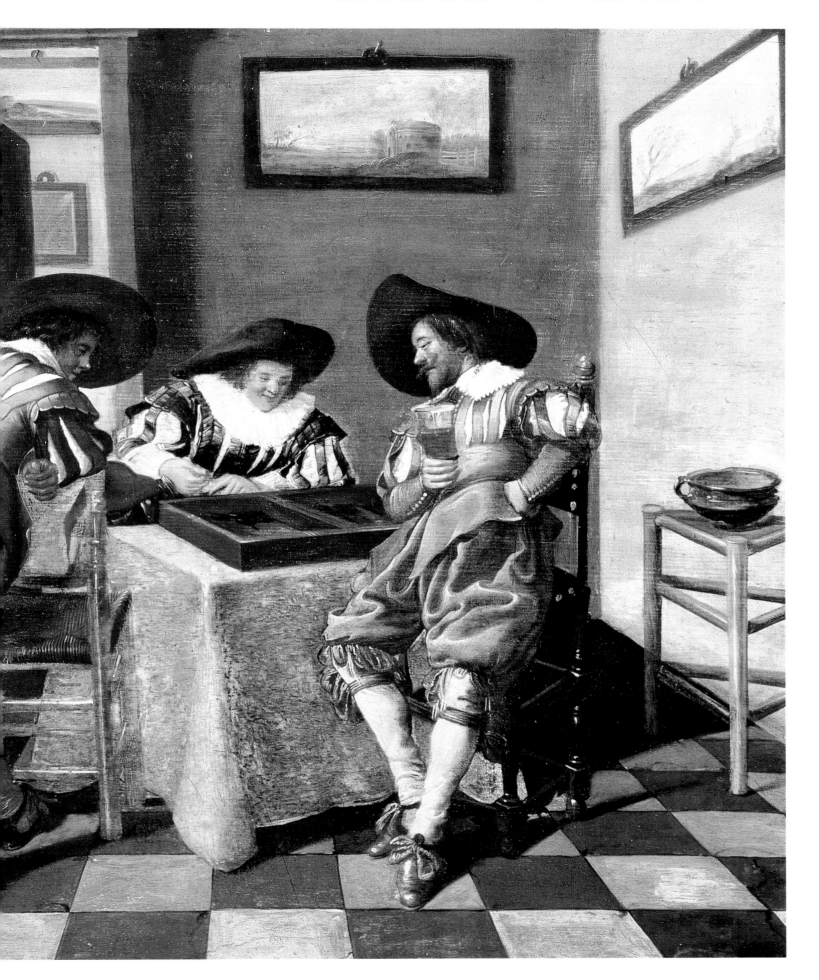

Pieter Neeffs, the Younger

FIGURES GATHERED IN A CHURCH INTERIOR

Born in Antwerp and probably died in Antwerp • 1620-c. 1675
Alan Jacobs Gallery, London, UK/Bridgeman Art Library, London

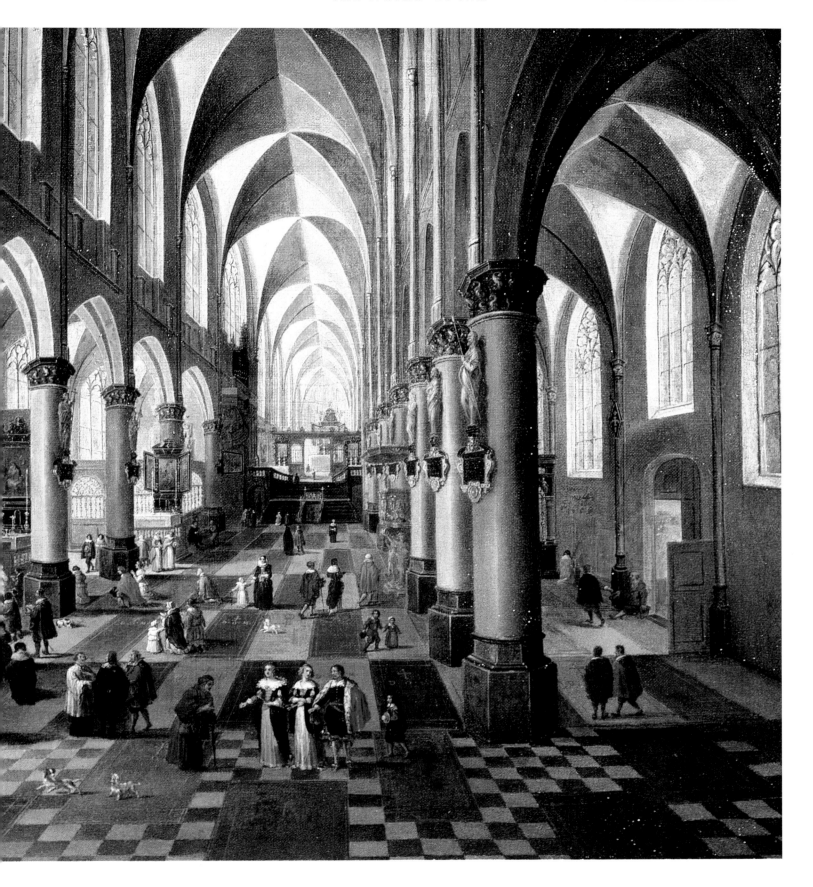

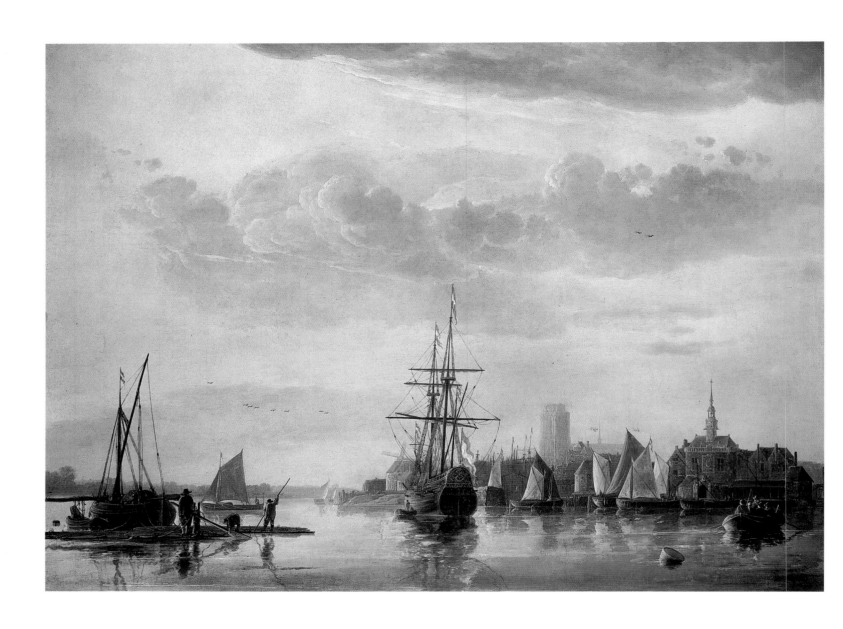

Aelbert Cuyp

VIEW OF DORDRECHT

Born and died in Dordrecht • 1620-91
Oil on canvas • 38.6 in x 54.3 in • Kenwood House, London, UK/Bridgeman Art Library, London

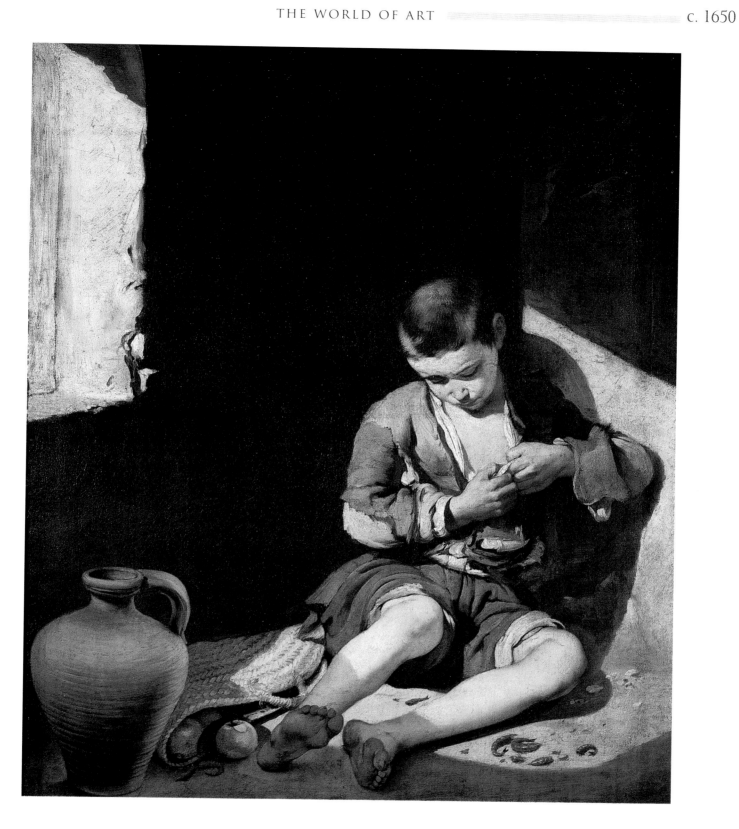

Bartolomé Esteban Murillo

THE YOUNG BEGGAR

Born and died in Seville • 1617-82
Oil on canvas • 52.8 in x 39.4 in • Musée du Louvre, Paris, France/Giraudon/Bridgeman Art Library, London

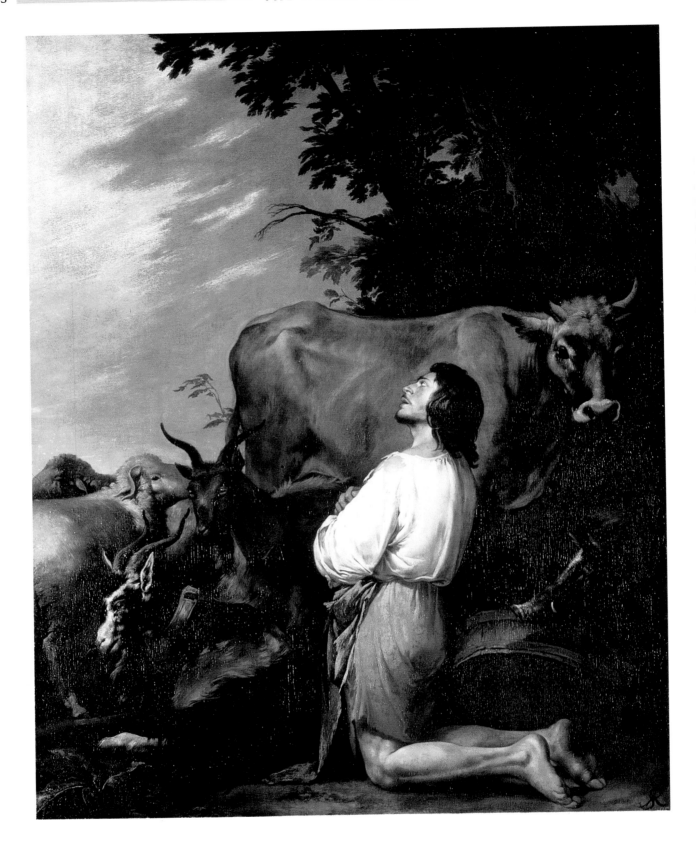

Salvator Rosa

THE PRODIGAL SON

Born in Naples • Died in Rome • 1615-1673
Oil on canvas • 99.8 in x 79.1 in • Hermitage, St. Petersburg, Russia/Bridgeman Art Library, London

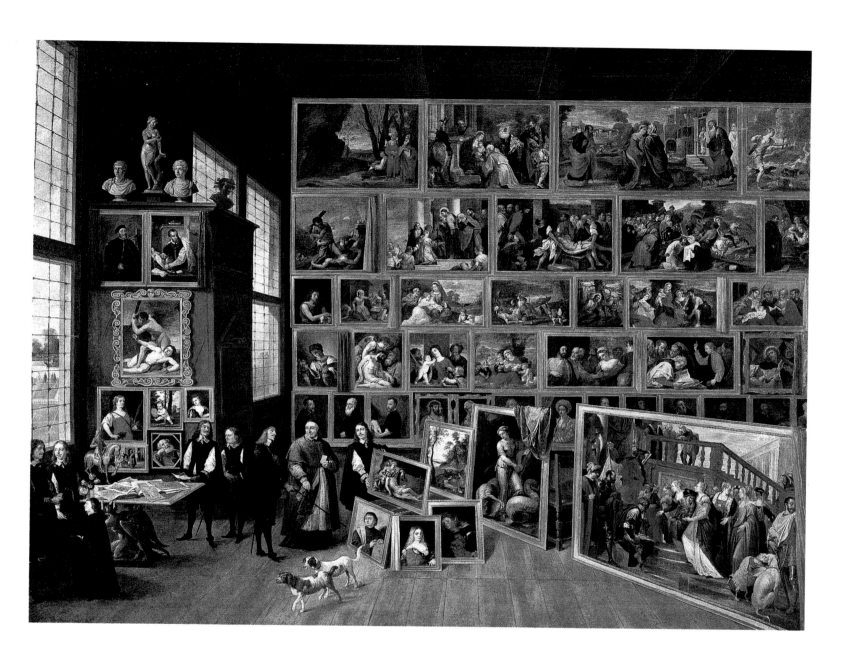

David Teniers, the Younger

THE ARCHDUKE LEOPOLD-WILHELM'S STUDIO

Born in Antwerp • Died in Brussels • 1610-90
Oil on canvas • 50 in x 64 in • National Trust, Petworth House, Sussex, UK/Bridgeman Art Library, London

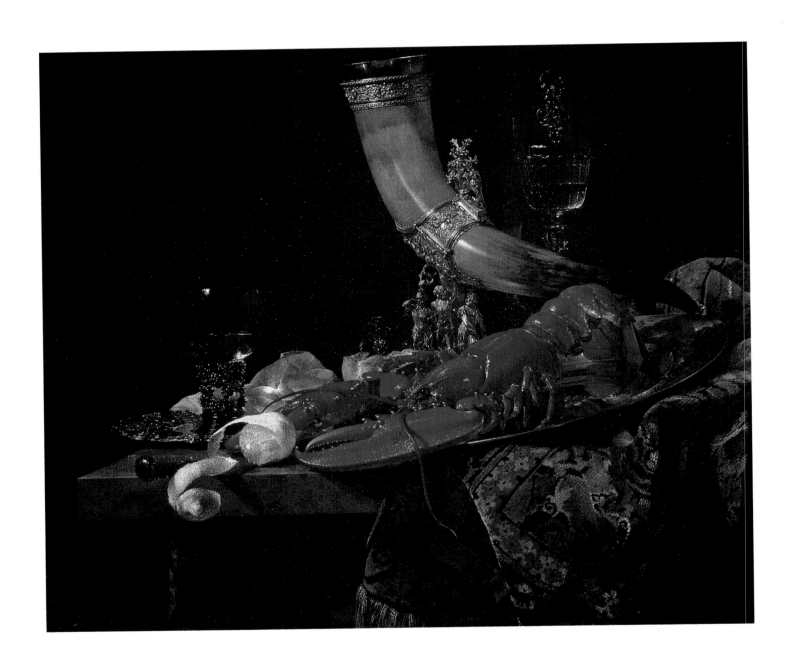

Willem Kalf

STILL LIFE WITH THE DRINKING-HORN OF THE ST. SEBASTIEN ARCHERS GUILD, LOBSTER & GLASSES

Born in Rotterdam • Died in Amsterdam • 1622-93
Oil on canvas • 34 in x 40.2 in • National Gallery, London, UK/Bridgeman Art Library, London

Diego Rodríguez de Silva y Velasquez

PHILIP IV OF SPAIN

Born in Seville • Died in Madrid • 1599-1660
Oil on canvas • 25.2 in x 21.1 in • National Gallery, London, UK/Bridgeman Art Library, London

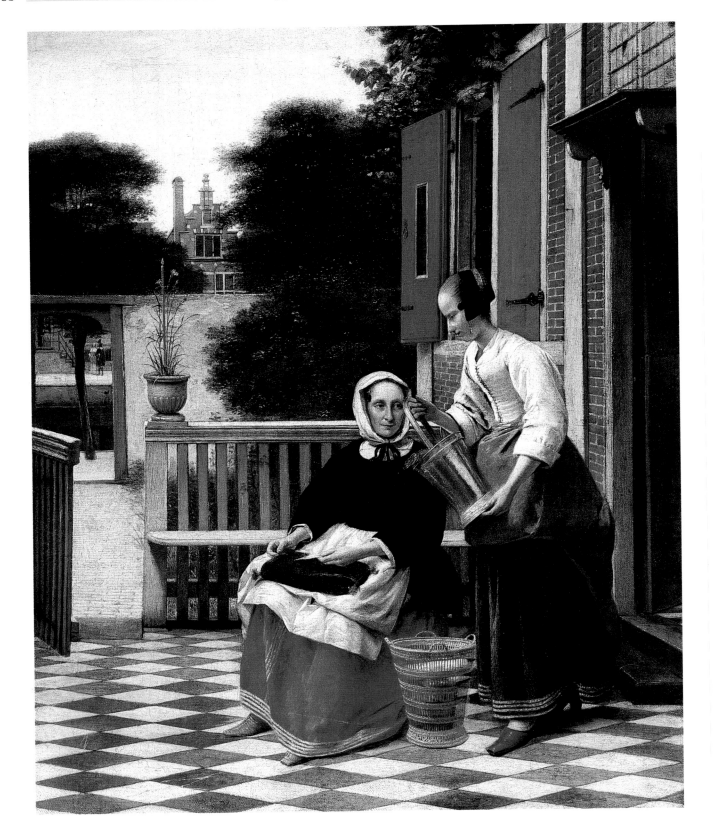

Pieter de Hooch

WOMAN AND MAID WITH A PAIL IN A COURTYARD

Born in Rotterdam • Died in Amsterdam • 1629-84
Oil on canvas • 20.9 in x 16.5 in • Hermitage, St. Petersburg, Russia/Bridgeman Art Library, London

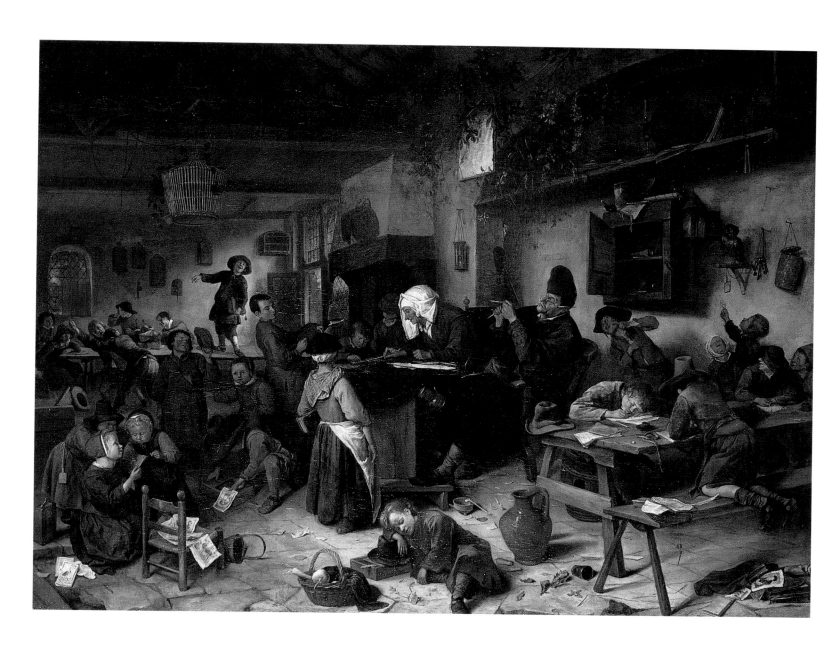

Jan Havicksz Steen

A SCHOOL FOR BOYS AND GIRLS

Born and died in Leiden • 1625/26-79
Oil on canvas • 32.1 in x 42.7 in • National Gallery of Scotland, Edinburgh, Scotland/Bridgeman Art Library, London

Meindert Hobbema

WOODED LANDSCAPE WITH THE RUINS OF A HOUSE

Born and died in Amsterdam • 1638-1709
Oil on panel • 23.6 in x 33.25 in • Harold Samuel Collection, Corporation of London, UK/Bridgeman Art Library, London

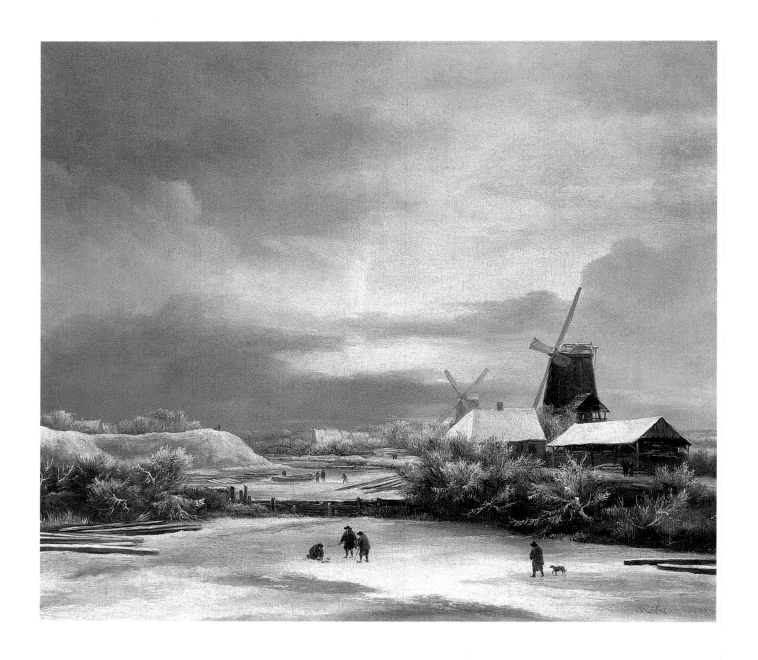

Jacob Issaksz van Ruisdael

WINTER LANDSCAPE

Born in Haarlem • Died in Amsterdam • 1628-82
Oil on canvas • 16.5 in x 19.3 in • Agnew & Sons, London,UK/Bridgeman Art Library, London

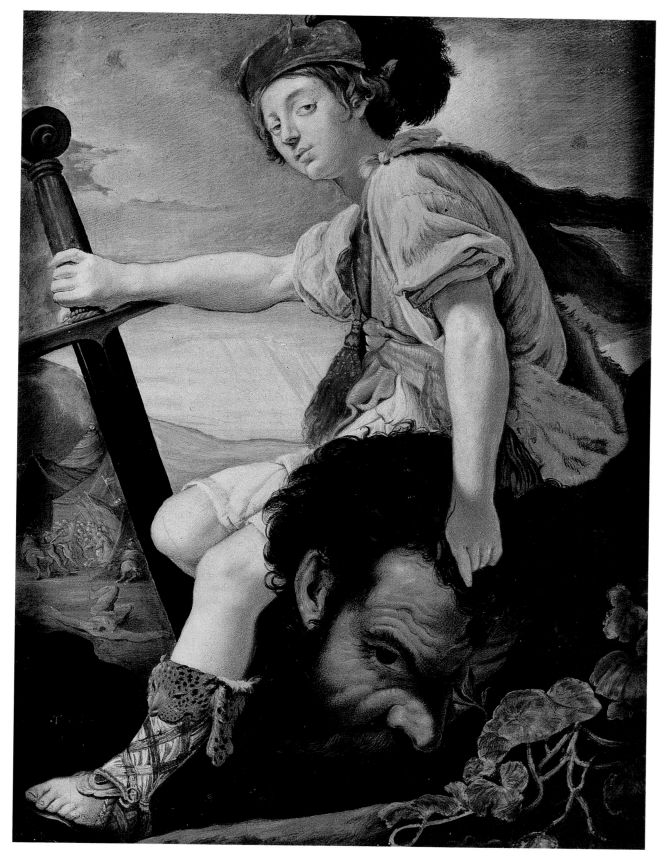

T. Flatman

DAVID WITH THE HEAD OF GOLIATH

Born and died in London • 1637-88
Watercolor on vellum • 7.3 in x 5.4 in • Victoria and Albert Museum, London/Bridgeman Art Library, London

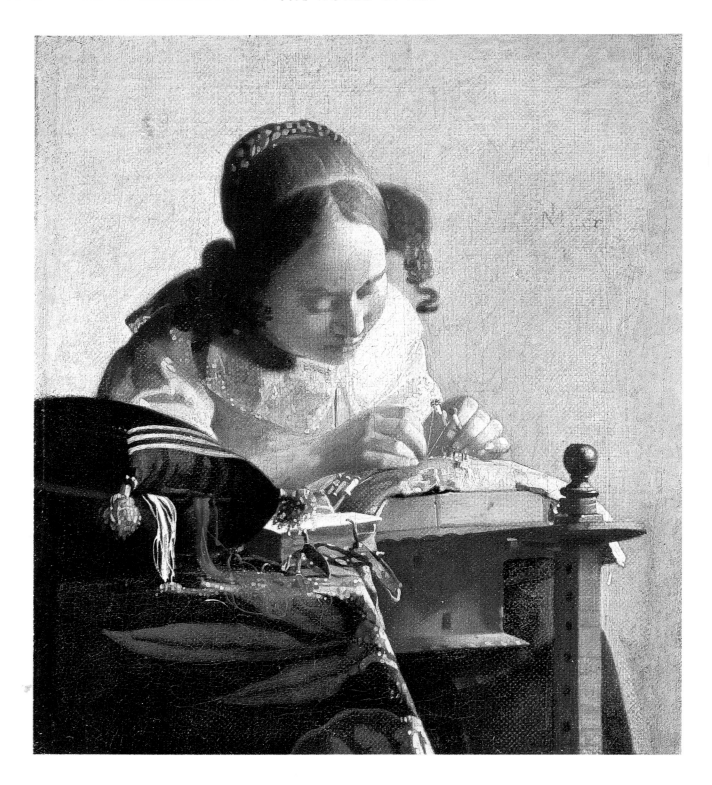

Jan Vermeer

THE LACEMAKER

Born and died in Delft • 1632-75
Oil on canvas on wood • 9.4 in x 8.3 in • Musée du Louvre, Paris, France/Lauros-Giraudon/Bridgeman Art Library, London

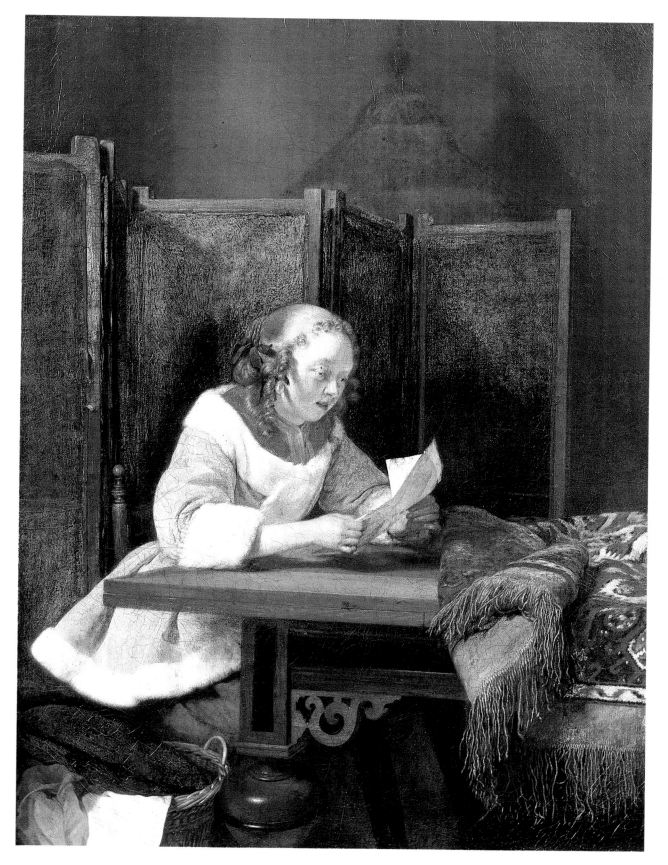

Gerard Ter Borch (Terborch)

A LADY READING A LETTER

Born and died in Zwolle • 1617-81
Oil on canvas • 17.75 in x 13.1 in • Wallace Collection, London, UK/Bridgeman Art Library, London

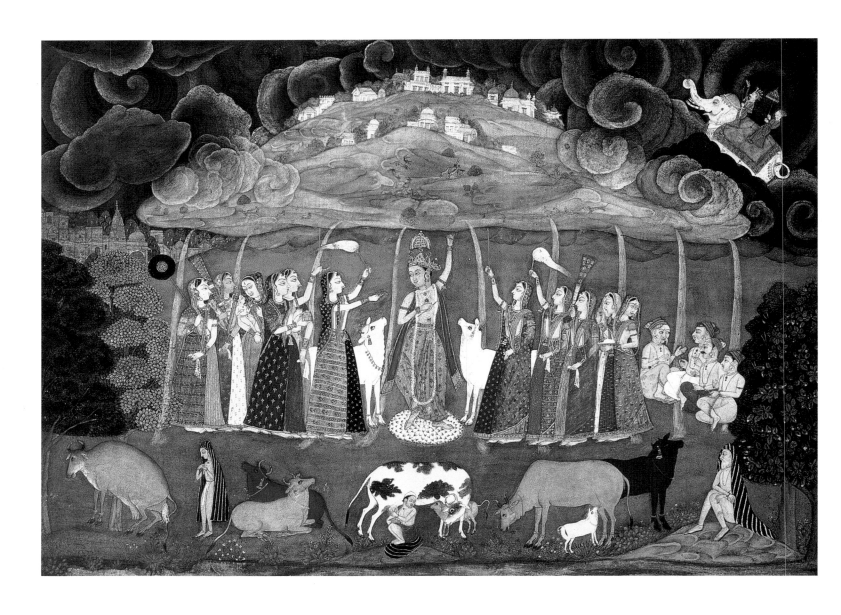

Ustad Sahibdin
Rajput School

KRISHNA SUPPORTING MOUNT GOVARDHANA

Watercolor • British Library, London, UK/Bridgeman Art Library, London

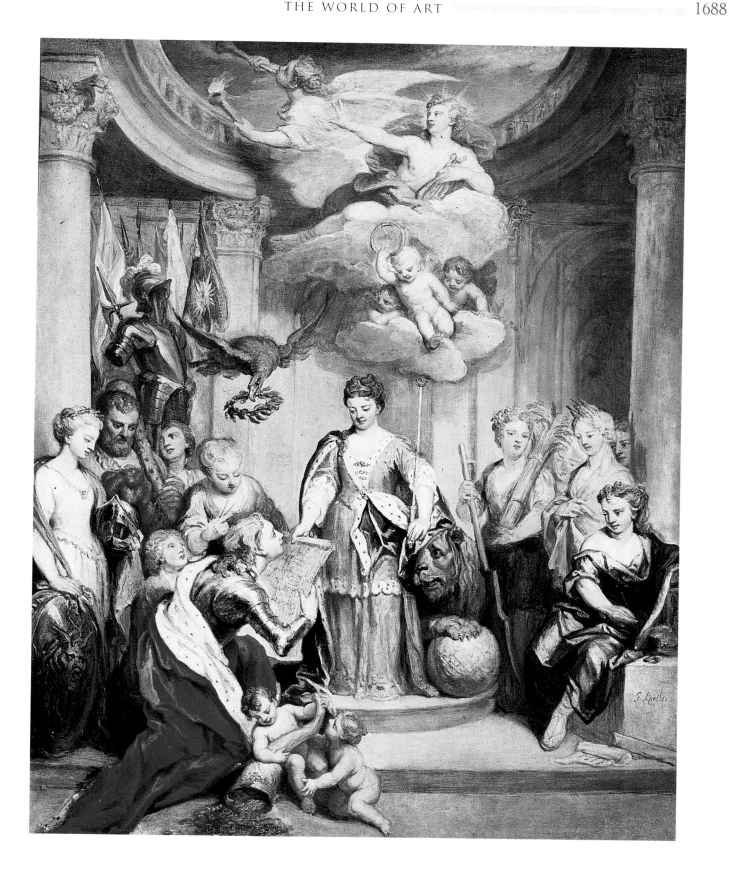

Sir Godfrey Kneller

QUEEN ANNE PRESENTING PLANS OF BLENHEIM TO MILITARY MERIT (DUKE OF MARLBOROUGH)

Born in Lübeck • Died in London • 1646-1723
Oil on canvas • 50 in x 40 in • Blenheim Palace, Oxfordshire, UK/Bridgeman Art Library, London

Luca Giordano

SOLOMON'S DREAM

Born and died in Naples • 1632-1705
Oil on canvas • 96.5 in x 142 in • Museo del Prado, Madrid, Spain/Bridgeman Art Library, London

Jean Antoine Watteau

LES PLAISIRS DU BAL

Born in Valenciennes • Died in Nogent-sur-Marne • 1684-1721
Oil on canvas • 20.7 in x 25.7 in • Dulwich Picture Gallery, London/
Bridgeman Art Library, London

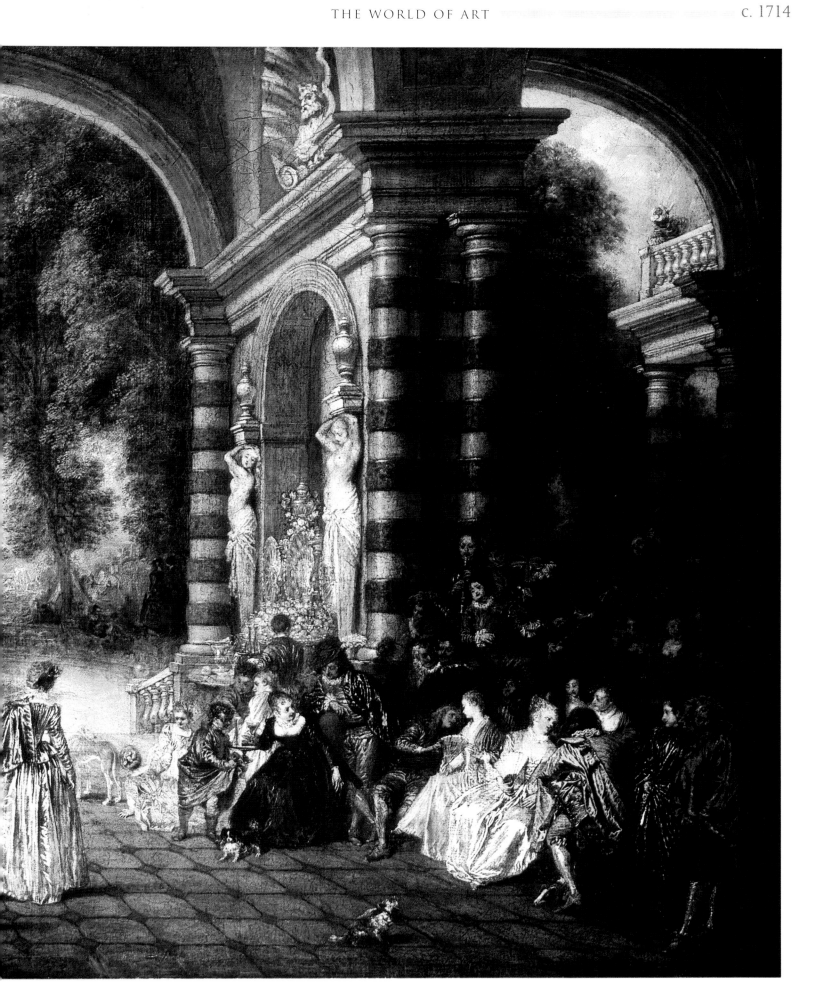

Rachel Ruysch

FLOWERS AND INSECTS

Born and died in Amsterdam • 1664-1750
Oil on canvas • 35 in x 27 in • Galleria Degli Uffizi, Florence,
Italy/Bridgeman Art Library, London

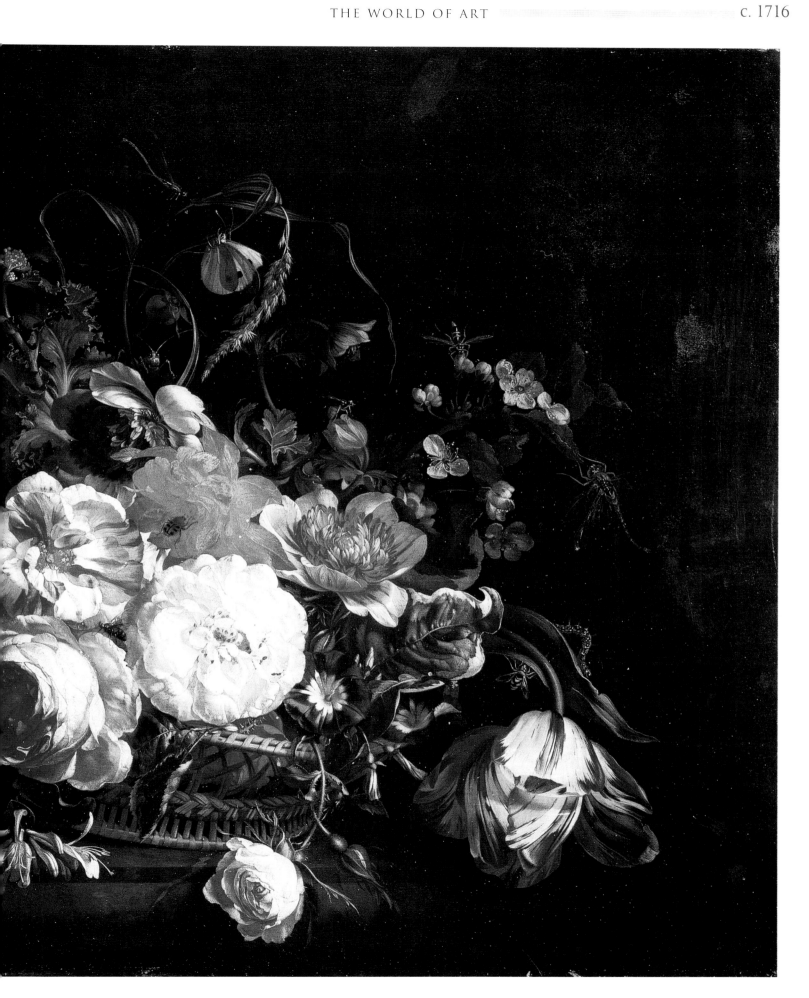

Gabrielle Bella

GAME OF RACQUETS

Probably born and died in Venice • 1730-1782
Oil on panel • Galleria Querini-Stampalia, Venice, Italy/Giraudon Bridgeman Art Library, London

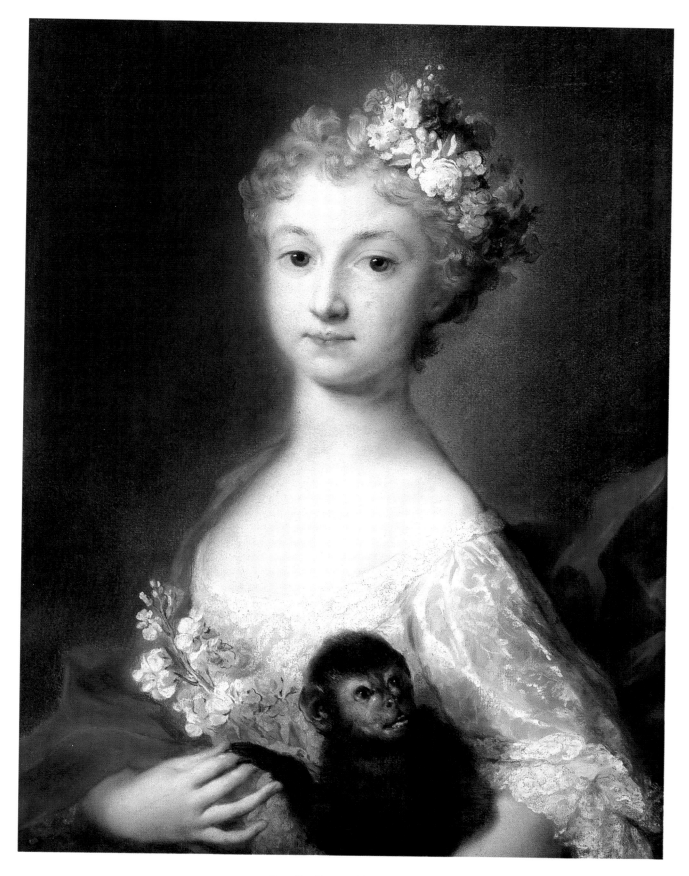

Rosalbo Giovanni Carriera

GIRL HOLDING A MONKEY

Born and died in Venice • 1675-1757
Pastel on paper • 24.6 in x 18.9 in • Musée du Louvre, Paris, France/Giraudon/Bridgeman Art Library, London

Pompeo Girolamo Batoni

HAGAR IN THE DESERT

Born in Lucca • Died in Rome • 1708-87
Oil on canvas • Galleria Nazionale d'Arte Antica, Rome, Italy/Bridgeman Art Library, London

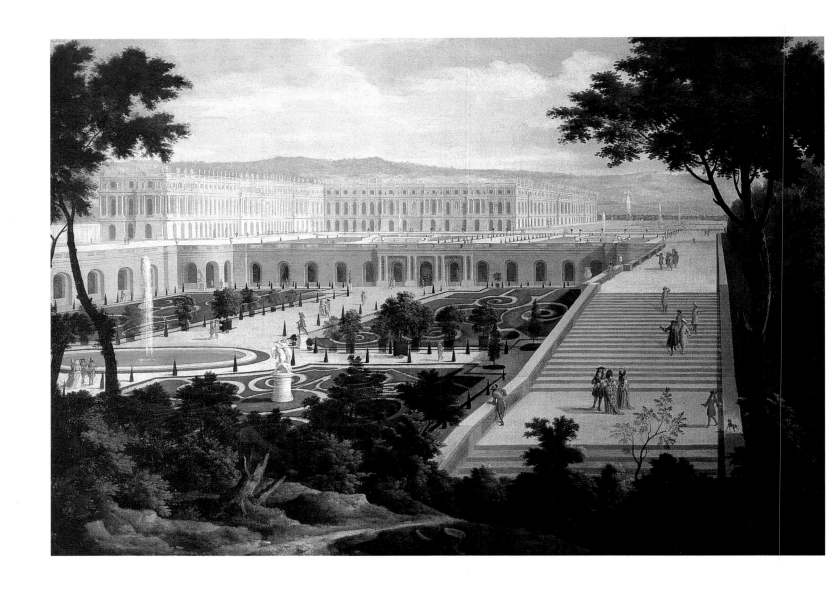

Pierre-Denis Martin

THE ORANGERY AT VERSAILLES

Born in Paris • 1663-1742
Oil on canvas • 72.4 in x 102.4 in • Château de Versailles, France/Giraudon/Bridgeman Art Library, London

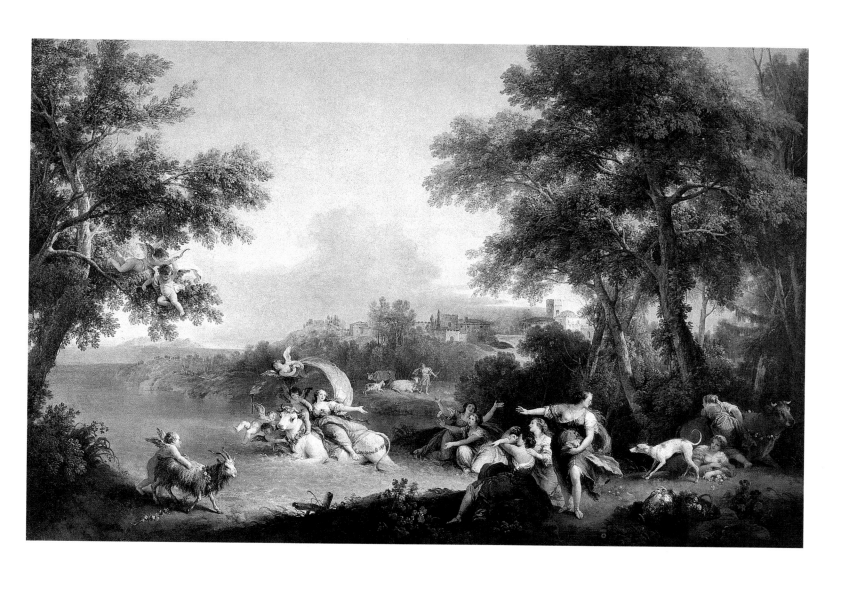

Francesco Zuccarelli

THE RAPE OF EUROPA

Born and died in Pitigliano • 1702-88
Galleria dell'Accademia, Venice, Italy/Bridgeman Art Library, London

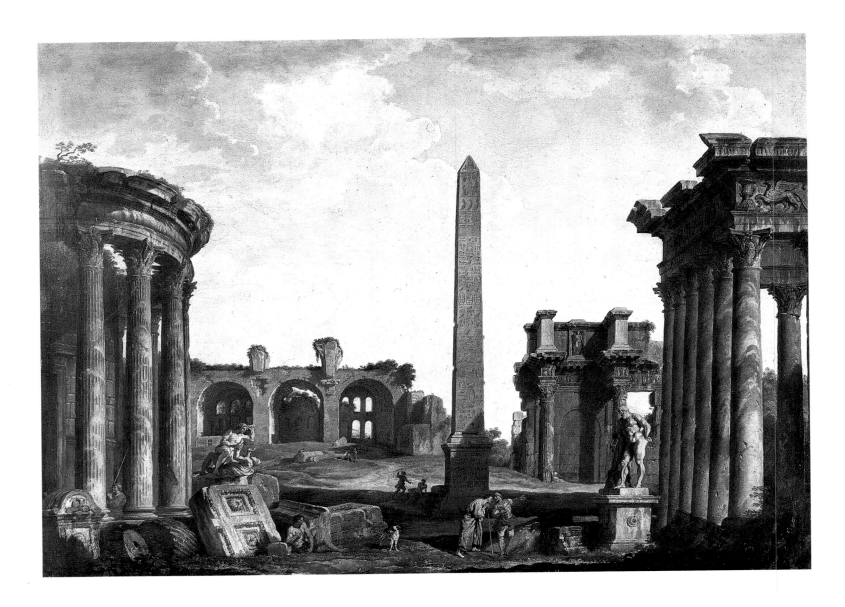

Giovanni Paolo Panini (Pannini)

ROMAN CAPRICCIO

Born in Piacenza • Died in Rome • 1691/2-1765
Oil on canvas • 38.3 in x 53 in • Maidstone Museum and Art Gallery, Kent, UK/Bridgeman Art Library, London

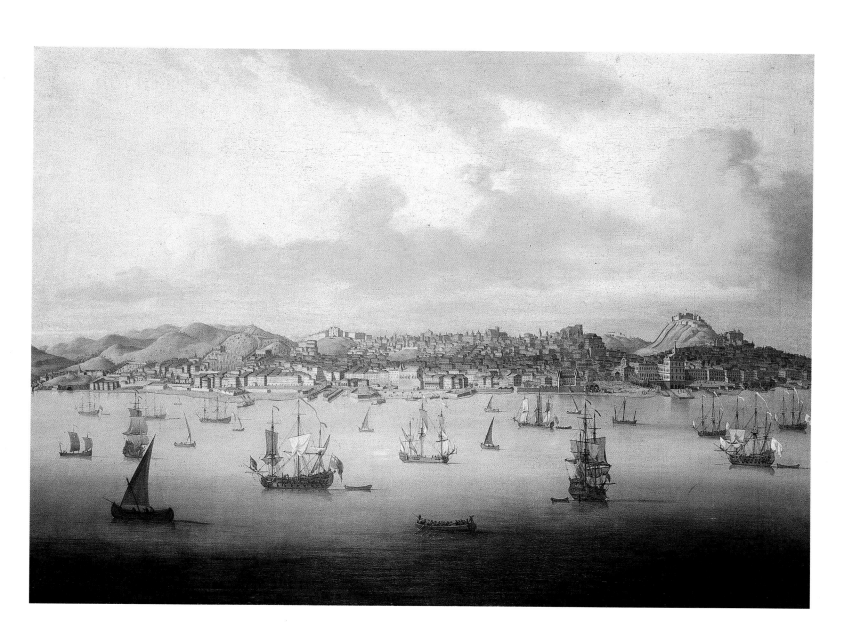

Peter Monamy

THE BRITISH FLEET SAILING INTO LISBON HARBOUR

Born and died in London • 1689-1749
Oil on canvas • 51.5 in x 70 in • Ackermann & Johnson Ltd, London, UK/Bridgeman Art Library, London

François Boucher

DIANA GETTING OUT OF HER BATH

Born and died in Paris • 1703-70
Oil on canvas • 22 in x 28.75 in • Musée du Louvre, Paris, France/Giraudon/Bridgeman Art Library, London

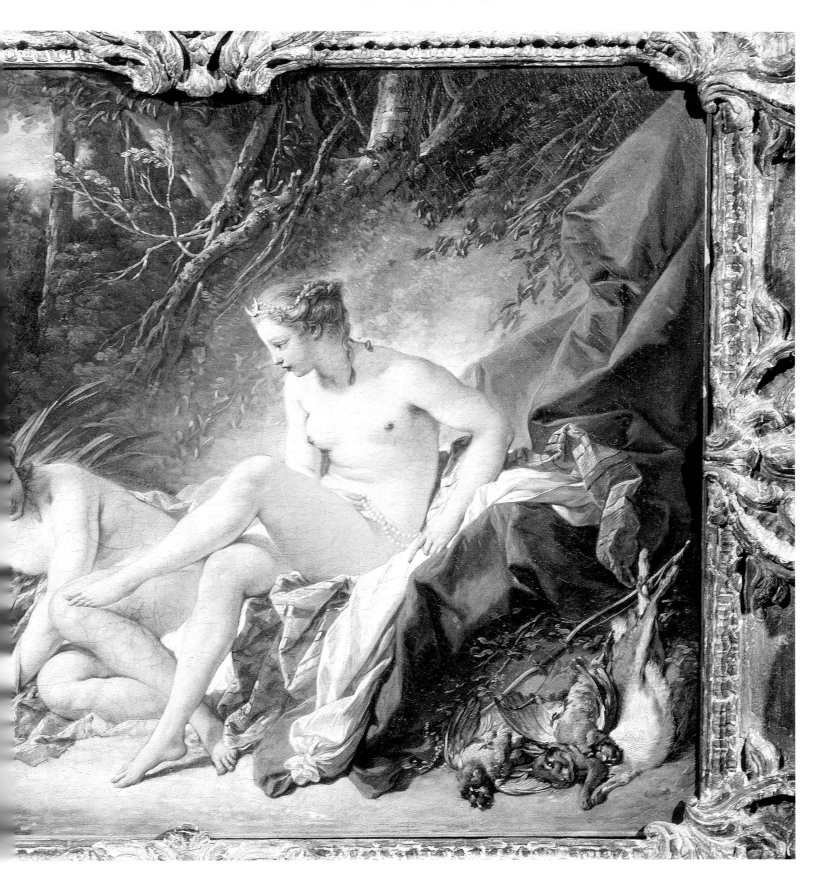

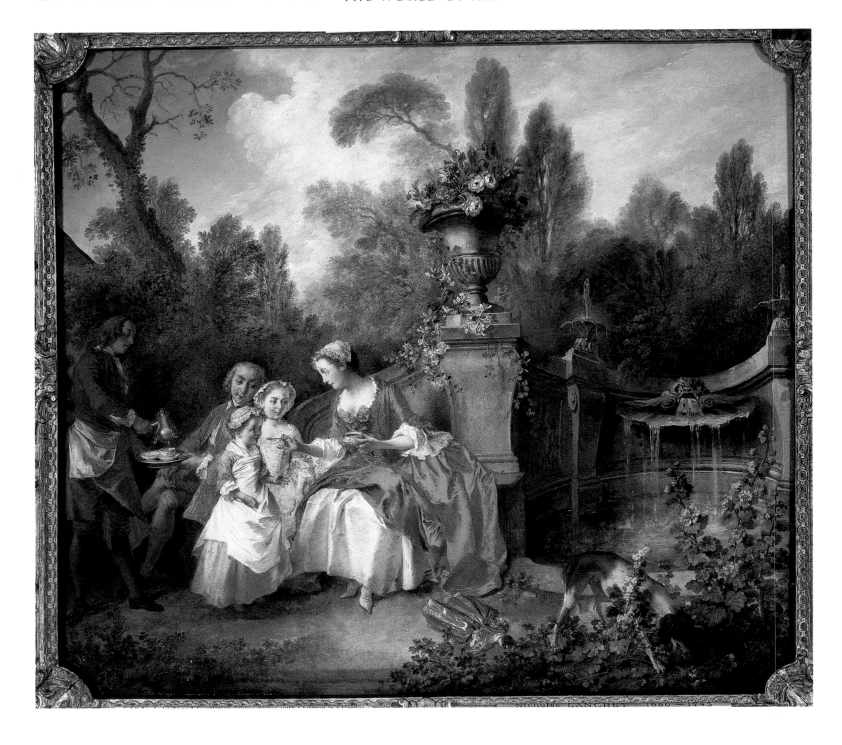

Nicolas Lancret

A Lady in a Garden Taking Coffee with some Children

Born and died in Paris • 1690-1743
Oil on canvas • 35 in x 38.5 in • National Gallery, London, UK/Bridgeman Art Library, London

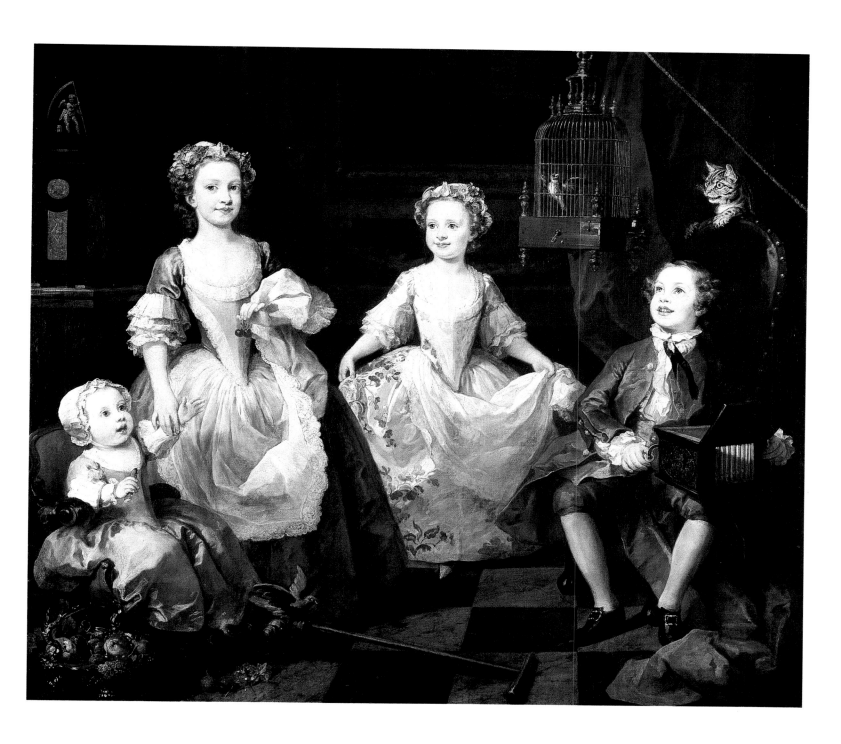

William Hogarth

THE GRAHAM CHILDREN

Born and died in London • 1697-1764
Oil on canvas • 63.2 in x 71.3 in • National Gallery, London, UK/Bridgeman Art Library, London

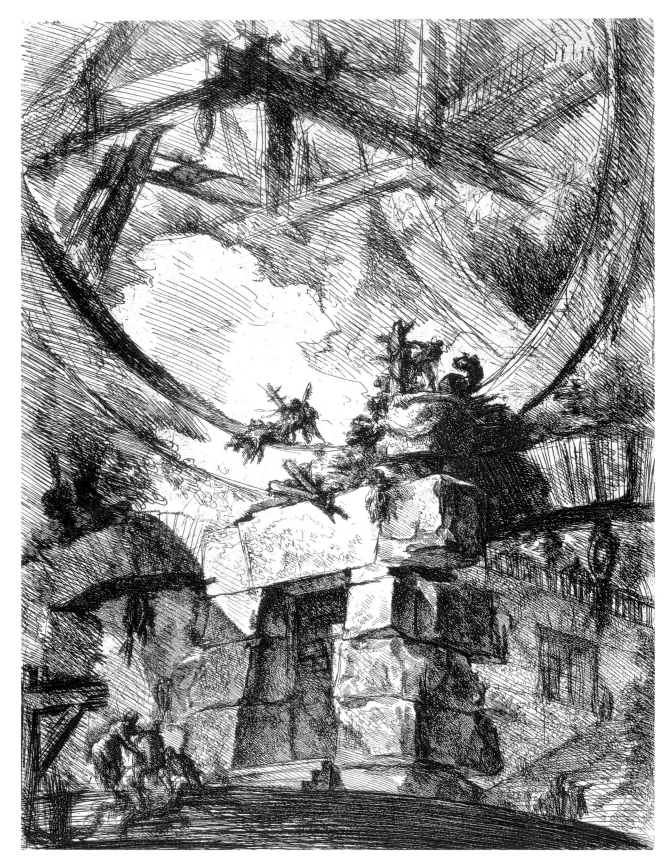

Giovanni Battista Piranesi

AN IMAGINARY PRISON
PLATE IX FROM THE *Carceri d'Invenzione* SERIES

Born Mogliano, nr Mestre • Died in Rome • 1720-78
Etching • 21.8 in x 16.1 in • Hermitage, St. Petersburg, Russia/Bridgeman Art Library, London

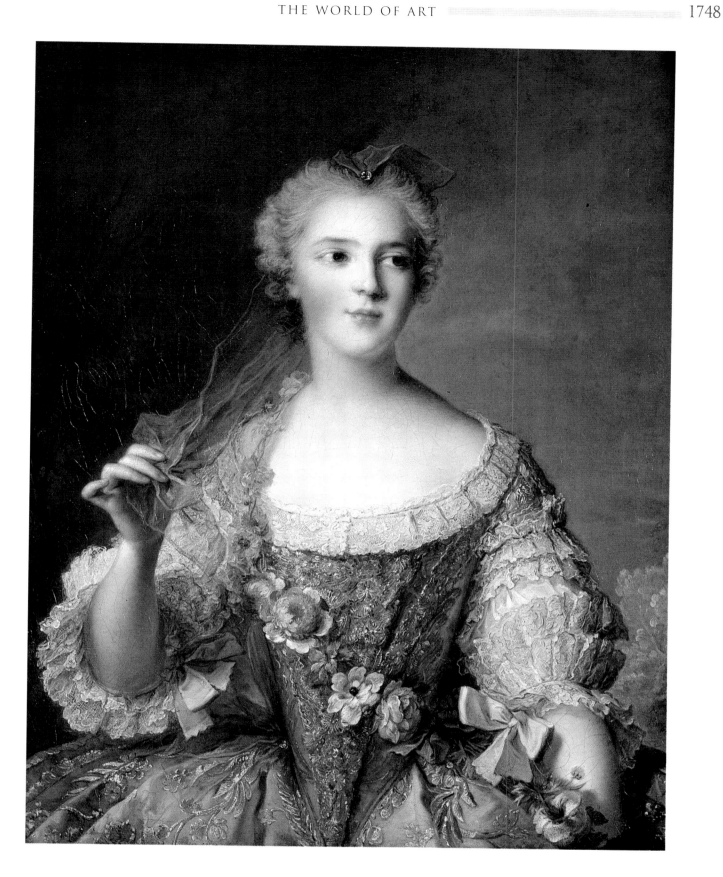

Jean-Marc Nattier

PORTRAIT OF MADAME SOPHIE (1734-82), DAUGHTER OF LOUIS XV

Born and died in Paris • 1685-1766
Oil on canvas • 31.1 in x 23.6 in • Château de Versailles, France/Giraudon/Bridgeman Art Library, London

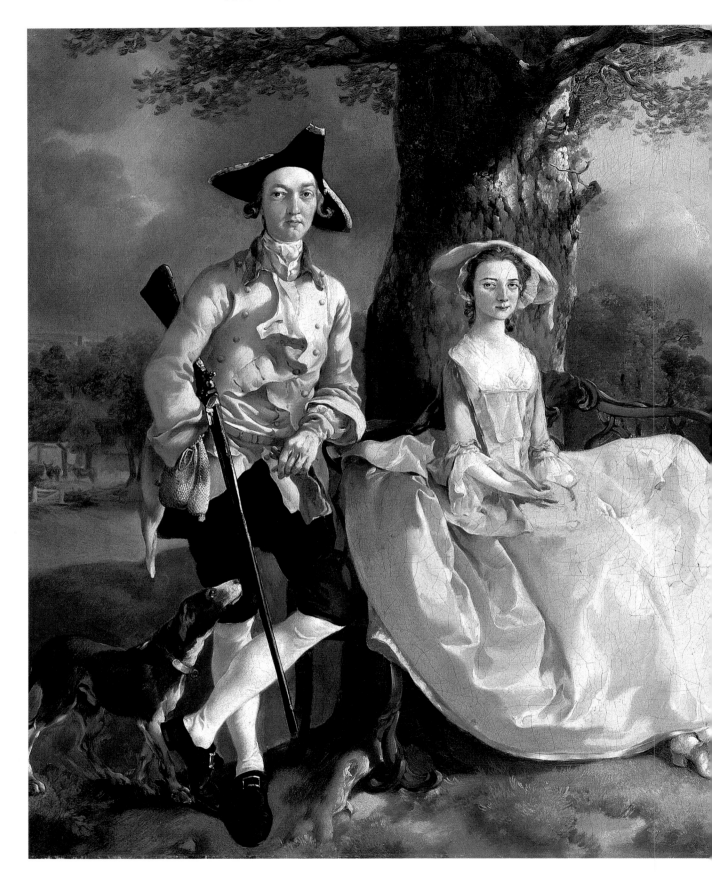

Thomas Gainsborough

MR AND MRS ROBERT ANDREWS

Born in Sudbury • Died in London • 1727-88
Oil on canvas • 27.5 in x 47 in • National Gallery, London, UK/Bridgeman Art Library, London

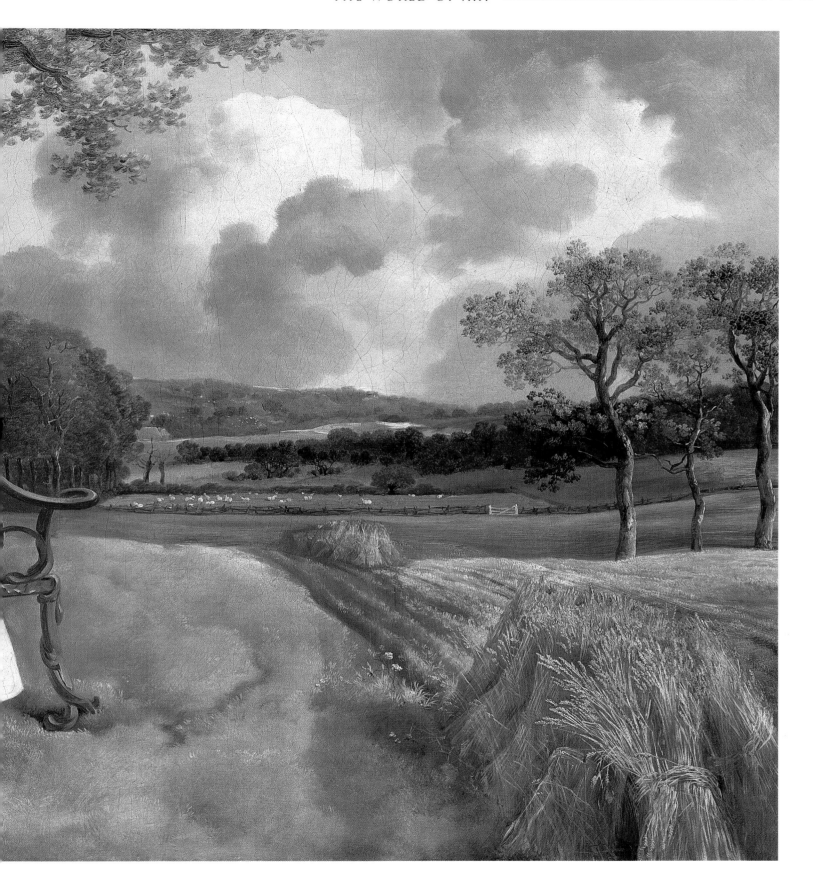

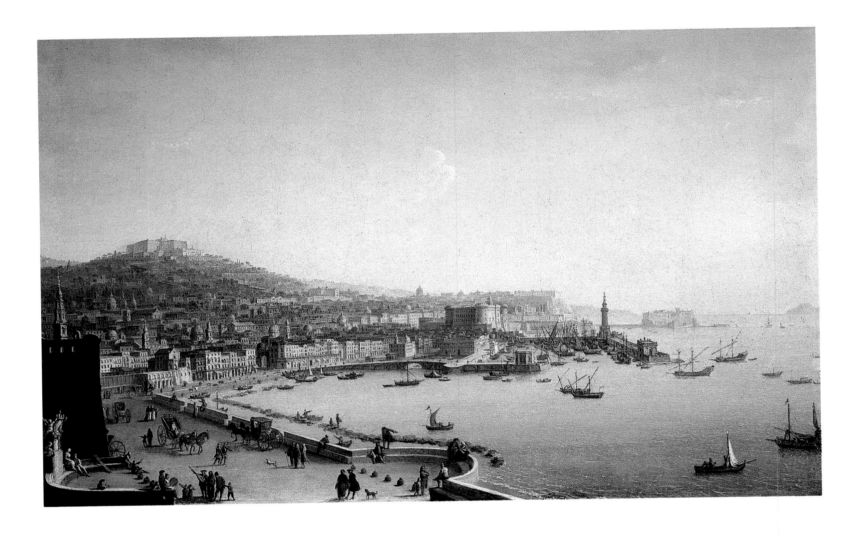

Antonio de Dipi Joli

VIEW OF NAPLES WITH THE CASTEL NUOVO

Born in Modena • Died in Rome • 1700-77
Oil on canvas • 30.5 in x 48.5 in • Christie's Images/Bridgeman Art Library, London

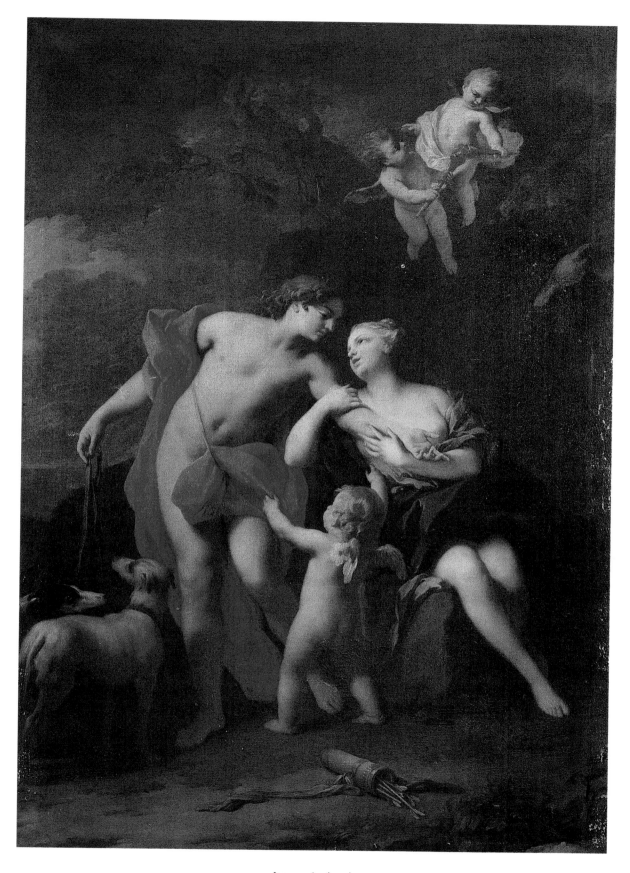

Jacopo Amigoni

VENUS AND ADONIS

Born in Venice • Died in Madrid • c. 1685-1752
Oil on canvas • 29.1 in x 21.3 in • Galleria dell'Accademia, Venice, Italy/Bridgeman Art Library, London

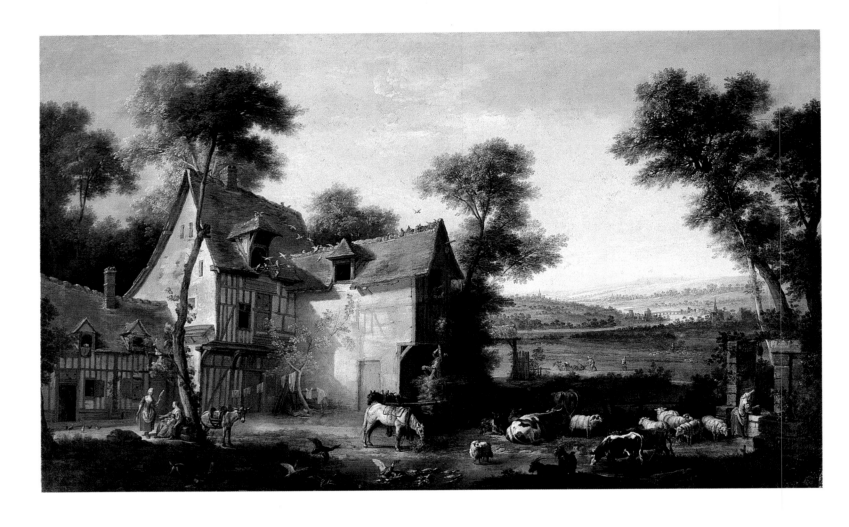

Jean-Baptiste Oudry

THE FARM

Born in Paris • Died in Beauvais • 1686-1755
Oil on canvas • 51.2 in x 83.5 in • Musée du Louvre, Paris, France/Giraudon/Bridgeman Art Library, London

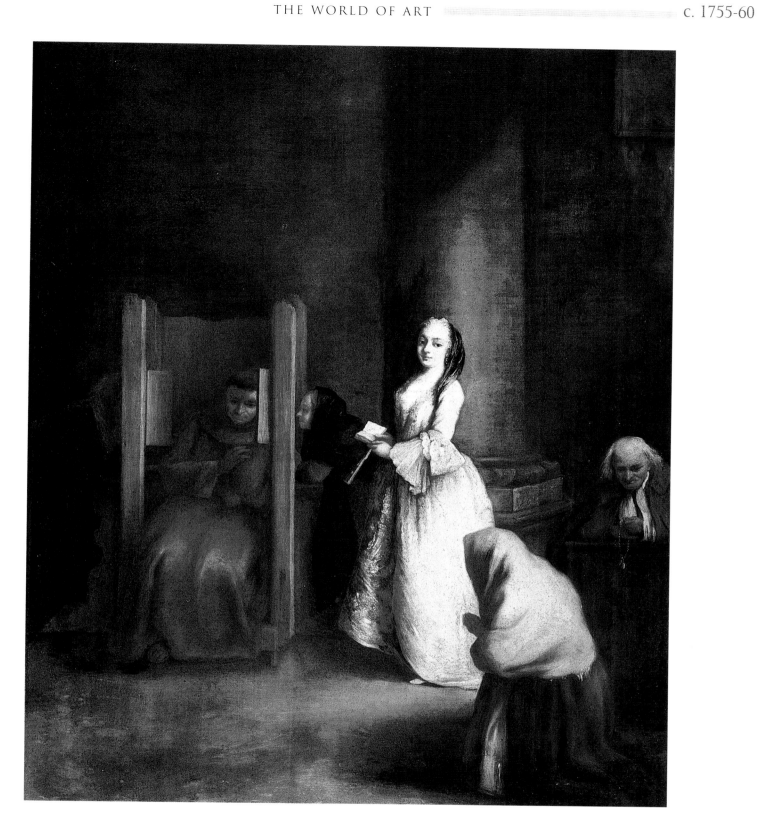

Pietro Longhi

THE CONFESSION

Born and died in Venice • 1702-88
Oil on canvas • 24 in x 19.5 in • Galleria Degli Uffizi, Florence, Italy/Bridgeman Art Library, London

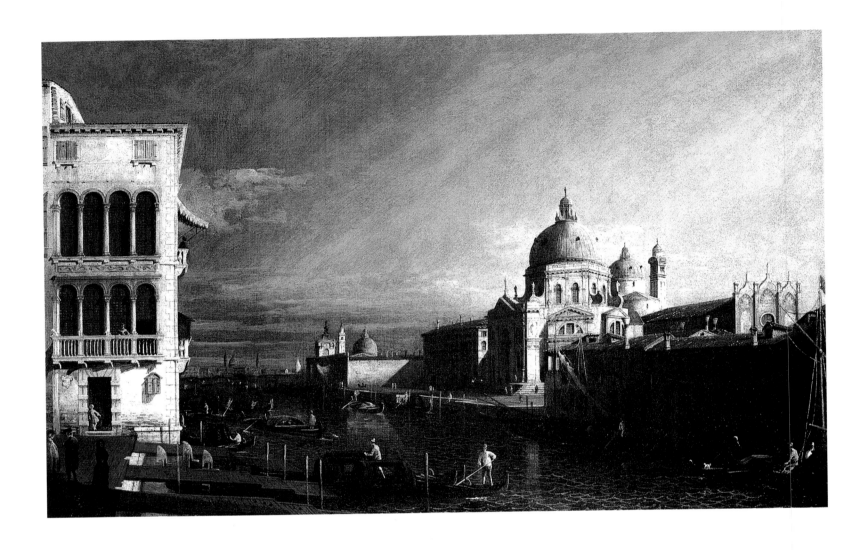

Bernardo Bellotto (Canaletto the Younger)

THE MOLO LOOKING WEST WITH THE DOGE'S PALACE IN THE DISTANCE

Born in Venice • Died in Warsaw • 1720-80
Oil on canvas • Johnny van Haeften Gallery, London, UK/Bridgeman Art Library, London

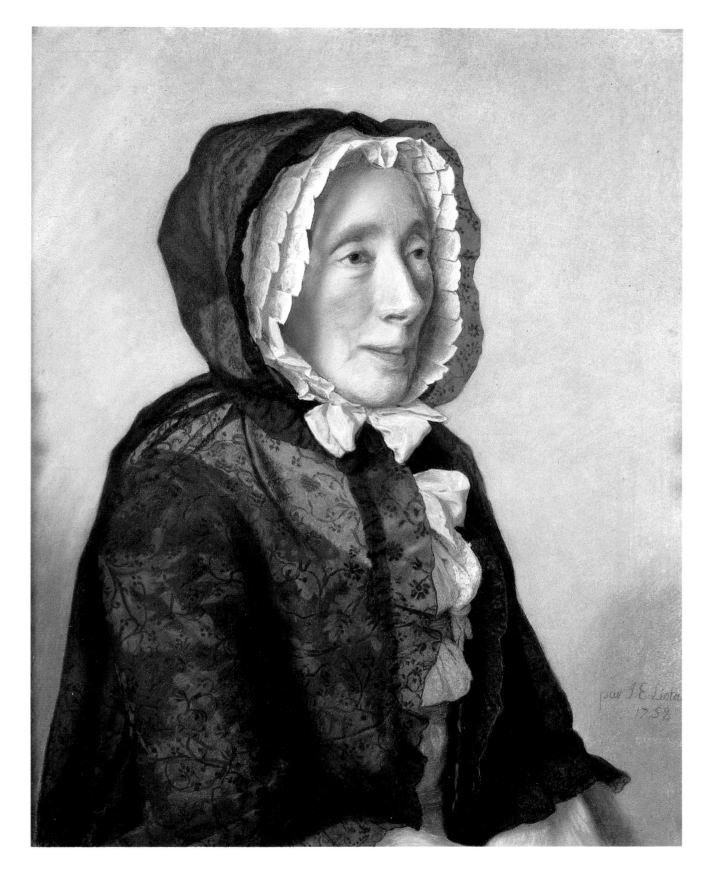

Jean-Etienne Liotard

PORTRAIT OF MADAME TRONCHIN

Born and died in Geneva • 1702-90
Pastel • 19.7 in x 24.8 in • Musée du Louvre, Paris, France/Giraudon/Bridgeman Art Library, London

245

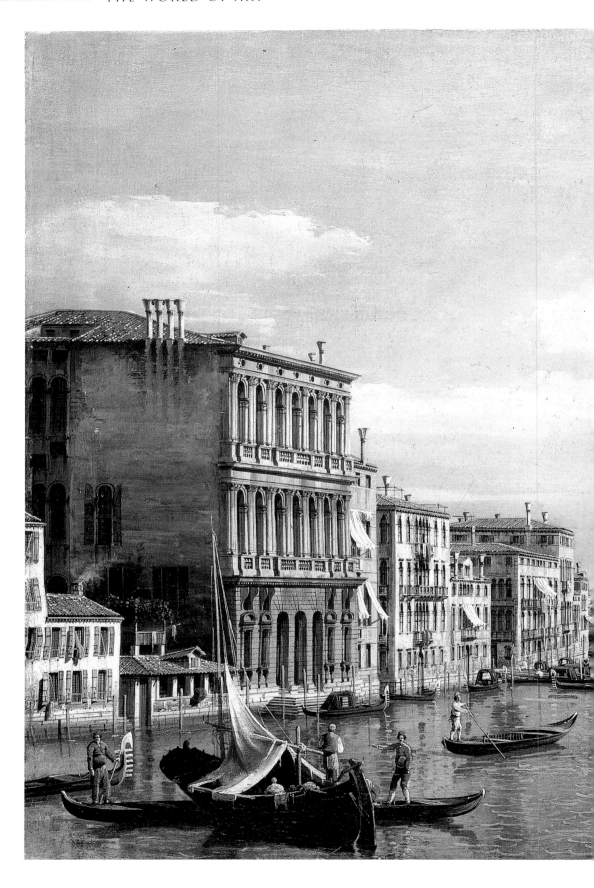

Giovanni Antonio Canal Canaletto

THE GRAND CANAL VENICE LOOKING EAST FROM THE CAMPO DI SAN VIO

Born and died in Venice • 1697-1768
Oil on canvas • 20.75 in x 39.75 in • Christie's Images, London, UK/Bridgeman Art Library, London

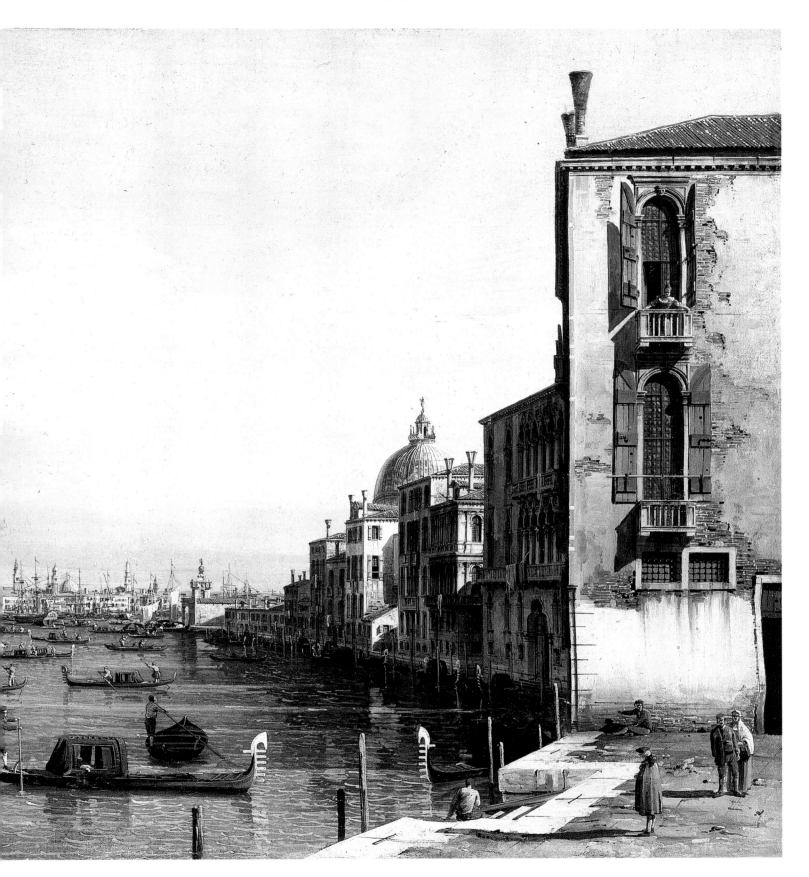

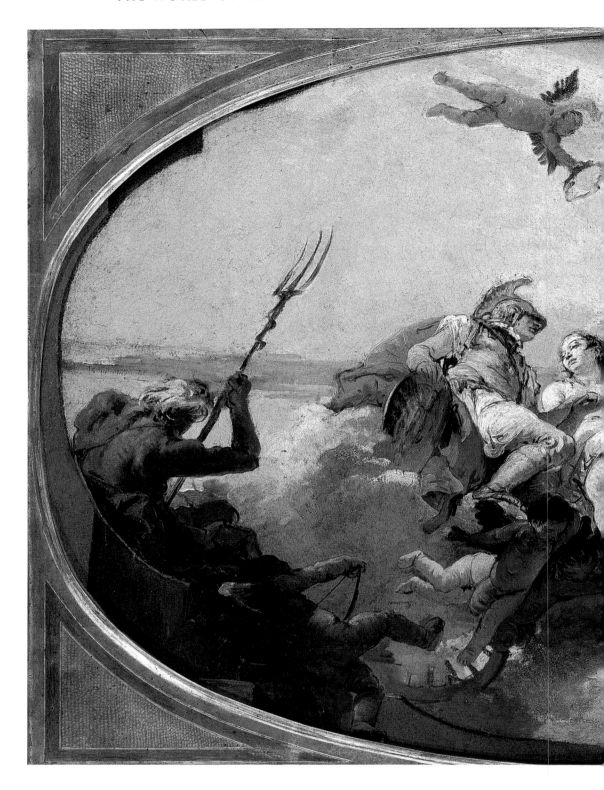

Giovanni-Battista Tiepolo

APOTHEOSIS OF ADMIRAL VITTOR PISANI

Born in Venice • Died in Madrid • 1696-1770
Fresco • 531.5 in x 925 in • Agnew & Sons, London, UK/Bridgeman Art Library, London

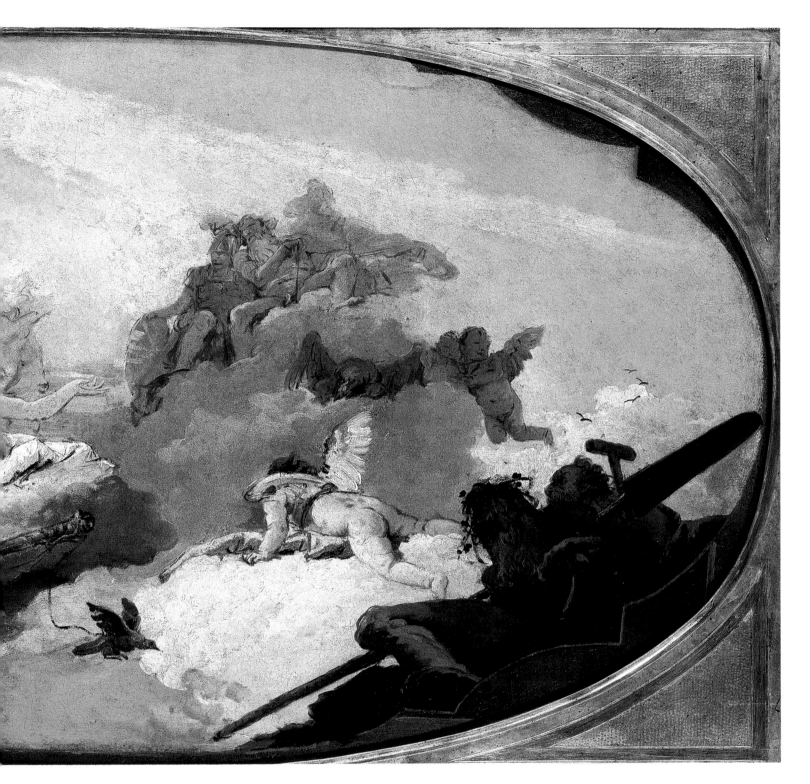

Jean-Baptiste-Siméon Chardin

THE OFFICERS' MESS OR THE REMAINS OF A LUNCH

Born and died in Paris • 1699-1779
Oil on canvas • 15 in x 18.1 in • Musée du Louvre, Paris,
France/Giraudon/Bridgeman Art Library, London

Jean-Baptiste Greuze

THE GUITARIST

Born in Tournus • Died in Paris • 1725-1805
Oil on canvas • 28 in x 22.4 in • Musée des Beaux-Arts, Nantes, France/Giraudon/Bridgeman Art Library, London

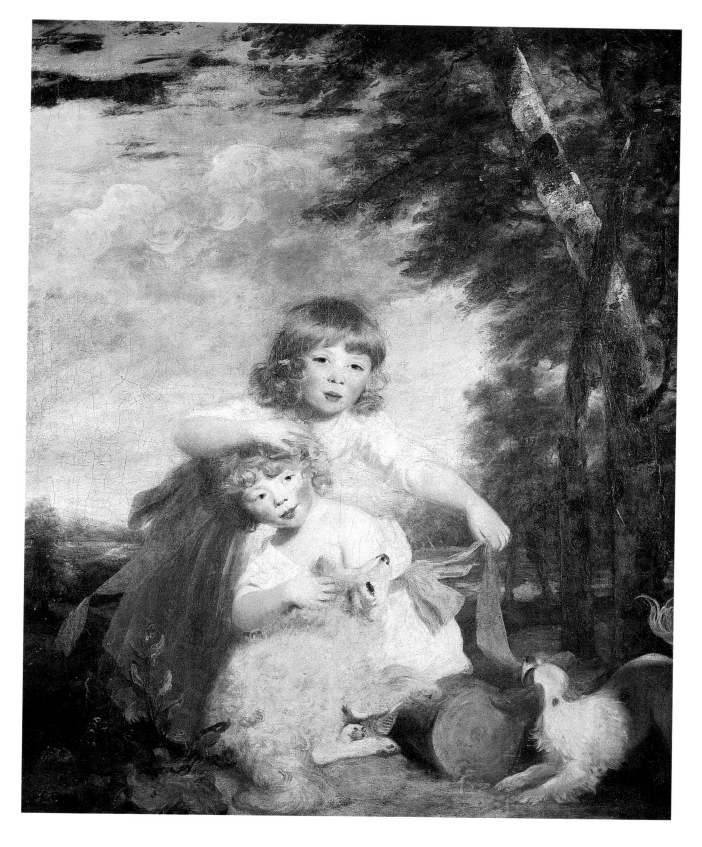

Sir Joshua Reynolds

THE BRUMMEL CHILDREN

Born in Plympton • Died in London • 1732-92
Oil on canvas • 56 in x 44 in • Kenwood House, London, UK/Bridgeman Art Library, London

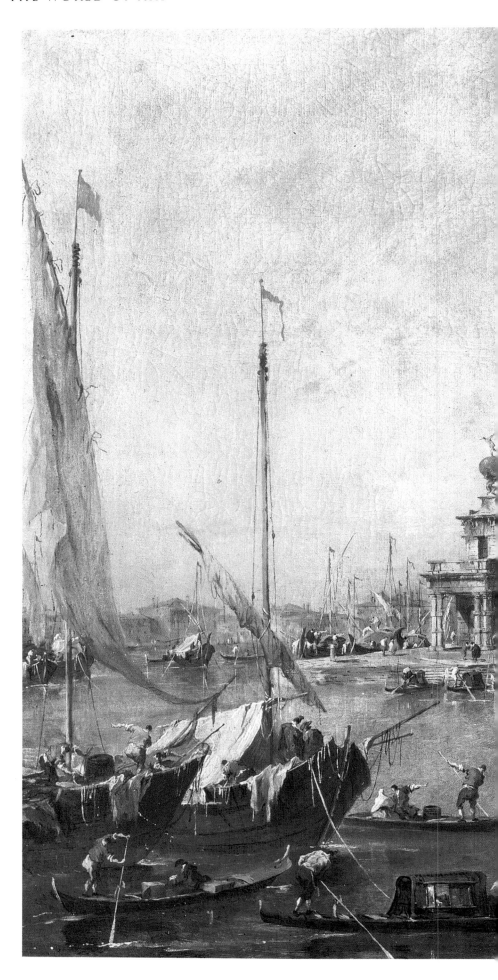

Francesco Guardi

VENICE, THE PUNTA DELLA DOGANA WITH
SANTA MARIA DELLA SALUTE

Born and died in Venice • 1712-93 • Oil on canvas
22.1 in x 29.9 in • National Gallery, London,
UK/Bridgeman Art Library, London

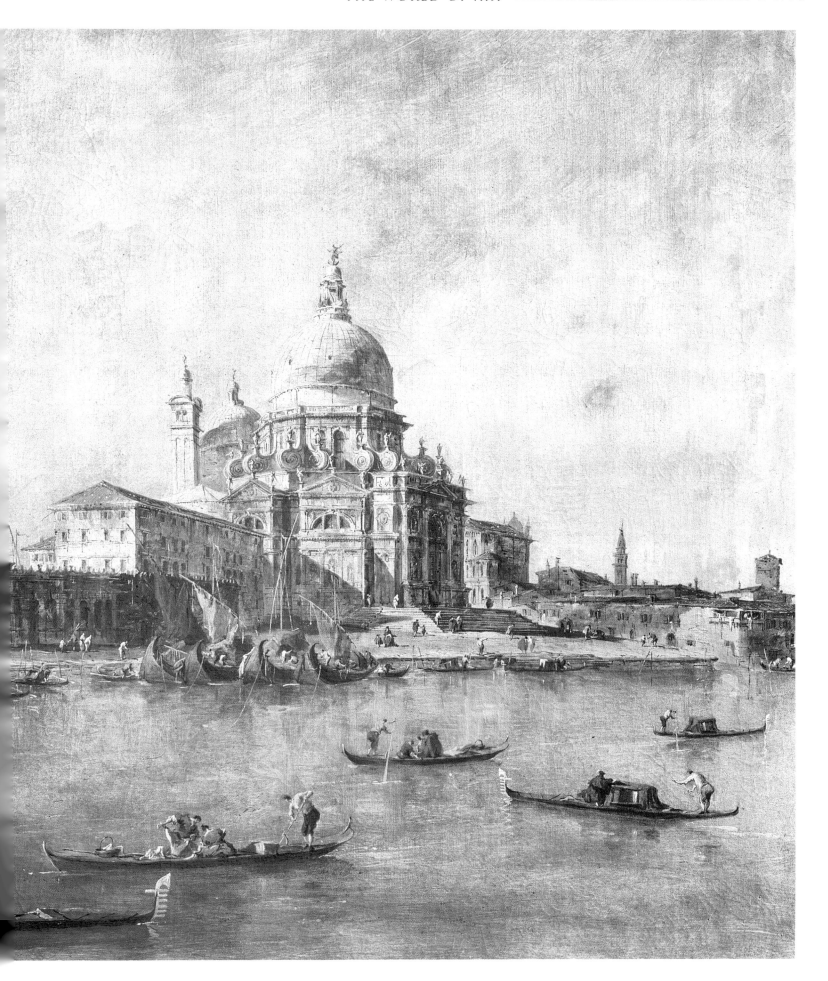

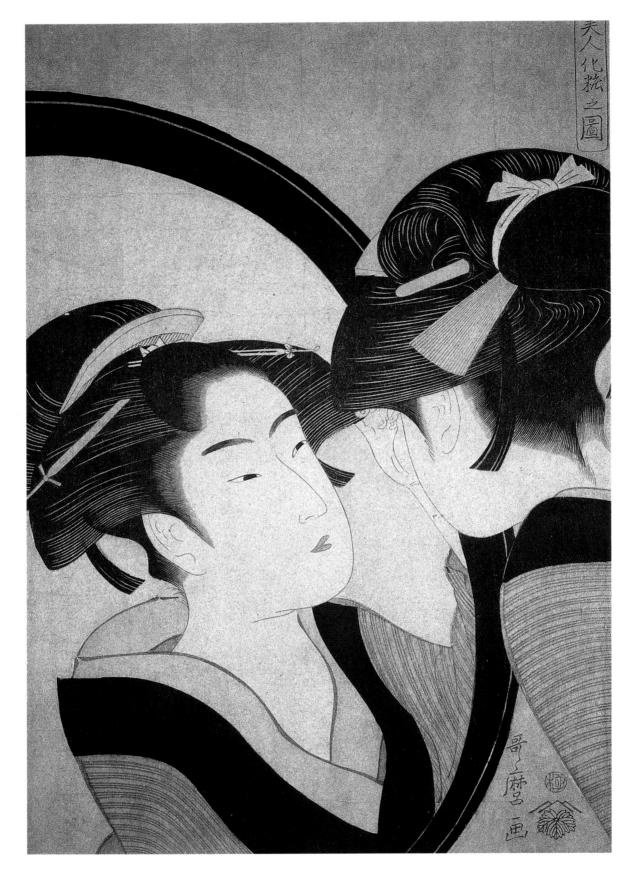

Kitagawa Utamaro

GIRL WITH A MIRROR

Born and died in Edo (Tokyo) • 1753-1806
Color woodblock print • British Library, London, UK / Bridgeman Art Library, London

Jan van Grevenbroeck

DREDGING A CANAL

1731-1807 • Oil on canvas • Museo Correr, Venice, Italy/Giraudon/Bridgeman Art Library, London

Joseph Wright of Derby

THE BLACKSMITH'S SHOP

Born and died in Derby • 1734-97
Oil on canvas • 41.3 in x 55.1 in • Hermitage. St. Petersburg. Russia/Bridgeman Art Library. London

Anton Raffael Mengs

SELF PORTRAIT

Born in Aussig • Died in Rome • 1728-79
Oil on canvas • 40.2 in x 30.5 in • Hermitage, St. Petersburg, Russia/Bridgeman Art Library, London

Claude-Joseph Vernet

CONSTRUCTION OF A ROAD

Born in Avignon • Died in Paris • 1714-89
Oil on canvas • 38.2 in x 63.8 in • Musée du Louvre, Paris, France/Giraudon/Bridgeman Art Library, London

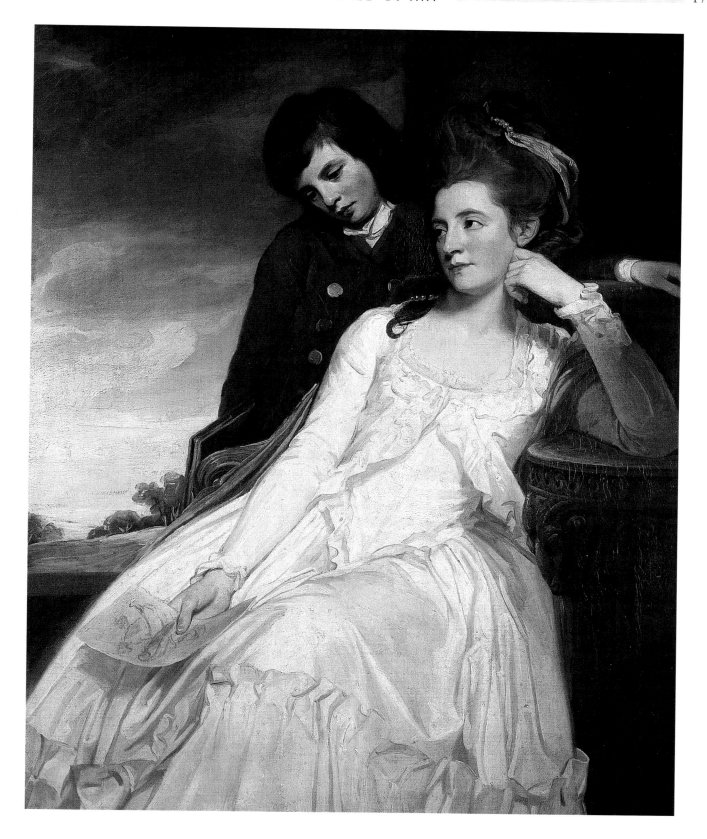

George Romney

JANE MAXWELL, DUCHESS OF GORDON (C. 1749-1812)
AND HER SON THE MARQUIS OF HUNTLY (1734-1802)

Born nr. Dalton le Furness, Lancs • Died in Kendal, Cumbria • 1734-1802
Oil on canvas • 49.8 in x 40.4 in • Scottish National Portrait Gallery, Edinburgh, Scotland, UK/Bridgeman Art Library, London

Jean-Honoré Fragonard

THE BOLT

Born in Grasse • Died in Paris • 1732-1806
Oil on canvas • 28.7 in x 36.6 in • Musée du Louvre, Paris,
France/Giraudon/Bridgeman Art Library, London

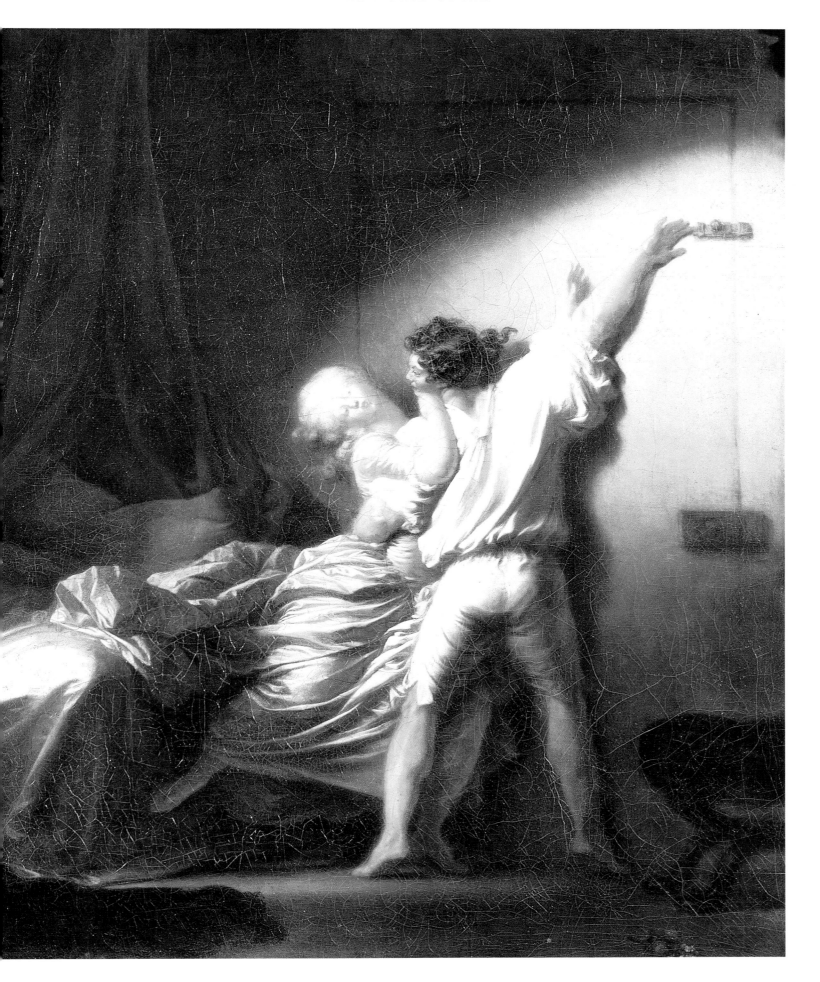

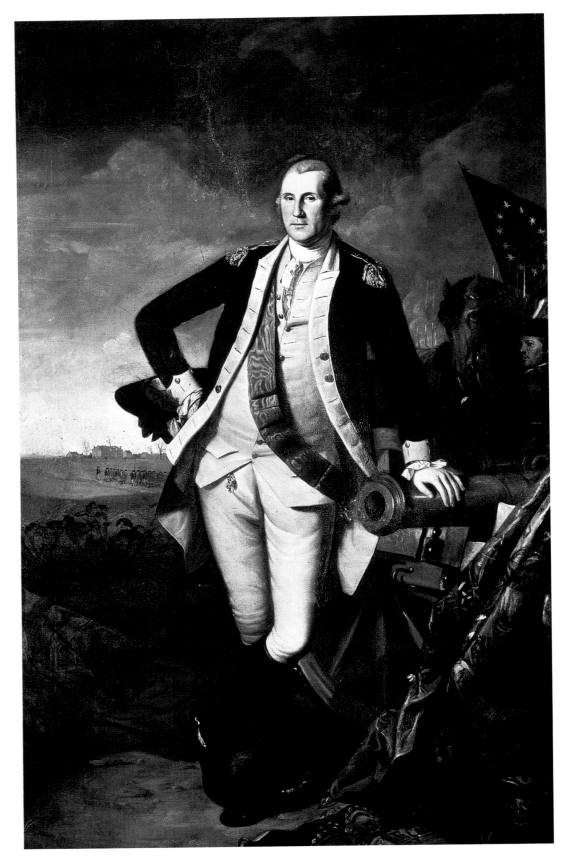

Charles Willson Peale

GEORGE WASHINGTON AT PRINCETON

Born in Queen Anne's Country • 1741-1827
Oil on canvas • 93 in x 58.5 in • Pennsylvania Academy of Fine Arts, Philadelphia, PA, USA/Bridgeman Art Library, London

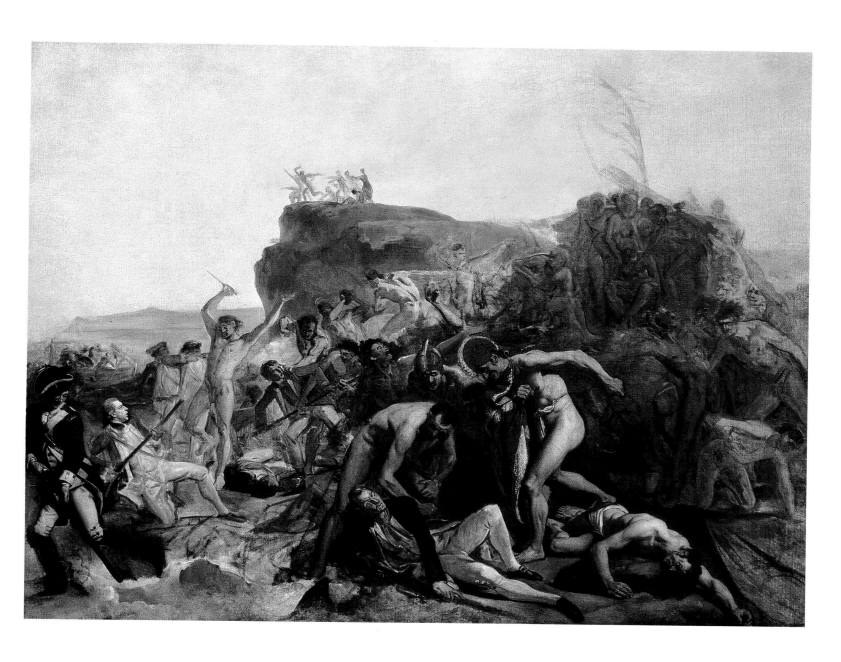

Johann Zoffany

THE DEATH OF COOK

Born near Frankfurt am Main • Died in London • 1733-1810
Oil on canvas • 53.9 in x 72 in • National Maritime Museum, London, UK/Bridgeman Art Library, London

George Stubbs

MARES AND FOAL

Born in Liverpool • Died in London • 1724-1806
Oil on canvas • 39 in x 62.5 in • Private Collection/Bridgeman Art
Library, London

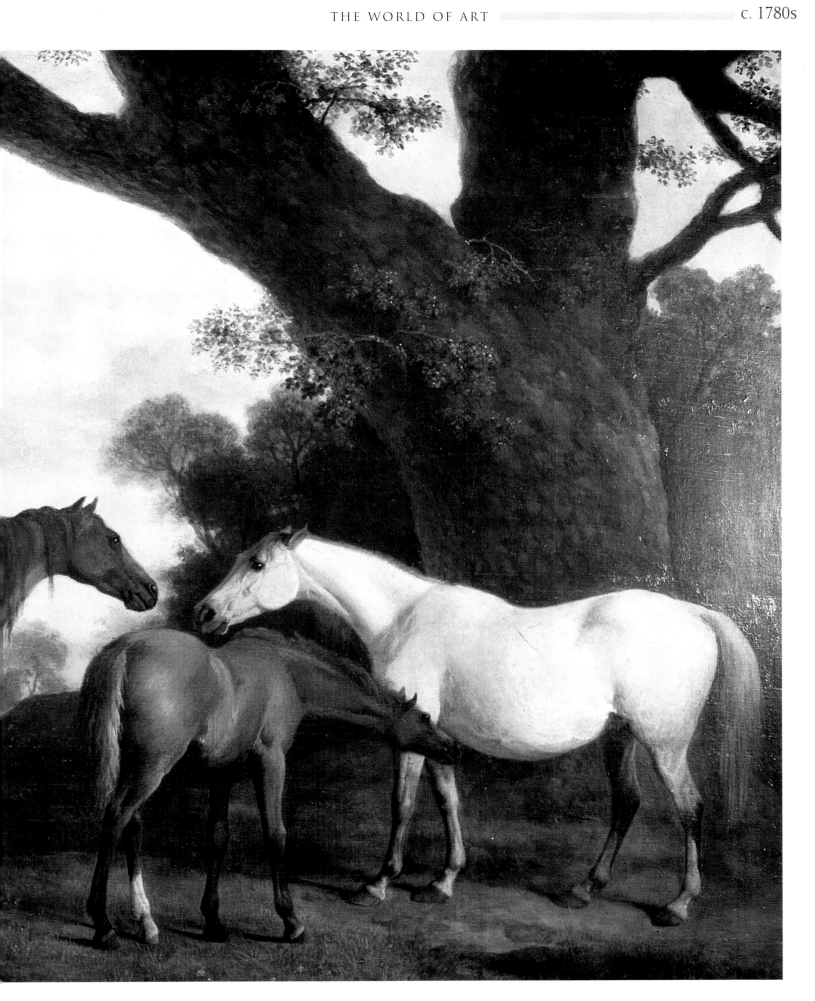

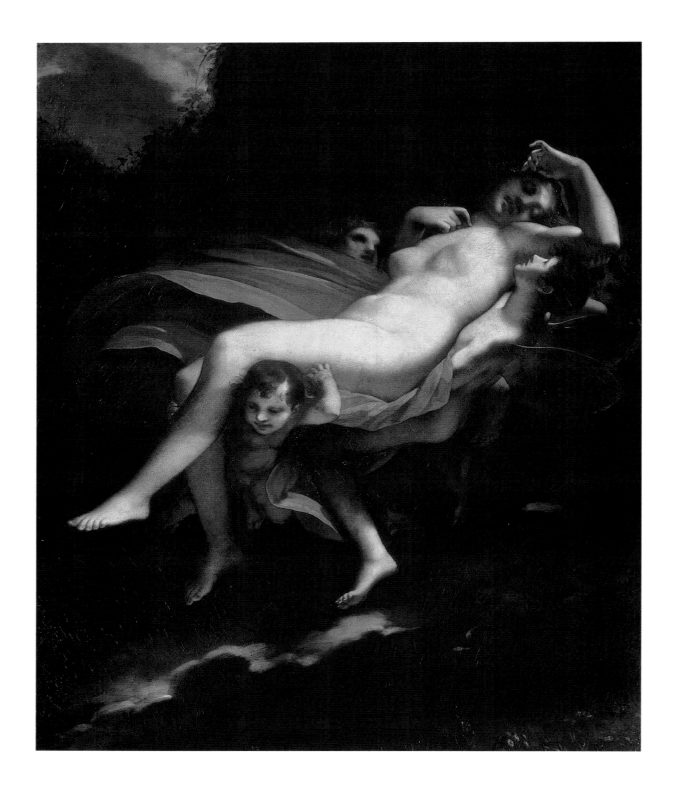

Pierre-Paul Prud'hon

PSYCHE TRANSPORTED TO HEAVEN

Born in Cluny • Died in Paris • 1758-1823
Oil on canvas • 76.8 in x 77.6 in • Musée du Louvre, Paris, France/Peter Willi Bridgeman Art Library, London

Louis Nicolael van Blarenberghe

THE SURRENDER OF YORKTOWN

Born in Lille • 1716-94
Oil on canvas • 23.2 in x 37 in • Château de Versailles, France/Giraudon/Bridgeman Art Library, London

John Robert Cozens

LAKE NEMI, CAMPAGNA, ITALY

Born and died in London • 1752-99
Watercolor, ink and pencil • 16.8 in x 24.6 in • Fitzwilliam Museum, University of Cambridge, UK/Bridgeman Art Library, London

Marie-Louise Élisabeth Vigée-Lebrun

SELF PORTRAIT

Born and died in Paris • 1755-1842
Oil on canvas • 39.4 in x 31.2 in • Galleria Degli Uffizi, Florence, Italy/Bridgeman Art Library, London

Thomas Girtin

RIEVAULX ABBEY, YORKSHIRE (DETAIL)

Born and died in London • 1775-1802
64.2 in x 123.2 in (whole painting) • Victoria and Albert Museum, London/Bridgeman Art Library, London

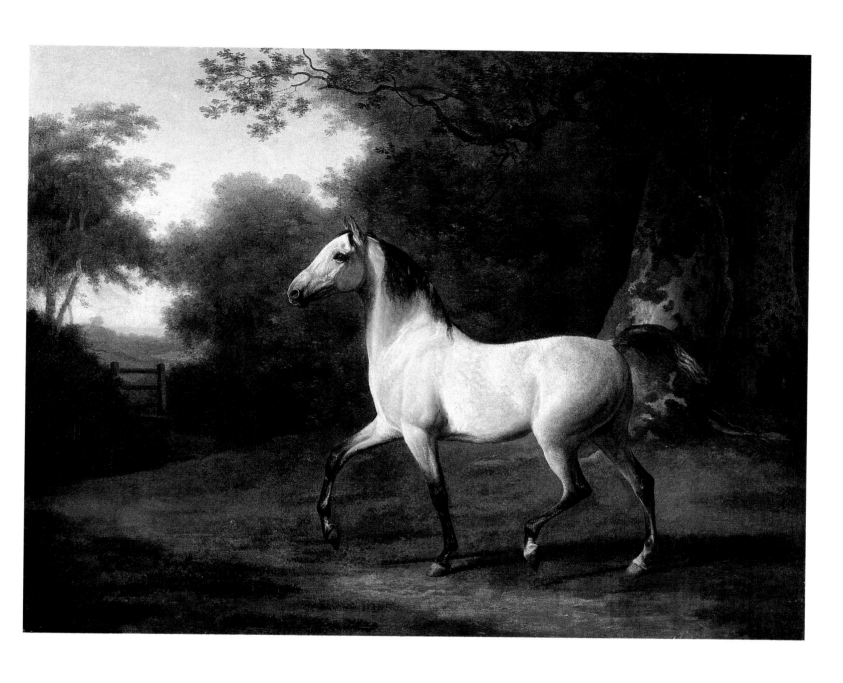

Jacques-Laurent Agasse

A GREY ARAB STALLION IN A WOODED LANDSCAPE

Born in Geneva • Died in London • 1767-1849
35 in x 44.5 in • Christie's Images/Bridgeman Art Library, London

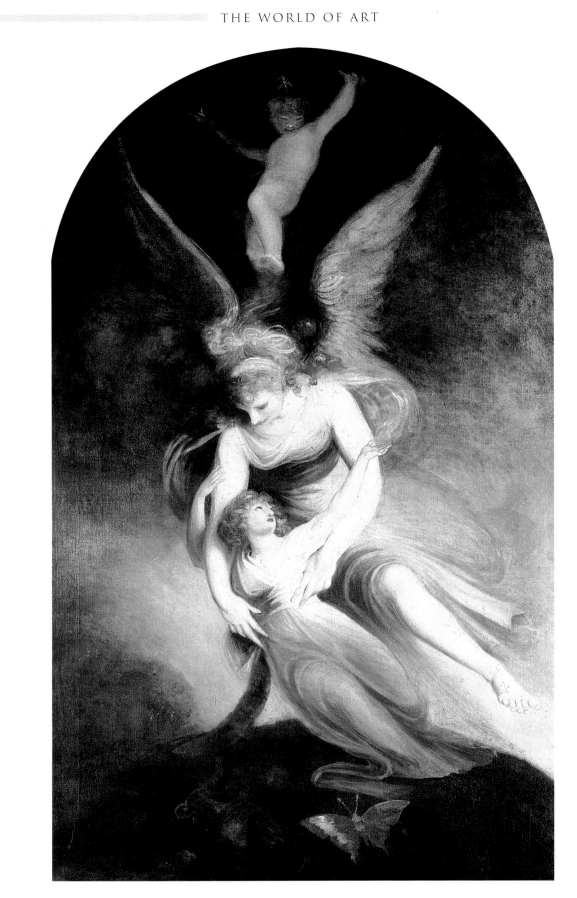

Henry Fuseli

THE APOTHEOSIS OF PENELOPE BOOTHBY

Born in Zurich • Died in Putney, London • 1741-1825
Oil on canvas • 84.1 in x 50.1 in • Wolverhampton Art Gallery, West Midlands, UK/Bridgeman Art Library, London

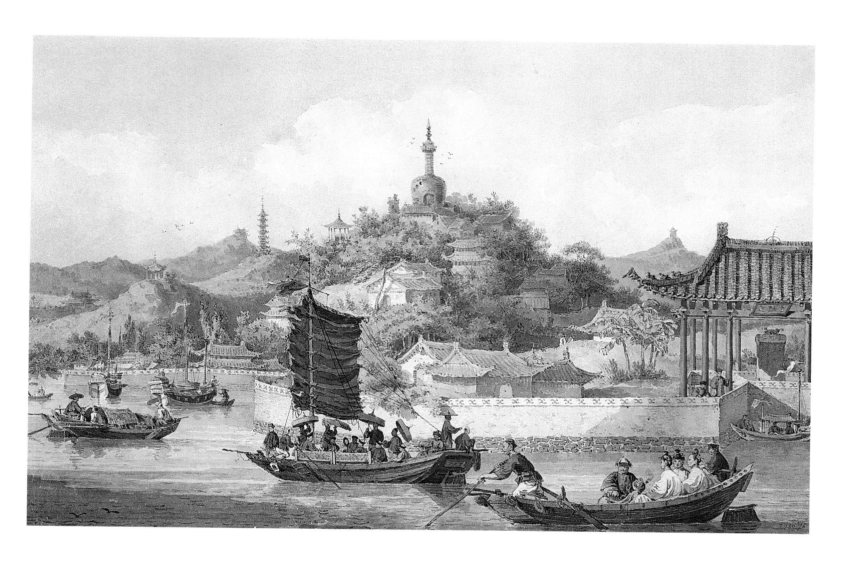

William Alexander

EMPEROR OF CHINA'S GARDENS, IMPERIAL PALACE, PEKING

Born and died in Maidstone, Kent • 1767-1816
Watercolor on paper • 9.25 in x 14 in • Victoria and Albert Museum, London/Bridgeman Art Library, London

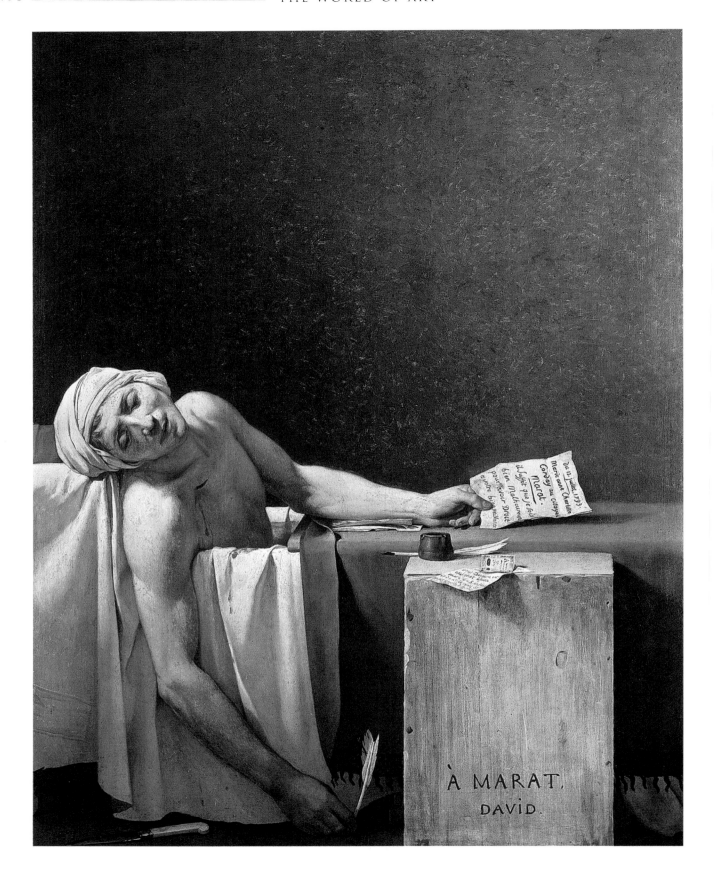

Jacques-Louis David

THE DEATH OF MARAT

Born in Paris • Died in Brussels • 1748-1825
Oil on canvas • 65 in x 50.5 in • Musées Royaux des Beaux-Arts de Belgique, Brussels, Belguim/Giraudon/Bridgeman Art Library, London

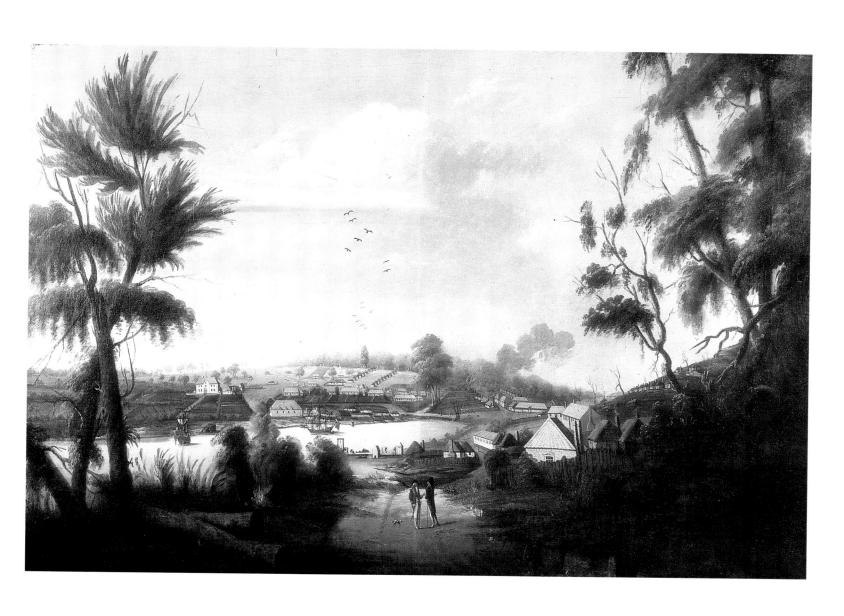

Thomas Watling (after)

A DIRECT NORTH GENERAL VIEW OF SYDNEY COVE

Born in Dumfries • 1762-1814
Oil on canvas • Dixson Galleries, State Library of NSW, Australia/Bridgeman Art Library, London

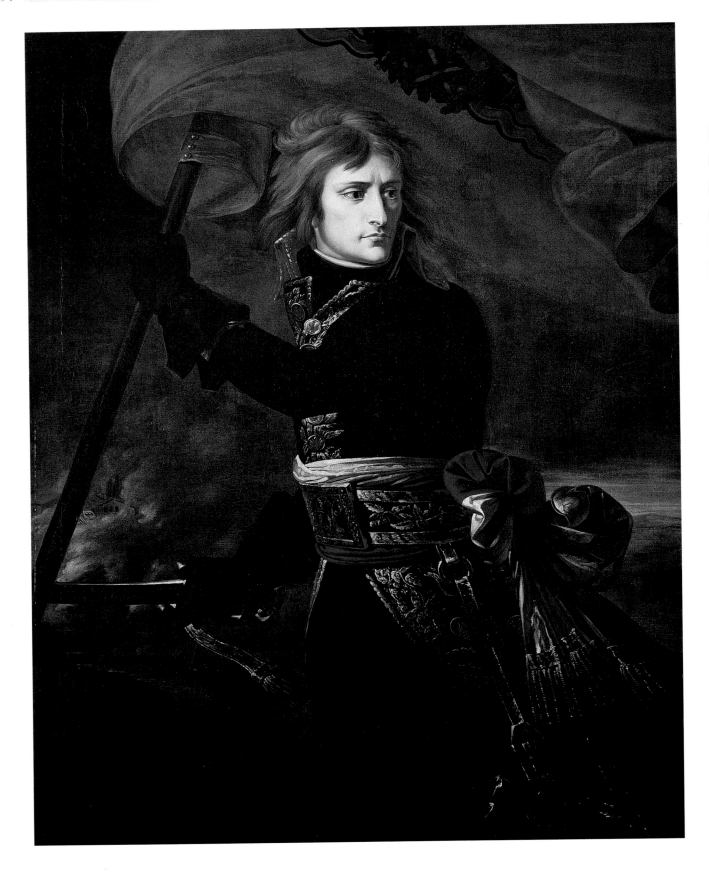

Baron Antoine-Jean Gros

NAPOLEON ON THE BRIDGE OF ARCOLE

Born in Paris • Died in Bas-Meudon • 1771-1835
Oil on canvas • 57.8 in x 40.9 in • Hermitage, St. Petersburg, Russia/Bridgeman Art Library, London

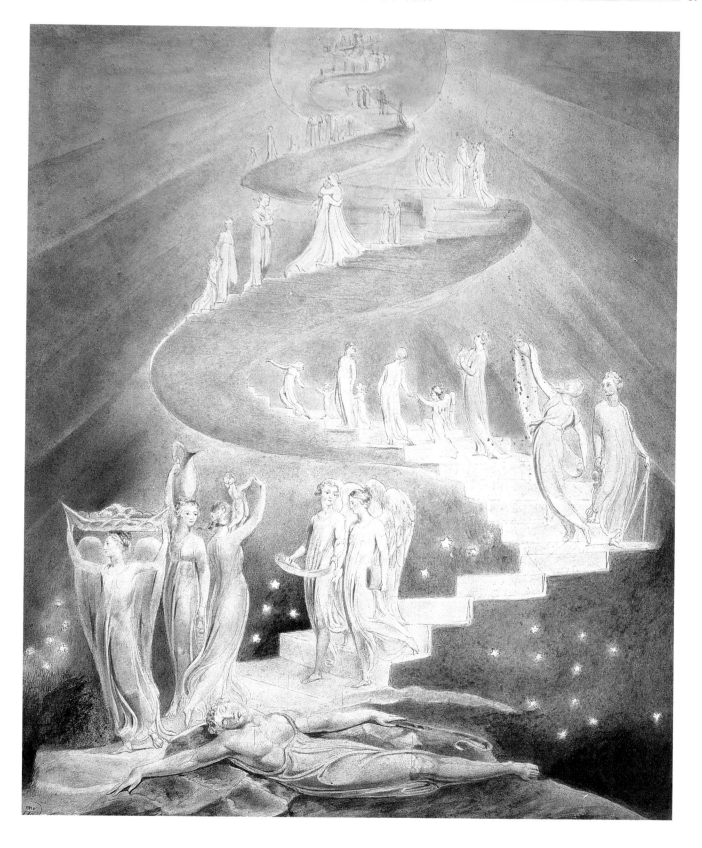

William Blake

JACOB'S LADDER

Born and died in London • 1757-1827
Pen and watercolor on paper • 15.7 in x 12.1 in • British Library, London, UK/Bridgeman Art Library, London

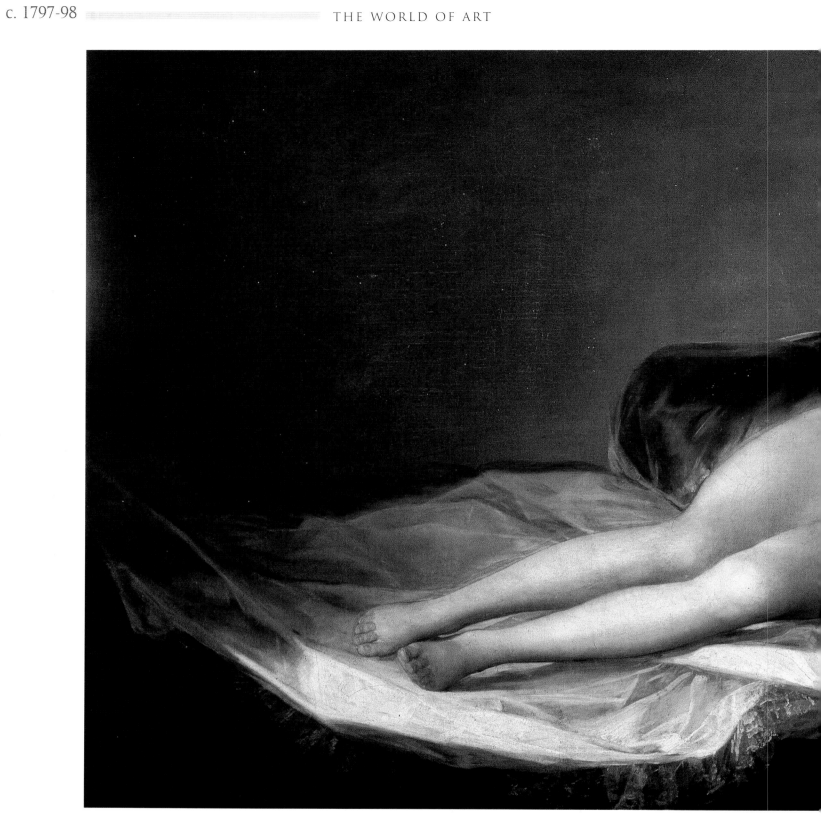

Francisco José de Goya y Lucientes

THE NAKED MAJA

Born in Fuendetodos • Died in Bordeaux • 1746-1828
Oil on canvas • 38.6 in x 75.2 in • Museo del Prado, Madrid, Spain/Bridgeman Art Library, London

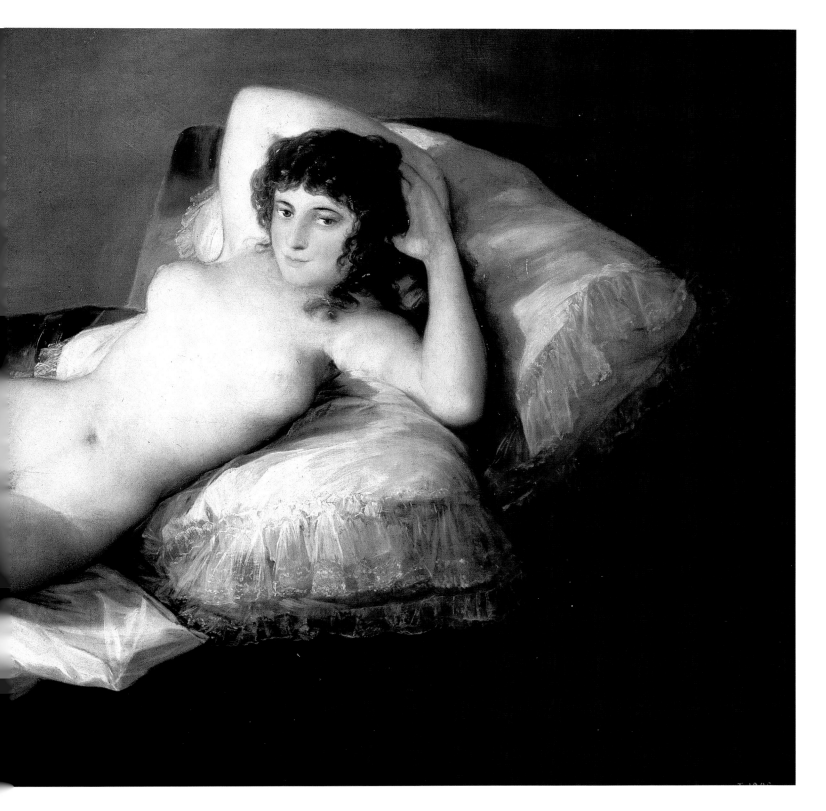

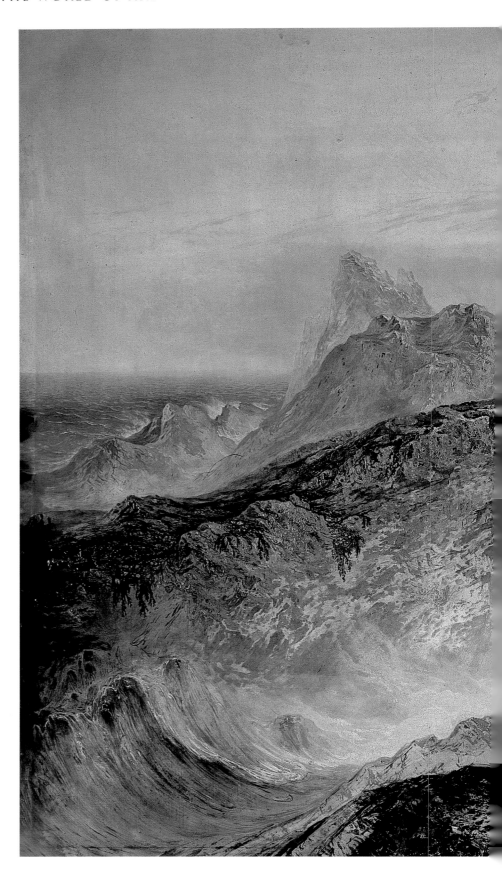

John Martin

ASSUAGING OF THE WATERS

Born Haydon Bridge • Died Douglas • 1789-1854
Oil on canvas • 56.3 in x 85.8 in • Church of Scotland General Assembly, Edinburgh, Scotland/Bridgeman Art Library, London

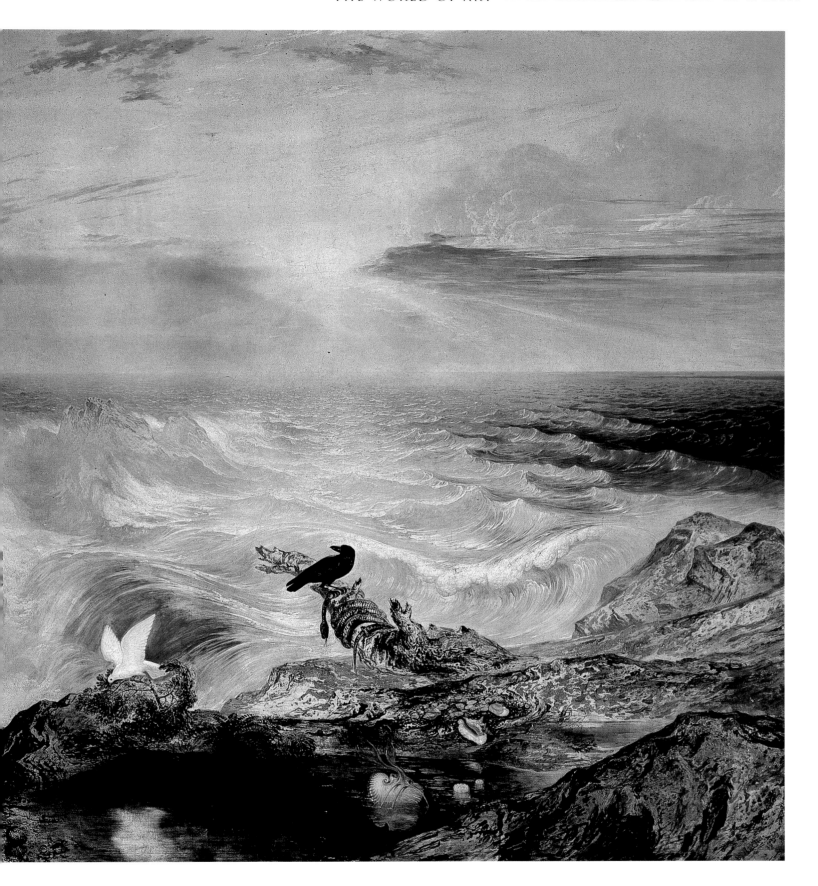

Washington Allston

LANDSCAPE WITH A LAKE

Born in Charleston SC. • Died in Cambridge, MA. • 1799-1843
Oil on canvas • 38 in x 51.3 in • Museum of Fine Arts • Boston, Massachusetts, MA, USA/Bridgeman Art Library, London

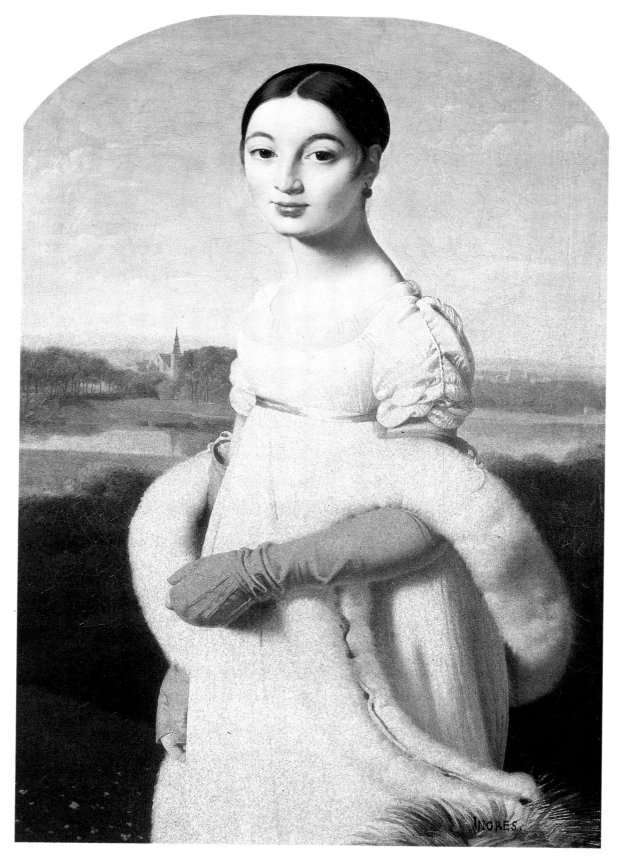

Jean Auguste Dominique Ingres

PORTRAIT OF MADEMOISELLE CAROLINE RIVIÈRE

Born in Montauban • Died in Paris • 1780-1867
Musée du Louvre, Paris, France/Bridgeman Art Library, London

John Eyre

FIRST GOVERNMENT HOUSE, SYDNEY

Born in Coventry • c. 1771-1812
Watercolor • 102.4 in x 13.4 in • Mitchell Library, State Library of NSW, Australia/Bridgeman Art Library, London

David Cox

IN THE HAYFIELD

Born in Birmingham • Died in Harborne • 1783-1859
Watercolor • 18.25 in x 25 in • Agnew & Sons, London, UK/Bridgeman Art Library, London

Benjamin West

THE DEATH OF NELSON

Born in Springfield, PA • Died in London • 1738-1820
Oil on canvas • 34.5 in x 28.5 in • National Maritime Museum, London, UK/Bridgeman Art Library, London

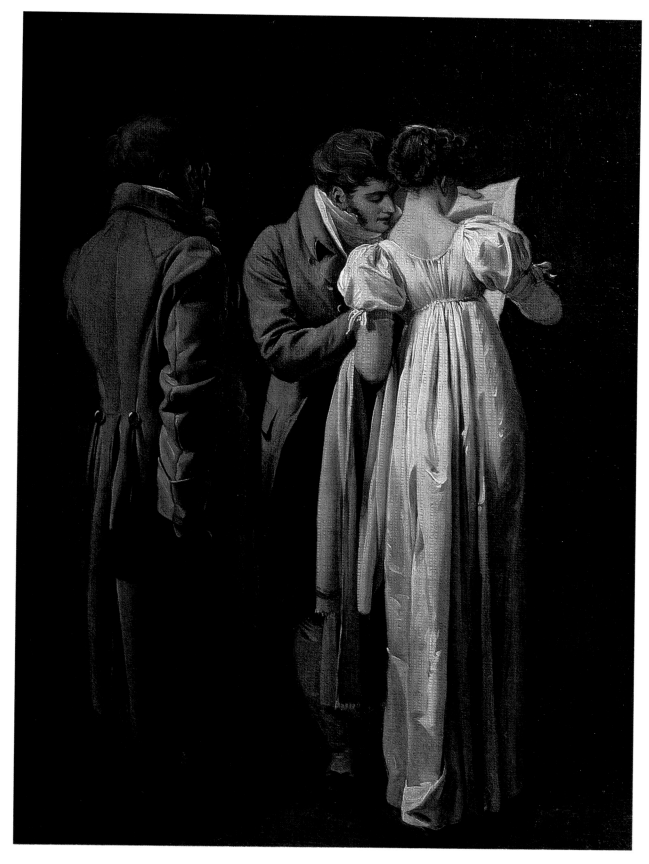

Louis-Léopold Boilly

THE AMATEUR PRINT COLLECTORS

Born in La Bassée, nr Lille • Died in Paris • 1761-1845
Oil on canvas • 12.8 in x 9.7 in • Musée du Louvre, Paris, France/Bridgeman Art Library, London

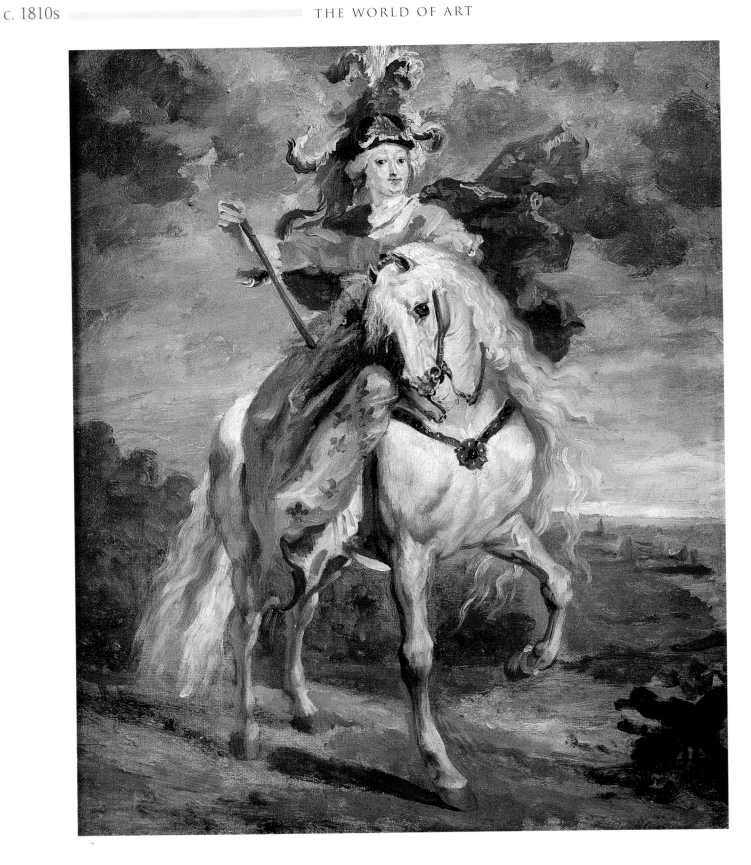

Jean Louis André Théodore Géricault

MARIE DE MEDICI AT PONT-DE-CE

Born and died in Rouen • 1791-1824
18 in x 15in • Christie's Images/Bridgeman Art Library, London

Samuel Prout

LANDSCAPE WITH RIVER AND VILLAGE

Born in Plymouth • Died in London • 1783-1852
Watercolor • 7.5 in x 10.5 in • Victoria and Albert Museum, London, UK/Bridgeman Art Library, London

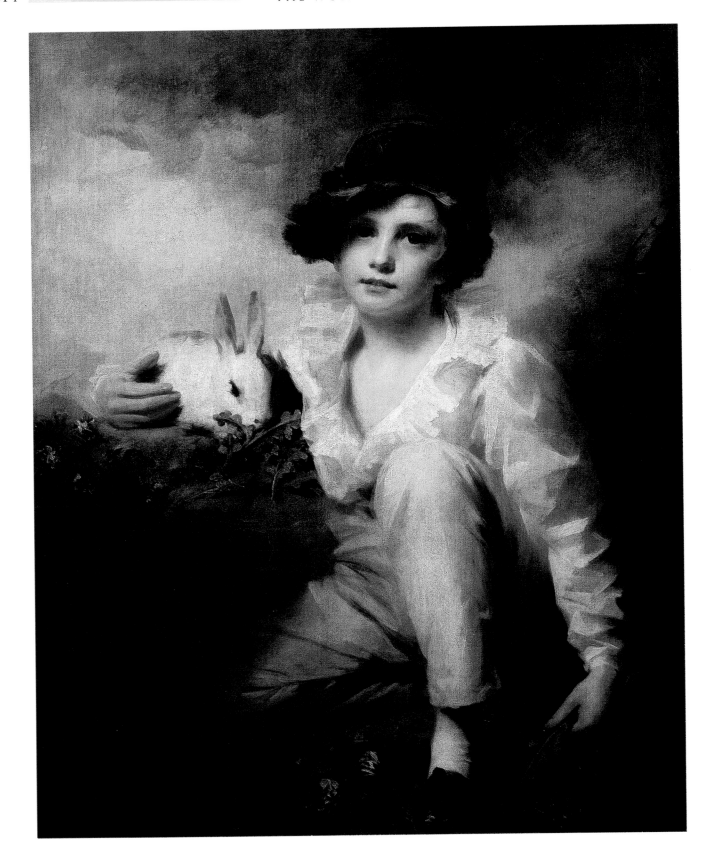

Sir Henry Raeburn

BOY AND RABBIT

Born and died in Edinburgh • 1756-1823
Oil on canvas • 40.6 in x 31.1 in • Royal Academy of Arts, London, UK/Bridgeman Art Library, London

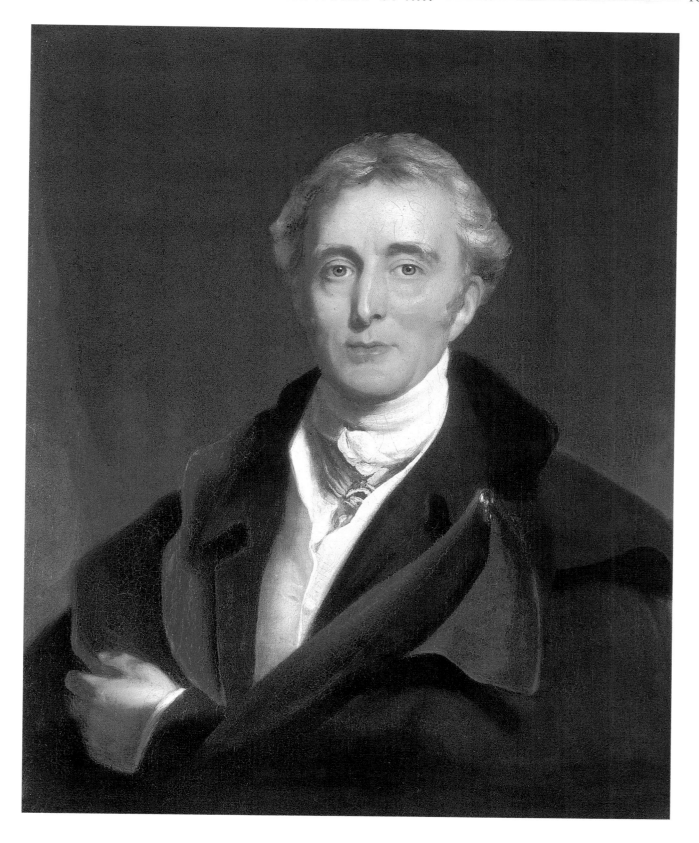

Sir Thomas Lawrence (Circle of)

PORTRAIT OF THE DUKE OF WELLINGTON

Born in Bristol • Died in London • 1769-1830
Oil on canvas • 156 in x 96 in • Bonhams, London, UK/Bridgeman Art Library, London

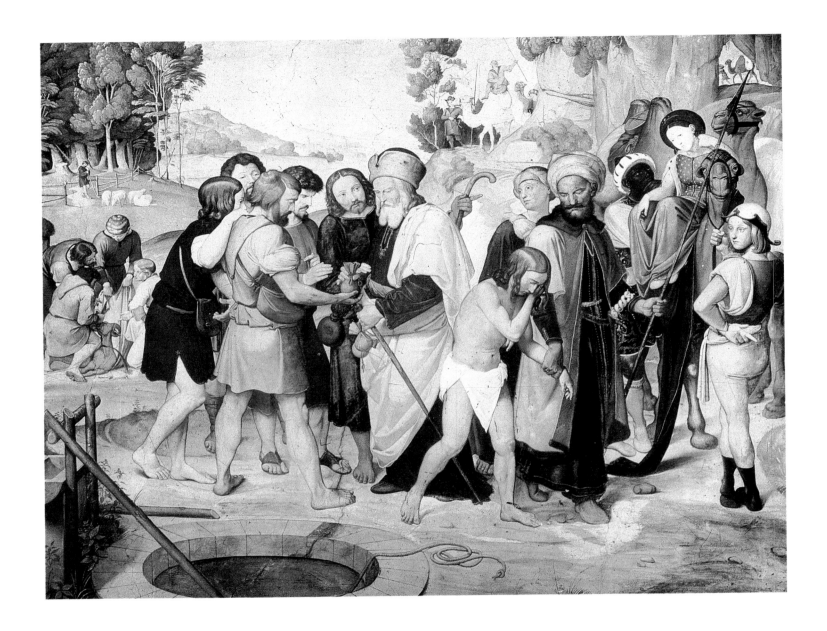

Friedrich Overbeck

JOSEPH BEING SOLD BY HIS BROTHERS
(CASA BARTHOLDY FRESCO CYCLE)

Born in Lübeck • Died in Rome • 1789-1869
Fresco • 92.13 in x 119.7 in • Alter Nationalgalerie, Berlin, Germany/Bridgeman Art Library, London

John Sell Cotman

GILLINGHAM CHURCH, NORFOLK

Born in Norwich • Died in London • 1782-1842
Watercolor and pencil • 9.4 in x 11.6 in • University of Liverpool Art Gallery and Collections, UK/Bridgeman Art Library, London

Joseph Mallord William Turner

Bridge Over the Usk

Born and died in London • 1775-1851
Oil on canvas • 16.25 in x 24.1 in • Victoria and Albert Museum, London/Bridgeman Art Library, London

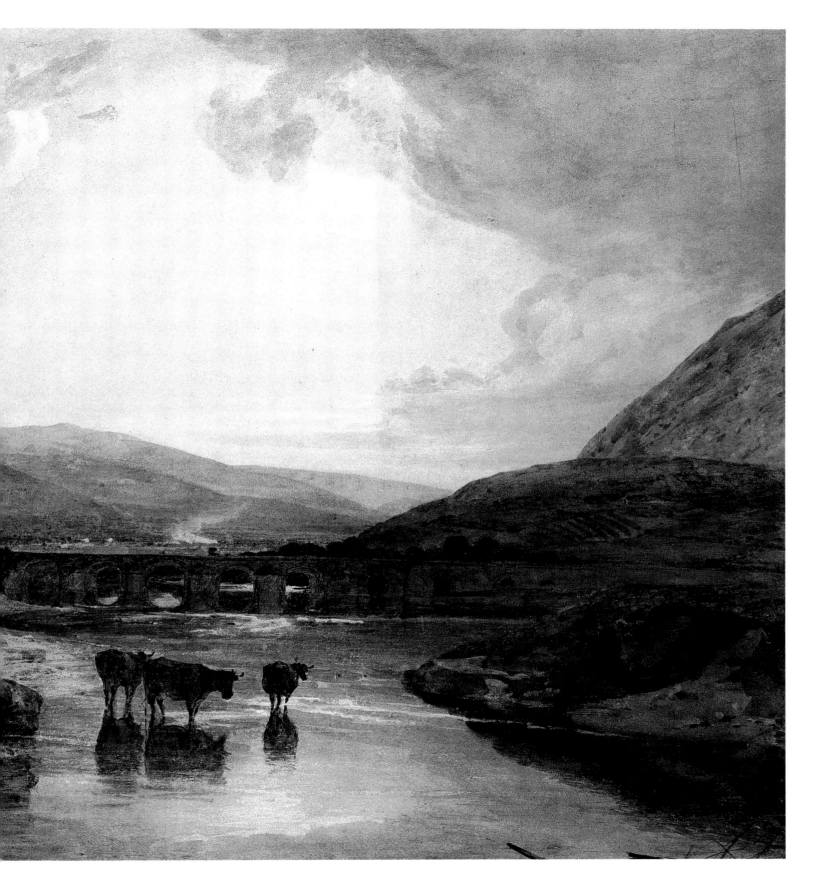

John Constable

THE HAYWAIN

Born in East Bergholt, Suffolk • Died in London • 1776-1837
Oil on canvas • 51.2 in x 73 in • National Gallery, London, UK/Bridgeman Art Library, London

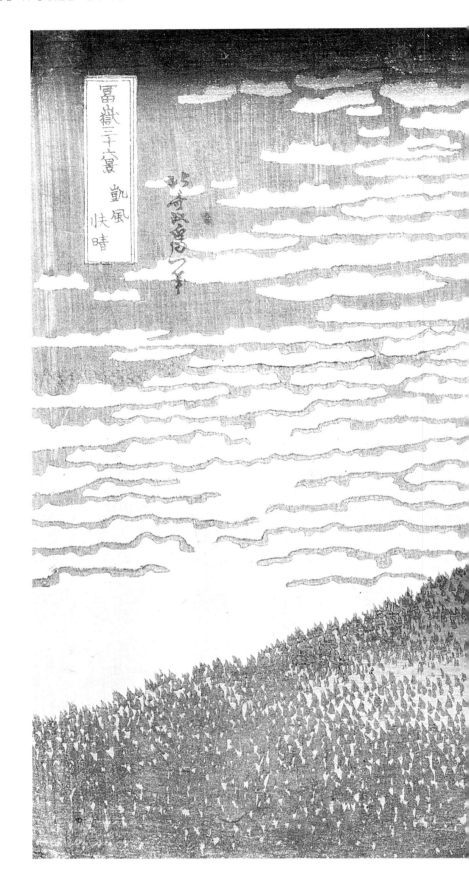

Katsushika Hokusai

FUJI IN CLEAR WEATHER, FROM SERIES, *Eugaku Sanjurokkei 36 views of Mount Fuji*

Born in Asakusa • Died in Honjo • 1760-1849
Woodblock print on paper • 10.6 in x 15 in • British Museum, London, UK / Bridgeman Art Library, London

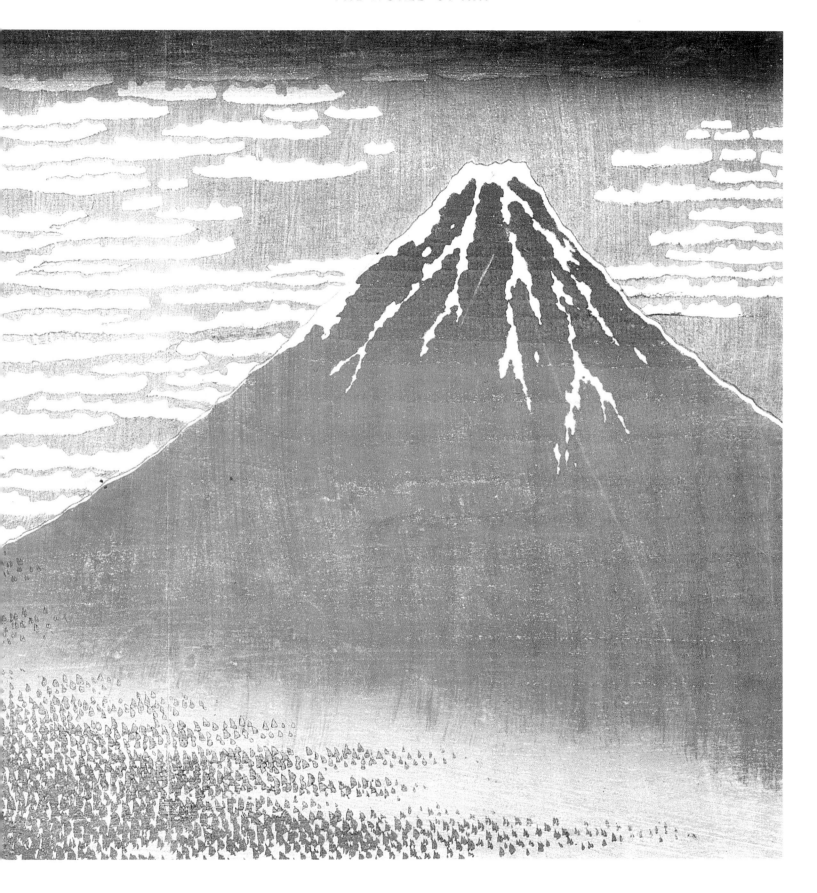

Samuel Palmer

CORNFIELD BY MOONLIGHT

Born in Stoke Newington, London • Died in Surrey • 1805-81
Watercolor • Private Collection/Bridgeman Art Library, London

Gulam Ali Khan

A VILLAGE SCENE IN THE PUNJAB

Watercolor • British Library, London, UK/Bridgeman Art Library, London

Richard Parkes Bonington

THE MEETING

Born in Arnold • Died in London • 1802-28
Watercolor • 5.6 in x 22.8 in • Victoria and Albert Museum, London/Bridgeman Art Library, London

Jean-Baptiste-Camille Corot

FORUM VIEWED FROM THE FARNESE GARDENS

Born and died in Paris • 1796-1875
Oil on paper mounted on canvas • 11 in x 19.7 in • Musée du Louvre, Paris, France/Bridgeman Art Library, London

William Havell

GARDEN SCENE ON THE BROGANZA SHORE, RIO DE JANEIRO

Born in Reading • Died in London • 1782-1857
Watercolour • 20.25 in x 13.5 in • Victoria and Albert Museum, London/Bridgeman Art Library, London

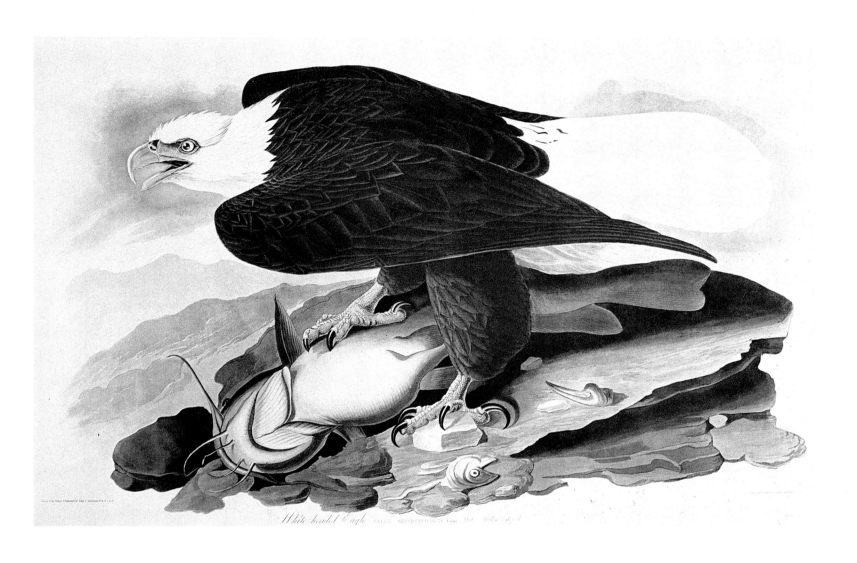

John James Audubon

THE BALD-HEADED EAGLE FROM *Birds of America*

Born in Les Cayes, Haiti • Died in New York, NY • 1785-1851
Engraving by R. Havell • 25.6 in x 38.25 in • British Library, London, UK/Owned by the New York Historical Society/
Bridgeman Art Library, London

Aleksandr Andreevich Ivanov

APOLLO WITH HYACINTHUS AND CYPARISSUS SINGING AND PLAYING

Born and died in St. Petersburg • 1806-58
Oil on canvas • 39.4 in x 55.1 in • Tretyakov Gallery, Moscow, Russia/Bridgeman Art Library, London

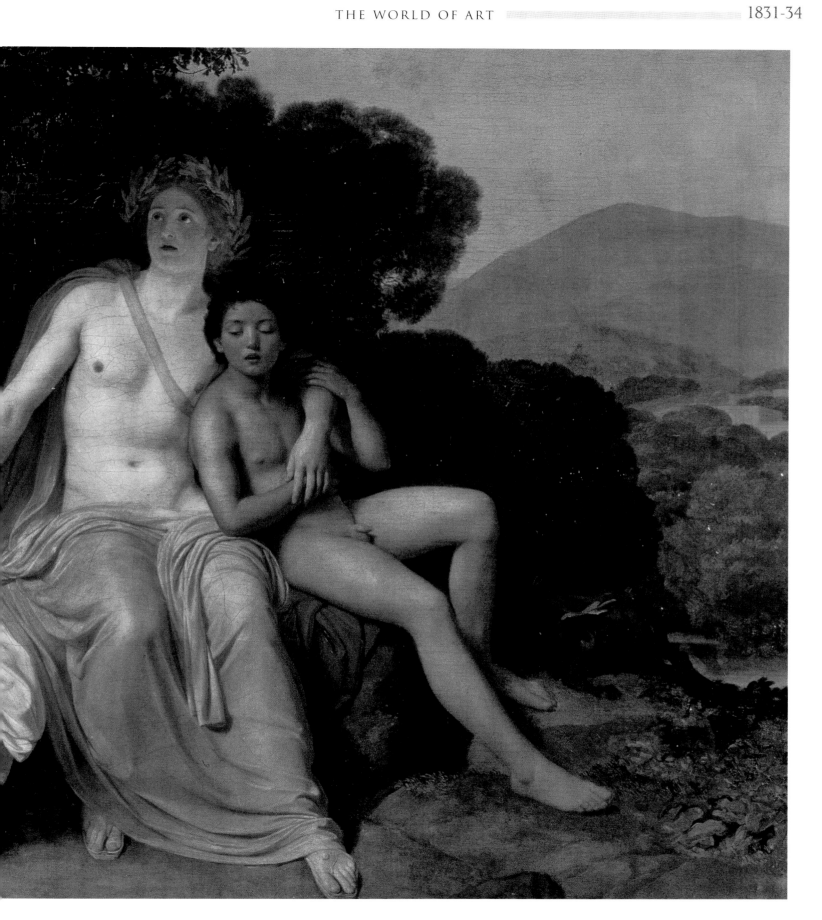

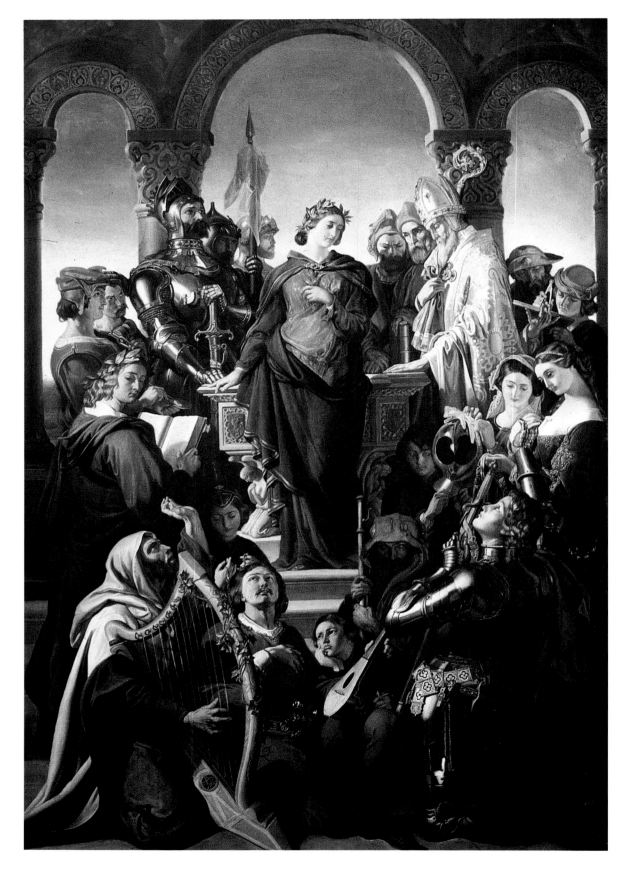

Daniel Maclise

THE SPIRIT OF CHIVALRY

Born in Cork • Died in London • 1806-70
Oil on Canvas • 50 in x 33.7 in. • Sheffield City Art Galleries, South Yorkshire, UK/Bridgeman Art Library, London

Conrad Martens

VIEW OF SYDNEY HARBOUR

Born in Venice • Died in Paris • 1801-78
Bonhams, London, UK/Bridgeman Art Library, London

Caspar-David Friedrich

THE DREAMER

Born in Greifswald • Died in Dresden • 1774-1840
Oil on canvas • 8.3 in x 10.6 in • Hermitage, St. Petersburg, Russia/Bridgeman Art Library, London

William Etty

THE PENITENT MAGDALEN

Born and died in York • 1787-1849
Oil on panel • 23.2 in x 18.5 in • Ashmolean Museum, Oxford, UK/Bridgeman Art Library, London

Cornelis Bernudes Buys

THE DUET

Born in Groningen, Netherlands • Born 1808
Oil on canvas • 24.4 in x 18.1 in • Haags Gemeentemuseum, Netherlands/Bridgeman Art Library, London

Asher Brown Durand

THE DANCE OF THE BATTERY IN THE PRESENCE OF PETER STUYVESANT (1592-1672)

Born Springfield Township, NJ • Died in Maplewood NJ • 1796-1886
Oil on canvas • 32 in x 46 in • Museum of the City of New York, USA/Bridgeman Art Library, London

Peter de Wint

CORNFIELD, WINDSOR

Born in Hanley, Staffs • Died in London • 1784-1849
Watercolor • 11.4 in x 18.1 in • Fitzwilliam Museum, University of Cambridge/Bridgeman Art Library, London

Edward Hicks

THE PEACEABLE KINGDOM

Born in Bucks County, PA • Died in Langhorne, PA • 1780-1849
Oil on canvas • 17.5 in x 23.4 in • Brooklyn Museum of Art, New York, USA/Bridgeman Art Library, London

Richard Dadd

TOMBS OF THE KHALIFS, CAIRO

Born in Chatham, Kent • Died in Broadmoor Hospital, Berkshire • 1819-87
Watercolor • 9.5 in x 14.5 in • Victoria and Albert Museum, London,UK/Bridgeman Art Library, London

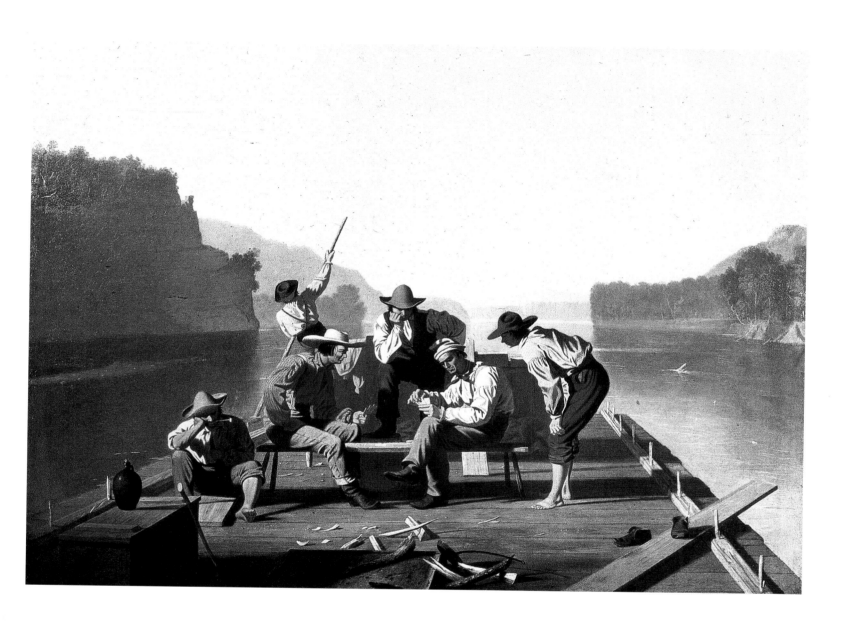

George Caleb Bingham

FERRYMEN PLAYING CARDS

Born in Augusta County, VA • Died in Kansas City, MS • 1811-79
Oil on canvas • 28 in x 38 in • St. Louis Art Museum, MO, USA/Bridgeman Art Library, London

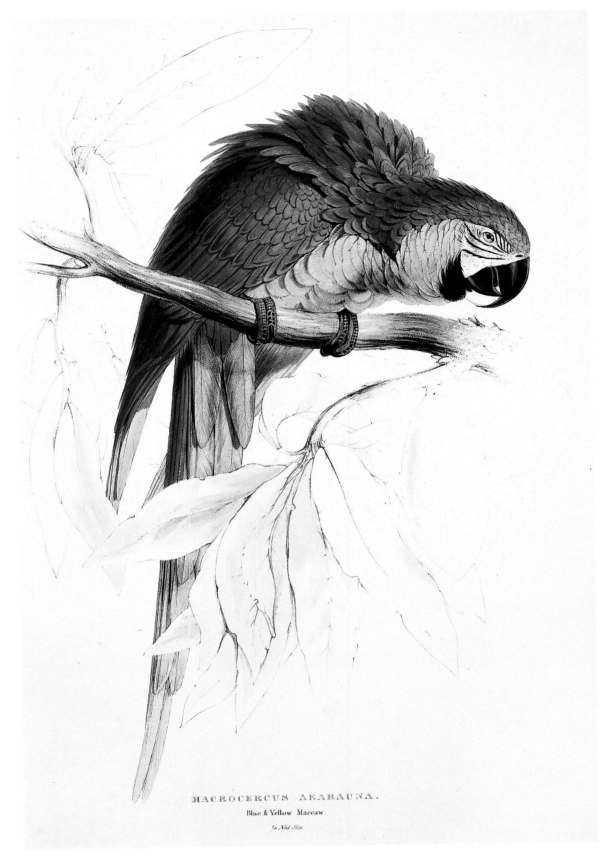

MACROCERCUS ARARAUNA.

Blue & Yellow Maccaw.

⅔ Nat Size

Edward Lear

BLUE AND YELLOW MACAW

Born in Holloway, London • Died in San Remo, Italy • 1812-1888
Pencil and watercolor on paper • Private Collection/Bridgeman Art Library, London

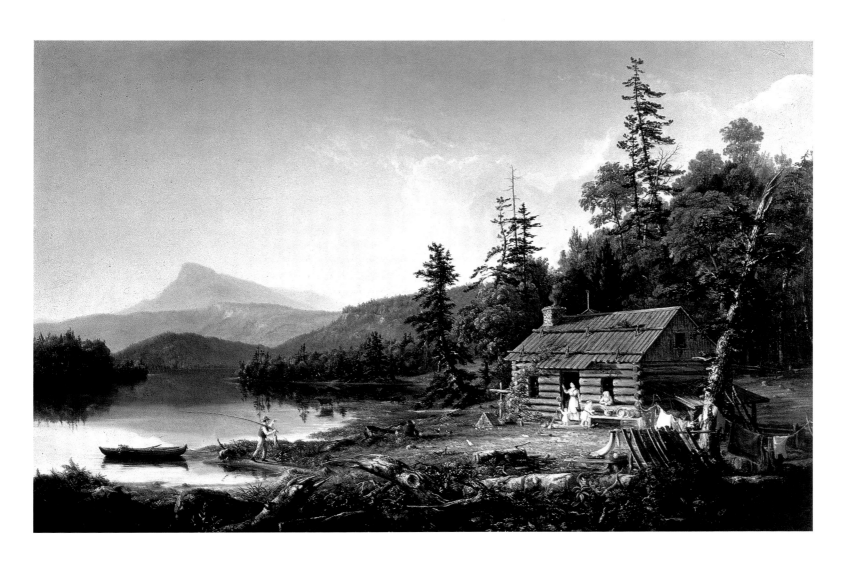

Thomas Cole

HOME IN THE WOODS

Born in Bolton-le-Moors, England • Died in Catskill, NY • 1801-48
Oil on canvas • 44 in x 66 in • Reynolds Museum, Winston Salem, NC, USA/Bridgeman Art Library, London

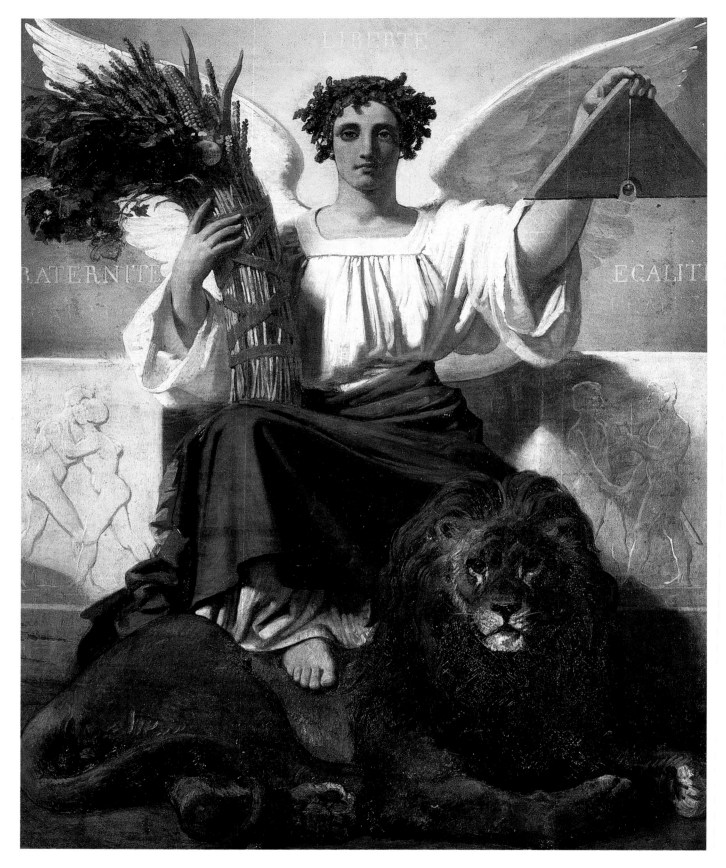

Jules Claude Ziegler

THE REPUBLIC

Born in Langres • Died in Paris • 1804-56
Oil on canvas • 41.3 in x 55.1 in • Musée des Beaux-Arts, Lille, France/Giraudon/Bridgeman Art Library, London

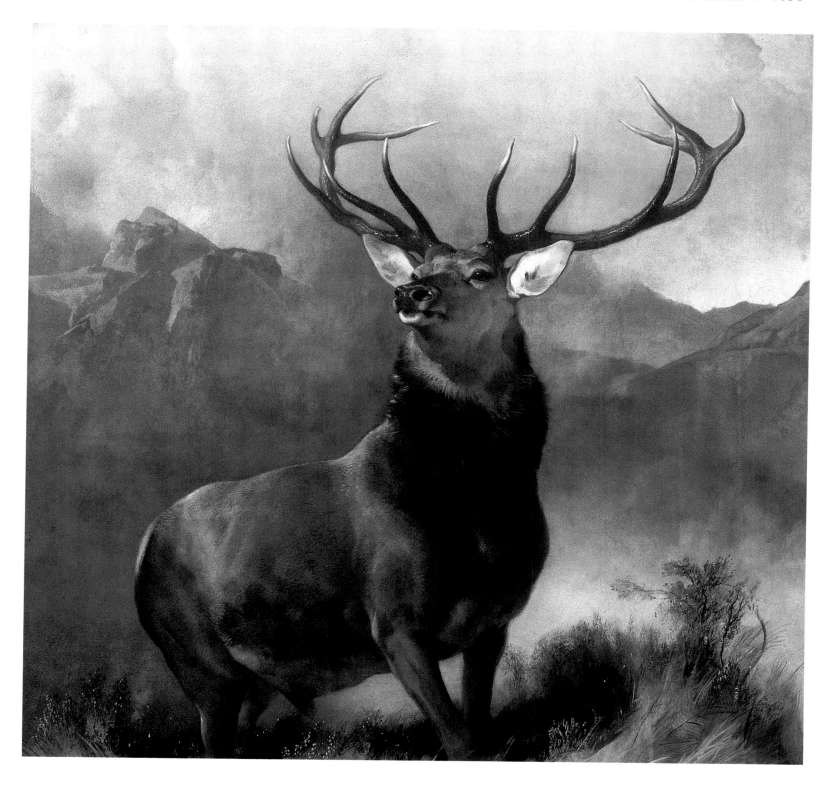

Sir Edwin Landseer

MONARCH OF THE GLEN

Born and died in London • 1802-73
Oil on canvas • 64.5 in x 66.5 in • United Distillers Ltd, London, UK/Bridgeman Art Library, London

Narcisse-Virgile Diaz de la Peña

STORMY LANDSCAPE

Born in Bordeaux • Died in Menton • 1807-76
Oil on canvas • 38.5 in x 51.4 in • Fitzwilliam Museum, University of Cambridge, UK/Bridgeman Art Library, London

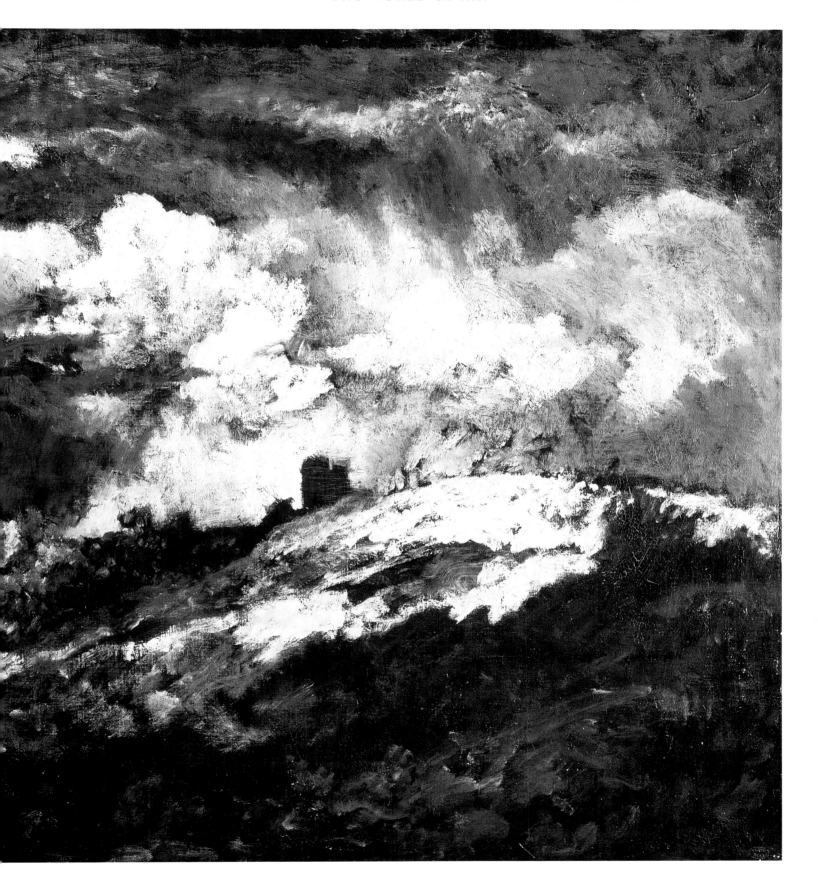

George Catlin

BEAR DANCE

Born in Wilkes-Barre, PA • Died in Jersey City, NJ • 1794-1872
Watercolor • 7in x 10.5 in • Private Collection, New York, USA/Bridgeman Art Library, London

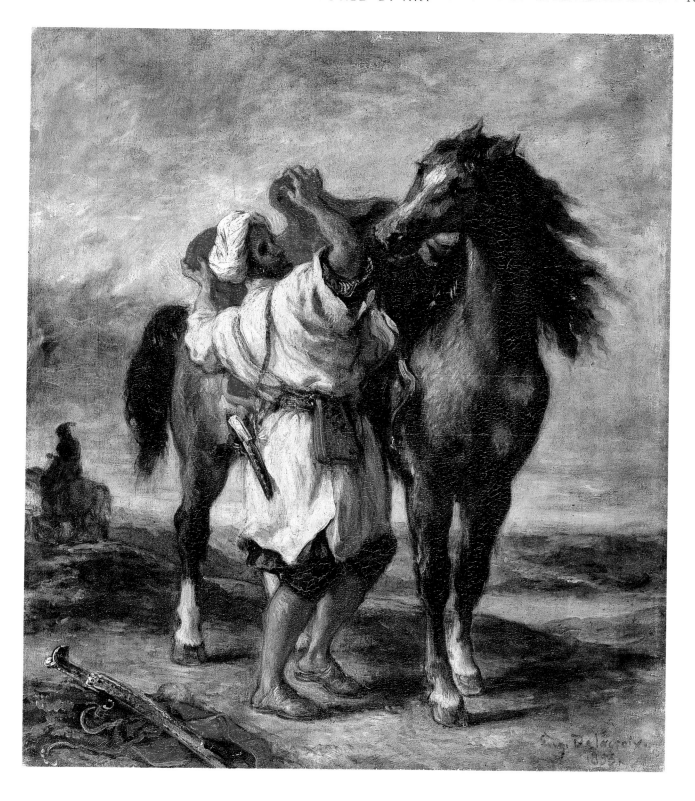

Ferdinand-Victor-Eugène Delacroix

A MOROCCAN SADDLING A HORSE

Born in Charenton-St-Maurice • Died in Paris • 1798-1863
Oil on canvas • 22 in x 18.5 in • Hermitage, St. Petersburg, Russia/Bridgeman Art Library, London

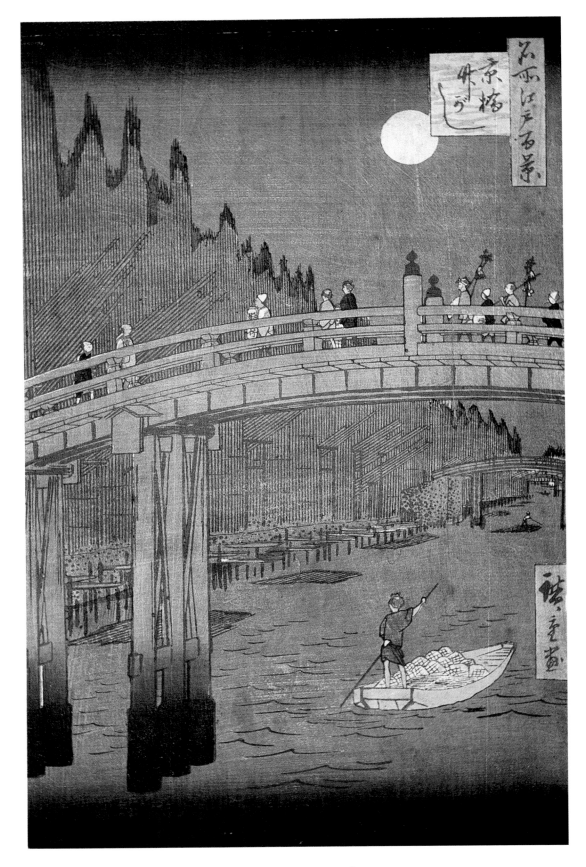

Ando or Utagawa Hiroshige

KYOBASHI BRIDGE – TAKEGASHI WHARF

Born and died in Edo (Tokyo) • 1797-1858
Hand-colored woodblock print • 13.9 in x 9.5 in • Victoria and Albert Museum, London, UK/Bridgeman Art Library, London

Charles Ferdinand Wimar

THE ATTACK ON THE EMIGRANT TRAIN

Born in Siegburg, nr Bonn • Died in St. Louis, MO • 1829-63
Oil on canvas • 55.1 in x 79.1 in • University of Michigan Museum of Art, USA/Bridgeman Art Library, London

Jean-François Millet

THE GLEANERS

Born in Gruchy • Died in Barbizon • 1814-75
Oil on canvas • 32.7 in x 43.3 in • Musée d'Orsay, Paris,
France/Bulloz/Bridgeman Art Library, London

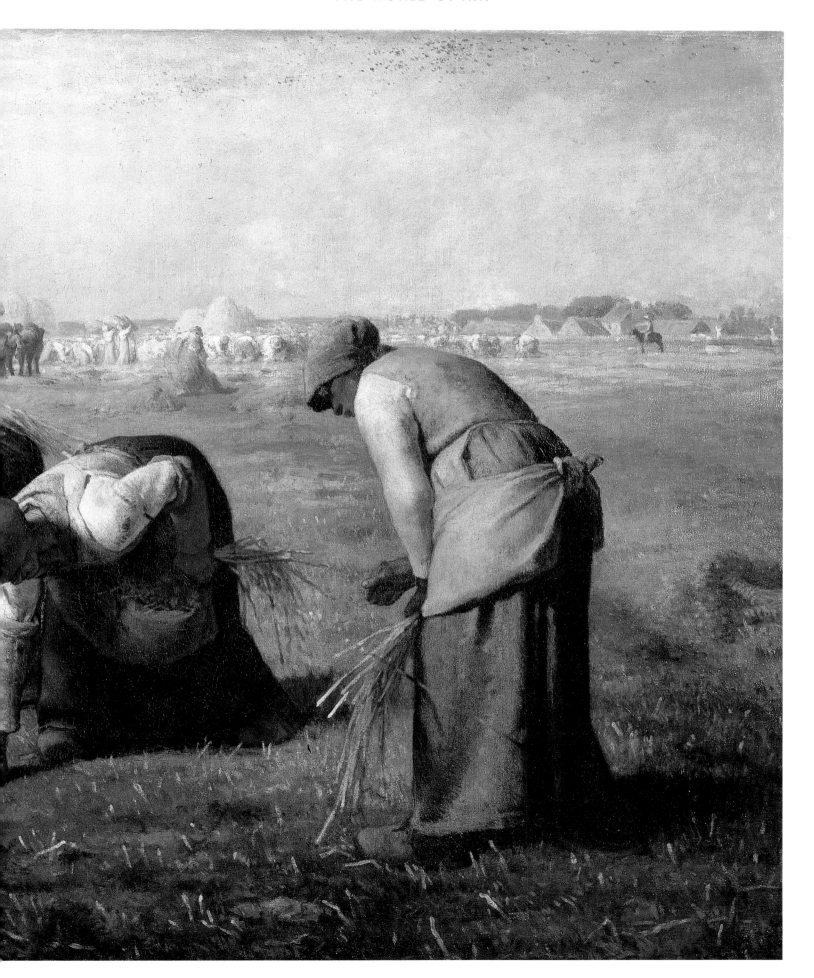

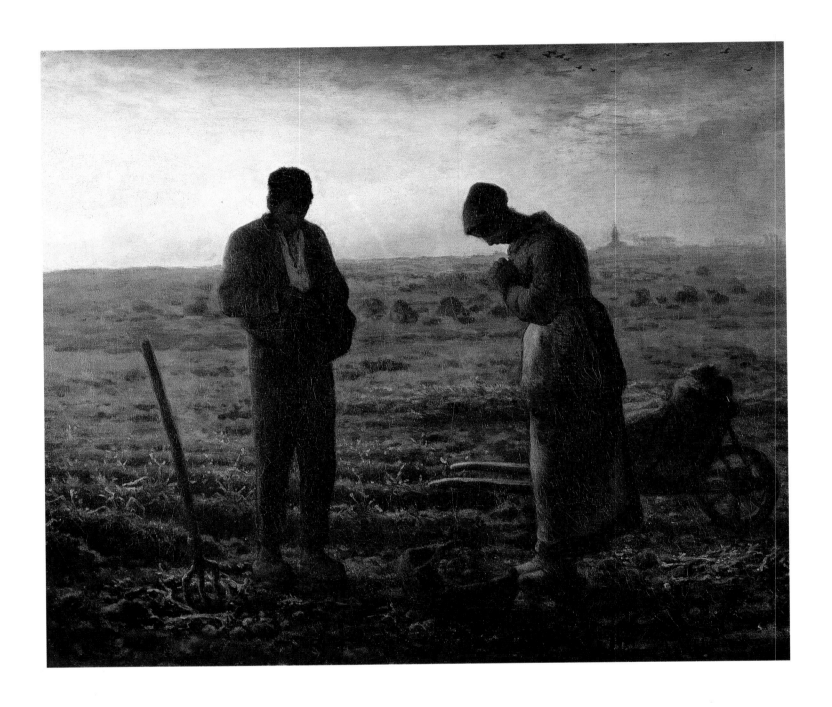

Jean-François Millet

THE ANGELUS

Born in Gruchy • Died in Barbizon • 1814-75
Oil on canvas • 21.9 in x 26 in • Musée du Louvre, Paris, France/Bridgeman Art Library, London

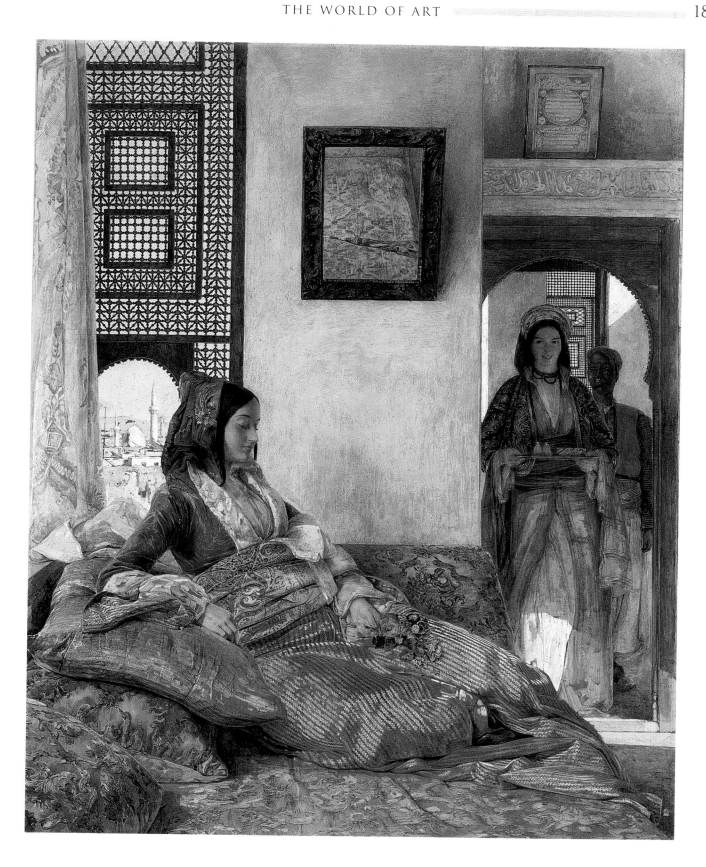

John Frederick Lewis

LIFE IN THE HAREM, CAIRO

Born in London • Died in Walton on Thames • 1805-76
Watercolor • 23.9 in x 18.8 in • Victoria and Albert Museum, London/Bridgeman Art Library, London

Henry Stacy Marks

STUDY OF A PENGUIN

Born and died in London • 1829-98
Watercolor • 12.25 in x 8.75 in • Victoria and Albert Museum/Bridgeman Art Library, London

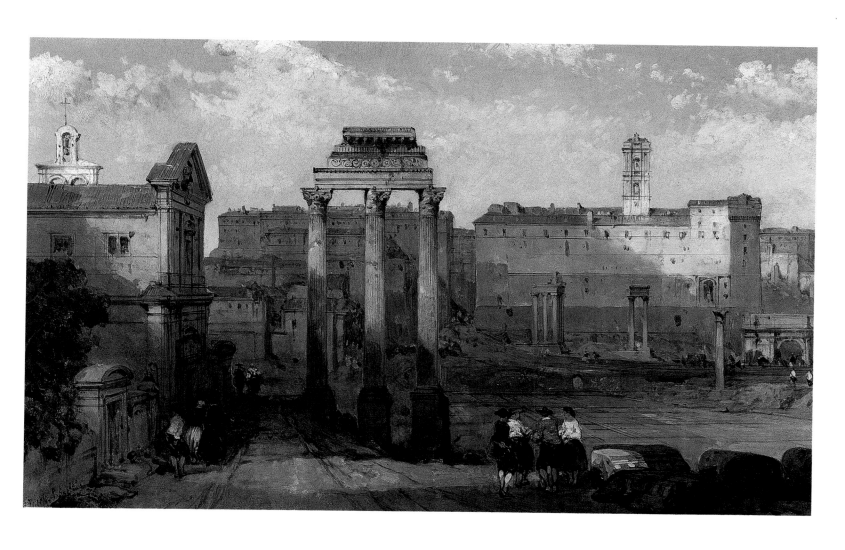

David Roberts

THE FORUM, ROME

Born in Edinburgh • Died in London • 1796-1864
Oil on canvas • 15 in x 24.5 in • Guildhall Art Gallery, Corporation of London, UK/Bridgeman Art Library, London

Charles West Cope

HOPE DEFERRED, AND HOPES AND FEARS THAT KINDLE HOPE

Born in Leeds • Died in London • 1811-90
Oil on panel • 40.6 in x 34.6 in • Rochdale Art Gallery, Lancashire, UK/Bridgeman Art Library, London

William Bell Scott

INDUSTRY ON THE TYNE: IRON AND COAL

Born in Edinburgh • Died in Penkill Castle, Strathclyde • 1811-90
Watercolor • By Courtesy of the Board of Trustees Wallington Hall, Northumberland, National Trust/Bridgeman Art Library, London

David Emil Joseph de Noter

A Maid in the Kitchen

Lived in Belgium • Born 1808
Oil on panel • 30.5 in x 25.25 in • Christie's Images/Bridgeman Art Library, London

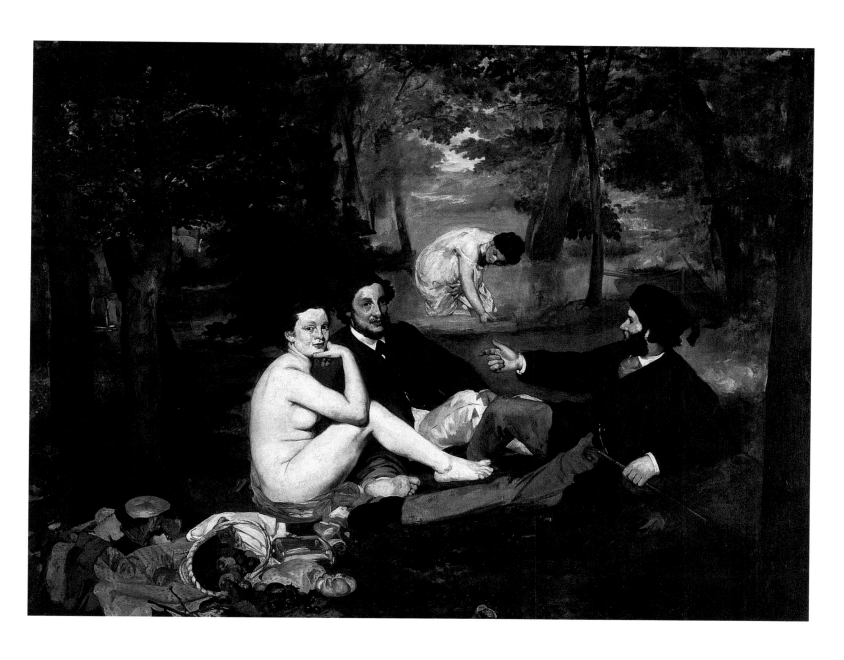

Edouard Manet

DÉJEUNER SUR L'HERBE

Born and died in Paris • 1832-83
Oil on canvas • 84.6 in x 106.7 in • Musée d'Orsay, Paris, France/Bridgeman Art Library, London

Honoré Daumier

THE LAUNDRESS

Born in Marseille • Died in Valmondois • 1810-79
Oil on panel • 19.3 in x 13.2 in • Musée d'Orsay, Paris, France/Bridgeman Art Library, London

Eugène Boudin

THE BEACH AT TROUVILLE

Born in Honfleur • Died in Deauville • 1824-98
Oil on canvas • 10.2 in x 18.9 in • Musée d'Orsay, Paris, France/Bridgeman Art Library, London

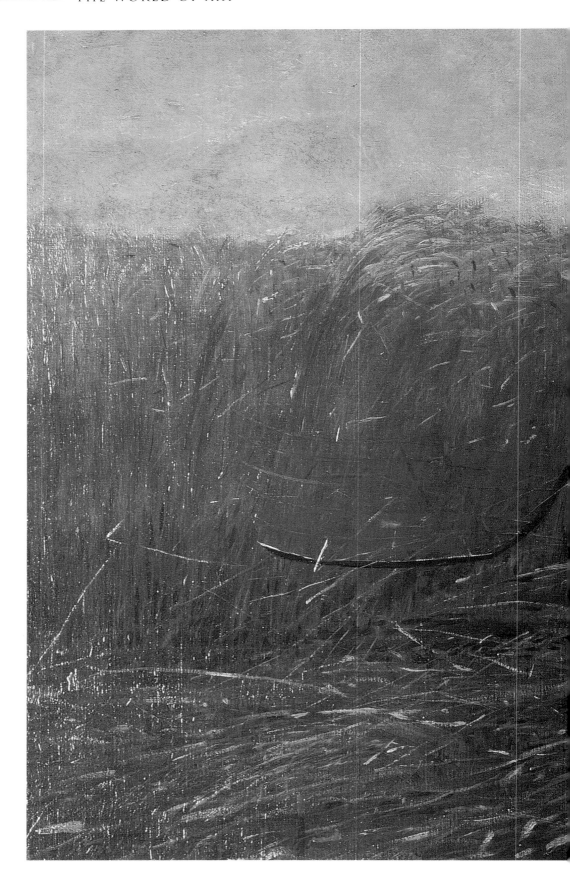

Winslow Homer

THE VETERAN IN A NEW FIELD

Born in Boston MA • Died in Prouts Neck, ME • 1836-1910
Oil on canvas • 24.1 in x 38.1 in • Metropolitan Museum of Art, New York, USA/Bridgeman Art Library, London

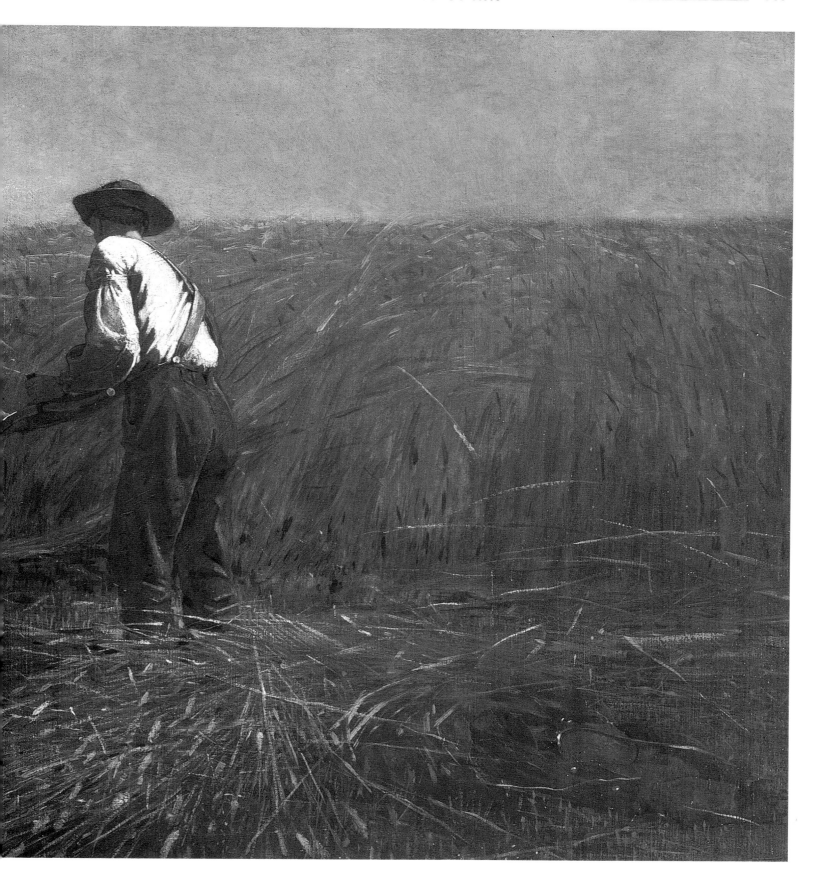

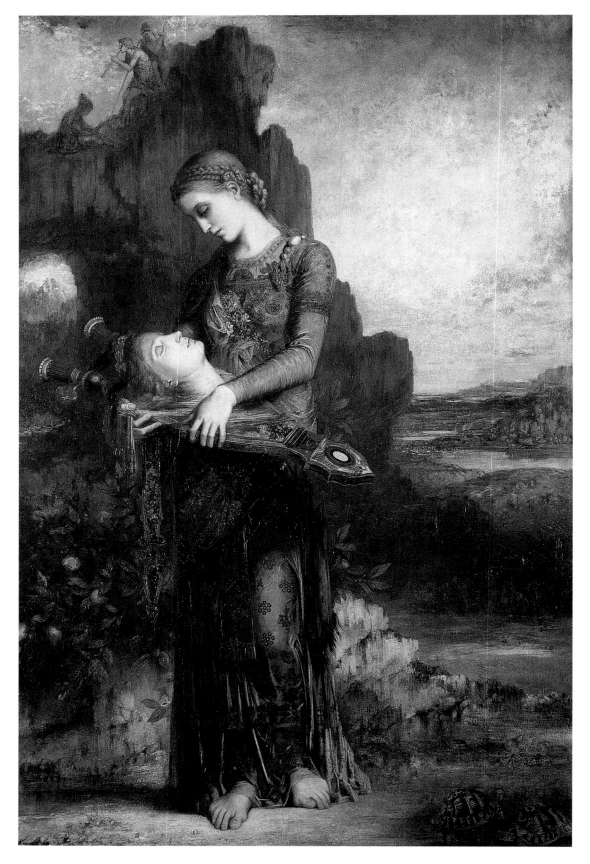

Gustave Moreau

ORPHÉUS

Born and died in Paris • 1826-98
Oil on panel • 60.6 in x 39.2 in • Musée d'Orsay, Paris, France/Peter Willi/Bridgeman Art Library, London

Johan-Barthold Jongkind

THE MARKET AT SAINTE-CATHERINE, HONFLEUR

Born in Latrop • Died La-Côte-Saint-André • 1819-91
Oil on canvas • 16.5 in x 26.2 in • Noortman (London) Ltd. UK/Bridgeman Art Library, London

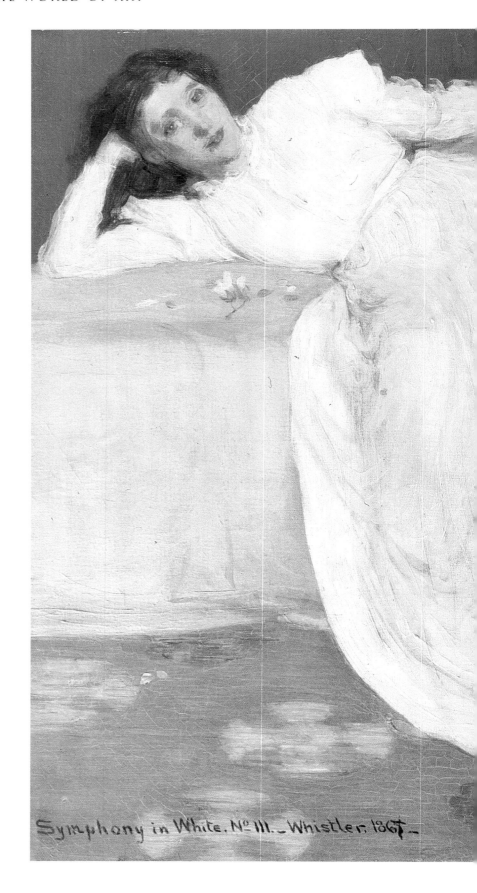

James Abbott McNeill Whistler

SYMPHONY IN WHITE NO III

Born in Lowell, MA • Died in London • 1834-1903
Oil on canvas • 20.2 in x 31.3 in • Barber Institute of Fine Arts, University of Birmingham/Bridgeman Art Library, London

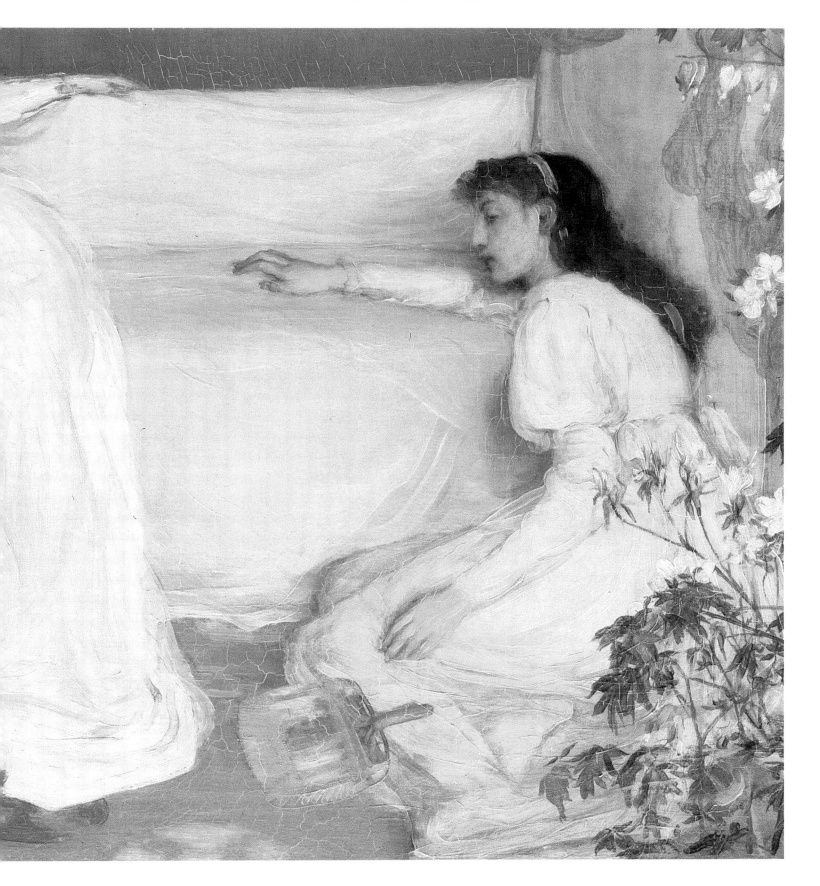

John Atkinson Grimshaw

AUTUMN

Born and died in Leeds • 1836-93
Roy Miles Gallery, London, UK/Bridgeman Art Library, London

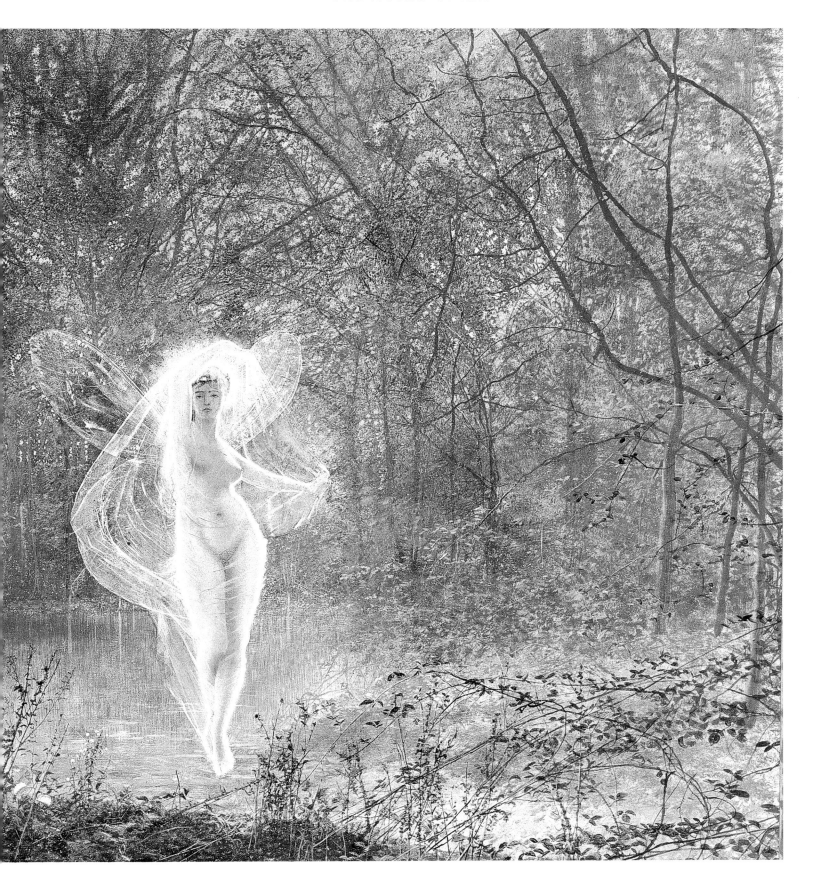

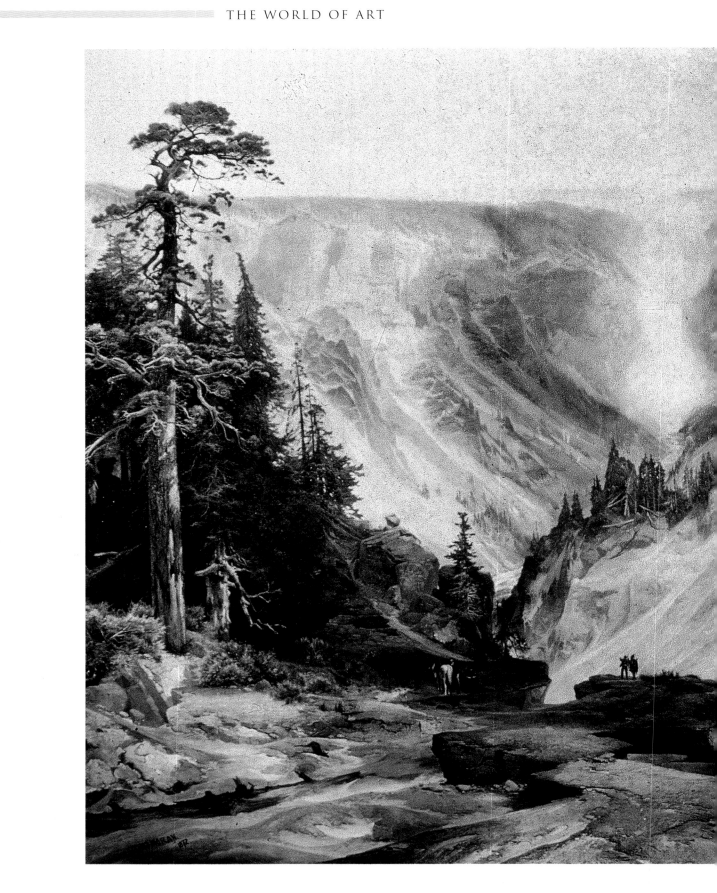

Thomas Moran

YELLOWSTONE GRAND CANYON

Born in Bolton, Lancs • Died in Santa Barbara, CA • 1837-1926
Oil on canvas • 86 in x 141 in • Smithsonian Institute, National Museum of American Art
(loan of US Department of Interiors)/Bridgeman Art Library, London

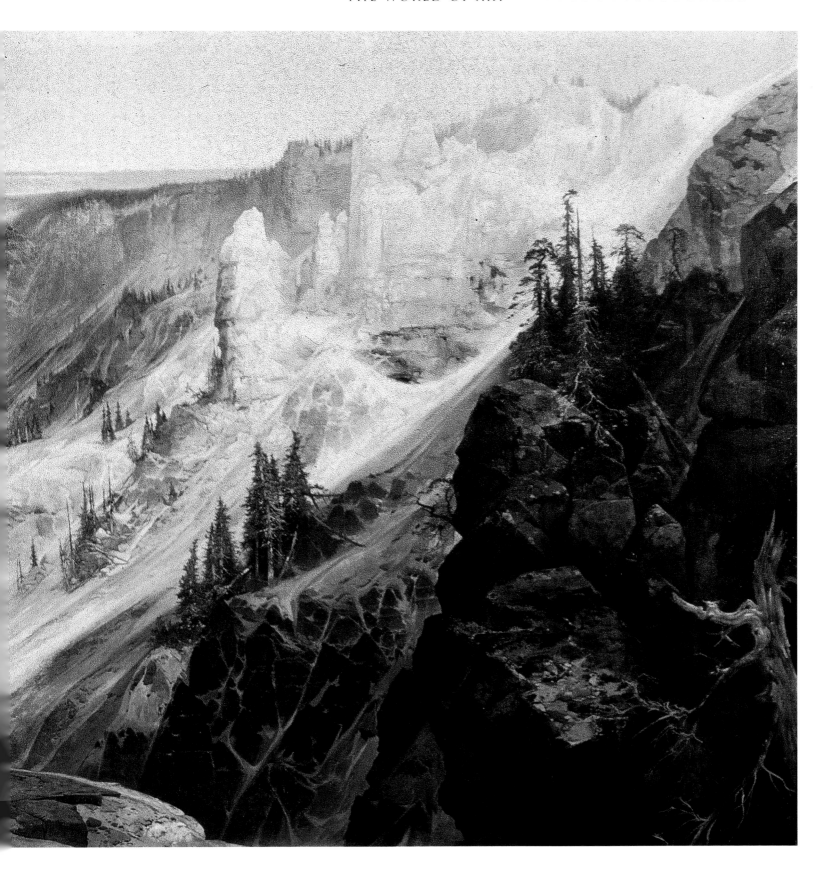

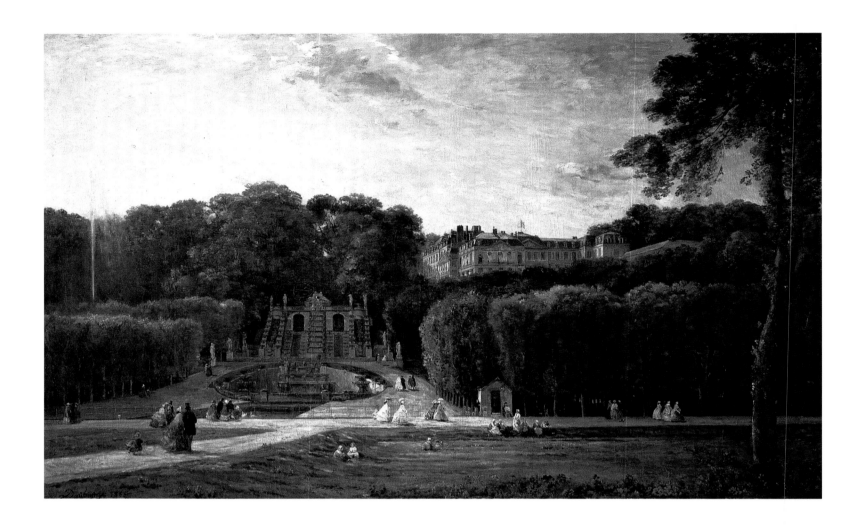

Charles-François Daubigny

THE PARK AT ST. CLOUD

Born and died in Paris • 1817-78
Oil on canvas • 48.8 in x 79.1 in • Musée Municipal de Châlons-Sur-Marne, France/Giraudon/Bridgeman Art Library, London

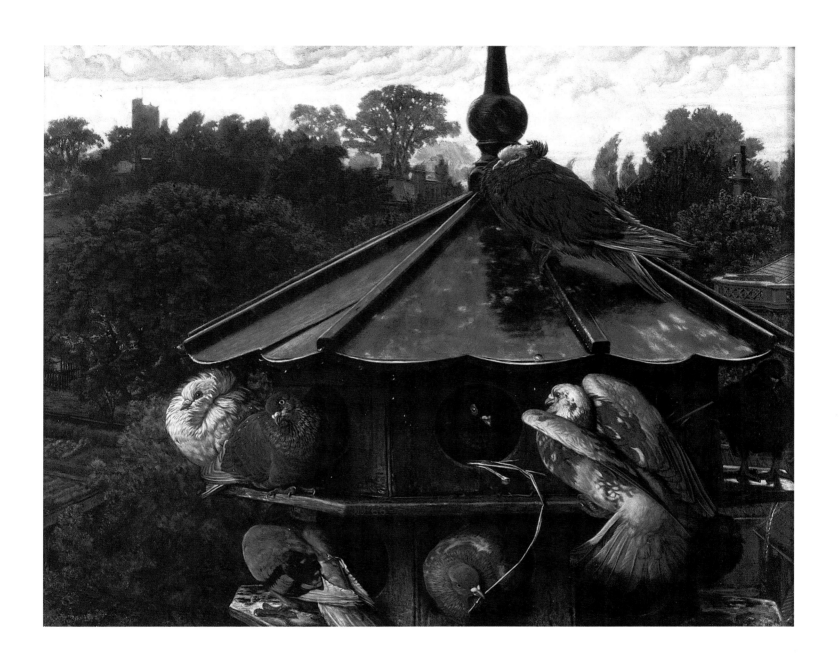

William Holman Hunt

THE FESTIVAL OF ST. SWITHIN OR THE DOVECOTE

Born and died in London • 1827-1910
Oil on canvas • 28.7 in x 35.8 in • Ashmolean Museum, Oxford, UK/Bridgeman Art Library, London

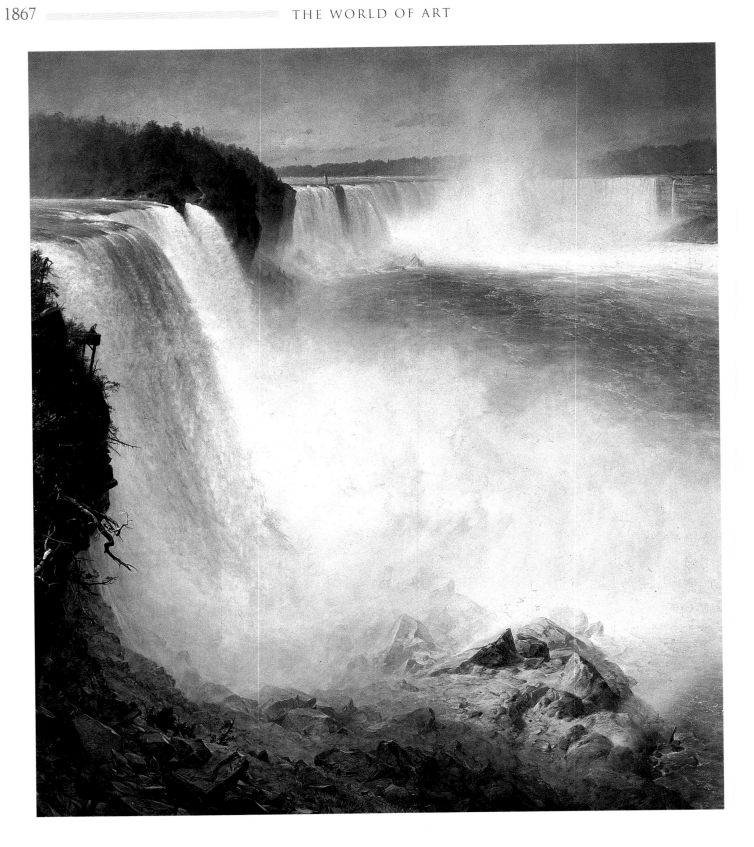

Frederick Edwin Church

NIAGARA FALLS

Born in Hartford, CT • Died in New York, NY • 1826-1900
Oil on canvas • 102.5 in x 91 in • National Gallery of Scotland, Edinburgh, Scotland/Bridgeman Art Library, London

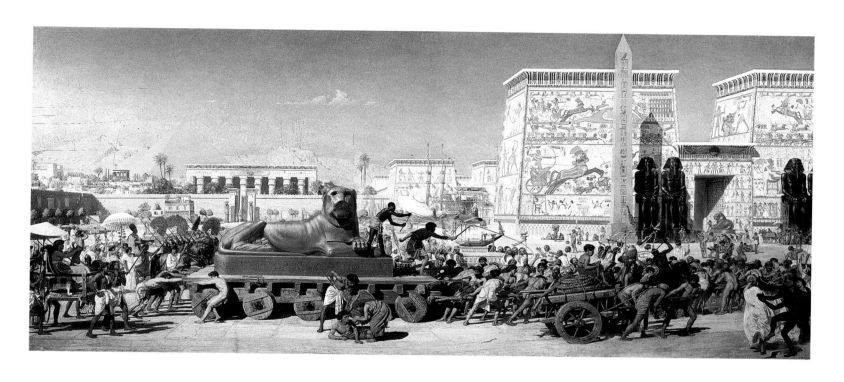

Sir Edward John Poynter

ISRAEL IN EGYPT

Born in Paris • Died in London • 1836-1919
Oil on canvas • 54 in x 125 in • Guildhall Art Gallery, Corporation of London, UK/Bridgeman Art Library, London

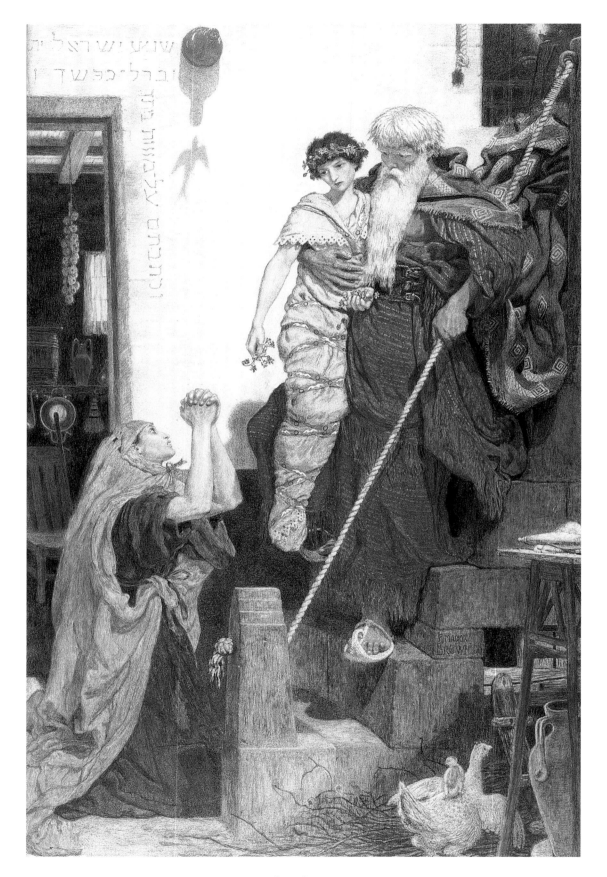

Ford Madox Brown

Elijah Restoring the Widow's Son

Born in Calais • Died in London • 1821-93
Watercolor • 37 in x 24.1 in • Victoria and Albert Museum, London/Bridgeman Art Library, London

Ignace Henri Jean Théodore Fantin-Latour

FLOWERS

Born in Grenoble • Died in Bure • 1838-1904
Oil on canvas • Victoria and Albert Museum, London/Bridgeman Art Library, London

Gustave Doré

THE SIEGE OF PARIS

Born in Strasbourg • Died in Paris • 1832-83
Watercolor • Musée des Beaux-Arts, Mulhouse, France/Giraudon/Bridgeman Art Library, London

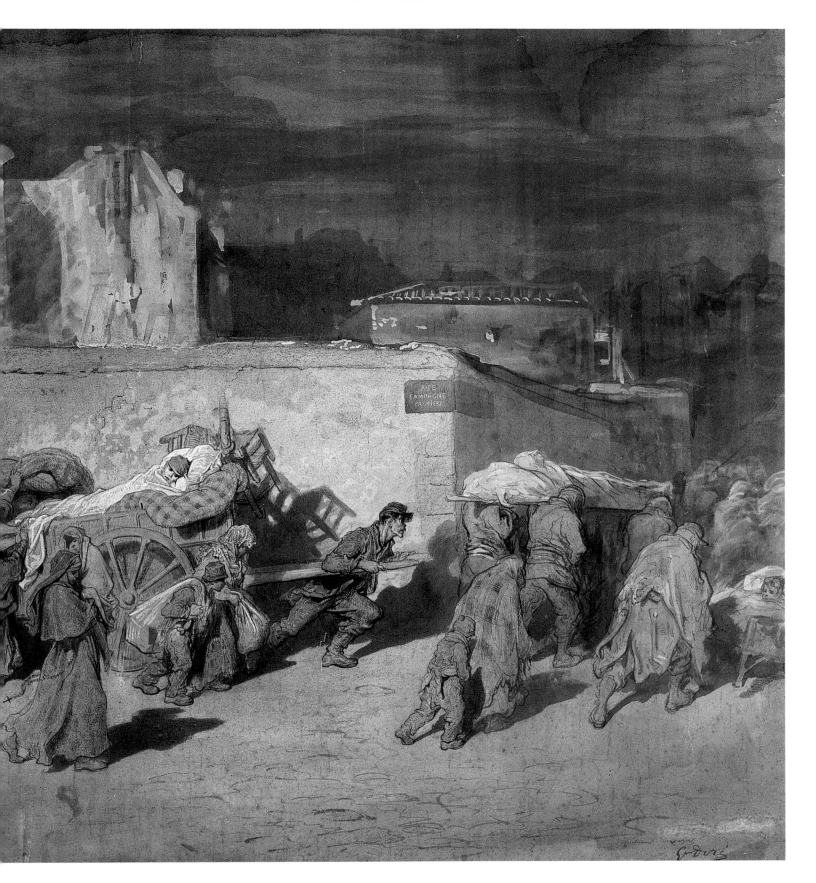

Frédéric Bazille

THE ARTIST'S STUDIO

Born in Montpelier • Died in Beaune-la-Rolande • 1841-70
Oil on canvas • 38.1 in x 44.1 in • Musée d'Orsay, Paris,
France/Bridgeman Art Library, London

F. Bazille 1870

Albert Bierstadt

VIEW OF ROCKY MOUNTAINS

Born in Solingen, Germany • Died in New York, NY • 1830-1902
Oil on canvas • 36.6 in x 54.75 in • White House, Washington, DC, USA/Bridgeman Art Library, London

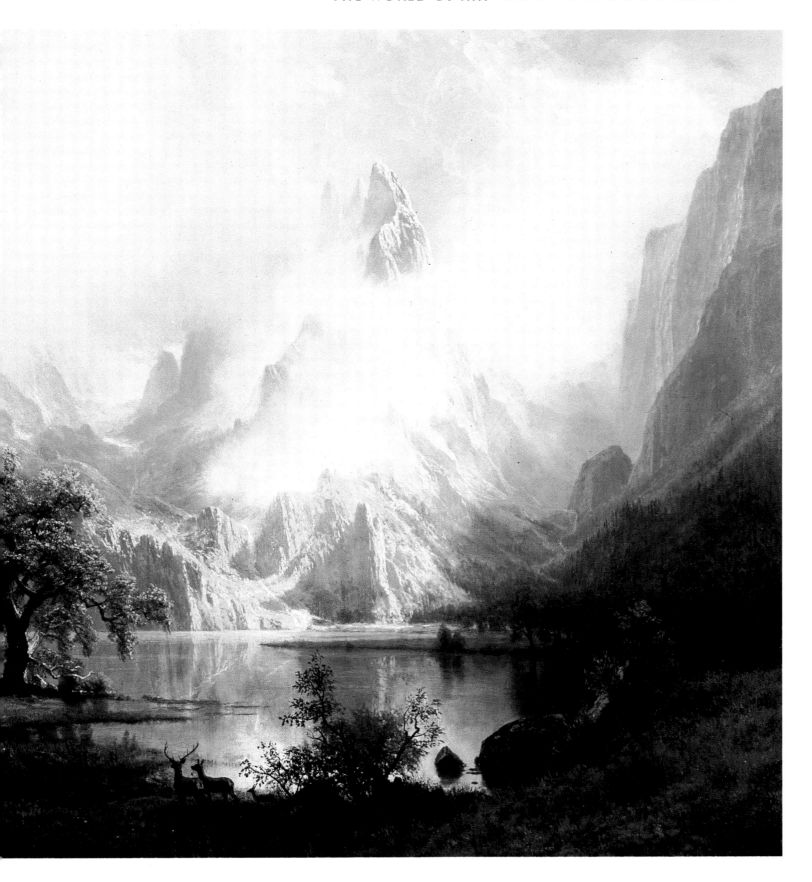

Edmund Blair Leighton

SIGNING THE REGISTER

Born in Scarborough • Died in London • 1853-1922
Oil on canvas • 36 in x 48 in • City of Bristol Museum and Art Gallery,
Avon, UK/Bridgeman Art Library, London

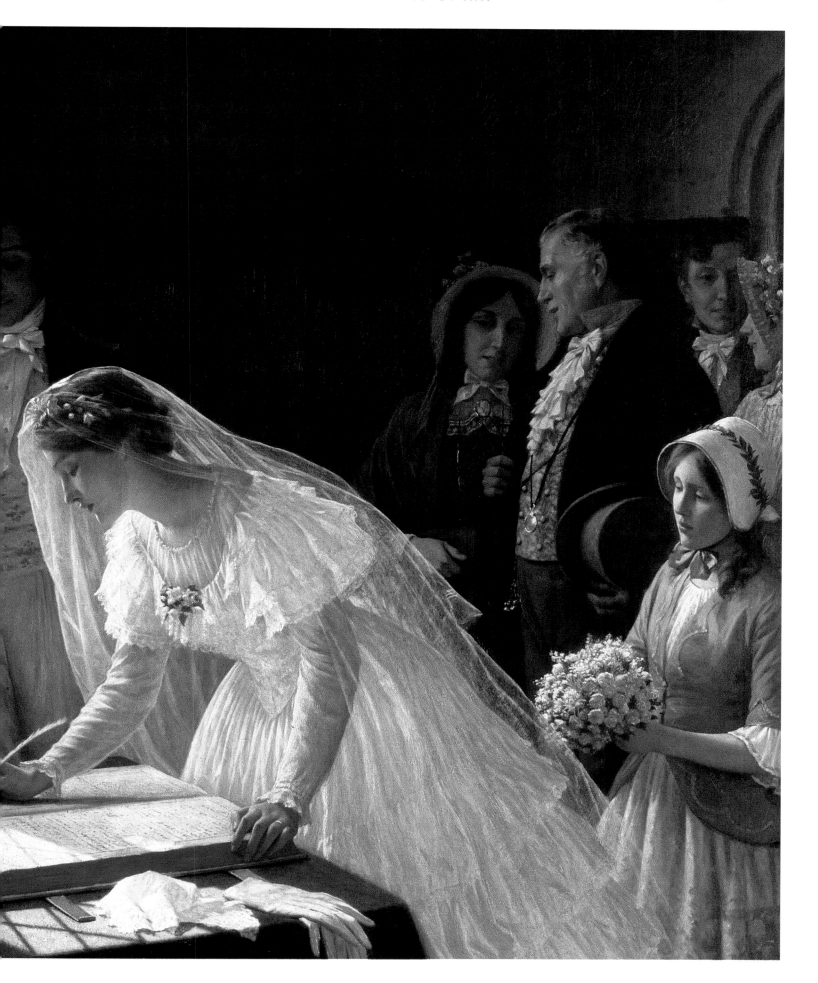

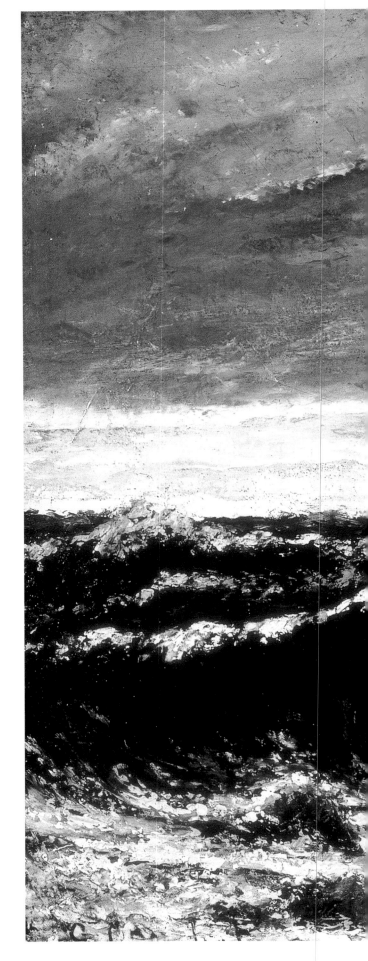

Gustave Courbet

THE WAVE

Born in Ornans • Died in Tour de Peitz • 1819-77
Oil on canvas • 18.1 in x 21.7 in • National Gallery, Edinburgh, Scotland/Bridgeman Art
Library, London

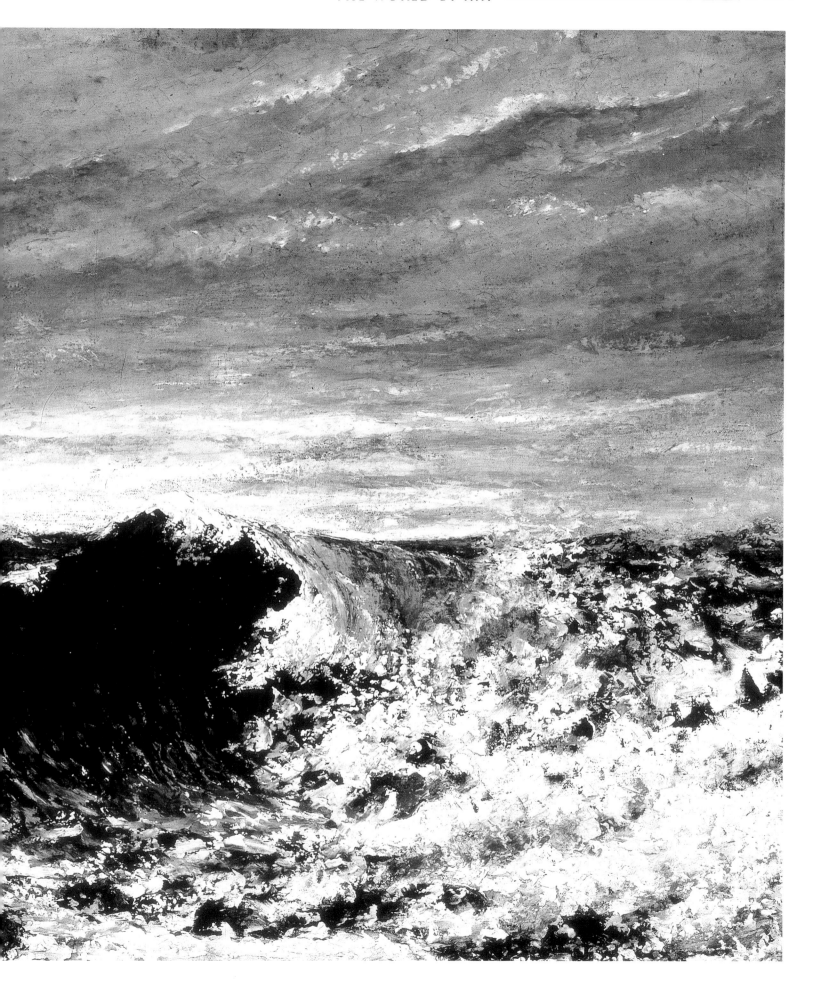

Étienne-Pierre-Théodore Rousseau

LANDSCAPE WITH A PLOUGHMAN

Born and died in Paris • 1812-67
Oil on wood • 6.7 in x 10 in • Hermitage,
St. Petersburg, Russia/Bridgeman Art Library, London

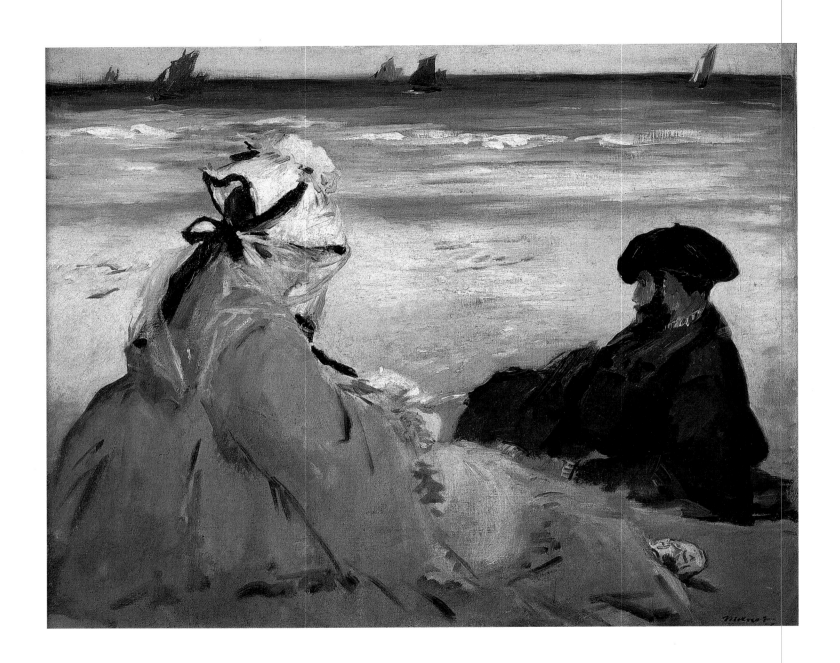

Edouard Manet

On the Beach (Sur la Plage)

Born and died in Paris • 1832-83
Oil on canvas • 23.4 in x 28.7 in • Musée du Louvre, Paris, France/Bridgeman Art Library, London

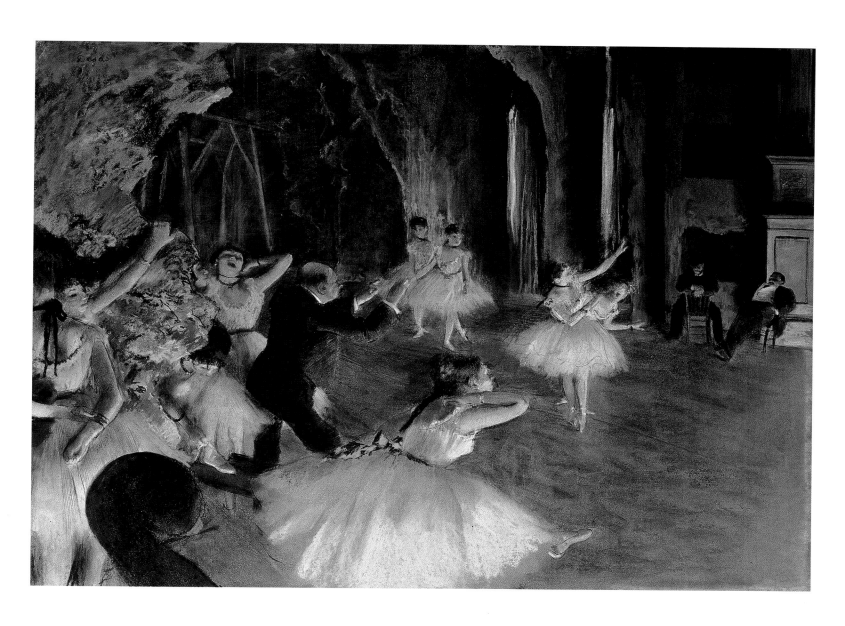

Edgar Degas

THE REHEARSAL OF THE BALLET ON STAGE

Born and died in Paris • 1834-1917
Oil and pastel on paper • 21.4 in x 28.7 in • Metropolitan Museum of Art, New York, USA/Bridgeman Art Library, London

Alfred Sisley

RUE DE LA MACHINE, LOUVECIENNES

Born in Paris • Died in Moret-sur-Loing • 1839-99
Oil on canvas • 19.9 in x 24 in • Musée d'Orsay, Paris,
France/Bridgeman Art Library, London

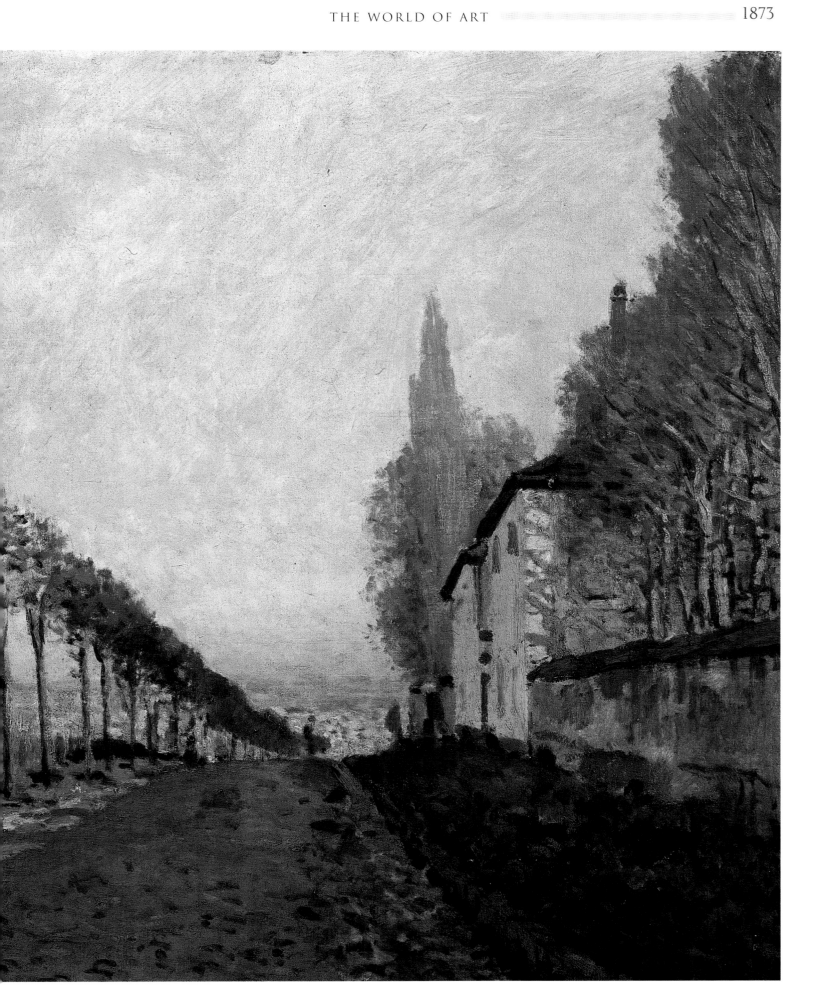

William Charles Thomas Dobson

MEDITATION

Born and died in London • 1817-98
Oil on canvas • Fine Lines (Fine Art), Warwickshire, UK/Bridgeman Art Library, London

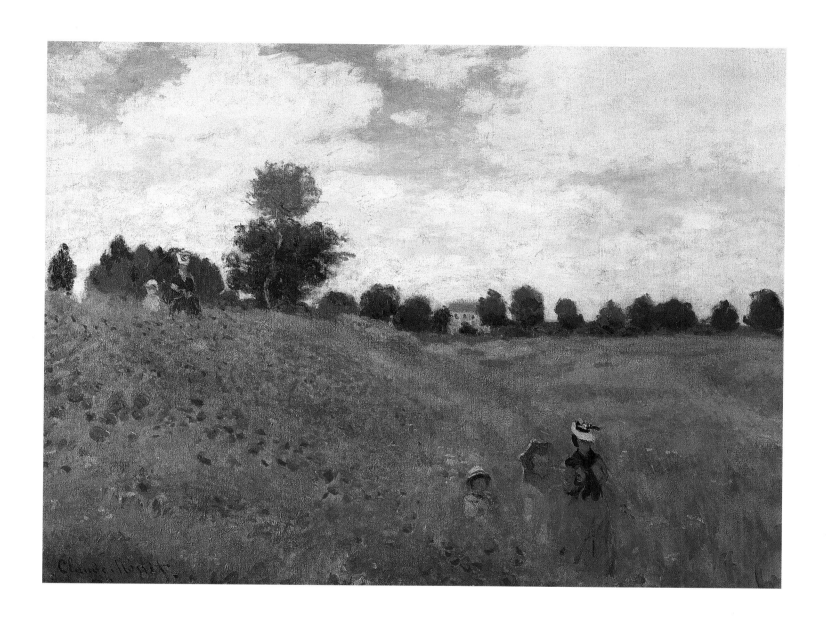

Claude Monet

WILD POPPIES, NEAR ARGENTEUIL (LES COQUELICOTS ENVIRONS D'ARGENTEUIL)

Born and died in Paris • 1840-1926

Oil on canvas • 19.7 in x 25.6 in • Musée d'Orsay, Paris, France/Peter Willi/Bridgeman Art Library, London

Frank Holl

THE SONG OF THE SHIRT

Born and died in London • 1845-88
Oil on canvas • 19 in x 26.1 in • Royal Albert Memorial Museum, Exeter, Devon, UK / Bridgeman Art Library, London

Eyre Crowe

THE DINNER HOUR, WIGAN

Born and died in London • 1824-1910
Oil on canvas • 30 in x 42.1 in • Manchester City Art Galleries, UK/Bridgeman Art Library, London

Eva Gonzales

A BOX AT THE ITALIAN THEATRE

Born and died in Paris • 1849-83
Oil on canvas • 38.6 in x 51.2 in • Musée d'Orsay, Paris, France/Bridgeman Art Library, London

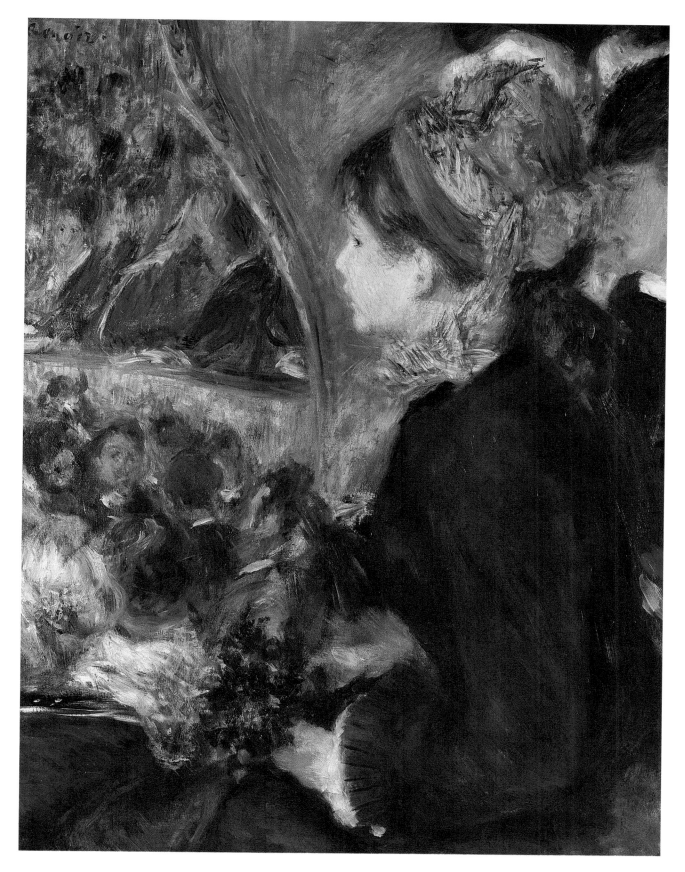

Pierre Auguste Renoir

AT THE THEATRE (LA PREMIÈRE SORTIE)

Born in Limoges • Died in Cagnes • 1841-1919
Oil on canvas • 25.6 in x 19.5 in • National Gallery, London, UK/Bridgeman Art Library, London

Gustave Caillebotte

Le Pont de l'Europe (detail)

Born and died in Paris • 1848-94

Oil on canvas • 48.8 in x 70.9 in (whole painting) • Petit Palais, Geneva, Switzerland/Bridgeman Art Library, London

Julian Bastien-Lepage

THE HAYMAKERS

Born in Damviller, Meuse • Died in Paris • 1848-84
70.9 in x 76.8 in • Oil on canvas • Musée d'Orsay, Paris, France/Bridgeman Art Library, London

Camille Pissarro

THE VEGETABLE GARDEN WITH TREES IN BLOSSOM, SPRING, PONTOISE

Born in St. Thomas • Died in Paris • 1831-1903
Oil on canvas • 25.3/4 in x 31.7/8 in • Musée d'Orsay, Paris, France/Giraudon/Bridgeman Art Library, London

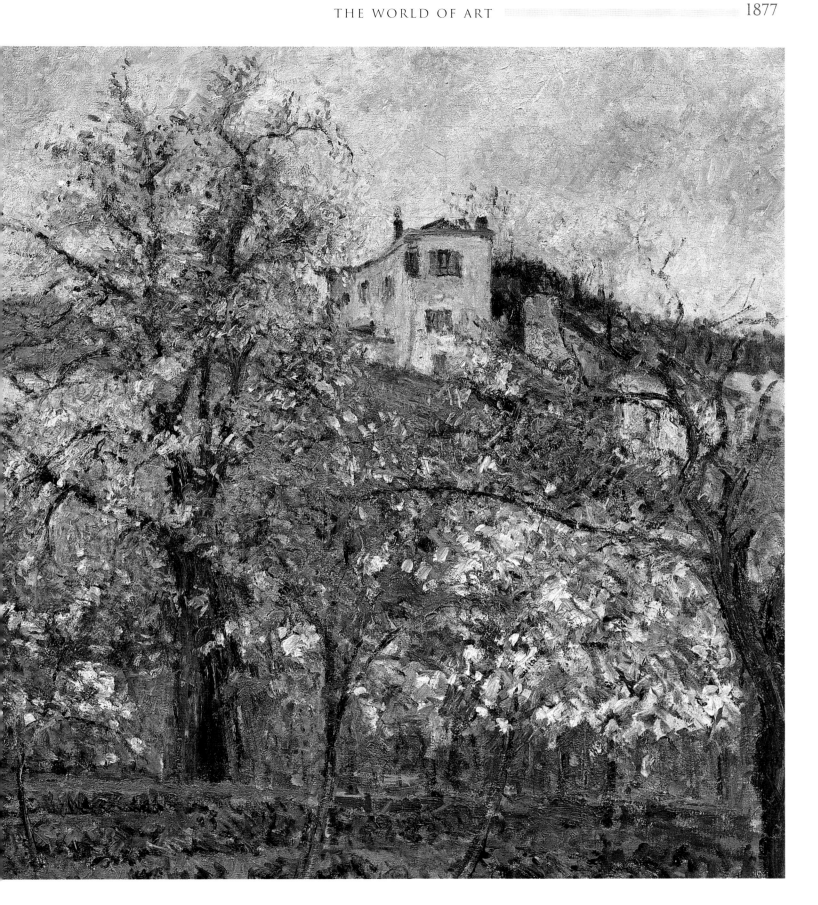

Mary Cassatt

Little Girl in a Blue Armchair

Born in Pittsburgh, PA • Died in Mesnil-Beaufresne • 1844-1926
Oil on canvas • 35.25 in x 51.1 in • Mellon Collection, National Gallery of Art, Washington DC, USA/Bridgeman Art Library, London

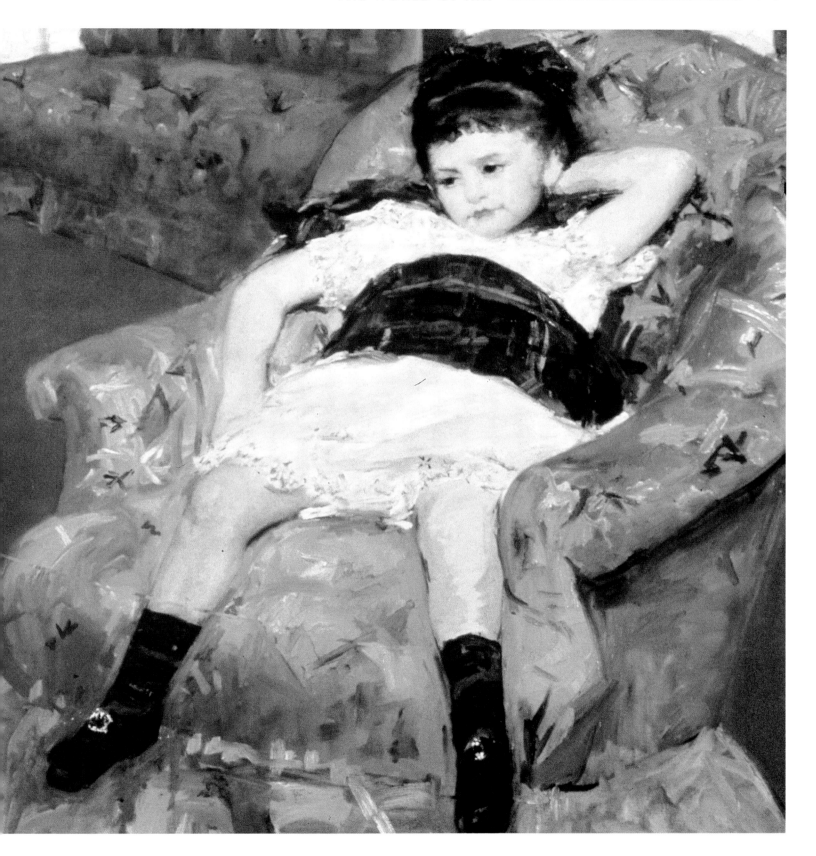

Henri Gervex

ROLLA

Born and died in Paris • 1852-1929
Oil on canvas • 68.9 in x 86.6 in • Musée des Beaux-Arts, Bordeaux,
France/Bridgeman Art Library, London

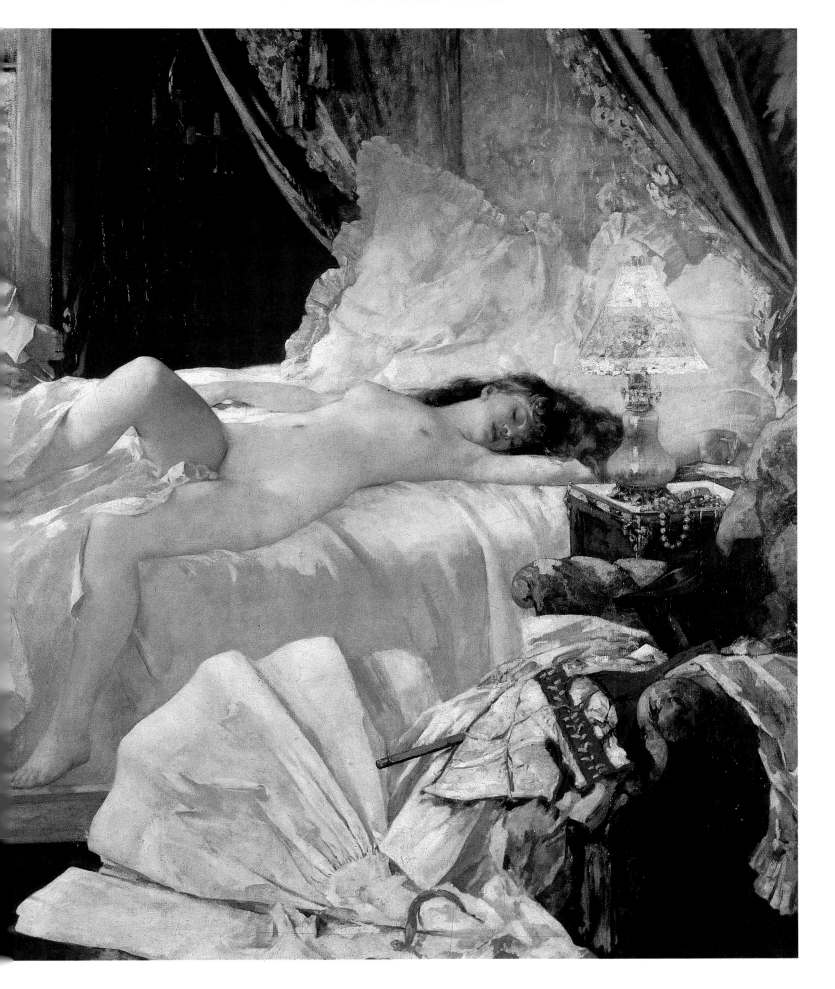

William Merritt Chase

PORTRAIT OF HARRIET HUBBARD AYERS

Born in Williamsburg, IN • Died in New York, NY • 1814-1916
Oil on canvas • 27.25 in x 22.25in • Palace of Legion of Honor, San Francisco, USA/Bridgeman Art Library, London

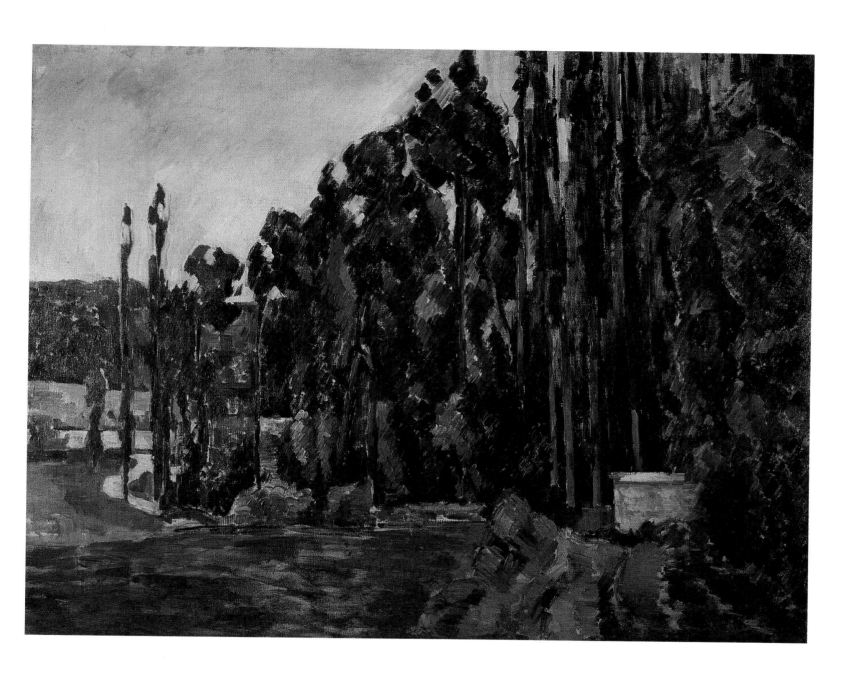

Paul Cézanne

THE POPLARS

Born and died in Aix-en-Provence • 1839-1906
Oil on canvas • 25.6 in x 31.9 in • Musée d'Orsay, Paris, France/Bridgeman Art Library, London

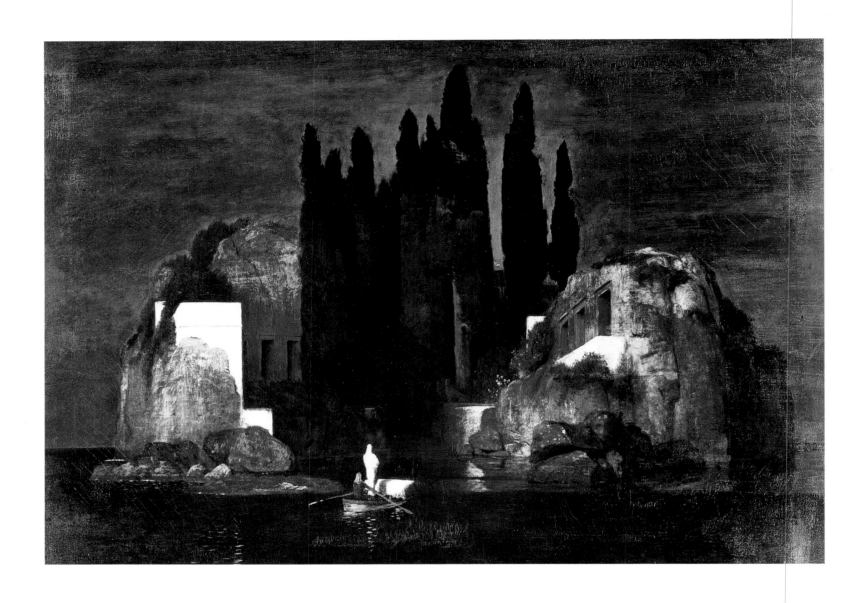

Arnold Böcklin

THE ISLAND OF THE DEAD

Born in Basle • Died in San Domenico, Italy • 1827-1901
Oil on canvas • 43.7 in x 61 in • Kunstmuseum, Basle, Switzerland/Bridgeman Art Library, London

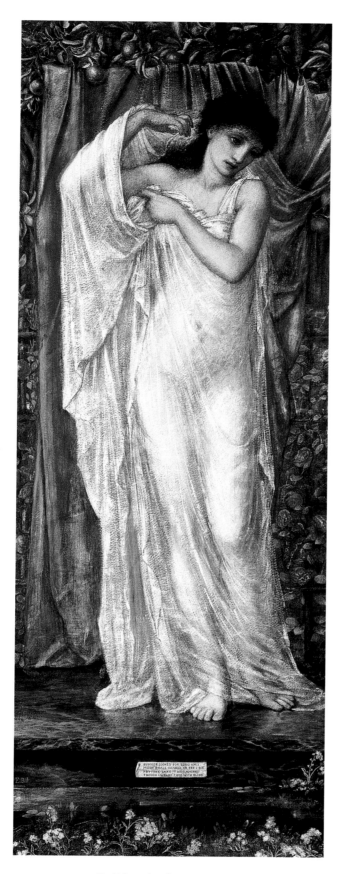

Sir Edward Coley Burne-Jones

SUMMER

Born in Birmingham • Died in London • 1833-98
Roy Miles Gallery, London, UK/Bridgeman Art Library, London

Frederic Remington

JUMP

Born in Canton NY • Died in Ridgefield, CT • 1861-1909
Watercolor wash drawing • David David Gallery, Philadelphia, PA, USA/Bridgeman Art Library, London

Arturo Ricci

THE GAME OF CHESS

Born Italy • 1854
Oil on canvas • 16.2 in x 11.5 in • Christie's Images/Bridgeman Art Library, London

Berthe Morisot

In the Garden

Born in Bourges • Died in Paris • 1841-95
Oil on canvas • 24 in x 28.9 in • Nationalmuseum, Stockholm, Sweden/Bridgeman Art Library, London

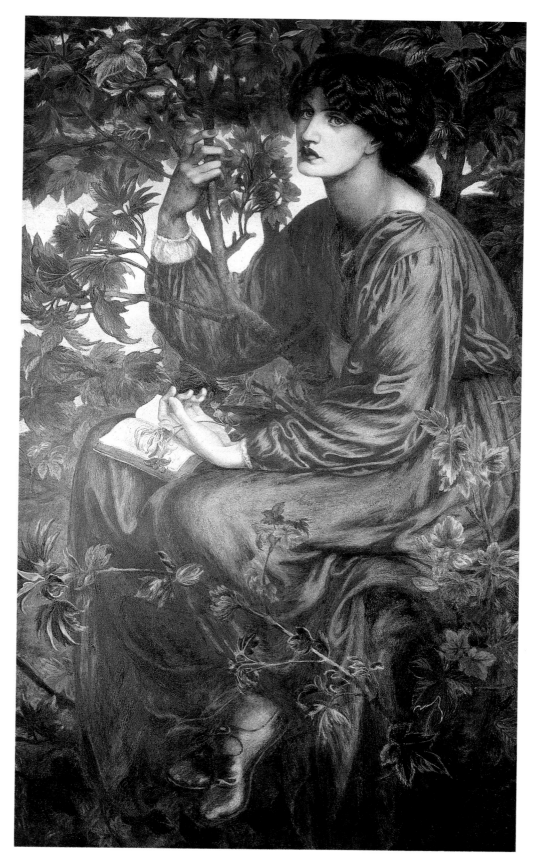

Dante Gabriel Rossetti

THE DAY DREAM

Born in London • Died in Birchington-on-Sea • 1828-82
Oil on canvas • 62.6 in x 36.6 in • Victoria and Albert Museum, London/Bridgeman Art Library, London

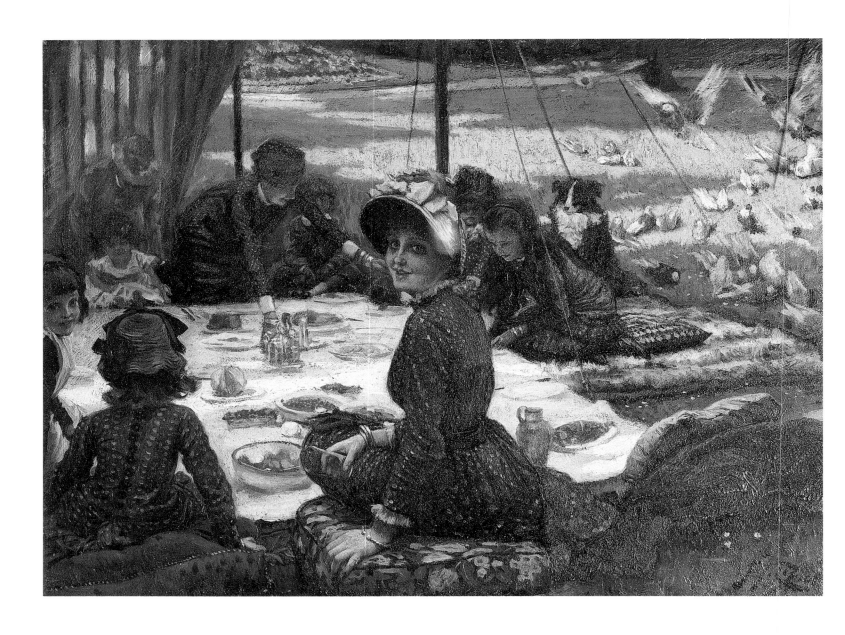

James Jacques Joseph Tissot

THE PICNIC (DÉJEUNER SUR L'HERBE)

Born in Nantes • Died in Buillon • 1836-1902
Oil on canvas • 7.8 in x 10.6 in • Musée des Beaux-Arts, Dijon/France/Bridgeman Art Library, London

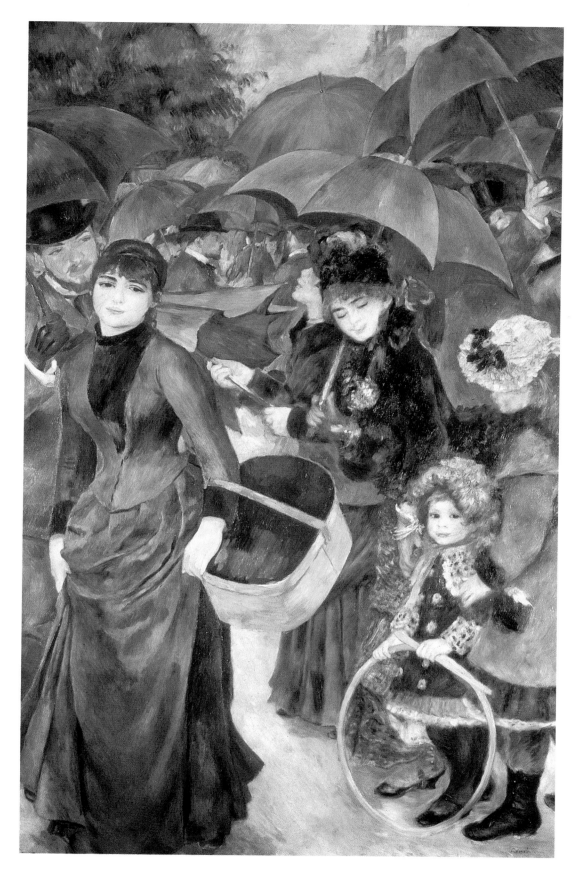

Pierre Auguste Renoir

THE UMBRELLAS (LES PARAPLUIES)

Born in Limoges • Died in Cagnes • 1841-1919
Oil on canvas • 71 in x 58.7 in • National Gallery, London, UK/Bridgeman Art Library, London

Rosa Bonheur

THE LION AT HOME

Born in Bordeaux • Died in Thomery, nr Fontainbleau • 1822-99
Oil on canvas • 63.75 in x 104 in • Ferens Art Gallery, Hull City Museums and Art Galleries, UK/Bridgeman Art Library, London

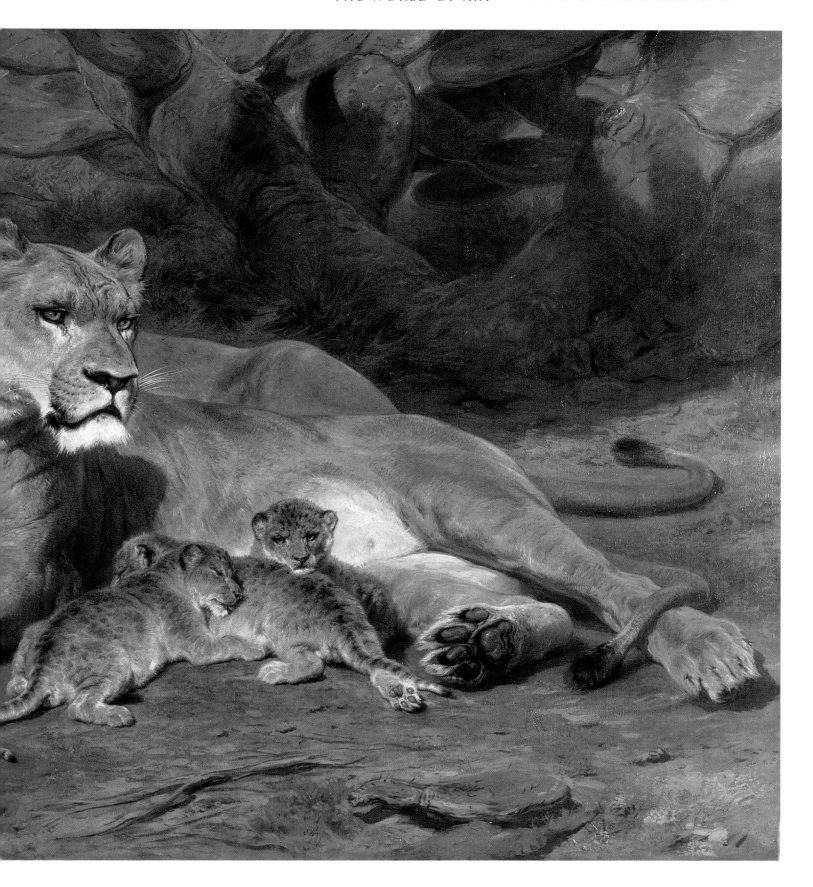

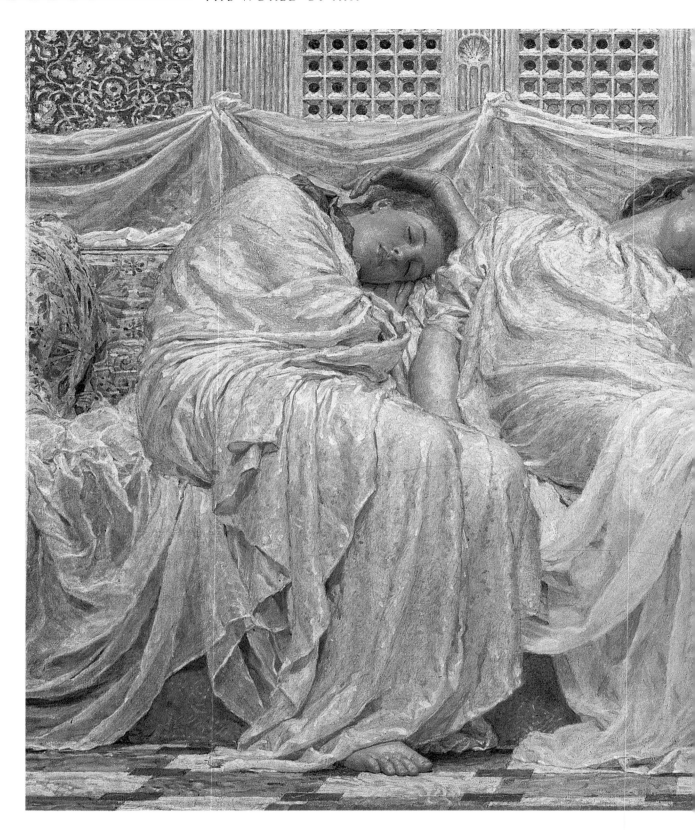

Albert Moore

DREAMERS

Born York • Died in London • 1841-93
Oil on canvas • 24 in x 47in • Birmingham Museums and Art Gallery/Bridgeman Art Library, London

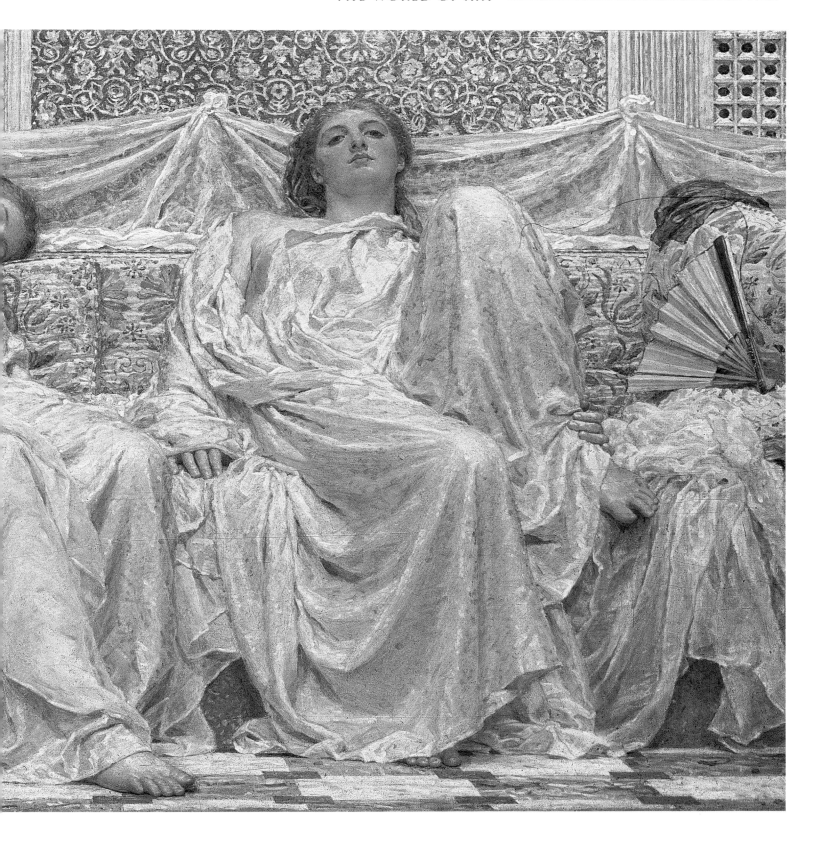

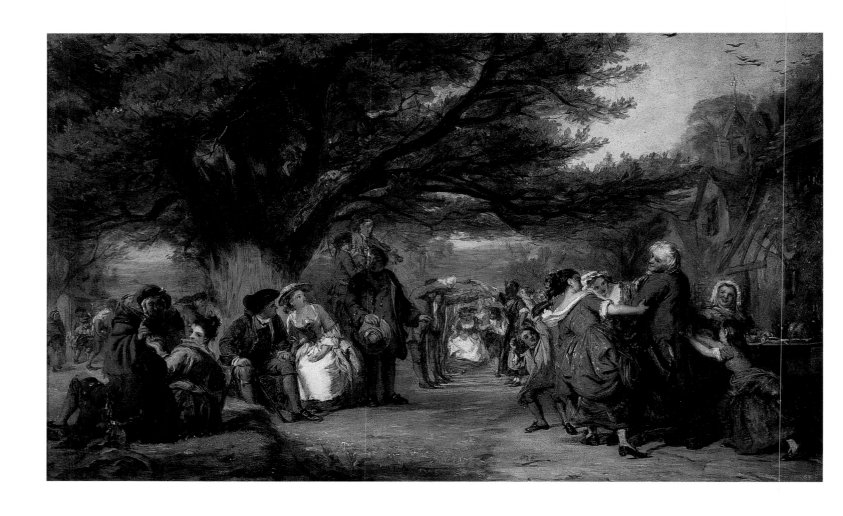

William Powell Frith

VILLAGE MERRYMAKING

Born in Adfield, nr Ripon, W. Yorkshire • Died in St. Johns Wood, London • 1819-1909
Canvas • 9.5 in x 16 in • Victoria and Albert Museum, London/Bridgeman Art Library, London

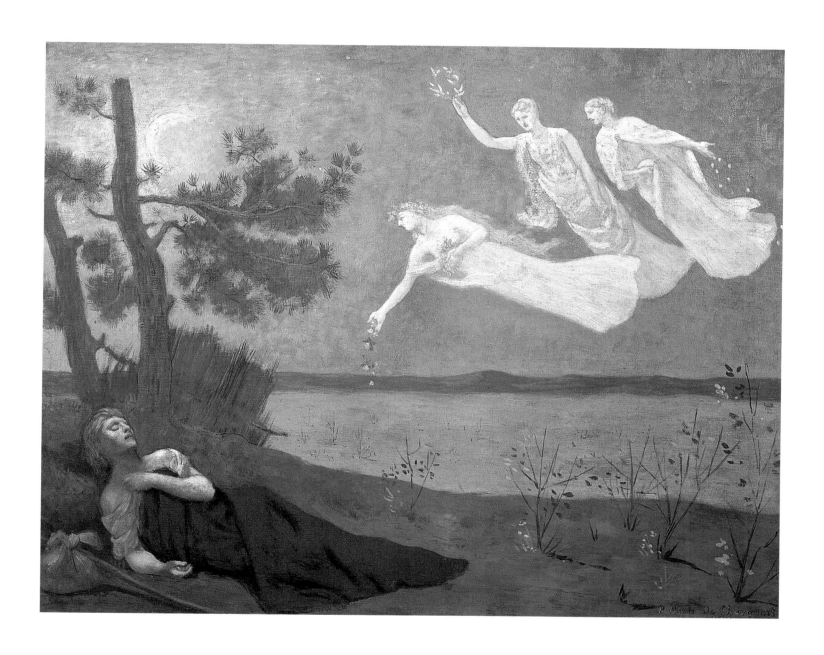

Pierre Puvis de Chavannes

THE DREAM: IN HIS SLEEP HE SAW LOVE, GLORY AND WEALTH APPEAR TO HIM

Born in Lyon • Died in Paris • 1824-98
Oil on canvas • 32.3 in x 40.2 in • Musée d'Orsay, Paris, France/Giraudon/Bridgeman Art Library, London

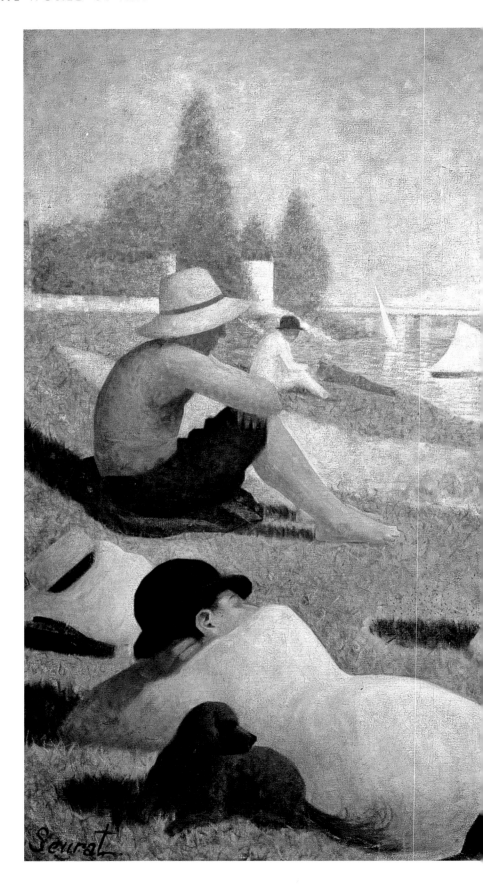

George Pierre Seurat

BATHERS AT ASNIÈRES

Born and died in Paris • 1859-91
Oil on canvas • 79.1 in x 118.1 in • National Gallery, London, UK/Bridgeman Art Library, London

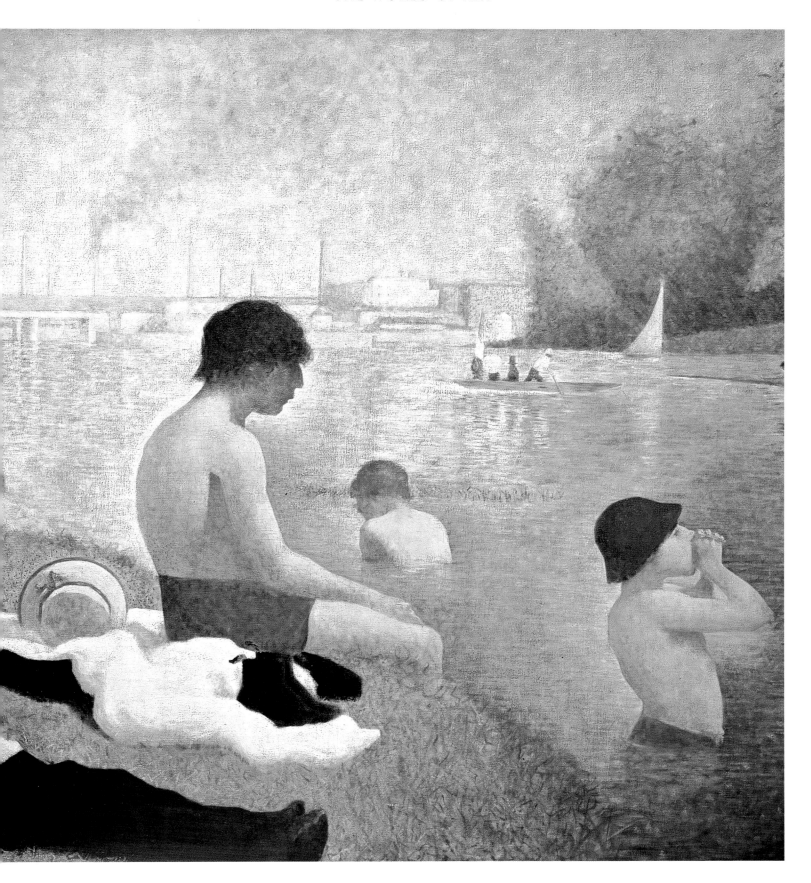

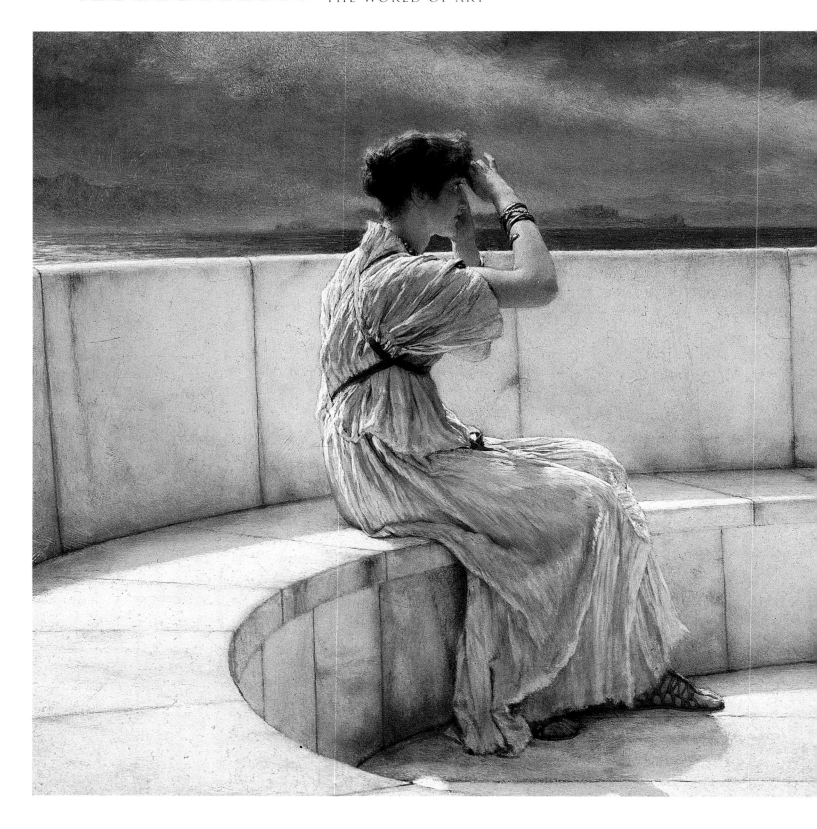

Sir Lawrence Alma-Tadema

EXPECTATIONS

Born in Drontyp • Died in Wiesbaden • 1836-1912
Oil on canvas • 8.9 in x 17.8 in • Private Collection/Bridgeman Art Library, London

Linton Park

FLAX SCRATCHING BEE (DETAIL)

1826-1906

Oil on panel • 50.2 in x 31.3 in • National Gallery of Art, Washington DC, USA/Bridgeman Art Library, London

Sir John Everett Millais

BUBBLES

Born in Southampton • Died in London • 1829-96
Oil on canvas • 43 in x 31 in • Elida Gibbs Collection, London, UK/Bridgeman Art Library, London

Edgar Degas

WOMAN DRYING HERSELF

Born and died in Paris • 1834-1917
Pastel on paper, mounted on cardboard • 40.9 in x 38.7 in • National Gallery, London, UK/Bridgeman Art Library, London

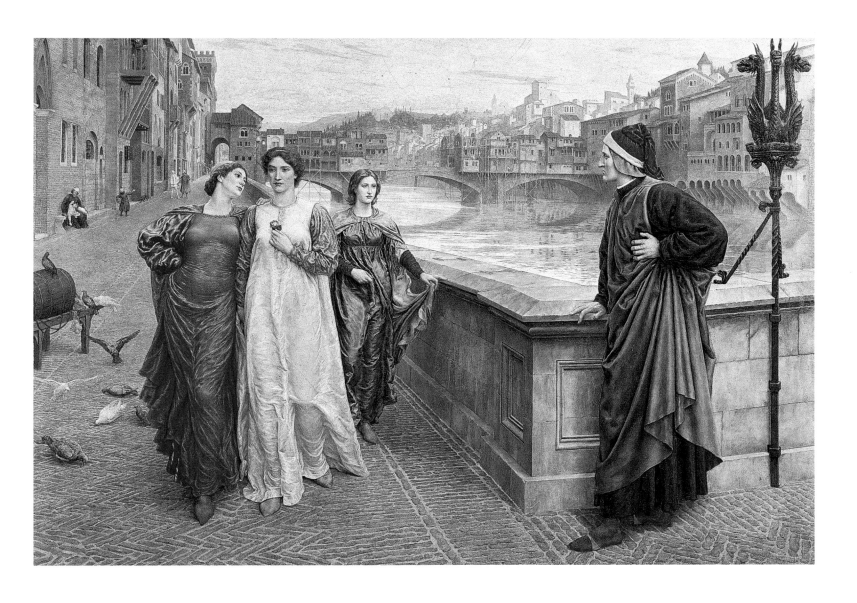

Henry Holiday

THE MEETING OF DANTE WITH BEATRICE

Born and died in London • 1839-1927
Oil on canvas • 56 in x 80 in • Walker Art Gallery, Liverpool, Merseyside, UK/Bridgeman Art Library, London

Heinrich Hansen

COPENHAGEN

Hadersleben, Denmark • 1821-90
Oil on canvas • 15.75 in x 25.5 in • Christie's Images/Bridgeman Art Library, London

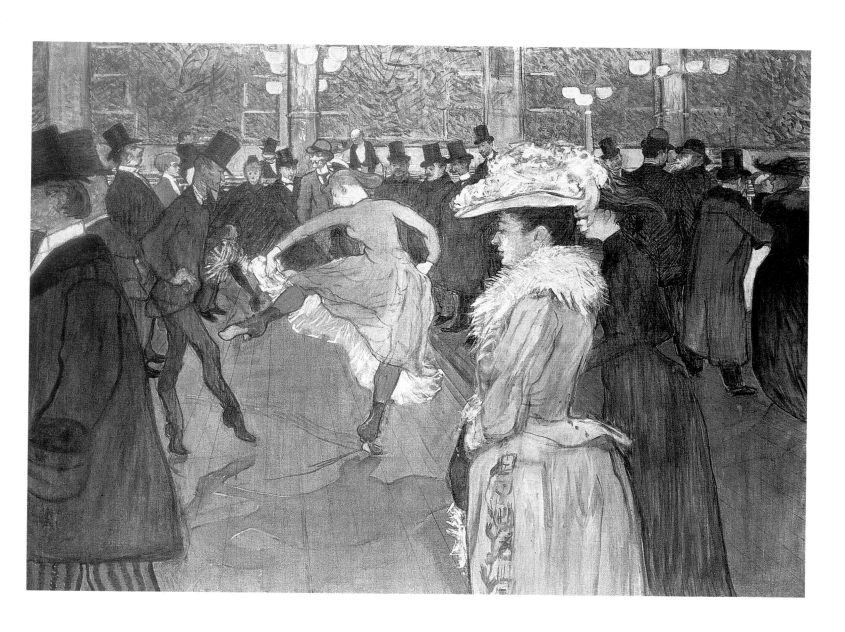

Henri de Toulouse-Lautrec

THE DANCE AT THE MOULIN ROUGE

Born in Albi • Died in Gironde • 1864-1901

Oil on canvas • 45.3 in x 59 in • Philadelphia Museum of Art, Pennsylvania, PA, USA/Bridgeman Art Library, London

Frederick Childe Hassam

RAIN STORM, UNION SQUARE

Born in Boston, MA • Died in New York, NY • 1859-1935
Oil on canvas • 28 in x 36 in • Museum of the City of New York,
USA/Bridgeman Art Library, London

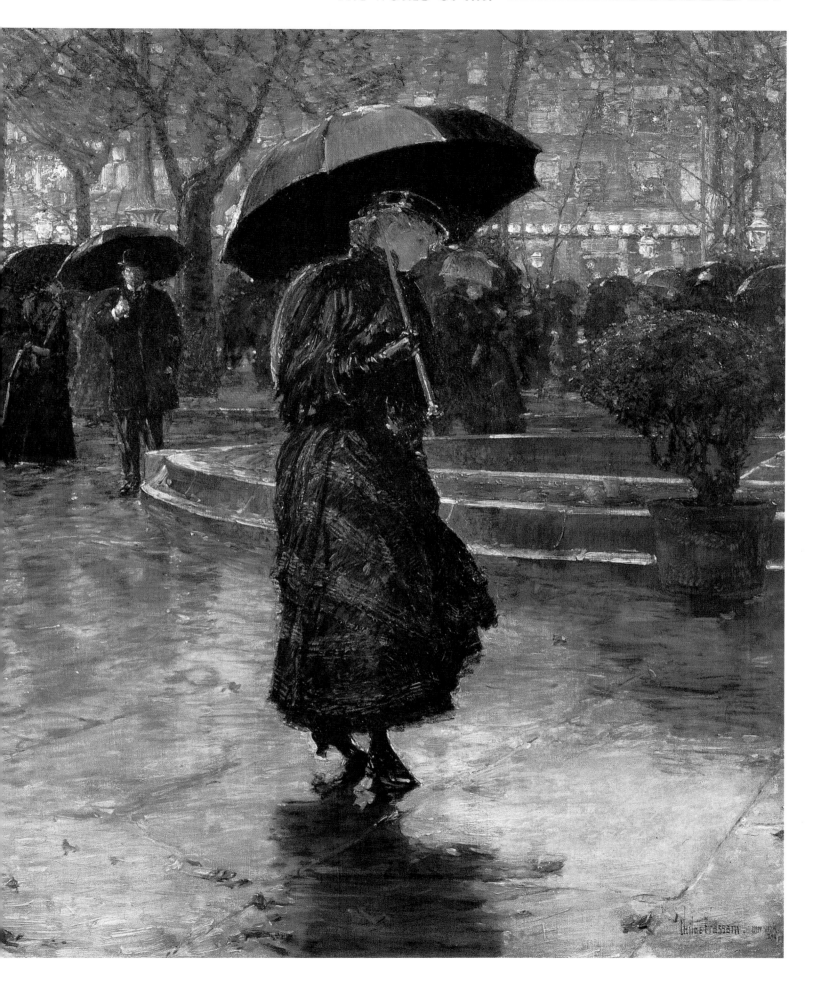

George Dunlop Leslie

FIVE O'CLOCK

Born in London. • 1835-1921
Oil on canvas • Forbes Magazine Collection, New York,
USA/Bridgeman Art Library, London

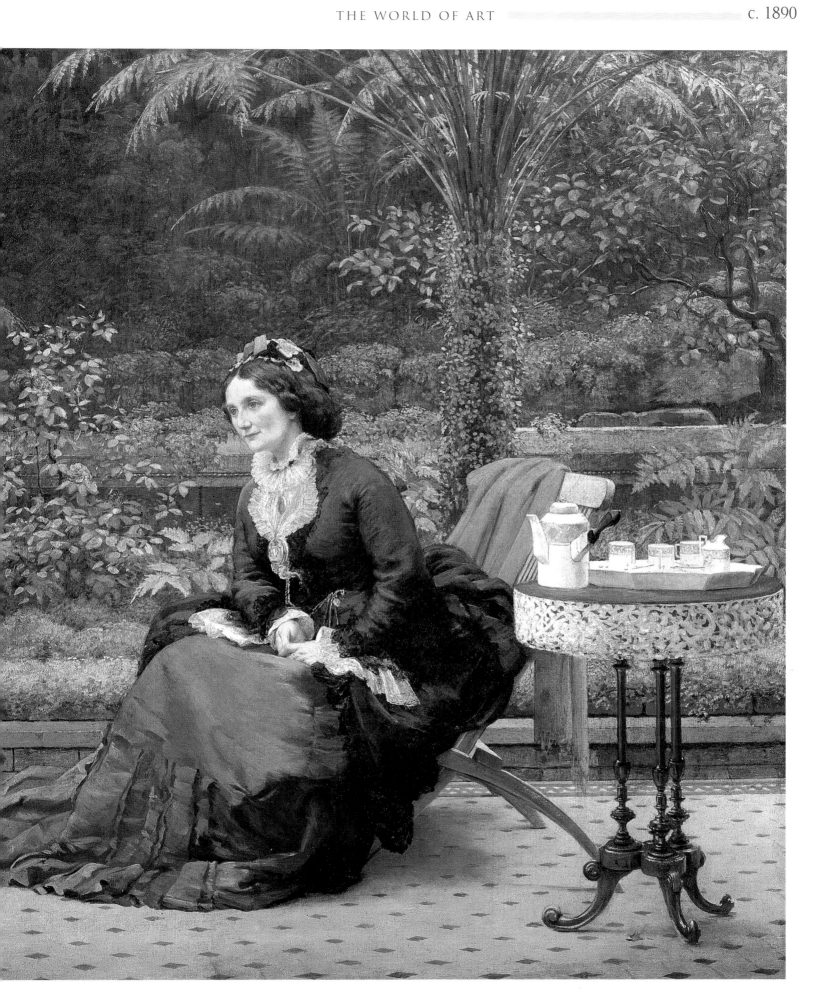

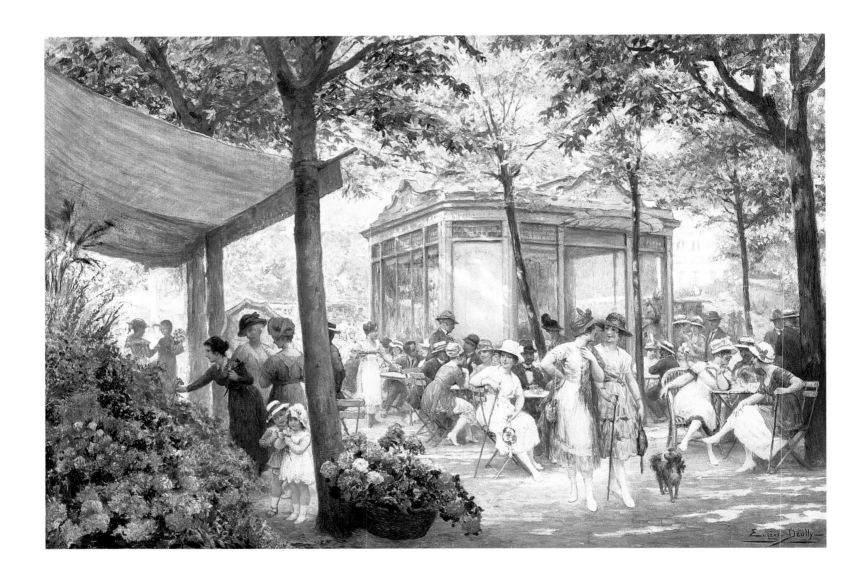

Eugène-Auguste François Deully

IN THE PARK

Born in Lille • Born in 1860
Oil on canvas • Gavin Graham Gallery, London, UK/Bridgeman Art Library, London

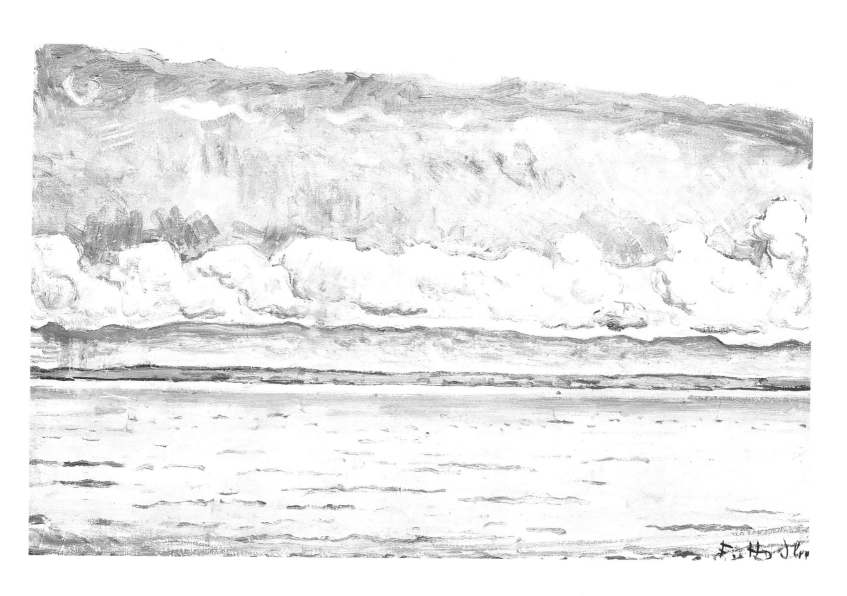

Ferdinand Hodler

THE LAKE

Born in Berne • Died in Geneva • 1853-1918
Oil on canvas • 17.5 in x 25.4 in • Hermitage, St. Petersburg, Russia/Bridgeman Art Library, London

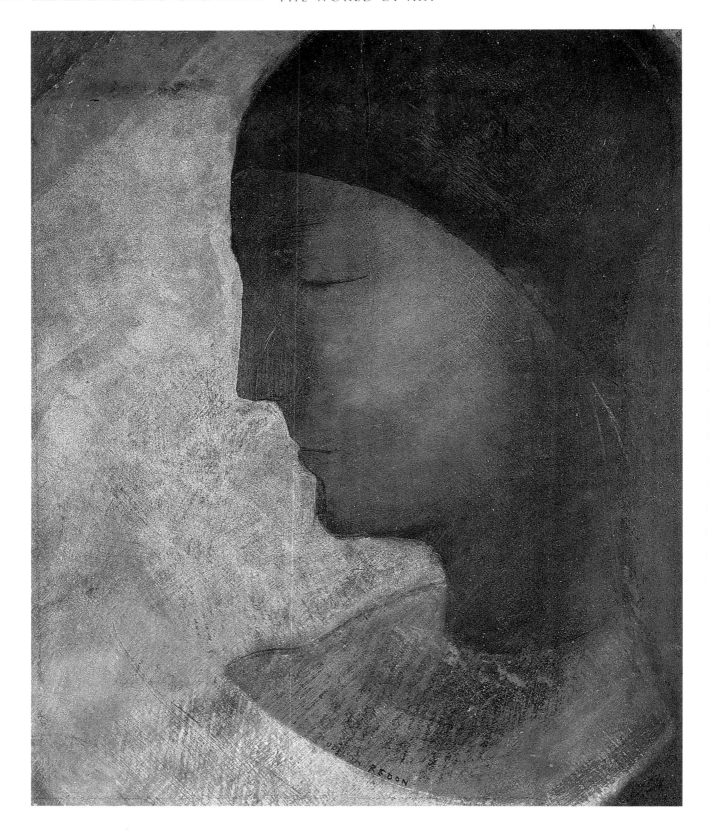

Odilon Redon

THE GOLDEN CELL

Born in Bordeaux • Died in Paris • 1840-1916
Oil and gold metallic paint on paper • 11.9 in x 9.7 in • British Museum, London, UK/Bridgeman Art Library, London

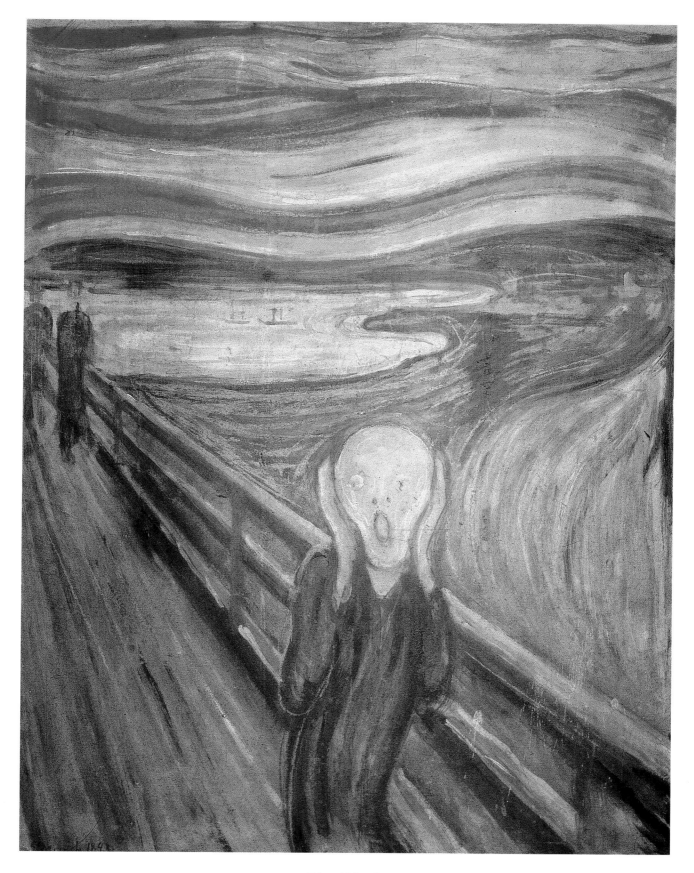

Edvard Munch

THE SCREAM

Born in Lote • Died in Oslo • 1863-1944
Tempera on panel • 32.9 in x 26 in • Nasjongalleriet, Oslo, Norway/Bridgeman Art Library, London. © Munch Museum,
The Munch Ellingsen Group/DACS 1998

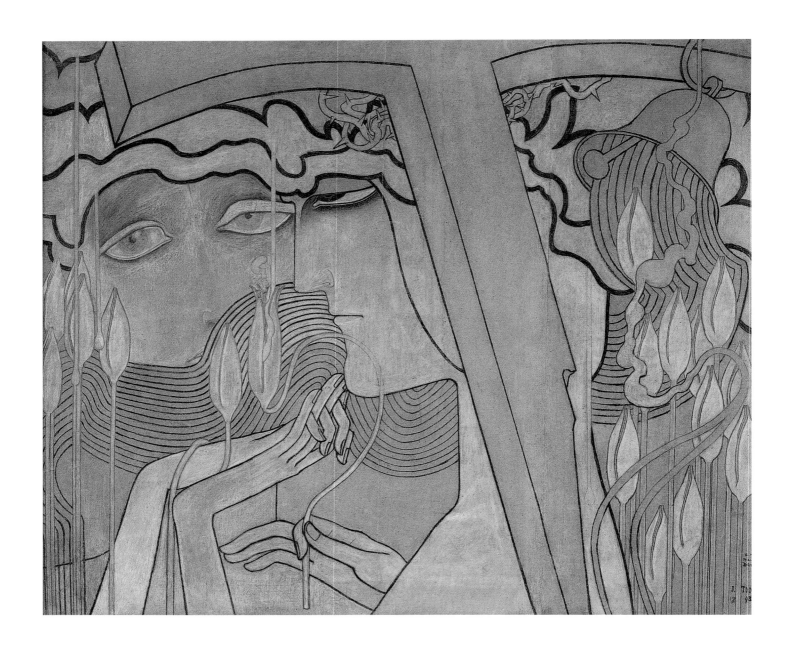

Jan Theodore Toorop

THE DESIRE AND THE GRATIFICATION

Born in Purworedjo, Java • Died in The Hague • 1858-1928
29.9 in x 35.4 in • Musée d'Orsay, Paris, France/Bridgeman Art Library, London

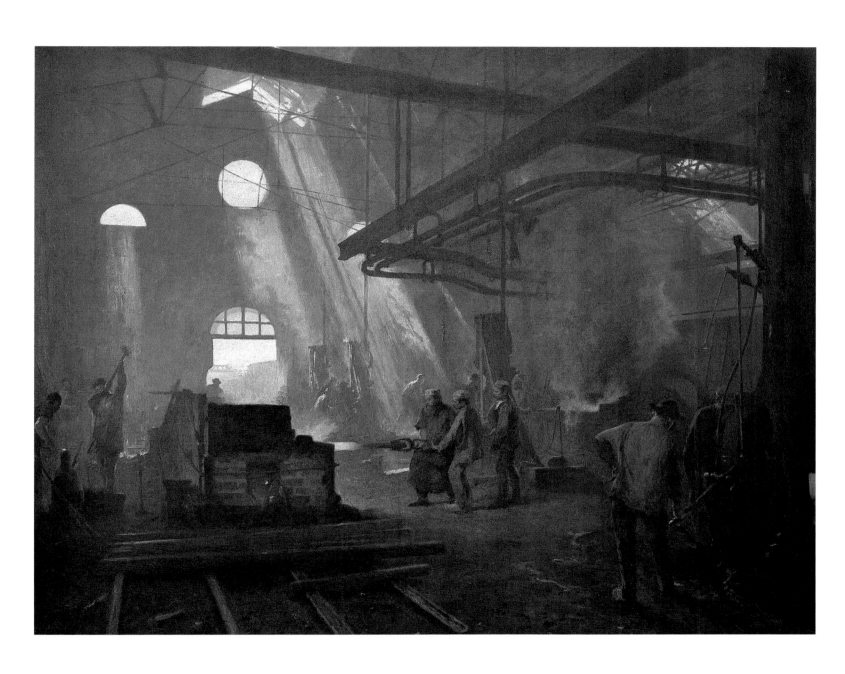

Fernand Cormon

INTERIOR OF A FACTORY (UNE FORGE)

Born and died in Paris • 1845-1924
Oil on canvas • 28.4 in x 35.4 in • Musée d'Orsay, Paris, France/Giraudon/Bridgeman Art Library, London

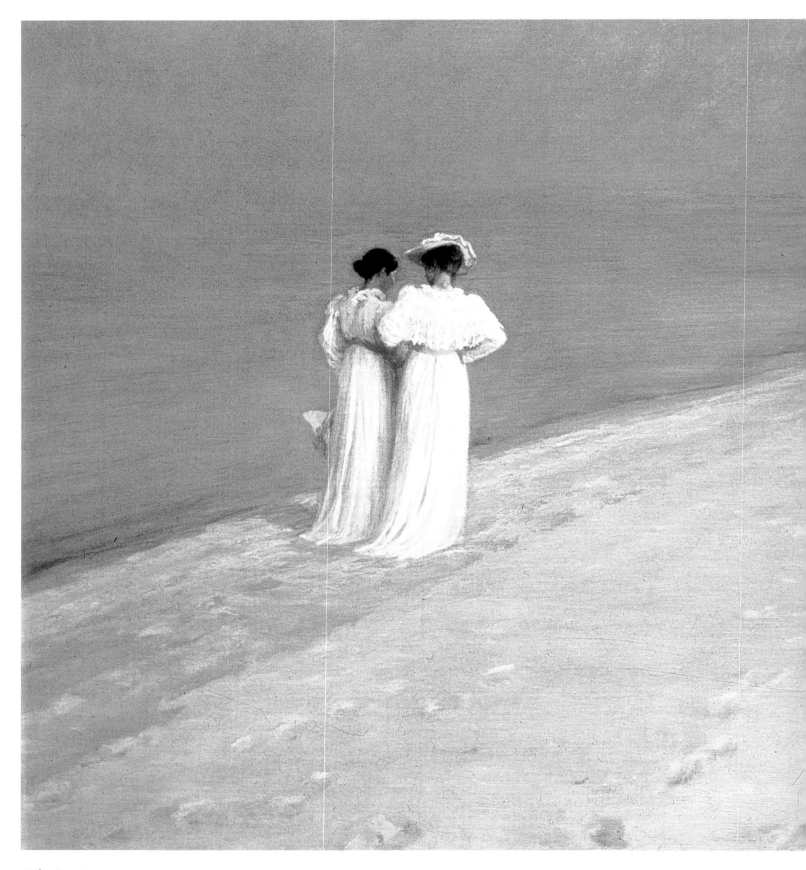

Peder Severin Krøyer

SUMMER EVENING ON THE SKAGEN SOUTHERN BEACH WITH ANNA ANCHER AND MARIE KRØYER

Born in Stavanger • Died in Skagen • 1851-1909
Oil on canvas • 39.4 in x 59.1 in • Skagens Museum, Denmark/Bridgeman Art Library, London

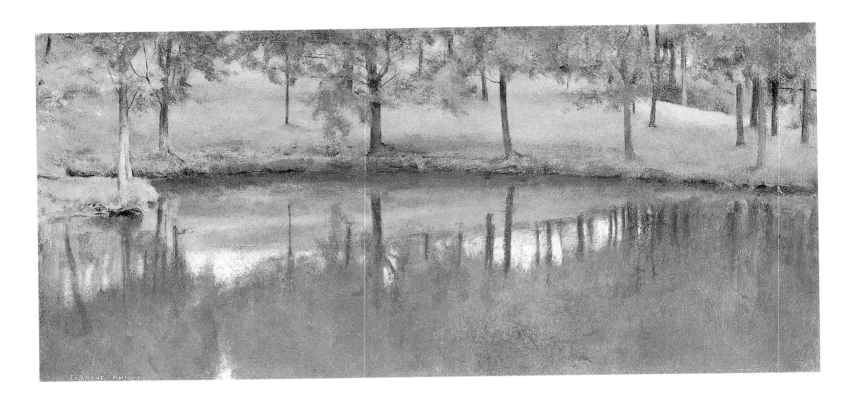

Fernand Khnopff

FOSSET: STILL WATER

Born near Termonde • Died in Brussels • 1858-1921
Oil on board • 6.5 in x 13.8 in • Whitford & Hughes, London, UK/Bridgeman Art Library, London

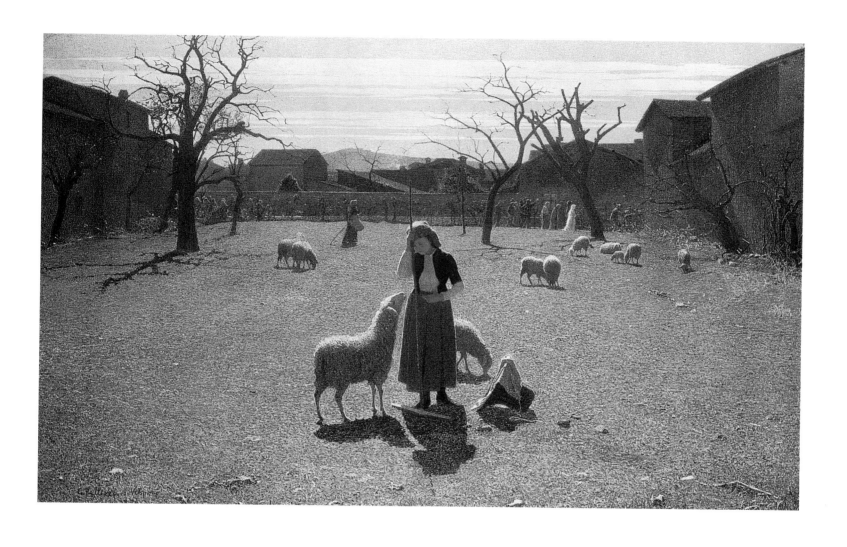

Giuseppe Pellizza da Volpedo

DELUDED HOPES

Born in Volpedo, Alessandria • 1868-1907
Oil on canvas • Private Collection/Bridgeman Art Library, London

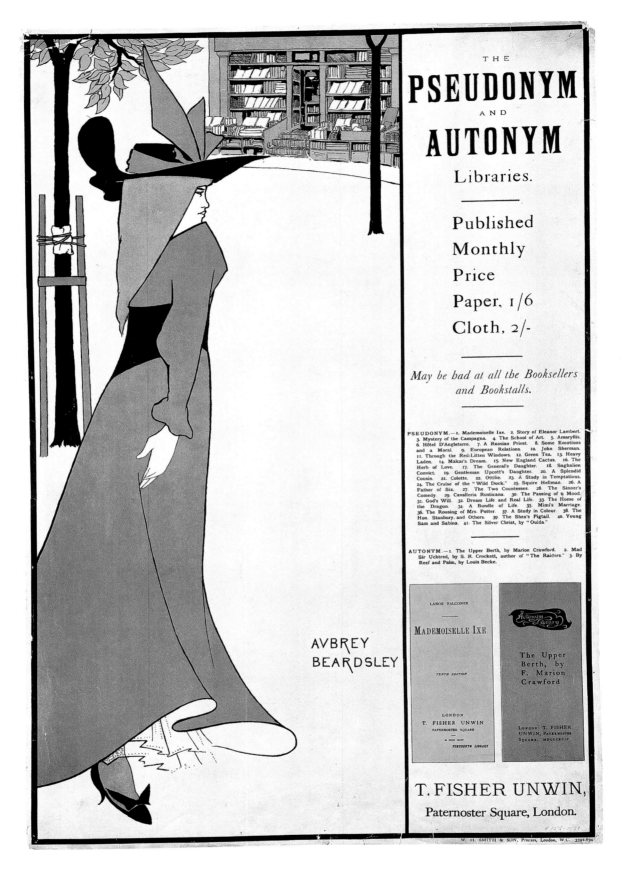

Aubrey Beardsley

Publicity poster for *The Yellow Book*

Born in Brighton • Died in Menton • 1872-98
Indian ink • 9.5 in x 6.1 in • Published 1894-97 in London by John Lane • Victoria and Albert Museum, London/Bridgeman Art Library, London

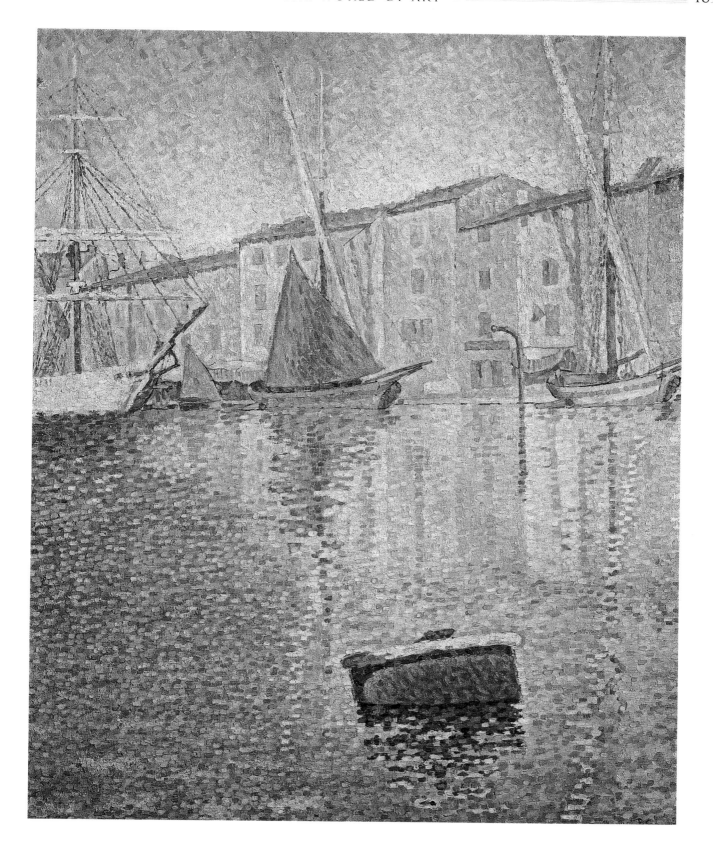

Paul Signac

THE RED BUOY, SAINT TROPEZ

Born and died in Paris • 1863-1935
Oil on canvas • 31.9 in x 25.6 in • Musée d'Orsay, Paris, France/Giraudon/Bridgeman Art Library, London

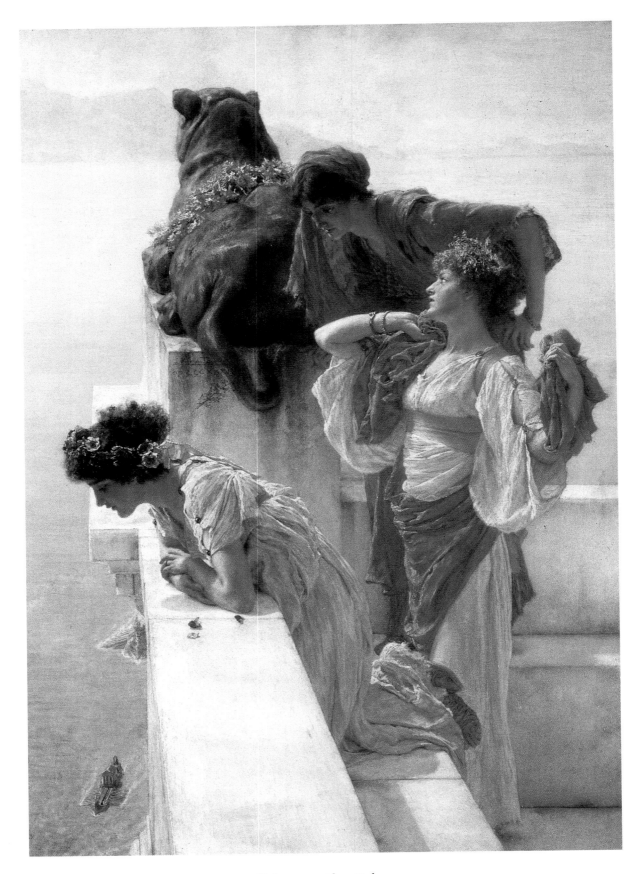

Sir Lawrence Alma-Tadema

A COIGN OF VANTAGE

Born in Drontyp • Died in Wiesbaden • 1836-1912
Oil on canvas • 25.3 in x 17.7 in • Private Collection/Bridgeman Art Library, London

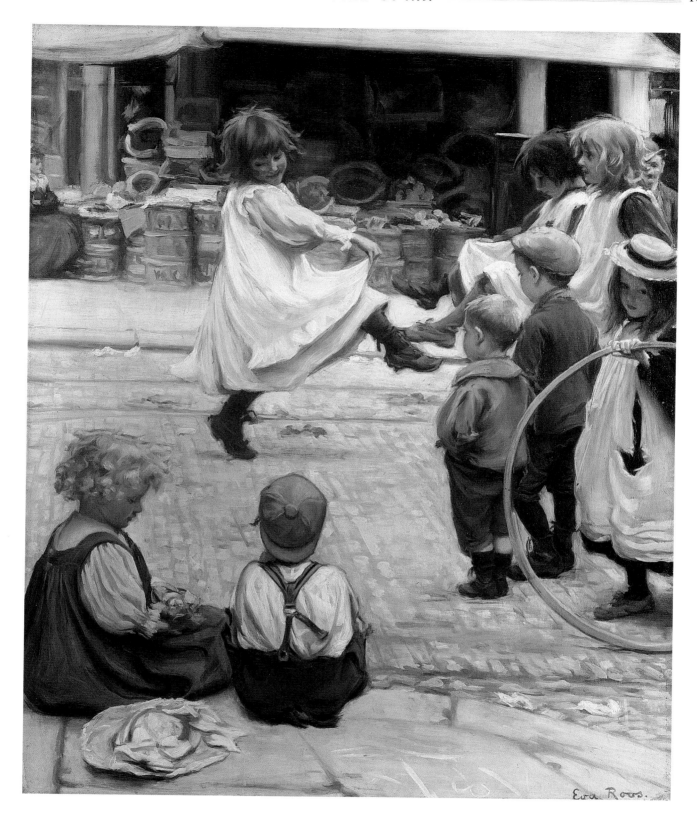

Eva Roos

An Impromptu Ball

Born in England
Oil on canvas • 31.5 in x 25 in • Christie's Images/Bridgeman Art Library, London

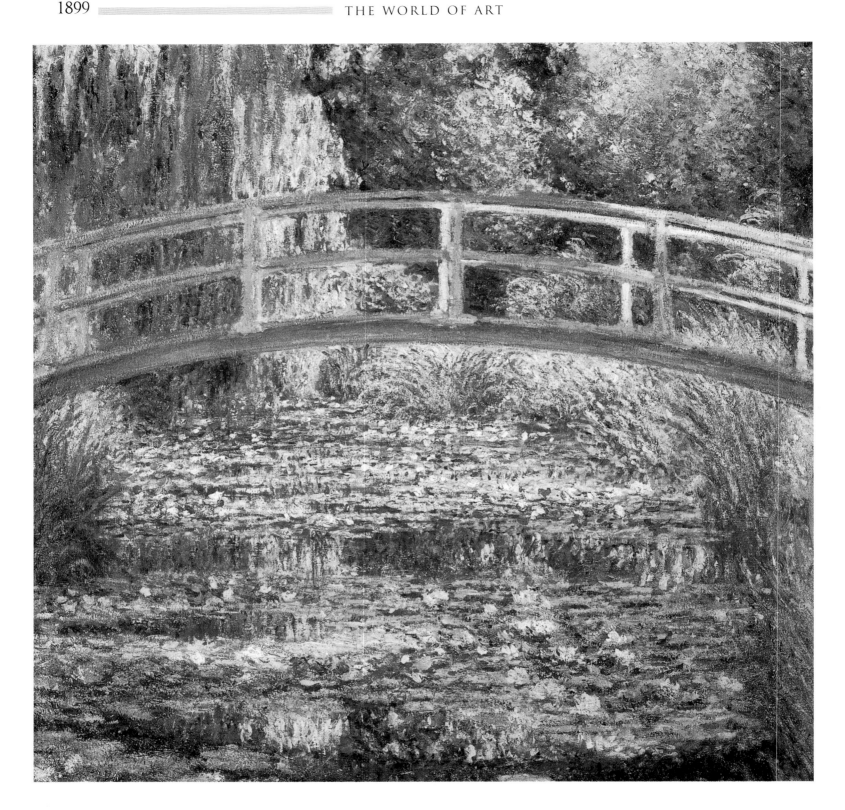

Claude Monet

WATERLILY POND

Born and died in Paris • 1840-1926
Oil on canvas • 34.6 in x 36.6 in • National Gallery, London, UK/Bridgeman Art Library, London

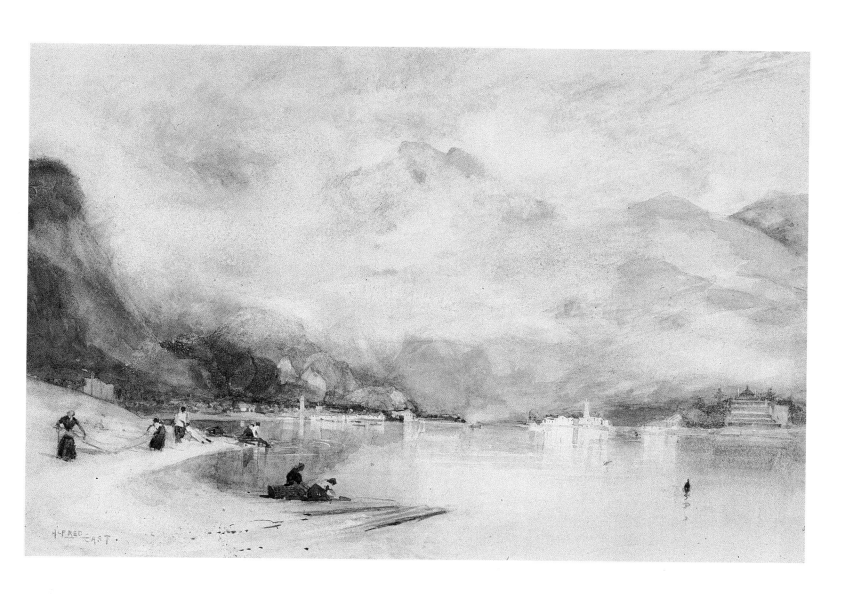

Sir Alfred East

LAKE MAGGIORE FROM STRESA

Born near Kettering, England • 1849-1913
Watercolor • 10.9 in x 15.1 in • Victoria and Albert Museum, London/Bridgeman Art Library, London
© ARS, NY & DACS, London 1998

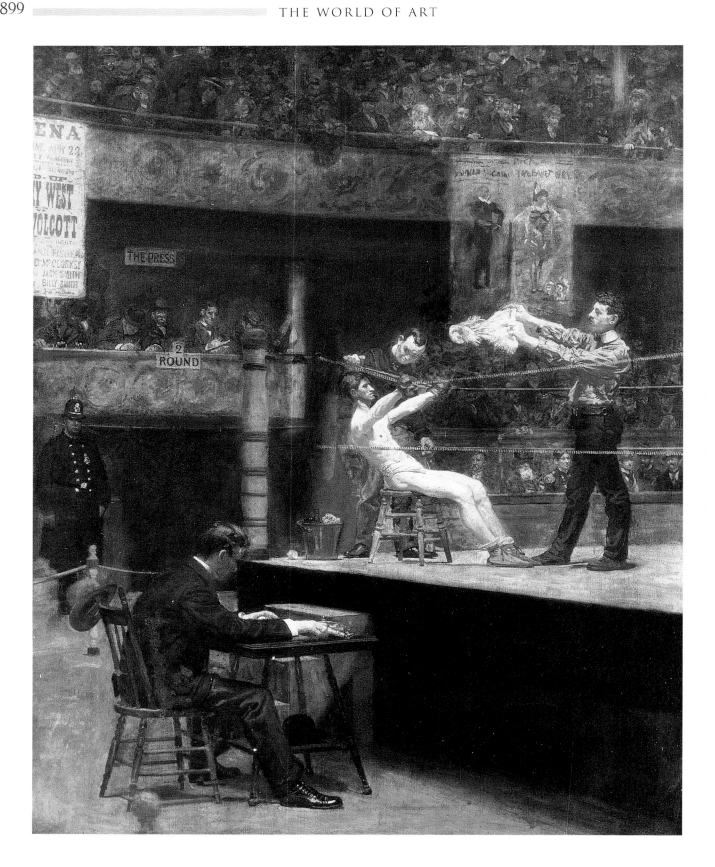

Thomas (Cowperthwaite) Eakins

BETWEEN ROUNDS

Born and died in Philadelphia, PA • 1844-1916
Oil on canvas • 50 in x 40 in • Philadelphia Museum of Art, Pennsylvania, PA, USA/Bridgeman Art Library, London

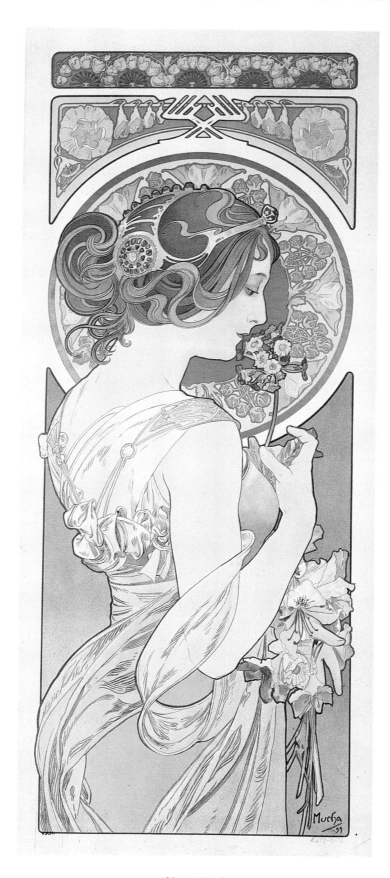

Alfonse Mucha

POSTER - LA PRIMAVERE ET LA PLUME
(A GIRL IN FRANCE)

Born in Ivancice • Died in Prague • 1860-1939
Color lithograph • 11.5 in x 29.1 in • Victoria and Albert Museum, London/Bridgeman Art Library, London
© ADAGP, Paris and DACS, London 1998

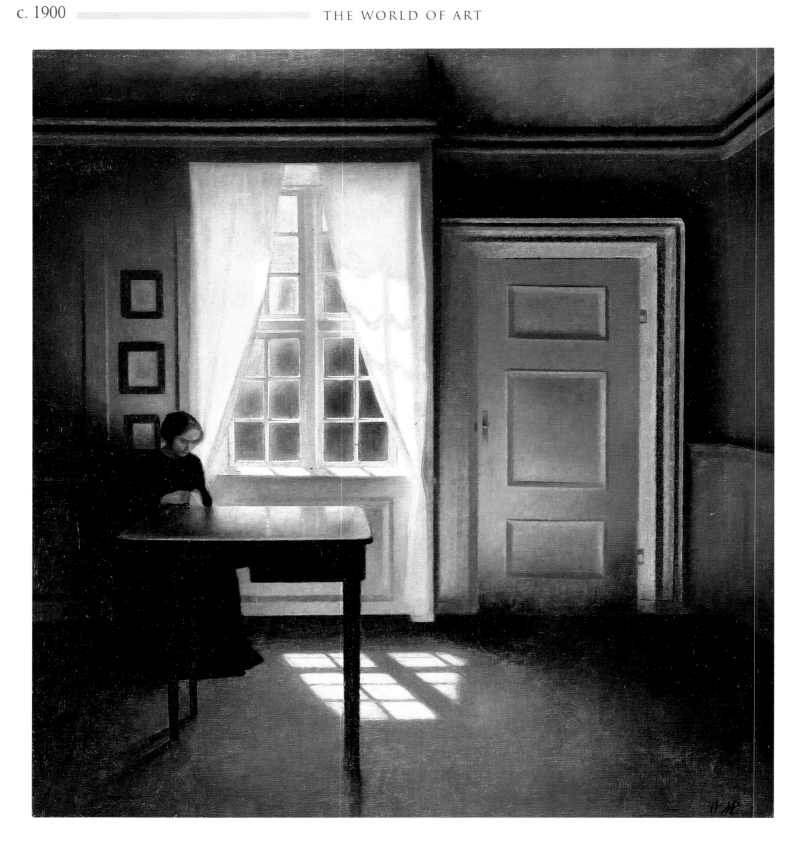

Vilhelm Hamershøi

A WOMAN SEWING IN AN INTERIOR

Born and died in Copenhagen • 1864-1916
Oil on canvas • 21.5 in x 20.5 in • Christie's Images/Bridgeman Art Library, London

Spencer Frederick Gore

GAME OF TENNIS

Born in Epsom, Surrey • Died in Richmond, Surrey • 1878-1914
Oil on canvas • Roy Miles Gallery, London, UK/Bridgeman Art Library, London

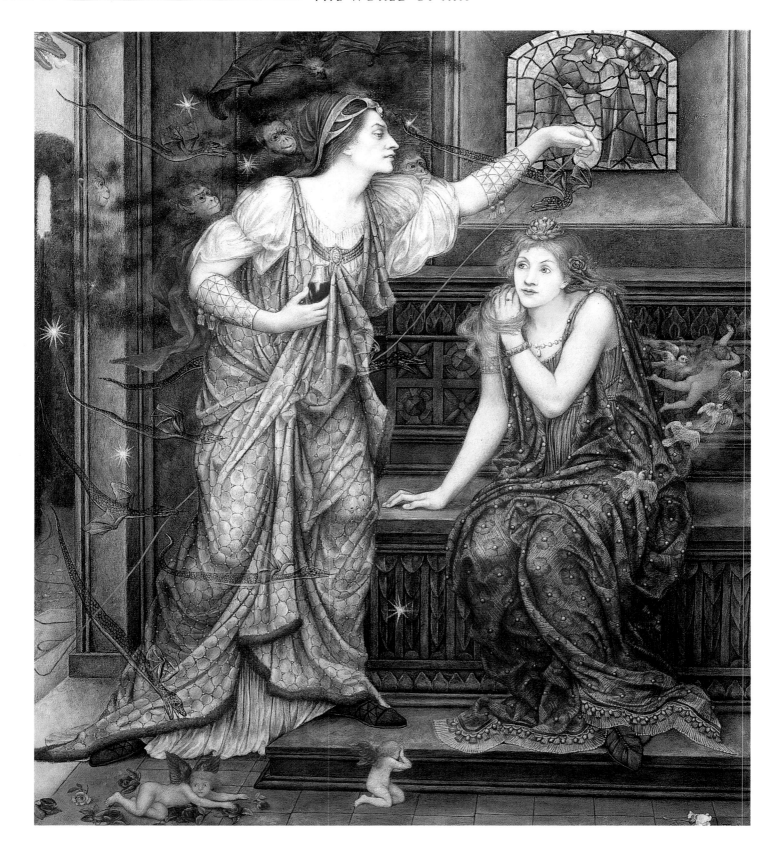

Evelyn de Morgan

QUEEN ELEANOR AND FAIR ROSAMUND

Born in Pickering, England • 1855-1919
Oil on canvas• 29 in x 25.5 • The De Morgan Foundation, London, UK/Bridgeman Art Library, London

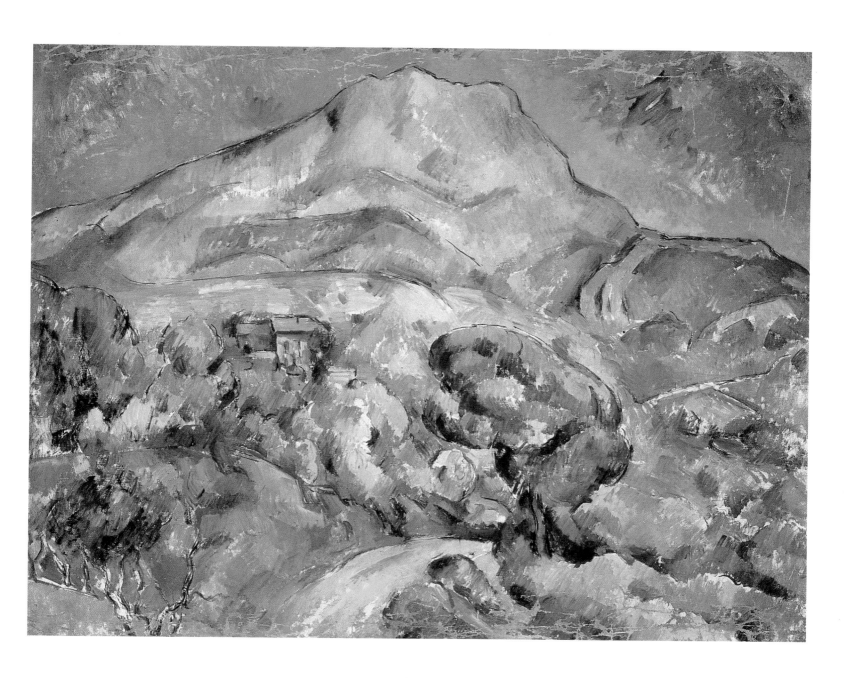

Paul Cézanne

Mont Saint Victoire

Born and died in Aix-en-Provence • 1839-1906
Oil on canvas • 30.7 in x 39 in • Hermitage, St. Petersburg, Russia/Bridgeman Art Library, London

447

Arthur Rackham

KING ARTHUR'S WEDDING FEAST

Born in Lewisham, London • Died in Limpsfield, Surrey • 1867-1939
Watercolor • The Maas Gallery, London, UK/Bridgeman Art Library, London

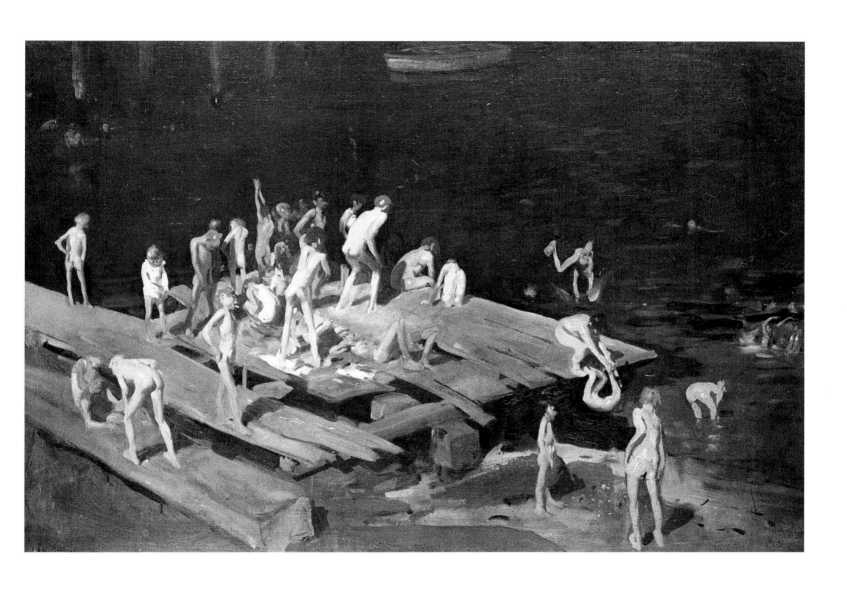

George Bellows

FORTY-TWO KIDS

Born in Columbus, OH • Died in New York, NY • 1882-1925
Oil on canvas • 42.4 in x 60.2 in • Corcoran Gallery of Art, Washington DC, USA/Bridgeman Art Library, London

Harold Gilman

THE ARTIST'S DAUGHTERS

Born in Rode • Died in London • 1876-1919
Oil on canvas • 24 in x 18 in • York City Art Gallery, Yorkshire, UK/Bridgeman Art Library, London

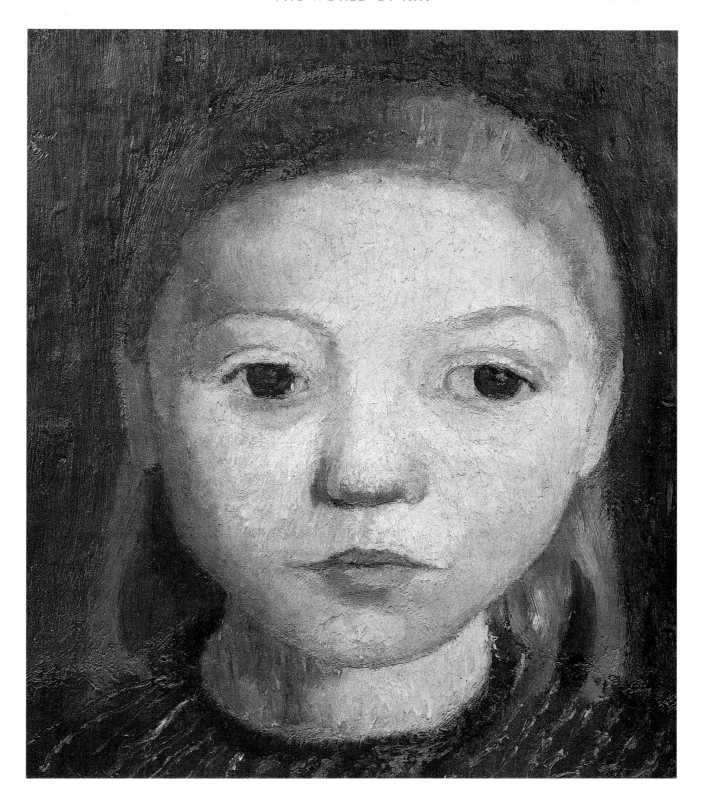

Paula Modersohn-Becker

HEAD OF A GIRL

Born in Dresden • Died in Worpswede • 1876-1907
Oil on canvas • Stadelisches Kunstinstitut, Frankfurt-am-Main, Germany/Bridgeman Art Library, London

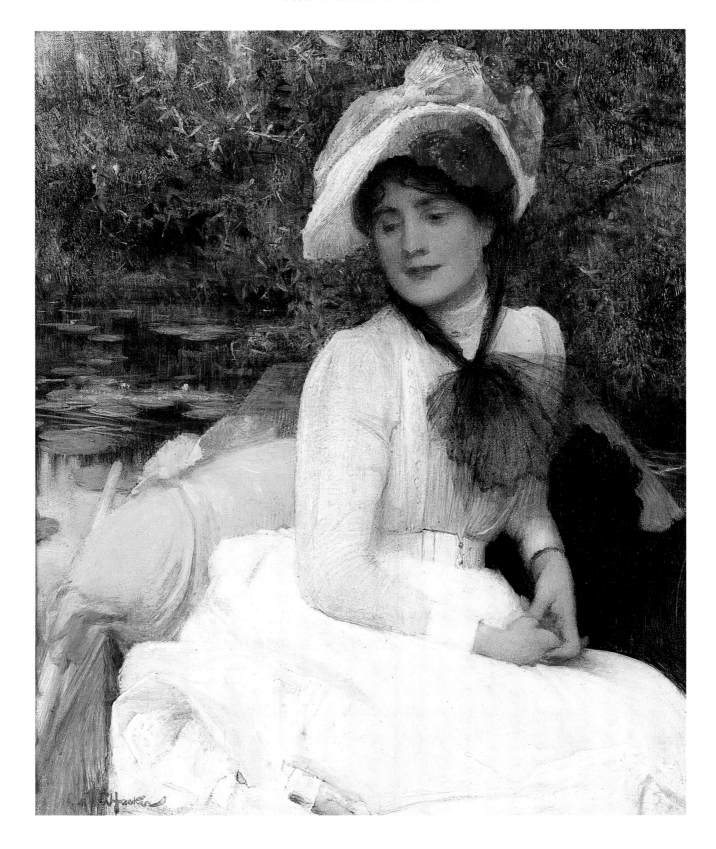

Arthur Hacker

Young Girl in a Punt

Born and lived in England • 1858-1919
Oil on canvas • The Fine Art Society, London, UK/Bridgeman Art Library, London

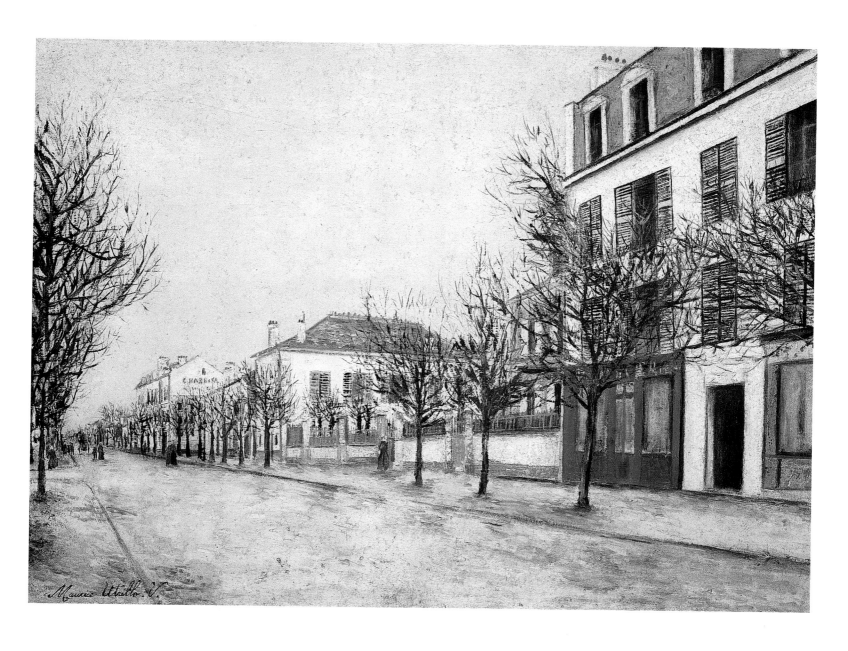

Maurice Utrillo

RUE DE BANLIEUE

Born in Paris • Died in Dax • 1883-1955
Oil on canvas • 20.2 in x 28.2 in • Christie's Images/Bridgeman Art Library, London
© ADAGP, Paris and DACS, London 1998

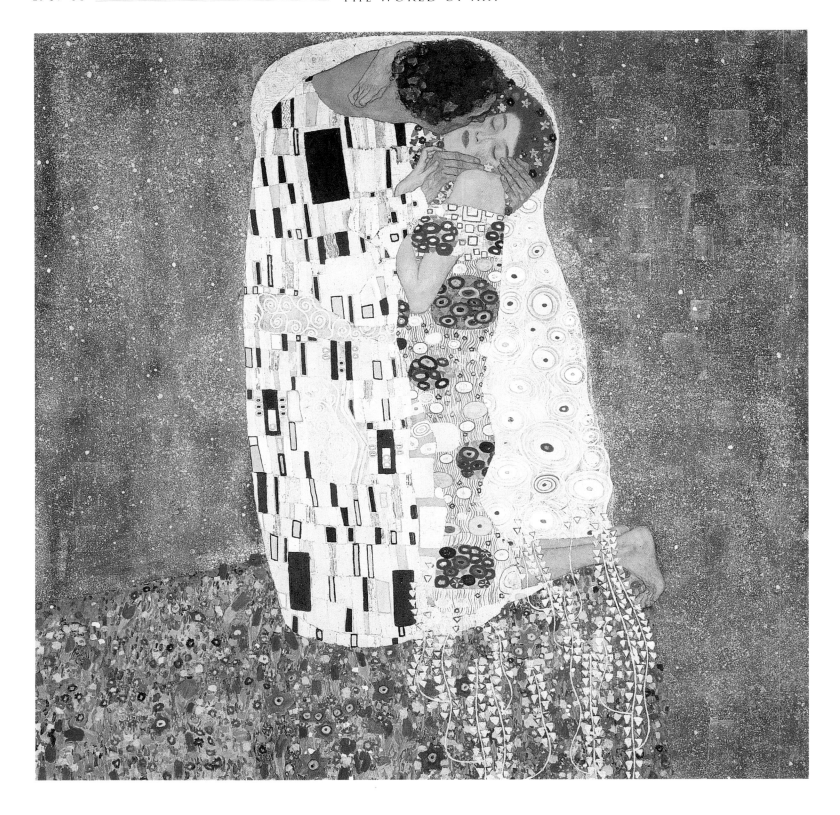

Gustav Klimt

THE KISS

Born and died in Vienna • 1862-1918
Oil on canvas • 70.1 in x 70.1 in • Osterreichische Galerie, Vienna, Austria/Bridgeman Art Library, London

Margaret Macdonald Mackintosh

TITANIA

Born near Glasgow, Scotland • 1865-1933
Watercolor • The Fine Art Society, London, UK/Bridgeman Art Library, London

Henri Rousseau (Le Douanier)

THE CASCADING GARDENS

Born in Laval • Died in Paris • 1844-1910
Oil on canvas • 15 in x 18.5 in • Hermitage, St. Petersburg, Russia/Bridgeman
Art Library, London

Edward Hopper

Summer Interior

Born in Nyack, NY • Died in New York, NY • 1882-1967
Oil on canvas • 24 in x 29 in • Private Collection/Bridgeman Art Library, London

Henri Matisse

LA DANSE

Born Le Cateau-Cambresis • Died Cimiez • 1869-1954
Oil on canvas • 102.4 in x 153.9 in • Hermitage, St. Petersburg, Russia/Bridgeman Art Library, London
© Succession H. Matisse/DACS 1998

Maurice de Vlaminck

A Small Town by a Lake

Born in Paris • Died in Rueil-la-Gadelière • 1876-1958
Pushkin Museum, Moscow, Russia/Bridgeman Art Library, London
© ADAGP Paris & DACS, London, 1998

Anders Leonard Zorn

DAGMAR

Born and died in Mora • 1860-1920
34.6 in x 24.8 in • Christie's Images/Bridgeman Art Library, London

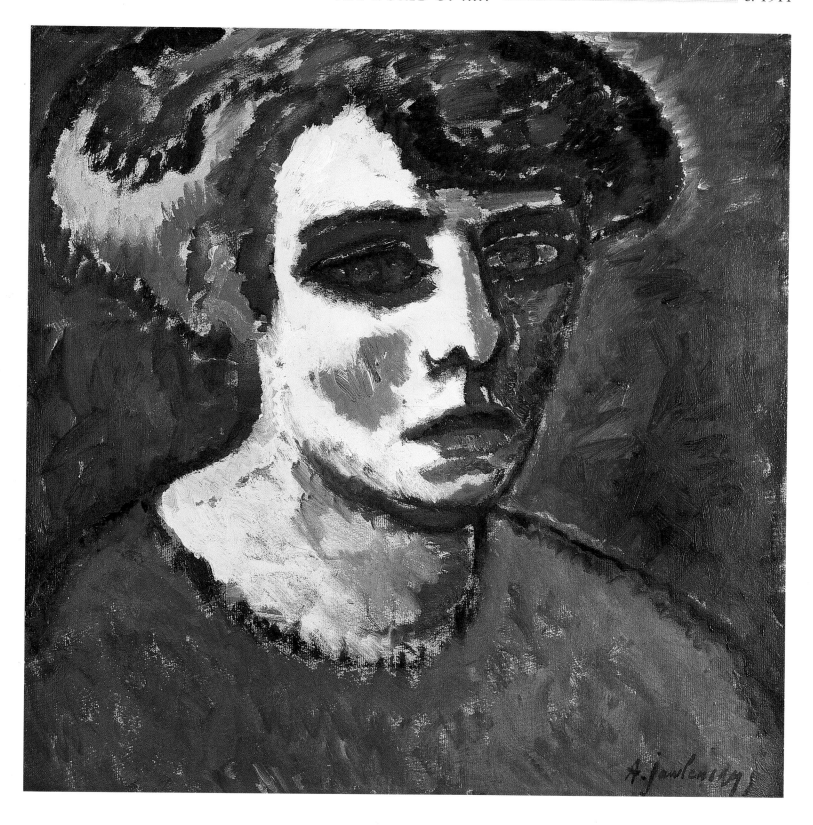

Alexej von Jawlensky

HEAD OF A WOMAN

Born in Kuslovo • Died in Wiesbaden • 1864-1941
Oil, cardboard, plywood • 20.6 in x 19.8 in • Scottish National Gallery of Modern Art, Edinburgh/Scotland/Bridgeman Art Library, London
© ADAGP, Paris and DACS, London 1998

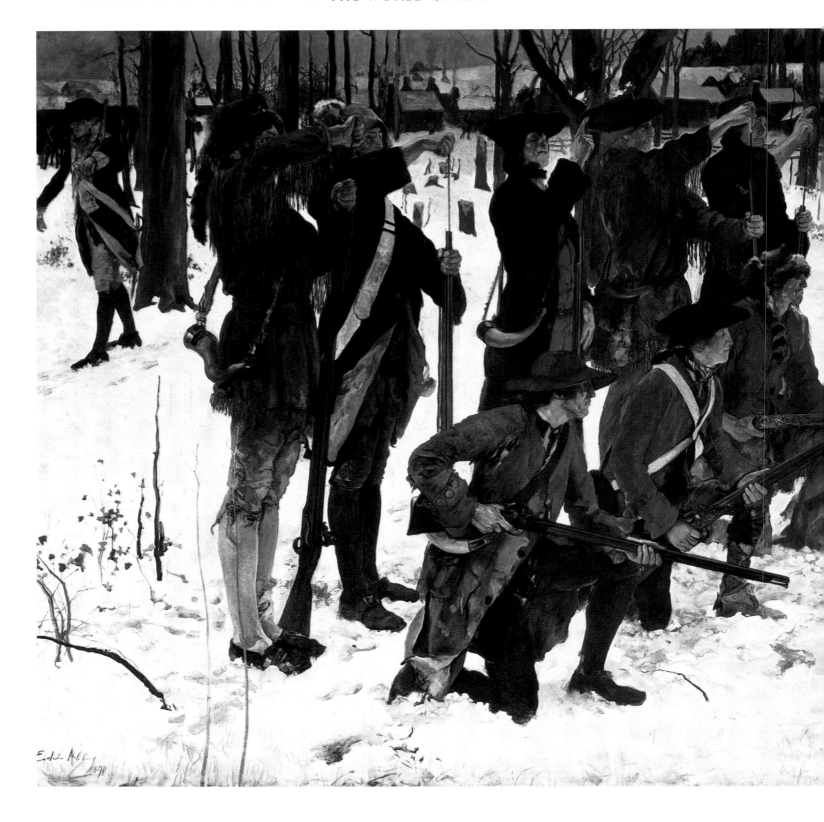

Edwin Austin Abbey

BARON VON STEUBEN DRILLING AMERICAN RECRUITS AT VALLEY FORGE IN 1778

Born Philadelphia PA • Died London • 1852-1911
Oil on canvas • 12.25 in x 9 in • Pennsylvania State Capitol, PA, USA/Bridgeman Art Library, London

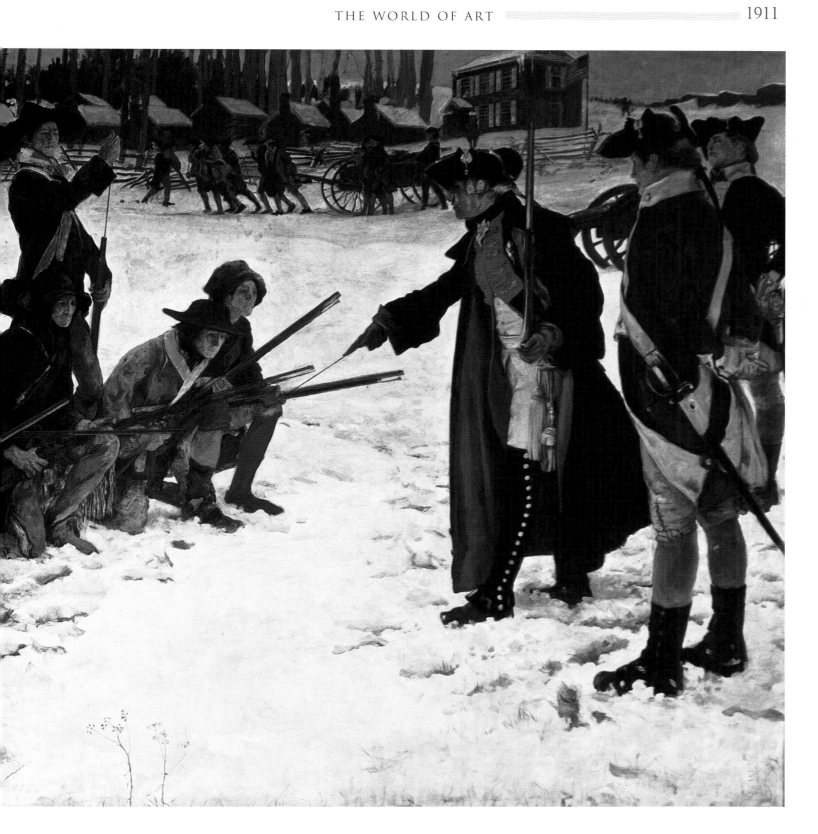

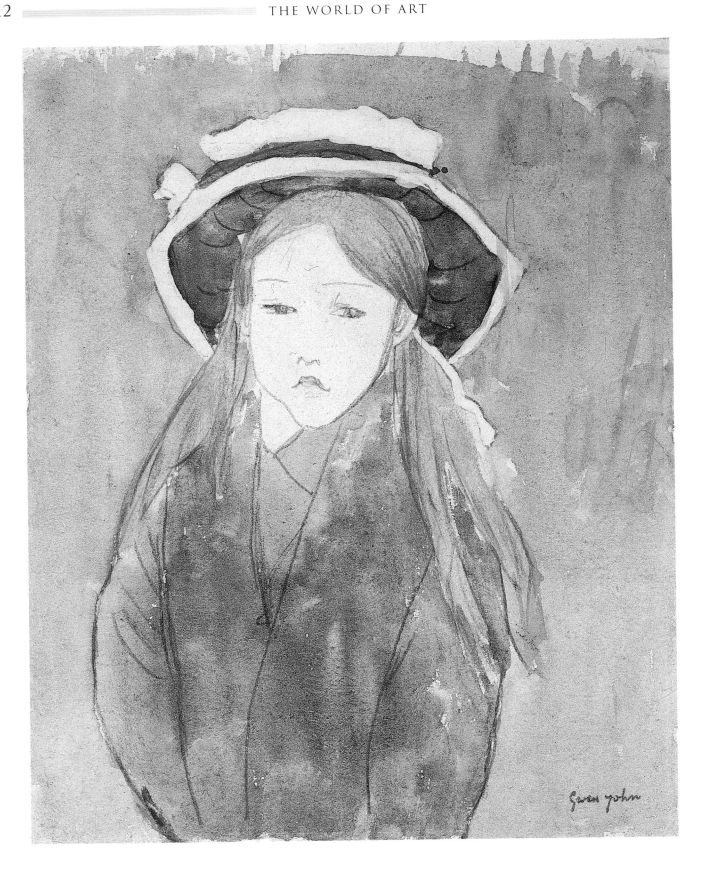

Gwen John

LITTLE GIRL WEARING LARGE HAT

Born in Haverfordwest, Wales • Died in Dieppe • 1876-1939
Watercolor and pencil on paper • 8.9 in x 6.9 in • City of Bristol Museum & Art Gallery, Avon, UK/Bridgeman Art Library, London

August Macke

A GLANCE DOWN AN ALLEY

Born in Meschede, Westphalia • Died near Perthes-Les-Hurlus, Champagne • 1887-1914
Watercolor • Stadtisches Museum, Mulheim, Germany/Bridgeman Art Library, London

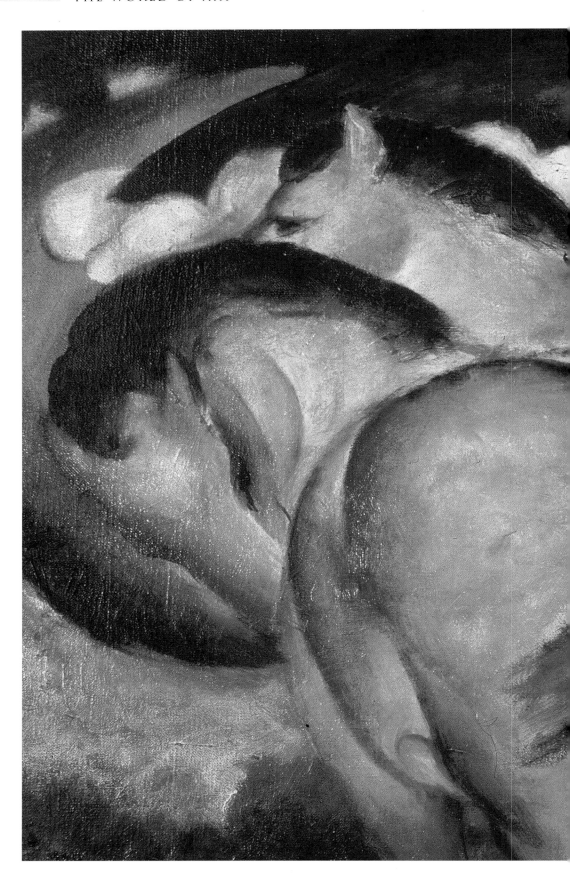

Franz Marc

LITTLE YELLOW HORSES

Born in Munich • Died in Verdun • 1880-1916
Oil on canvas • 26 in x 41.4 in • Staatsgalerie, Stuttgard, Germany/Bridgeman Art Library, London

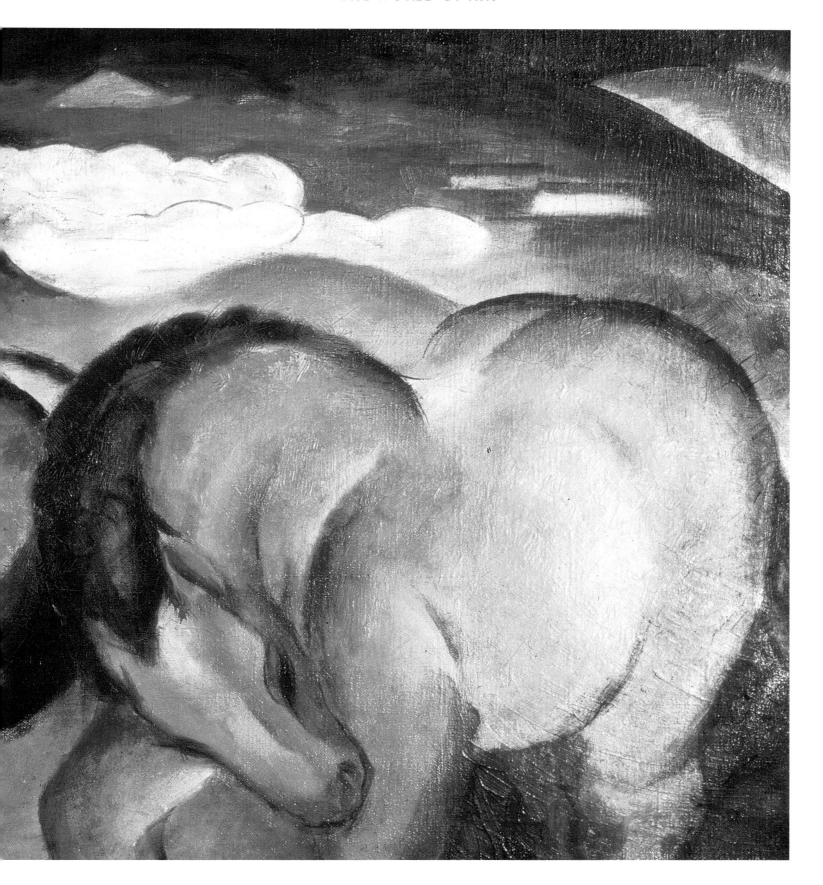

Thomas William Roberts

BUST PORTRAIT OF MABEL PERSIS

Born in Dorchester • Died in Kallist, Victoria • 1856-1931
Oil on board • 22.5 in x 18.5 in • Bonhams, London, UK/Bridgeman Art Library, London

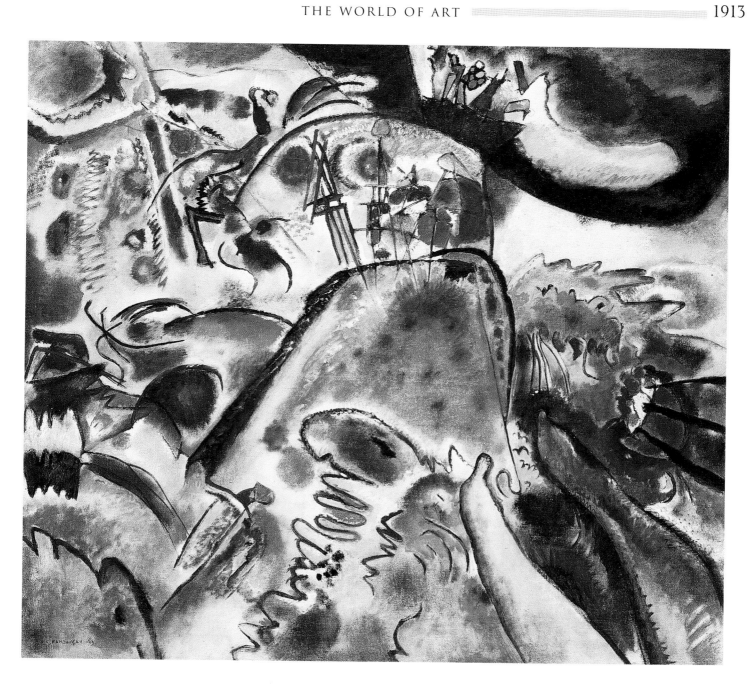

Wassily Kandinsky

SMALL PLEASURES

Born in Moscow • Died in Paris • 1866-1944
Oil on canvas • 43.2 in x 47.1 in • Soloman R. Guggenheim Museum, New York, USA/Bridgeman Art Library, London
© ADAGP, Paris and DACS, London 1998

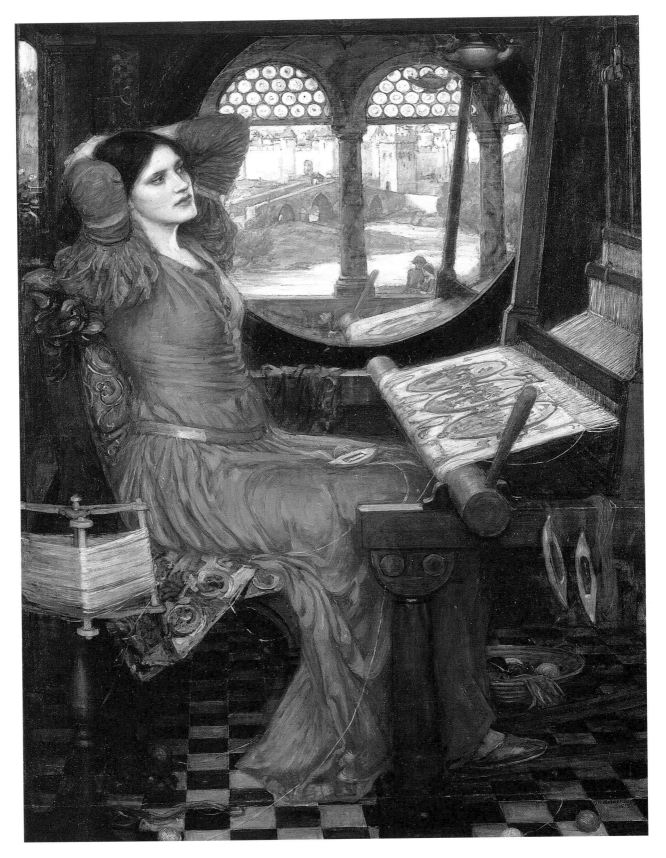

John William Waterhouse

I Am Half Sick of Shadows Said the Lady of Shalott

Born in Rome • Died in London • 1849-1917
Oil on canvas • 39.5 in x 29 in • Art Gallery of Ontario, Toronto, Canada/Bridgeman Art Library, London
Gift of Mrs Phillip B. Jackson, 1971

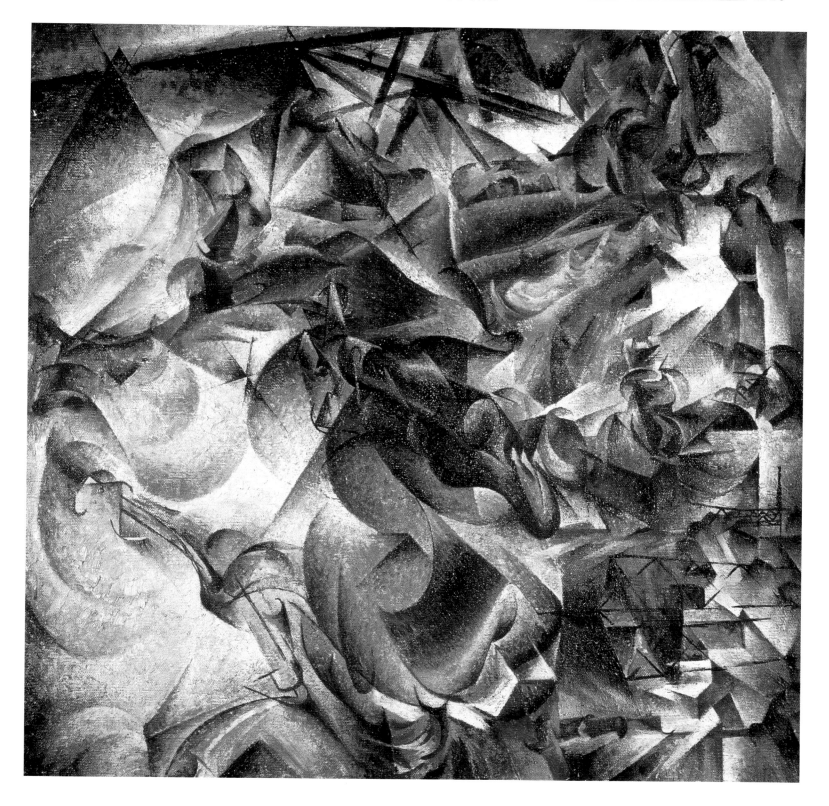

Umberto Boccioni

ELASTICITY

Born in Reggio di Calabria • Died in Sorte • 1882-1916
Oil on canvas • Pinacoteca di Brera, Milan, Italy/Bridgeman Art Library, London

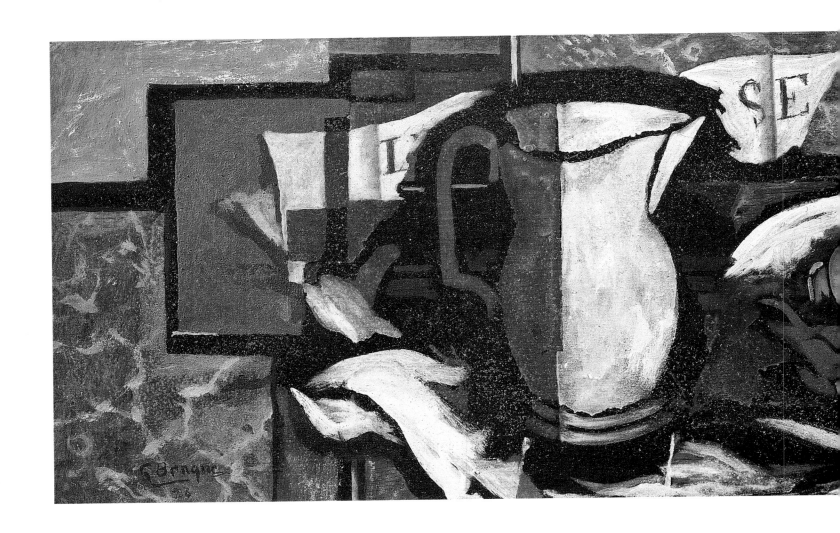

Georges Braque

STILL LIFE; BOTTLE, FRUIT AND NAPKIN

Born Argenteuil-sur-Seine • Died in Paris • 1882-1963
Oil on board • 19 in x 25 in • Christie's Images/Bridgeman Art Library, London/©ADAGP, Paris and DACS, London 1998

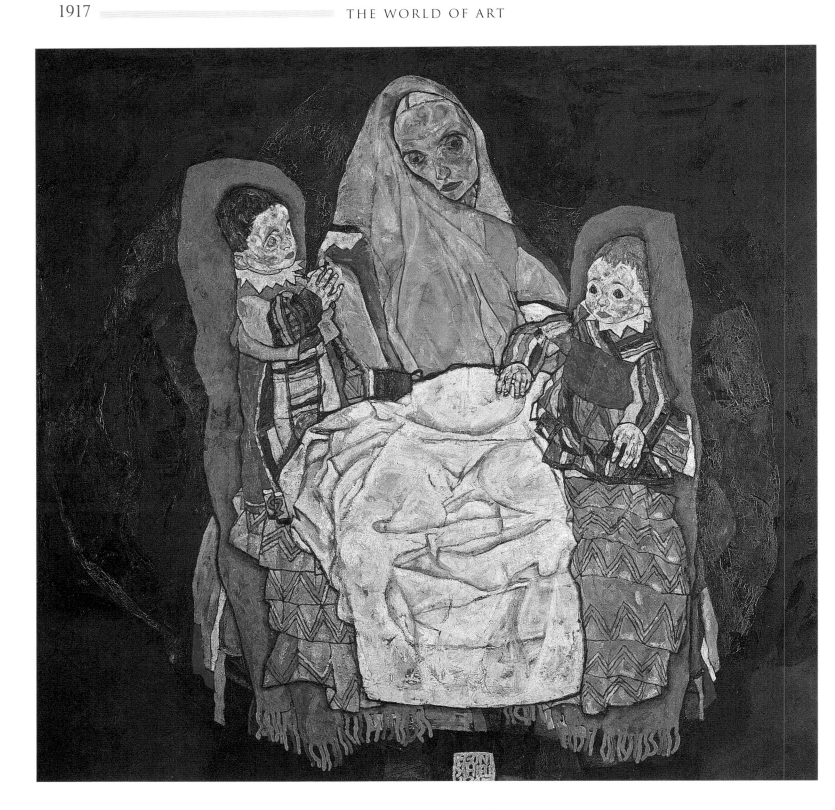

Egon Schiele

MOTHER WITH TWO CHILDREN

Born and died in Vienna • 1890-1918
Oil on canvas • 59 in x 62.6 in • Österreichische Galerie, Vienna, Austria/Bridgeman Art Library, London

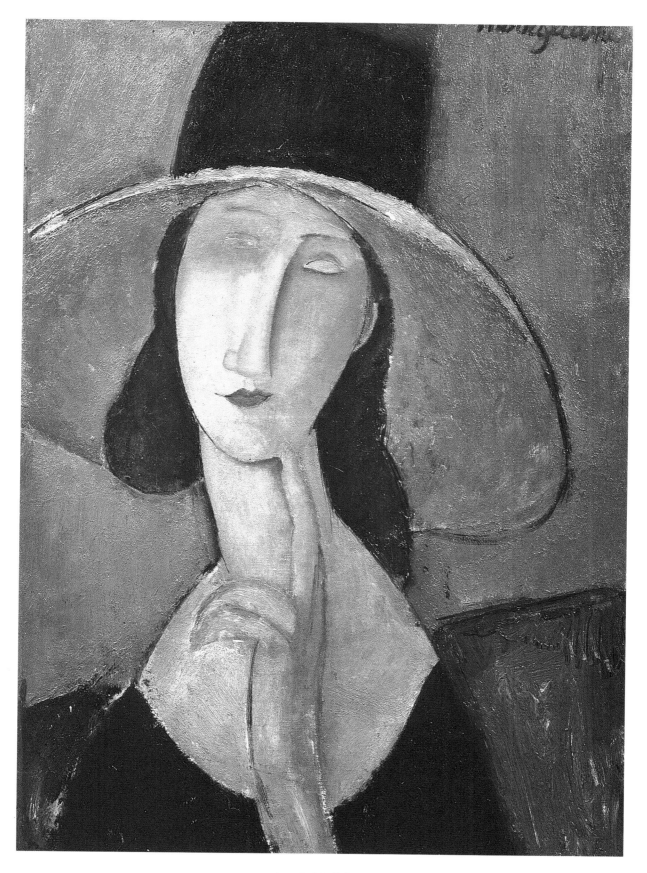

Amedo Modigliani

PORTRAIT OF JEANNE HÉBUTERNE IN A LARGE HAT

Born in Livorno • Died in Paris • 1884-1920
Oil on canvas • 36 in x 28.75 in • Metropolitan Museum of Art, New York, USA/Bridgeman Art Library, London

Maxfield Frederick Parrish

GARDEN OF ALLAH

Born in Philadelphia PA • Died in Plainfield, NH • 1870-1966
Oil on paper laid down on panel • 15.5 in x 30.4 in • Private Collection/Christie's Images/Bridgeman Art Library, London.
© Maxfield Parrish /Vaga, NY & DACS, London 1998

Piet Mondrian

COMPOSITION WITH A GRID 8 (CHECKERBOARD WITH DARK COLORS)

Born in Amersfoort • Died in New York, NY • 1872-1944

Oil on canvas • 40 in x 33 in • Haags Gemeentemuseum, Netherlands/Bridgeman Art Library, London © Mondrian/Holtzman Trust
c/o Beeldrecht, Amsterdam, Holland/DACS 1998

Pierre Bonnard

THE OPEN WINDOW

Born in Rontenay-aux-Roses • Died in Le Cannet • 1867-1947
Oil on canvas • 46.5 in x 37.8 in • Phillips Collection, Washinton DC, USA/Giraudon/Bridgeman Art Library, London
© ADAGP, Paris and DACS, London 1998

Charles Marion Russell

THE WAGONS

Born in St. Louis, MO • Died in Great Falls, MT • 1865-1926
Oil on canvas • 30 in x 48 in • Kennedy Galleries, New York, USA/Bridgeman Art Library, London

Paul Klee

LOMOLARM

Born in Munchenbuchsee • Died in Muralto-Locarno • 1879-1940
Watercolor on paper • Musée National d'Art Moderne, Paris, France/Peter Willi/Bridgeman Art Library, London
© DACS 1998

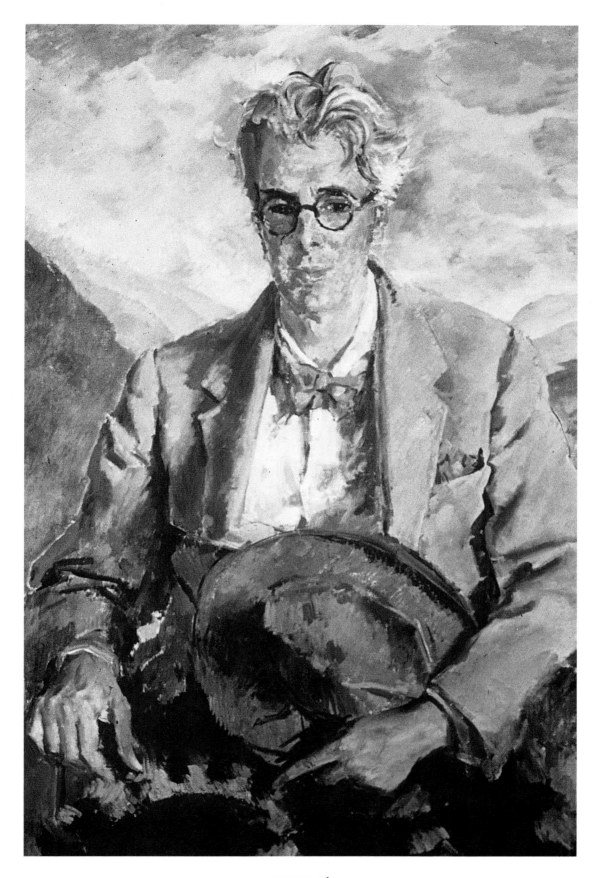

Augustus John

PORTRAIT OF YEATS

Born in Tenby, Wales • Died in Fordingbridge, Hants • 1878-1961
Oil on canvas • 48 in x 30 in • Glasgow Art Gallery and Museum, Scotland/Bridgeman Art Library, London

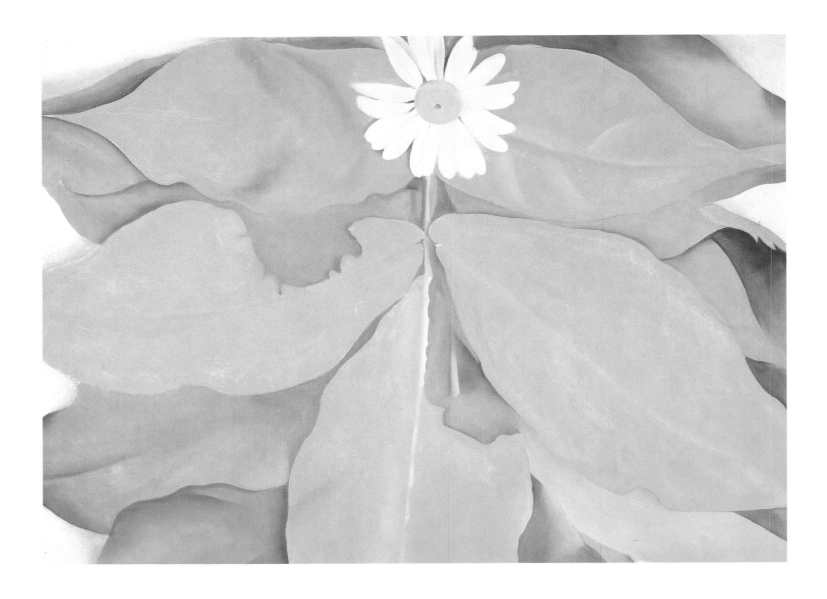

Georgia O'Keeffe

YELLOW HICKORY LEAVES WITH DAISY

Born in Sun Prairie, WI • Died in Santa Fé, NM • 1887-1986
Oil on canvas • 29.90 in x 39.90 in • Art Institute of Chicago, IL, USA/Bridgeman Art Library, London
© ARS, NY & DACS, London 1998

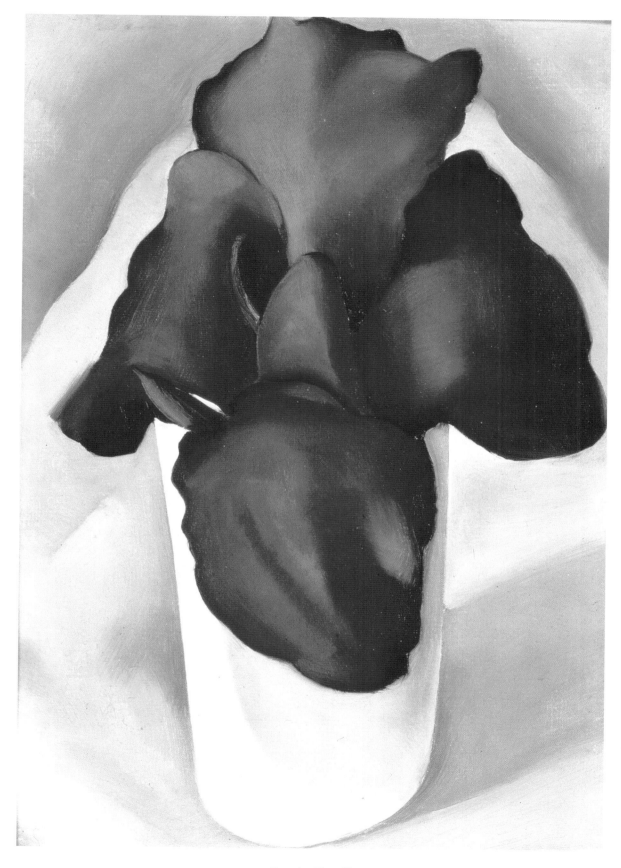

Georgia O'Keeffe

RED GLADIOLA IN WHITE VASE

Born in Sun Prairie, WI • Died in Santa Fé, NM • 1887-1986
Oil on canvas • 10.15 in x 7 in • Private Collection/Christies Images/Bridgeman Art Library, London
© ARS, NY & DACS, London 1998

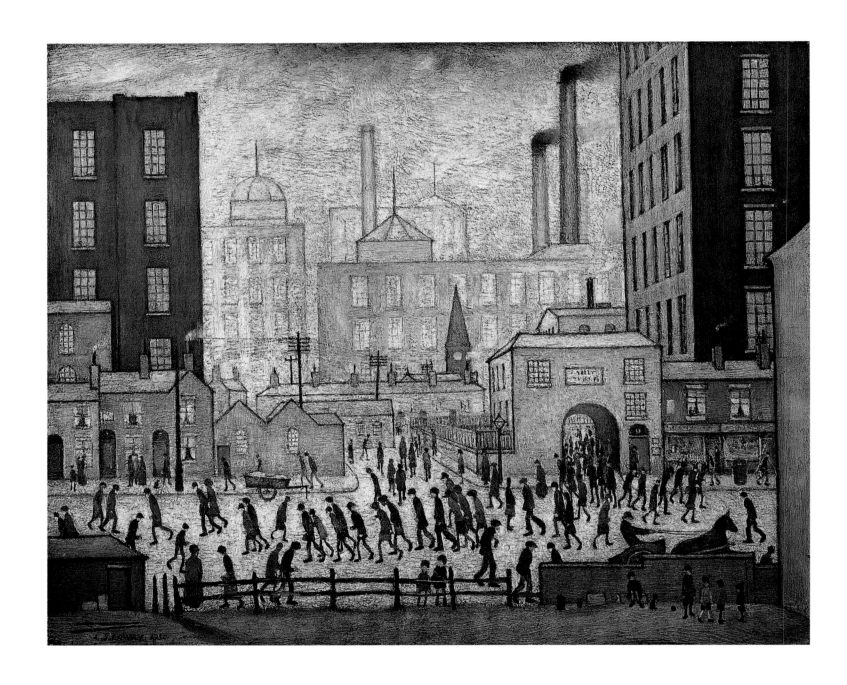

Laurence Stephen Lowry

COMING FROM THE MILL

Born in Manchester • Died in Glossop • 1887-1976
Oil on canvas • 16.5 in x 20.5 in • Salford Museum and Art Gallery, Lancashire, UK/Bridgeman Art Library, London

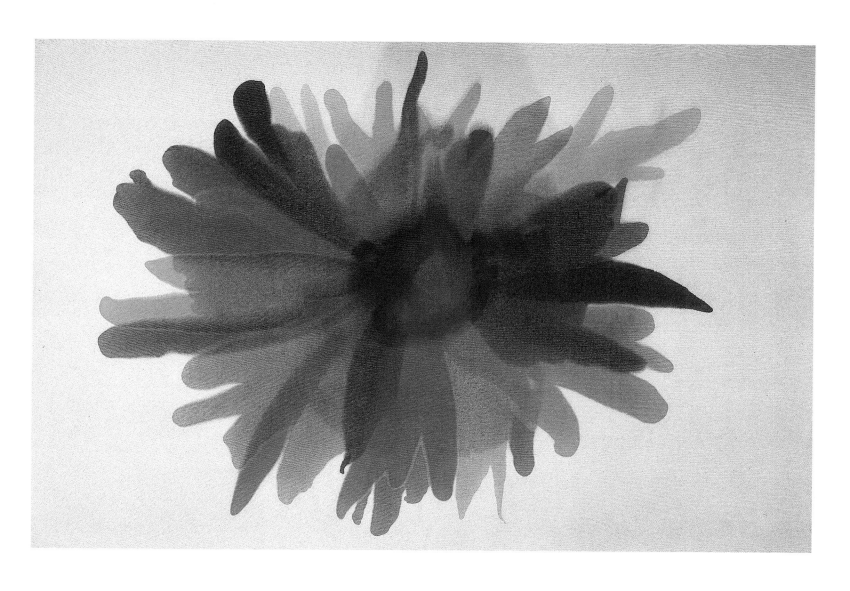

Morris Louis

SPAWN

Born in Baltimore, MD • Died in Washington DC • 1912-62
Private Collection/Bridgeman Art Library, London

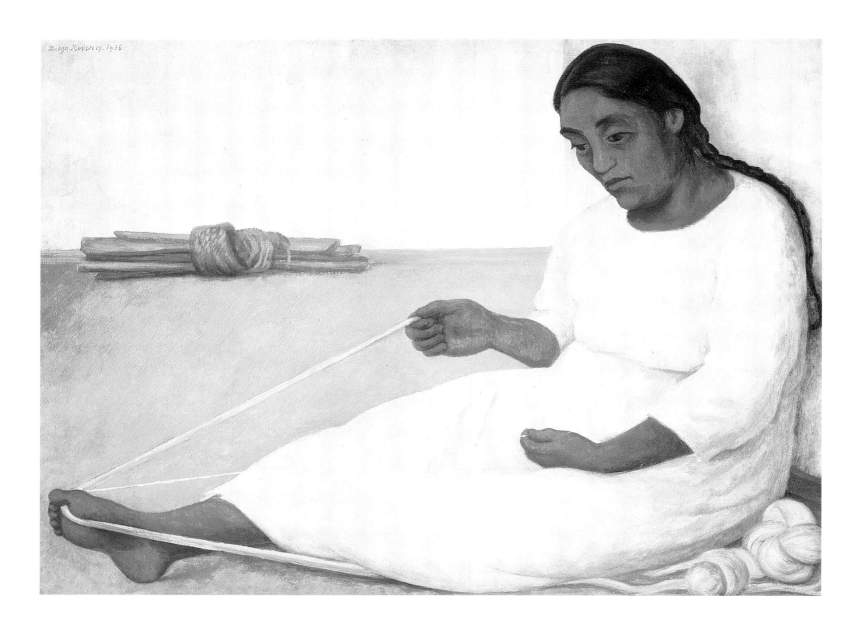

Diego Rivera

SOUTH AMERICAN INDIAN SPINNING

Born in Guanajuato • Died in Mexico City • 1886-1957
Oil on canvas • 23.5 in x 32 in • Phoenix Art Museum, Mexico/Index/Bridgeman Art Library, London
© DACS 1998

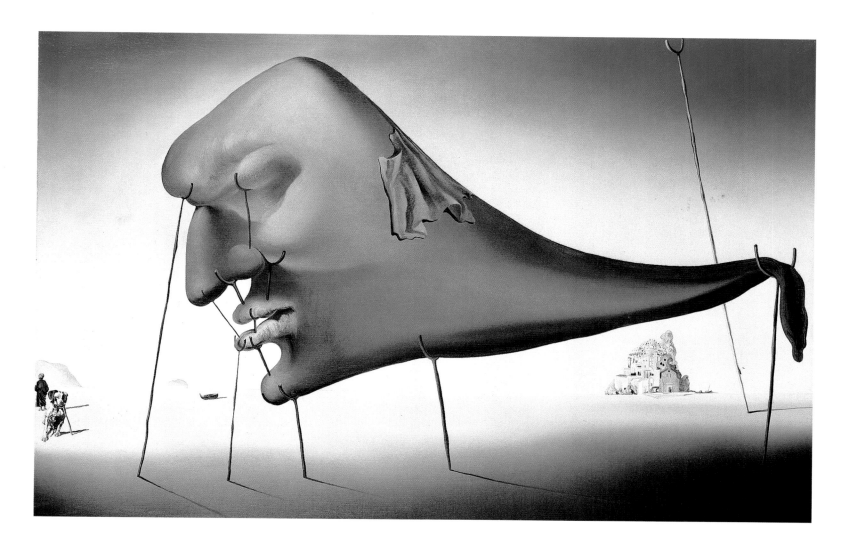

Salvador Dali

SLEEP

Born in Figueras • Died in Barcelona • 1904-89
Oil on canvas • 20 in x 30.8 in • Ex-Edward James Foundation, Sussex, UK/Bridgeman Art Library, London
© Salvador Dali - Poundation Gala - Salvador Dali/DACS, London 1998

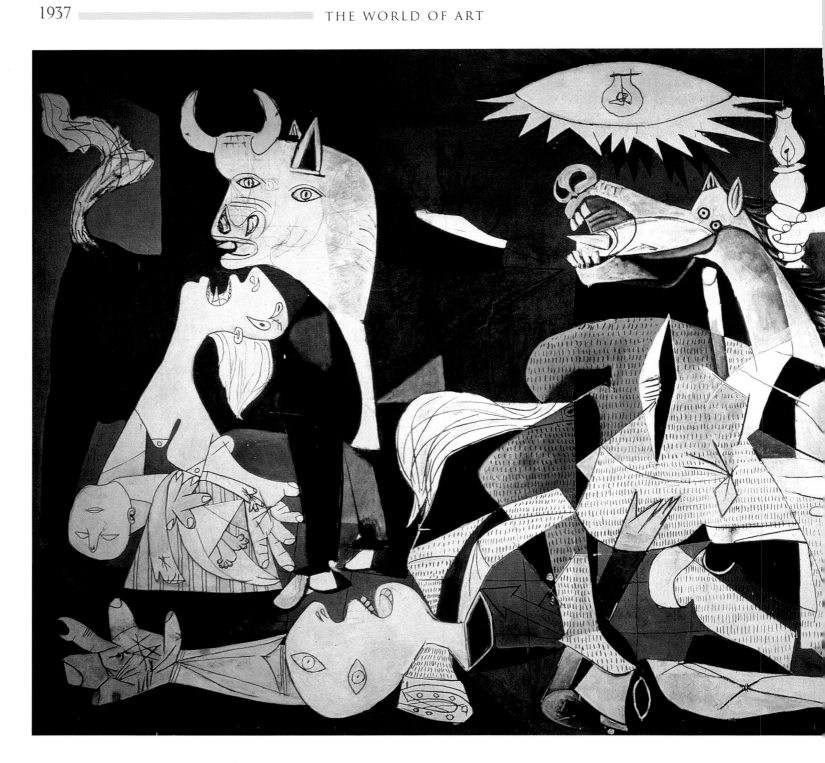

Pablo Picasso

GUERNICA

Born Malaga • Died Mougins • 1881-1973
Oil on canvas • 137.4 in x 303.9 in • Museo Nacional Centro de Arte Reina Sofia, Madrid, Spain/Giraudon/Bridgeman Art Library, London.
© Succession Picasso/DACS 1998

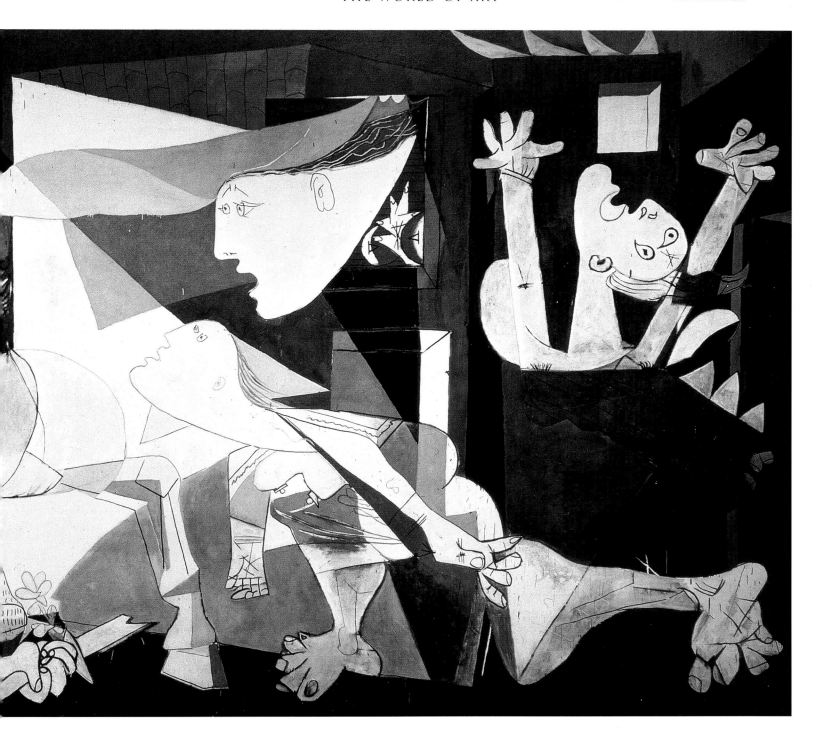

Percy Wyndham Lewis

MEXICAN SHAWL

Born at sea (off Nova Scotia) • Died in London • 1882-1957
Oil on canvas • 25 in x 30 in • City of Bristol Museum and Art Gallery, Avon, UK/Bridgeman Art Library, London

Grant Wood

PARSON WEEM'S FABLE

Born and died in Anamosa IA • 1892-1942
Charcoal and chalk on paper • Christie's Images/Bridgeman Art Library, London/© Estate of Grant Wood/VAGA, NY & DACS, London, 1998

Roberto Matta

PSYCHOLOGICAL MORPHOLOGY

Born in Chile • Born 1911
Oil on canvas • 18 in x 28 in • Art Gallery of Ontario, Toronto, Canada. Purchased with Donations from Ago Members and V.C. Fund 1991
© ADAGP, Paris and DACS, London 1998

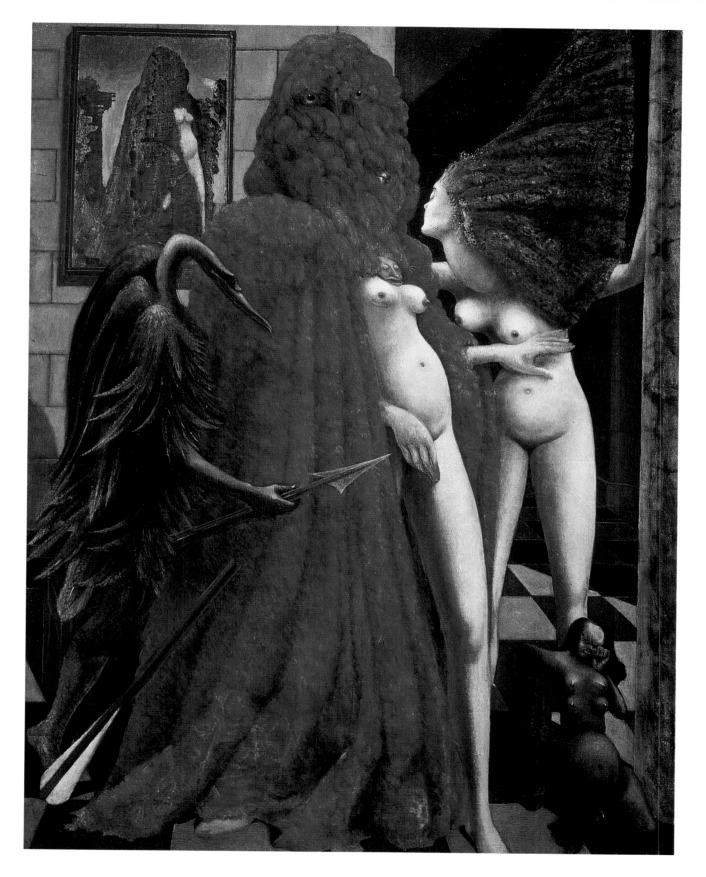

Max Ernst

THE ROBING OF THE BRIDE

Born in Bruhl • Died in Paris • 1891-1976
Oil on canvas • 51 in x 37.9 in • Solomon R. Guggenheim Museum, New York, USA/Bridgeman Art Library, London
© ADAGP, Paris and DACS, London 1998

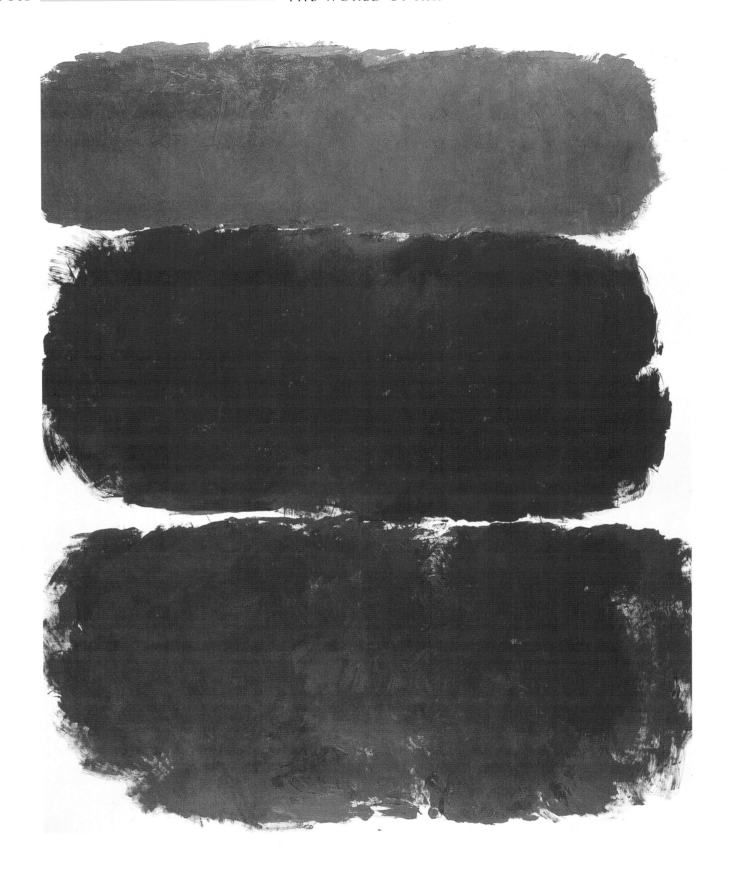

Mark Rothko

UNTITLED

Born in Dvinsk • Died in New York, NY • 1903-70
Private Collection/Bridgeman Art Library, London • © Kate Rothko Prizel & Christopher Rothko, London, DACS 1998

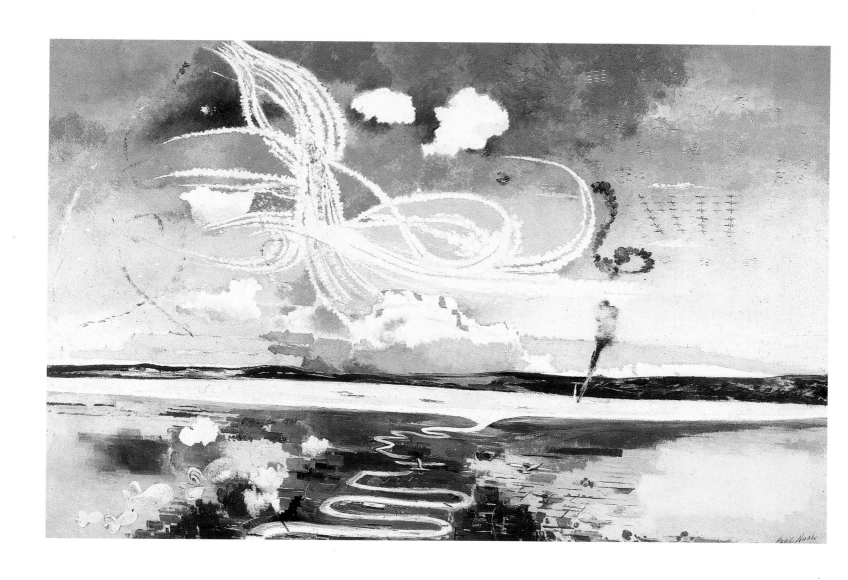

Paul Nash

THE BATTLE OF BRITAIN, AUGUST TO OCTOBER 1940

Born in London • Died in Boscombe, Sussex • 1889-1946
Oil on canvas • 48 in x 72 in • Imperial War Museum, London, UK/Bridgeman Art Library, London

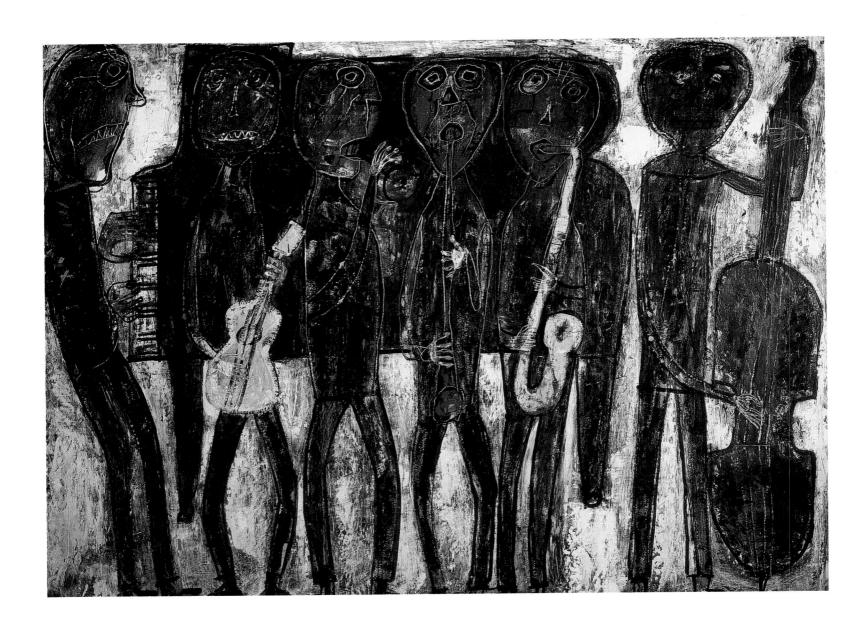

Jean Dubuffet

JAZZ BAND DIRTY STYLE BLUES

Born in Le Havre • Died in Paris • 1901-85
38.2 in x 40.6 in • Madeline Malraux Coll, Paris, France/Bridgeman Art Library, London
© ADAGP, Paris and DACS, London 1998

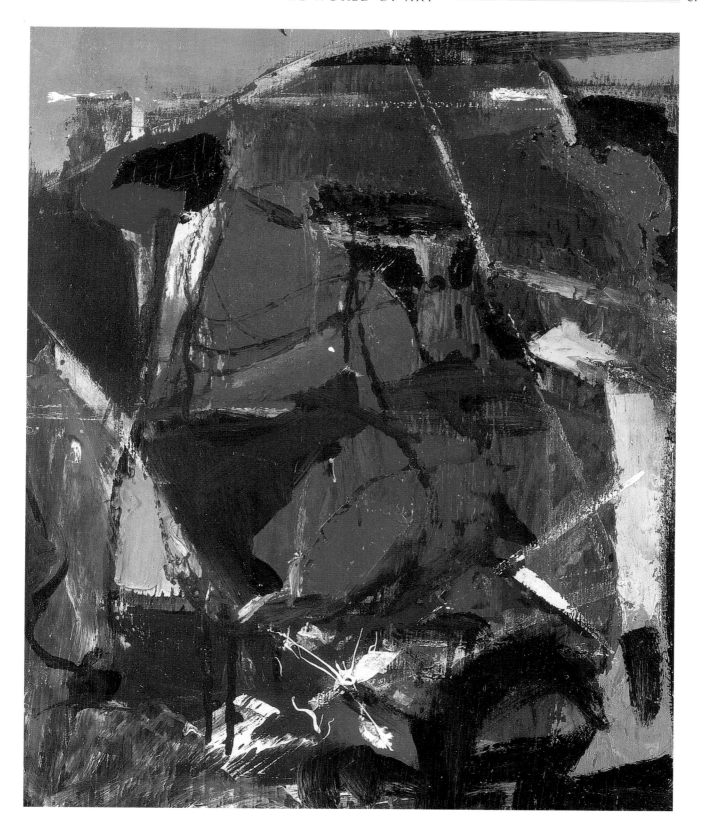

Franz Kline

ABSTRACT

Born in Wilkes-Barre, PA • Died in New York, NY • 1910-62
Oil on panel • 16.5 in x 19.7 in • Private Collection/Bridgeman Art Library, London

Oskar Kokoschka

VENICE, SANTA MARIA DELLA SALUTE III

Born in Pochlarn • Died in Montreux • 1886-1980
Oil on canvas • 33.5 in x 43.3 in • Private Collection/Bridgeman Art Library, London
© DACS 1998

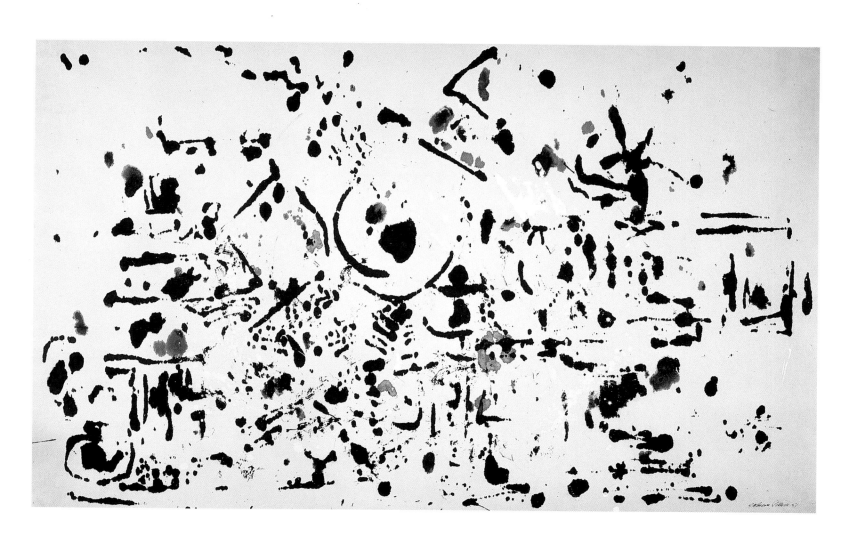

Jackson Pollock

UNTITLED

Born in Cody WY • Died in Springs, Long Island, NY • 1912-56
Ink and gouache on paper • 24.8 in x 39.3 in • Scottish National Gallery of Modern Art, Edinburgh, Scotland/Bridgeman Art Library, London
© ARS, NY & DACS, London 1998

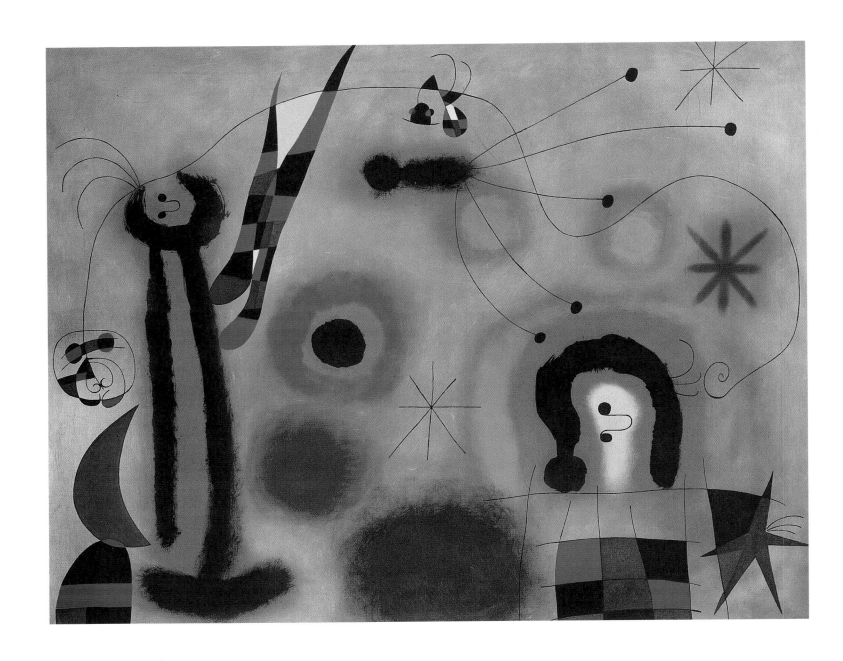

Joan Miró

DRAGONFLY WITH RED WINGS CHASING A SERPENT WHICH SLIPS AWAY IN A SPIRAL TOWARDS THE COMET

Born Montroig • Died Palma • 1893-1983
Oil on canvas • 31.9 in x 39.4 in • Museo del Prado, Madrid, Spain/Bridgeman Art Library, London
© ADAGP, Paris and DACS, London 1998

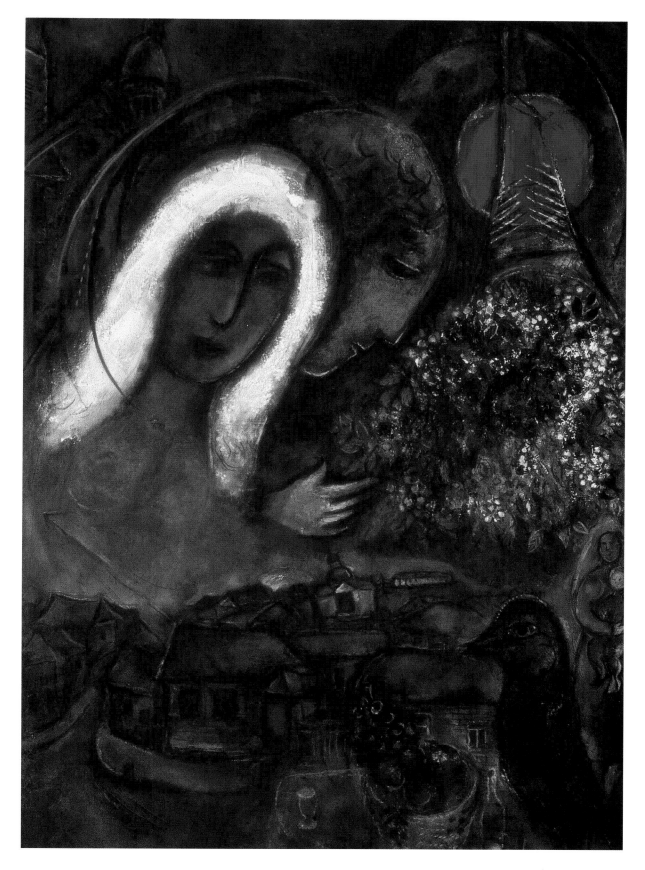

Marc Chagall

CHAMPS DE MARS

Born in Vitebsk • Died in St. Paul-de-Vence • 1887-1985
Oil on canvas • 58.9 in x 41.3 in • Museum Folkwang, Essen, West Germany/Bridgeman Art Library, London
© ADAGP, Paris and DACS, London 1998

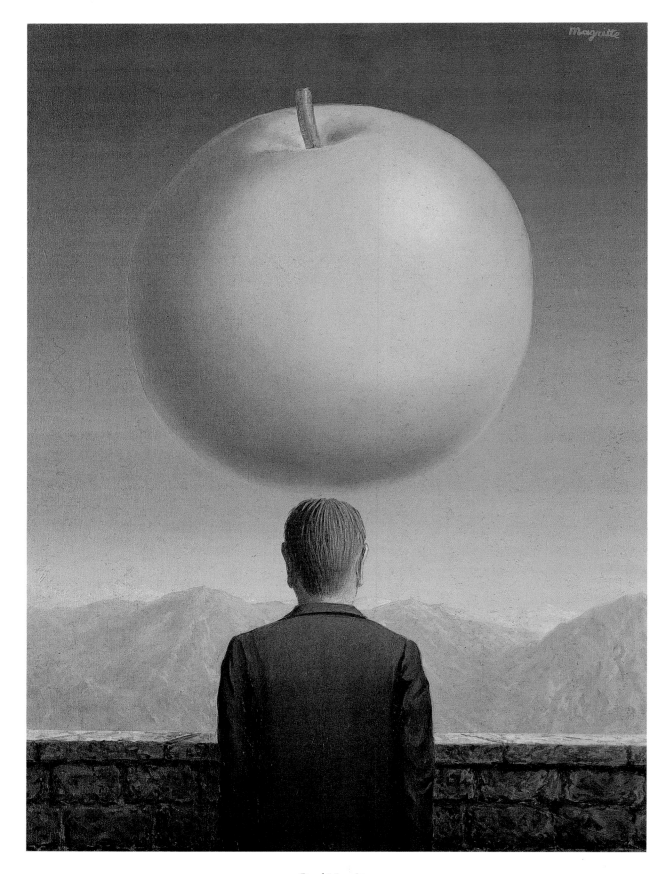

René Magritte

LA CARTE POSTALE

Born in Lessines • Died in Brussels • 1898-1967
Oil on canvas • 27.6 in x 19.7 in • Mayor Gallery/Private Collection, London, UK/Bridgeman Art Library, London
© ADAGP, Paris and DACS, London 1998

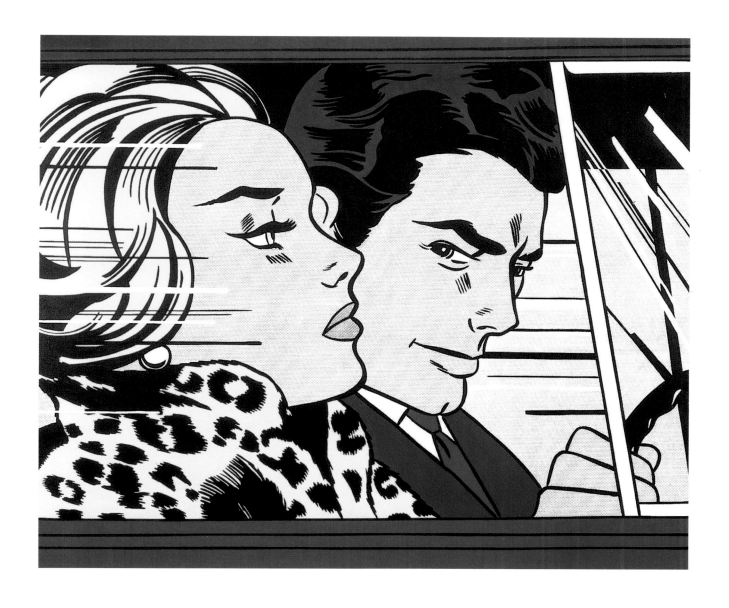

Roy Lichtenstein

IN THE CAR

Born in New York, NY • 1923-97
Magna on canvas • 67.7 in x 80.1 in • Scottish National Gallery of Modern Art, Edinburgh, Scotland/Bridgeman Art Library, London
© Estate of Roy Lichtenstein/DACS/London 1998

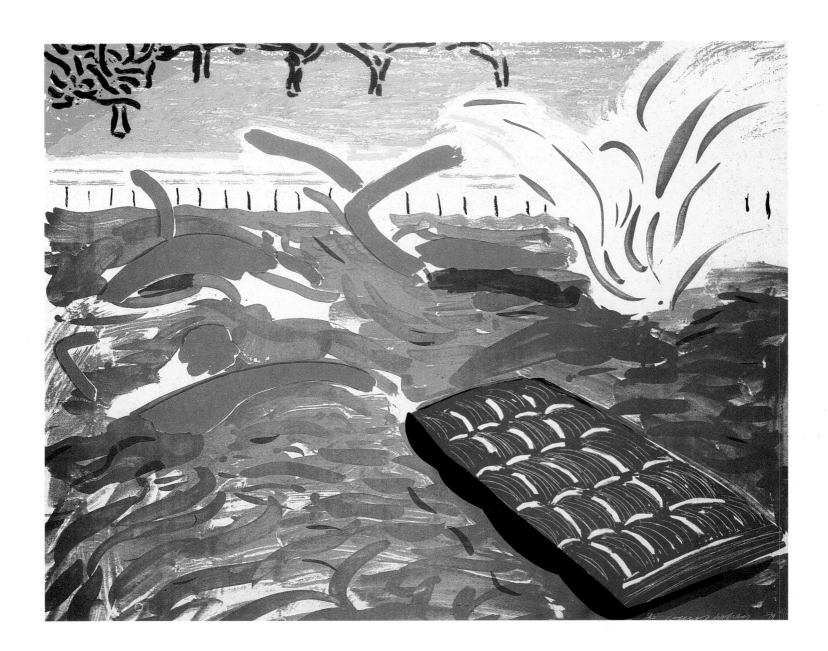

David Hockney

AFTERNOON SWIMMING

Born in Bradford, West Yorkshire • Born 1937
Lithograph • Christie's Images/Bridgeman Art Library, London

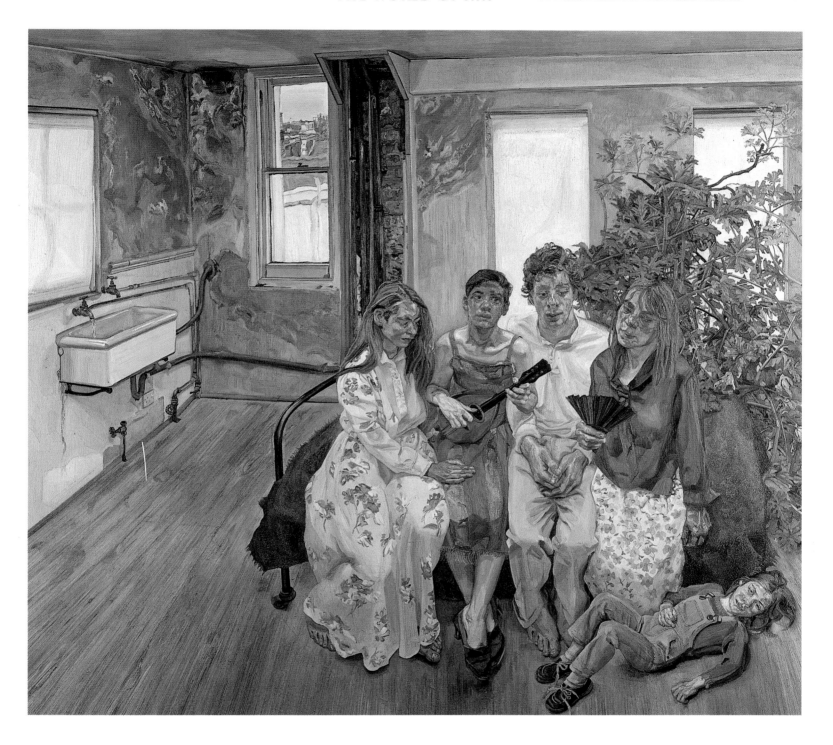

Lucian Freud

LARGE INTERIOR

Born and died in Berlin • 1922
Oil on canvas • 73.2 in x 78 in • Private Collection/Bridgeman Art Library, London

THE ARTISTS